Creative Reckonings

Stanford Studies in Middle Eastern and Islamic Societies and Cultures

Creative Reckonings

THE POLITICS OF ART AND CULTURE
IN CONTEMPORARY EGYPT

Jessica Winegar

Stanford University Press
Stanford, California 2006

Stanford University Press

Stanford, California

Printed in the United States of America on acid-free, archival-quality paper

Library of Congress Cataloging-in-Publication Data
Winegar, Jessica.
 Creative reckonings : the politics of art and culture in contemporary Egypt / Jessica Winegar.
 p. cm.--(Stanford studies in Middle Eastern and Islamic societies and cultures)
 Includes bibliographical references and index.
 ISBN-10: 0-8047-5476-4 (cloth : alk. paper)
 ISBN-10: 0-8047-5477-2 (pbk. : alk. paper)
 ISBN-13: 978-0-8047-5476-7 (cloth : alk. paper)
 ISBN-13: 978-0-8047-5477-4 (pbk. : alk. paper)
 1. Art and society--Egypt--History--20th century. 2. Art and society--Egypt--History--21st century. 3. Art--Political aspects--Egypt--History--21st century. I. Title.

N72.S6W58 2006
701'.030962--dc22 2006022051

Designed by Bruce Lundquist
Typeset at Stanford University Press in 10/14 Minion.

To my parents

CONTENTS

LIST OF ILLUSTRATIONS

Figures

Plates

Following Page 162

NOTE ON TRANSLITERATION

I HAVE USED the *International Journal of Middle East Studies* system to transliterate words from Modern Standard Arabic, modified to exclude diacritical marks. ' represents the consonant *ayn*, and ' is used for the *hamza* glottal stop. Words or phrases spoken in Cairene colloquial Arabic are also transliterated within this system according to how they sound, with the exception of the *qaf*. I have retained this consonant, usually made into a *hamza* by Egyptian speakers in Cairo and to its north, so that readers familiar with other Arabic dialects can recognize what was said. However, those readers should take note that in this form of Arabic, the letter *jim* is often made into a gutteral *g*, the *tha'* often becomes an *s*, and *dhal* and *za'* often become a *z*.

Nearly all of the people in this book transliterate their own names in English-language texts such as books, brochures, and catalogues. Even though they may be known by or prefer particular transliterations, different spellings of their names often persist throughout their printed materials. Therefore, I have chosen to spell all names according to the IJMES system in order to avoid any confusion. I have, however, used a *g* instead of a *j* to represent *jim*, because these individuals' names are universally pronounced in the Cairene Arabic. Proper nouns commonly recognized by another English spelling, such as "Nasser," are written as they usually appear in English.

PREFACE

NATIONAL CROSSROADS

Liberation Square, located in the heart of Cairo and named after Egypt's independence from Britain, is a symbolic manifestation of the local and global forces that have shaped the Egyptian nation for nearly a century. A million or more city dwellers pass through it daily, making it a virtual geographic crossroads of the country. Midan al-Tahrir, as it is known in Arabic, is also the nexus of the various paths that visual artists take every day, from home, to art school, to supply stores, to galleries, and to cafés. Criss-crossing the midan, they pass by various sites, each of which signifies a magnetic node within the field of forces where they live as artists and as Egyptians.

On one side of Liberation Square stands the state's Egyptian Museum, home to the famed material culture of ancient Egypt and built during the colonial period in the same neoclassical style as European national museums. Inside, tourists mix with schoolchildren, some of whom will one day become artists, to view the only art—Pharaonic art—for which Egypt is commonly known. Contemporary artists remember their own childhood visits there and talk about being inspired by the papyrus paintings and granite and alabaster sculptures in the museum's collection. Although proud of their heritage, they simultaneously feel burdened by it. They fear that they cannot live up to what they see as an artistic standard set by their ancestors. Furthermore, they know that the fame of Pharaonic art overshadows their own work. It is one of the reasons that their art is largely unknown or ignored both within Egypt and internationally.

Adjacent to this national institution sits the Hilton Hotel, built by a public sector company along with the international Hilton corporation, and opened by Egypt's President Gamal 'Abd al-Nasser (1954–70) and Yugoslavia's Marshal Tito in 1959 as part of the Non-Aligned Movement. As with many businesses in Egypt, private investors have since taken over the government's share of ownership. The hotel's restaurants and discotheque are favorite nightspots for Egyptian and other Arab elites, who sometimes buy local art. The hotel hosts the American and European tourists who also purchase art, or, more often, the imitation Pharaonic knickknacks that many artists make to support their careers. They are joined by foreign curators, who have recently started coming to Egypt in search of a new frontier in contemporary art.

Right next to the Hilton is another building that has changed with the political and economic tides of postcolonial Egypt. Formerly the headquarters of Nasser's Arab Socialist Union, it was converted into an Islamic bank when President Anwar al-Sadat (1970–81) began dismantling the socialist agenda and courting religionists. The major exhibition space that the headquarters had housed was simultaneously closed down. Today, the building is the headquarters of President Husni Mubarak's National Democratic Party, whose members make many of the decisions that determine the shape of cultural policy. The Arab League headquarters next door serve as a reminder of Egypt's continuing, though not uncontested, role as leader of the Arab world, including its arts.

Across the way sits the most potent symbol of the state's centralizing power and bureaucratic inefficiency—the Mugamma'—a massive concrete structure built in a local style of socialist realism. Along with millions of their co-citizens, artists pass through the tight security to stand in long lines waiting for permissions and papers from the branches of various government ministries located inside. Among these documents are their passports to go to exhibitions and residencies abroad.

Behind this imposing building lies the 'Umar Makram mosque. This is where state dignitaries and other elites pray and have funerals, sometimes broadcast on television. It is where they can show that they value Islam while also containing its political dimensions, to broadcast the "correct" practice of it to a nation that has produced some of the most famous Islamist groups in history. Behind that mosque, and behind ever-growing concrete barriers and walls, looms the largest U.S. embassy in the world, which declares the centrality of Egypt to U.S. strategic planning in the Middle East. It is also where art-

ists have waited anxiously for visas that will enable them to study for higher degrees in the United States, to go on State Department–sponsored trips to visit American museums, or to visit New York galleries.

The American University in Cairo is adjacent to this constellation of government buildings. Combined with the neighboring McDonald's, Kentucky Fried Chicken, and Pizza Hut franchises, it is another striking reminder of the centrality of the United States in Egyptian politics, society, and economic life, especially since the 1970s. This is the place where I learned Arabic with other Americans, alongside the children of those who made it rich through Sadat's open door trade policy that encouraged American-style capitalist investment. It is also where I, along with foreign curators, have been asked to lecture on contemporary Egyptian art. But the subjects of our talks, the middle-class Egyptians who comprise the vast majority of artists in the country, can only gain entry to the university if we beg the guards or personally escort them through the security that "protects" this world of the upper class and foreign academics.

The entire square has also been the focal point of Egyptian citizens' agency. Masses of people poured into it for the funerals of Nasser and the immensely popular nationalist singers Umm Kulthum and 'Abd al-Halim Hafiz. It has also been the site of clashes with the police—in demonstrations against the end of major state subsidies, against the U.S. invasion of Iraq, and against Mubarak's hold on power. Secularists have stood next to Islamists in demonstrations supporting the Palestinian intifada and calling for an end to Israel's occupation of Palestine.

This central crossroads in the capital city of Egypt and the name "Liberation Square" graphically signify several key dynamics that continue to shape what it means to be an Egyptian artist, and also what it means to be an Egyptian. These include colonialism, post-independence state socialism, nationalism and claims of artistic patrimony, Egypt's role in the Middle East, the growth of Islamism, privatization and market liberalization, and foreign political, economic, and military interventions. This book examines how each of these dynamics played out in the field of artistic production and consumption at the turn of the twenty-first century. This is a field that bears the contradictions set in motion by these modern dynamics most noticeably. By focusing on this evocative yet marginalized (in Egypt and in the scholarship) set of practices, I look at the exceptional in order to say something more general about social life in post-independence Egypt.

ACKNOWLEDGMENTS

LONG AGO while standing in Washington Square Park in New York City, Omnia El Shakry convinced me that this was a project worth doing. I'll be forever indebted to her, and to all the people in Egypt who subsequently let me into their lives and helped me understand something about them. *Shukran khass* to Amal 'Abd al-Ghani, Walid 'Abd al-Khaliq, Muhammad Abu al-Naga, Muhammad al-Ginubi, 'Aliya' al-Giridi, Stefania Angarano, Nagi Farid, Khalid Hafiz, Samih al-Halawani, Rim Hasan, Adam Hinayn, Salwa al-Maghrabi, 'Izz al-Din Nagib, Sabah Na'im, Shadi al-Nushuqati, Hisham Nawwar, Mustafa al-Razzaz, Muhammad Rizq, Mu'taz al-Safti, Wa'il Shawqi, Mahmud Shukri, Nazir al-Tanbuli, and William Wells. I shall always value the friendship and assistance of 'Ayda Khalil, Tariq Ma'mun, Khalid Shukri, and my "nephew" Sharif Sa'd.

Notes and drafts for this book were carried across two continents and five institutions, and I incurred many debts along the way. The basic ideas were developed while I was a graduate student at New York University, and I owe my deepest intellectual debt to my Ph.D. advisors, Fred Myers and Lila Abu-Lughod. I hope that they see in these pages the myriad ways in which they have inspired my thinking through their constant prodding and support. From graduate school days (and some beyond) I must also thank Michael Gilsenan, Zachary Lockman, Vera Zolberg, Susan Carol Rogers, and Claudio Lomnitz, who probably has no idea how much he got me to think. The International Center for Advanced Study at NYU funded a critical year of dissertation write-up, during which I greatly benefited from conversations

with Mark Alan Healey. Special thanks to dissertation co-conspirators Steve Albert, Melissa Checker, Wendy Leynse, Jennifer Patico, and Shalini Shankar for their very early readings, along with Maggie Fishman and Peter Zabielskis, who both gave insightful comparisons with the New York art world.

The Sultan Program of the Center for Middle Eastern Studies at the University of California, Berkeley, and especially Nezar AlSayyad and Beshara Doumani (who initially inspired my interest in the Middle East), supported the project early on. I also thank friends and colleagues at Cornell University for their support while I was working through some of the major ideas. Audra Simpson, Jakob Rigi, and Dominic Boyer lent keen comments on some of the chapters. I also thank Hiro Miyazaki, David Holmberg, Salah Hassan, Brett de Bary, Jane Fajans, Deborah Starr, and Terry Turner for their encouragement and suggestions.

There is no place quite like the School of American Research in Santa Fe. I was so fortunate to have spent an idyllic year there letting my ideas mature and revising the entire manuscript among the best colleagues anyone could ask for. I really miss the daily intellectual camaraderie given me by Laura Gomez, Ivan Karp, Cory Kratz, Joe Masco, Paul Nadasdy, Sean Teuton, Marina Welker, and Kay Yandell and thank them all for their many contributions. My work in Santa Fe also benefited from conversations with, and readings from, Rebecca Allahyari, James Brooks, Catherine Cocks, Jim Faris, and Nancy Owen-Lewis. I am especially grateful to Fordham University for giving me the time to write the book at SAR, and I owe special thanks to Ayala Fader, Allan Gilbert, and Dominic Balestra for their support.

The final round of fieldwork and revisions in Egypt was greatly facilitated by 'Umar 'Abd al-Mu'iz, 'Ayda Khalil, 'Imad Ibrahim, Hamdi Attia, Khalid Shukri, Hazim Salim, Sharif Sa'd, Khalid Hafiz, Karim Mostafa, and Tariq Ma'mun. For assistance with the images and last-minute details, I greatly appreciate the Herculean efforts of Muhammad 'Abd al-Ghani, Dalila al-Kirdani, Akram al-Magdub, Hamdi Attia, Parastou Hassouri, Lee Keath, Amir Moosavi, Mustafa al-Razzaz, Hani Yasin, the Zamalek Art Gallery, and especially 'Ayda Khalil.

I thank Mona Abaza, Kamran Ali, and Walter Armbrust for inviting me to present portions of the book at key junctures. Elliott Colla and Ted Swedenburg generously reviewed the entire manuscript, and I especially appreciate Elliott's commitment and wise advice. Other intellectual contributions were graciously offered by Waiel Ashry, Muhammad al-Ginubi, Laura Bier, Erica

Bornstein, Jessica Cattelino, John Collins, Sherine Hamdy, Mark Peterson, Christa Salamandra, Hazim Salim, and John Willis. Kate Wahl has made the process of publishing a first book very enjoyable. Her diligence and commitment to the project is very much appreciated. I also thank Peter Dreyer for his expert editing.

Various agencies supported the nuts and bolts of research and writing. I thank the Joint Committee on the Near and Middle East of the Social Science Research Council, the Binational Fulbright Commission in Egypt, the Mellon Foundation, and the National Endowment for the Humanities. Cornell University's Society for the Humanities and Department of Anthropology, along with the School of American Research, provided precious space and time to write. I am also grateful to the Center for Arabic Study Abroad for its superb language training.

Kirsten Scheid, Elizabeth Smith, and especially Lori Allen have been my closest readers and interlocutors, always pushing me to consider alternatives and new possibilities, always ready to answer queries, and to read the occasional thought, paragraph, or note sent by email. I am humbled by their generosity and amazed by their acumen.

And to those family and friends who waited so long to hear me say, "I'm done!"—well, I wouldn't have been able to say it now without your love, gifts of food, money, and places to stay, and your supply of phone calls, emails, and good music to lift my spirits. My deepest thanks to the Shilla, Barb and Steve Kapner, Bayt 'Atiyya, Bayt 'Abd al-Nasir, my grandmother Elizabeth Winegar, my parents Rick and Janice Winegar, and my sister Natasha Winegar. Hamdi Attia helped me keep it all in perspective, and for that and so much more, I am eternally grateful.

INTRODUCTION
Cultural Politics and Genealogies of the Modern
in the Postcolony

THIS BOOK IS ABOUT what it means to practice modern art from a location and history traditionally positioned at the periphery of Euro-American modernisms. As such, it is about how people construct meaningful and creative lives through their reckoning with genealogies of the modern that have given them a vision of a more equitable future, but at the cost of constant reminders about Western superiority and the failures of postcolonial nation-building. The field of art constitutes a particularly fraught space in Egyptian society, because it insists on making apparent these contradictions in the genealogies of the modern as experienced in the postcolony. Modern art is simultaneously considered a colonial import and an elite interest, an expression of things Egyptian and a cordoned-off zone of national authenticity, a vehicle of nationalist globalization and a wholly cosmopolitan enterprise. It is seen as both a means of making money and as something to be protected from capitalist interests. Modern art is made both to embody and to deny teleological notions of progress and their attendant Western cultural hierarchies (often rooted in objects). And it forms the basis of appeals to "universal" standards and the sublime, while at the same time laying bare the chauvinism of universalist claims. Every act of producing, purchasing, or interacting with modern art in Egypt therefore constitutes a reckoning with the processes of capitalist modernity, as experienced by those elites designated as its "local" cultural emissaries, while also suffering its "international" discriminations.

This book is more specifically about how this reckoning took place within the context of a society where post-independence state socialist institutions were being dismantled in the interest of neoliberal economic "reform," where

1

all that had seemed solid was melting into the air, and where people wondered whether they would be lifted skywards or disappear altogether. Socialism in Egypt had also been an anti-colonial ideology, so transformation from it in the era of post–Cold War American global intervention produced cultural politics of the most intense order, particularly in the visual art field.[1] People working in the arts tried to make sense of the uncertainties surrounding them through debates over the nature, purpose, and future of Egyptian culture and cultural production. In this book, I try to capture this process as I saw and experienced it during fieldwork between 1996 and 2004—a period in which people in Egypt marveled, many warily, at the drastic changes in material life, visual culture, social space, and transnational connections wrought by neo-liberalism. I show the historically constructed ideologies of artistic produc-tion and consumption that preceded and were coterminous with the shift, and how artists, critics, curators, and collectors drew on these ideologies as frame-works to understand the transformation. I argue that the historical constitu-tion of the field of visual arts through colonialism, and its cementing through the institutions of nationalist socialism, necessarily linked visual art practice to national ideology, and that the nation became the dominant frame through which the majority of art world people made sense of the transformation. I also give a sense of the "structures of feeling" (Williams 1977) that I, along with my informants, felt emerging. These were often related to the nation in some way although not necessarily to the nation-state's institutions. Finally, I try to communicate the high stakes for people involved in the visual arts, and the culture industries more generally, as the Egyptian economy underwent restructuring. Indeed, much was at stake—from people's personal welfare to their entire worldview and the system of values constituting it, to their sense of artistic and national community and, ultimately, their integrity.

Also at stake was the question of whose modernism, or whose terms, would dominate as Egyptian art and cultural production globalized along the lines of capital. This process was different from the internationalization of socialism and Bandung Third Worldism—during which leftist artists and intellectuals in Egypt had clearer bases for political and artistic action, imagination, and engagement with the world, and during which there was still hope that the concepts of "progress" and "development" could be wrested from the West's monopoly, and Egyptians could become equal participants in the community of nations. By the 1990s, the Third Worldist socialist project had suffered seri-ous discrediting (but not complete rejection), and the limitations of Euro-

pean Enlightenment versions of modernist concepts came to be recognized alongside their utility. It is my hope that this ethnographic exploration of the art world in Egypt will help provincialize these concepts (Chakrabarty 2000), because it takes seriously the lives, art, and thought of those who worked from different social and historical locations than those of their colleagues born and raised in Europe and the United States. These locations led them especially (as "conscripts of modernity") to recognize the "inadequacy" and "indispensability" of the terms of European modernity in their ongoing struggle for justice and cultural/national self-determination "after Bandung" (see Scott 1999, 2004; Chakrabarty 2000). What can we learn from their reckoning with genealogies of the modern, their attempt to create meaningful lives and artworks that engage with people, concepts, and forms from other locations but are not reducible to lesser imitations of them?

Euro-American modernist modes of assessing artists and cultural production from the postcolony persist, even among intellectuals sympathetic to "post" theories associated with going beyond such modes (e.g., postmodernism, poststructuralism, postcolonialism). Time and again, critics, curators, and scholars working from Western institutions have judged the art and artists discussed in this book according to a teleological notion of artistic progress that maps onto a "West before and above the rest" cultural hierarchy. Artists have been assessed according to the persistent idea that they should be individualist malcontents, always challenging social norms. Their work has been judged through hierarchies of value that emphasize the "shock of the new" and a break with "tradition." It has also been assessed according to a Kantian-inspired view that art should be autonomous, not sullied by mechanical or utilitarian connections to politics, class, money, or self-interest. The problem is that all of these evaluations assume a universal hierarchy of artistic value. This assumption caused no small amount of distress and anxiety among the artists I knew, particularly because their nation-based inspirations for and understandings of art, art history, and art careers were at the bottom of this hierarchy.

Why do otherwise savvy scholars and critics seem wedded to these modernist universals when engaging with art and artists from the postcolony, even when they have decried the application of these universals in other fields?[2] And, moreover, why is assessment usually their first and primary mode of engagement? Later in the book, I offer some answers specific to ethnographic research I did with such people when they came to Cairo.[3] Here, I want to suggest that

because of the legacy of Euro-American modernist concepts of art's autonomy, such postures of assessment based on an assumed universal hierarchy of value are especially tenacious when it comes to art. If art (or aesthetics for that matter) is viewed as, or is hoped to be, autonomous from utilitarian or mundane concerns, then it remains a privileged and "objective" space of social critique, boundary making, and hierarchy creating (see Marcus and Myers 1995 for a full explication of this process).

Yet the claim of objectivity, which is akin to the illusion of disinterest that Pierre Bourdieu (1984) and Terry Eagleton (1990) identify as central to ideologies of so-called natural taste and the aesthetic, takes place on an unequal playing field. Those doing the judging have significantly more power than those being judged. The "objective" appeal to universal, "natural" standards enabled by the idea of art's autonomy masks all kinds of actual "interests" in non-Western art and artists. These interests include making money off the work, advancing careers by representing and writing about it,[4] and claiming that other people's intellectual prowess and critical artistic capabilities are less sophisticated than one's own. But I also believe that such modernist assessments endure because those of us who work in Western institutions and who share leftist sentiments maintain an interest in a more utopian and liberatory future, and find in art from the postcolony a site where we can articulate and push for our visions without fear of having them criticized as naïve, as they would be in other realms.

It seems to me that such art, because of the particularly powerful fantasy of autonomy attached to it, becomes a site where Euro-American scholars and critics can displace the anxieties caused by the challenges that "post" theories have made to their art's autonomy, and to standards and universals. Art, a classic site of redemptive value,[5] is a place where one can maintain visions of utopian, often liberal and secular, political projects. Such visions find particular opportunities for elaboration when it comes to Egyptian art, and arts from the Middle East in general, because it is assumed that art should be a space of freedom from the supposed strictures of Middle Eastern societies, particularly in the realms of gender and Islam (often misunderstood as an image-forbidding religion).[6] If artists do not fight for art's complete autonomy from political, economic, or social power (see Bourdieu 1993), as I argue that they indeed do not in Egypt, then they and their art can be deemed "not quite there yet." Middle Eastern art, then, becomes not just a space for the elaboration of utopian visions of autonomy. It also becomes the locus of West/East difference,

the site of ultimate Eastern backwardness: even their artists do not know what freedom is.

Because of the unrelenting persistence of such thinking when it comes to art from the postcolony, I find the project of provincializing Europe put forward by Dipesh Chakrabarty (2000) particularly necessary and productive to extend to the field of the visual arts.[7] Through careful and detailed ethnographic understanding of an art world whose genealogies of the modern are differently situated, but not wholly different, from Euro-American ones, we can destabilize what might very well be the last bastion of colonial-modernist thinking in critical engagements with cultural others. One sees the "inadequacy" of such thinking, both for those making art in Egypt and for those consuming it (Chakrabarty 2000).

This ethnographic material goes a step further. It also speaks back to "post" theories that have critiqued modernist concepts in other realms, because it shows what Chakrabarty insists is the "indispensability" of some of these concepts for social life and political projects in the postcolony (2000). In this material, we see a modern that does not insist on a break with concepts of tradition, the past, or the mundane world. We are forced to confront people's respect for certain kinds of essentialisms and their recognition of the utility of some teleologies. We see their refusal to abandon desires for national liberation, and a pragmatic approach to that end that is not denuded by anti-essentialist critique. In sum, we learn how Egyptian modernism involves the selective adoption and repudiation of certain concepts of European modernity (Abu-Lughod 1998; Chatterjee 1993), but always through a process of translation that produces "difference" (Chakrabarty 2000, 17). As I shall show, this process has been fundamentally shaped by the histories of colonialism and socialism, the politics of nationalism, social class dynamics, and the transformations associated with neoliberalism.

Although this ethnography of artists, critics, curators, and collectors in turn-of-the-twenty-first-century Egypt has the potential to lay bare some unexpected assumptions and chauvinisms of much contemporary critical theory concerning cultural production, I do not want to put these people's lives at the total service of such a project. Thus, the major thrust of this book is to explore how they created meaning and value in a period of social, economic, and political transformation through what I call their "reckoning" with genealogies of the modern. Later I shall explain more precisely what I mean by genealogies of the modern, but here I want to describe the concept

of reckoning and why it is useful. The etymology of the term (from the Old English *recenian*) and its various instantiations contain rich notions of working out, calculating, thinking, narrating, arranging, dealing with, taking into account, and settling accounts. The nautical use of reckoning adds a sense of navigation, of charting unknown waters through known or set points. If we think of Egyptian arts interlocutors as navigating their way through the major social transformations of post–Cold War Egypt by creatively calculating their positions and dealing with the exigencies and problematics put forward by various genealogies of the modern, we arrive at a much more accurate and dynamic understanding of postcolonial cultural production than that usually found in Western art writing about it.

Most important, the concept of reckoning has agentive and processual qualities. It therefore emphasizes Egyptian arts interlocutors' active, creative, and ongoing engagement with the many different values, forms, ideologies, and histories associated with the modern. It therefore works against the curatorial moves that accuse Egyptians of imitating Western artists. And it resists the totalizing aspects of the "progress" narrative to which, it is claimed by everyone from Western curators to the World Bank and the U.S. government, Egyptians must eventually submit. To reckon is to think about something, to figure it out. Things are weighed and considered at an individual level and also in debates with others. Conclusions, although often temporary, are then narrated to one's interlocutors. Reckoning, therefore, constitutes an inherently interpretive and social process.

Reckoning makes room for two key senses of knowledge that were operative in the Egyptian art world: knowledge as a process of discovering, and knowledge as something that is constantly being made.[8] These interacted in creative tension with each other, as arts interlocutors hoped for an enlightened ending to the process of discovery but also knew that such an ending is elusive, partly because the process is itself fraught with problems that need to be tackled so that knowledge can be made anew. Thus "reckoning" captures people's sense of having to deal with (or discover) things that appear to have already been set (such as Western superiority, definitions of modernism, the brilliance of Pharaonic art, state nationalism, socialist ideology). Actions, artworks, ideas, social events, and so on, were then judged according to these things, or interpreted as challenges to the apparent truthfulness of these things, depending on both the context and the position and opinions of the interlocutor. The concept of reckoning therefore enables us to recognize agency without un-

critically adopting a notion of individual or cultural autonomy, and without utopian claims of "local" people's self-creation in the face of "Western" domination.[9] It does so because reckoning takes place within sets of circumstances and imperatives, that each have varying degrees of fixedness.

"Reckoning" also communicates the urgency of having to calculate the past and present through consideration of various genealogies of the modern, and of using those calculations to estimate, and indeed create, the future. Reckoning is thus a way of creating knowledge that can be a new formulation, but is never without reference to a "tradition" in the sense of a set of discourses that "relate conceptually to *a past . . .* and *a future* through *a present*" (Asad 1986:14, emphasis in original). As Talal Asad argues, tradition is not a "reaction," "fiction," or "repetition." It is a living thing. At the risk of extending the concept too far, I suggest that reckoning is then akin to *ijtihad*, the process (usually in Islamic law) of independent (*not* imitative), interpretive reasoning by reference to, and as part of, a tradition. Like *ijtihad*, artistic reckoning occurs within a discursive tradition. It is motivated by disagreement and results in a decision for the present—a decision that makes knowledge through conceptual reference to the past but is also geared toward an ultimate truth to be more fully discovered and experienced in the future. This process is much like that of dead reckoning on the open seas.

Finally, the mathematical connotations of reckoning invoke the image of settling accounts. Accounts to be settled were those between different individuals, groups, and institutions in the art world, and, perhaps more important, between "Egypt" and the "West." Calculations were also a part of this process. As a dramatic word (e.g., "day of reckoning"), reckoning puts a spotlight on the high stakes that social actors perceived as central to their disputes with one another and with the "West." To put it another way, reckoning itself was also motivated by these stakes.

I shall show how one major aspect of this process of reckoning involved making, exhibiting, collecting, and talking about art in ways that foregrounded nation-oriented concepts of culture, history, authenticity, and progress. This process did not proceed smoothly. It was marked by heated battles about cultural politics, in which people fought over definitions of these concepts and, in fact, over the nation itself. The ethnographies of Lila Abu-Lughod (2005) and Walter Armbrust (1996) have both, in different ways, looked at how Egyptian television and film are central to the production of national culture on a national scale. Fine artists can only dream that their productions might have

the kind of national effect that these mass media have had in Egyptian life. What my study adds to these major works on Egyptian cultural production is an exploration of the marginal, as well as a sustained focus on cultural politics and on the anxieties that are intensified and motivated by this marginality. Indeed, attention to a marginalized practice like the visual arts is an especially illuminating way to get at the contours of the production of the nation, because debates over the nation itself are often intensified among those whose relationship to its truth claims is compromised in whatever way. The art world was a space of vigorous contestation around issues of national pasts and futures because visual art itself (unlike film, television, and indeed music, dance, theater, literature, and the verbal arts) had been made to index and embody the key tensions inherent in national projects over the decades. The art world was a site of heightened comment and critique about the nation, not because it was wholly autonomous, but because it was a space where different genealogies of the modern constantly chafed against one another. Such frictions were first set in motion by colonialism, accelerated by nationalist socialism, and then, at the end of the twentieth century, reinvigorated by neoliberal capitalist globalization. For many Egyptian artists and intellectuals, the first and last periods are not unrelated.

The main fieldwork for this book was conducted during the latter period, when concerns about foreign domination were intensified (1996–97 and 1999–2000, with additional one-to-three-month research trips in 2002, 2003, and 2004).[10] During these years, Egyptian society went on a roller-coaster ride as the government followed Western donors' prescriptions to enact wide-ranging neoliberal reforms. Dramatic changes wrought by these reforms set intellectual circles on fire. The ensuing debates among visual artists, in particular, reveal the key tensions that the post–Cold War realignment of power created in the culture industries throughout the global South, and, one could argue, in majority Muslim societies in particular. A central problematic posed by these shifts, at least in Egypt, was how culture producers reconciled the various forces pushing towards the privatization (and what they saw as the Islamicization) of culture with their own ideologies about the role of culture in society, which were often secular, middle-class-oriented, state-centric, socialist-inspired, and produced through the colonial encounter.

In what follows, I analyze the forces that gave rise to this problematic and Egyptians' various attempts to resolve it. I highlight how, in different realms of artistic production and consumption, the nation was being continually

reformulated, partly because it was the dominant frame through which the majority of art world people made sense of the transformation from socialism towards neoliberalism,[11] as well as of the concomitant rise of American dominance, often read locally as a new imperialism. The transformation precipitated historically constituted debates over the nature of the nation, as well as debates over artistic progress, integrity, and expression that most often proceeded from senses of community and identity centered on Egypt.

It is by now obvious that "globalization" did not render the nation or nation-state obsolete, as some scholars predicted.[12] In the Egyptian art world, debates about cultural politics both reproduced the nation and significantly altered its meaning, particularly for the younger generation. Nation-oriented frames of understanding and engaging with the world endured among many Egyptians, just as they remained important among many culture producers in formerly colonized and/or (post)socialist countries, because in these contexts, cultural production, while not reducible to or wholly defined by national allegory,[13] was certainly shaped by histories in which culture and nation became intertwined in struggles against colonialism, imperialism, and capitalism (e.g., Guha-Thakurta 2004; Verdery 1991). These histories often served as organizing frameworks through which people made sense of the global transformations at the turn of the twenty-first century and staked out different positions amidst them.

LOCATING THE SUBJECTS: ART, AESTHETICS, AND ARTS INTERLOCUTORS

Artists, critics, curators, collectors, arts professors, and administrators form the focus of my investigation.[14] I need to say this up front, because many readers will expect me to give a sustained formal analysis of the art objects or to outline a culturally specific aesthetic; some will be disappointed that I do not. I concentrate on those people who created the "work" of art, which involved, but was not limited to, the artwork itself.[15] Even if I had wanted to focus exclusively on the art objects, it would have been difficult to do so.

Egyptian artists, critics, curators, and collectors would have taught me otherwise. I learned from them that the work of making art was often less about the physical construction of the art object and more about all the activities that went along with it. Not only did they spend much of their time talking about art and art world people, and viewing, displaying, buying and selling objects, but they also engaged in many other activities that were less

obvious (to outsiders) but nonetheless very important aspects of art-making in Egypt. These activities often had little to do with the objects but everything to do with their identities as Egyptian artists and elites. They included such things as working in government institutions, complaining about U.S. foreign policy at a café, inviting family members to Ph.D. defenses in art, telling jokes about the minister of culture, breaking the Ramadan fast with friends, giving guests a tour of one's art collection, walking and driving through the city, wearing well-pressed clothing, praying, getting married, and having children. All of these practices made up the "work" of art. They also became, at some level, part of cultural politics. Thus, I follow my informants who, like the sociologist-artist Howard Becker (1982), knew that art worlds are about a lot more than just art itself. Taking a broad approach to the activities of artistic production and consumption, I examine its unfolding in a variety of realms, each connected in its own way to genealogies of the modern in Egypt: artists' studios; institutions like state art colleges, public sector galleries, and the Ministry of Culture; private sector galleries and universities; state and private media; conferences and lectures; and spaces of casual social interaction among arts interlocutors, like homes, restaurants, cafés, and vacation spots.

Of all the activities that went into art-making in Egypt, none was more prominent and widespread than discourse. For this reason, I have chosen to call the art world people whom I studied "arts interlocutors"—a term that emphasizes the importance of discussion and debate in their lives. Arts interlocutors performed their "culturedness" through discourse. Their view of themselves as intellectuals and cultural elites with advanced discursive powers led them to privilege discourse among all of their activities. Discourses were also, as they often are, the stuff of cultural politics. In her book on the cultural politics of Romanian intellectuals, Katherine Verdery writes that "the categories of language and of discourse *produce the social world*," and that "language and discourse are among the *ultimate* means of production" (1991:91; emphasis hers). Likewise in the field of Egyptian art, discourses became "signifying practice[s]," a complex of ideas about the world that were "materialized in action" (1991:9). In a Foucauldian sense, it is important to note, these were often truth claims, materialized in relationship to institutions and genealogies. They were articulated through forms of social, political, and economic power that overlapped with institutional structures, and they drew on genealogies of the modern for their potency. Given that cultural politics were (and are) so central to artistic production and consumption in Egypt, it is no surprise that

discourses themselves were just as important to the "work" of making art as putting a brush to canvas, for instance, if not more important.

It would obviously be a mistake to completely ignore the place of objects in this whole process. Objects were used to constitute the local category of "art" itself: *al-fann al-tashkili* (the fine arts, or the plastic arts). For Egyptians, this category consisted of paintings, sculptures, drawings, graphic prints, installations, performance art pieces, art photographs, video works, and ceramics, and was related to poetry, cinema, music, and dance—all of which were included in the general field of "the arts" (*al-funun*). It did not include "handicrafts" (*ashghal yadawiyya*, e.g., mosaics, baskets, weavings, metalwork, woodwork), although the distinction between the two was not as strongly marked as in some Western contexts.

Art objects were also attached to discursive positionings and became evidence for certain truth claims in battles of cultural politics. They were vehicles of meaning. They became part of other systems of objects, and of visual culture, that constituted social class distinction, national patrimony claims, cultural policy initiatives, and evidence of neoliberal capitalist globalization, among other things. Objects were, in Maureen Mahon's phrase, "the visible evidence of culture producers" (2000) and the material instantiation of their ideas and those of their consumers. They also had a certain agency, a power to act on the world by calling forth differing interpretations and instigating certain cultural political debates (Gell 1998).[16]

The challenge is how to discuss the place of objects in the Egyptian art world's processes of reckoning without reproducing Euro-American modernist categories and their apparatuses of judgment. For example, in art history, art criticism, and ethnoaesthetics (a kind of anthropology of art), there is often a focus on style as one of the primary aspects of art. The problem with analyzing style is that, in borrowing the dominant thematic used to analyze European and American art, such a project unwittingly places Egyptian art next to this canon in a comparative manner. For example, Burn et al. argue that critics' focus on style led to a theory of Australian stylistic dependency on European modernism (1988:42–44). A similar theory of dependency abounds both among Egyptian artists and among foreign curators who view their work. Rather than slipping into an examination of Western stylistic influence on Egyptian art, then, I have chosen to focus on how people conceived of such influence and dependency (or not) and the battles of cultural politics that were waged as a result. I realize that by subordinating formal properties such

as style, or by looking at style in this way, I run the risk of incurring art cura-tors' well-worn criticism of anthropologists: that by emphasizing context, we deny these objects value as "art."[17] Part of my goal in this book is to show that my own positioning is but one among those of the curators, critics, and others who represent Egypt through its art, and it is this field of different cultural framings that reveals the contested value and meaning of Egyptian art. My other goal is to show that Egyptian artists were quite anthropological in their highly contextual approach to understanding objects.

In the conceptual apparatus of traditional art history and the anthropol-ogy of art, as well as cultural studies, style has been closely related to aesthet-ics. The logic goes like this: if one studies the style(s) of a culture or subculture (in art, music, clothing, etc.), one will be able to work out its entire aesthetic system. Style, aesthetic, and culture/subculture often appear as uniform, in unitary correspondence, and agreed upon. The cultural construction, politi-cal work, and contested nature of the categories of style, aesthetic, and even culture, frequently go unexamined. Yet Terry Eagleton (1990) makes a power-ful argument that the aesthetic is a very particular concept that emerged with the rise of the bourgeoisie in modern Europe. And Alfred Gell, among other anthropologists, has argued that we should not assume that the people we study have an idea comparable to this, or any, notion of the aesthetic (1998; see also the debates in Ingold 1996). Delineating aesthetic systems in corre-spondence to a "style" or "culture," or examining artworks in the interest of finding an Egyptian style or cultural aesthetic, runs the risk of unthinkingly transporting analytical schemata to practices where they might not be the most applicable or relevant.[18] To address this issue, I take a cue from Gell, who argues that "the anthropology of art cannot be the study of the aesthetic prin-ciples of this or that culture, but of the mobilization of aesthetic principles (or something like them) in the course of social interaction" (1998:4).

Among the Egyptian artists, critics, collectors, and curators I knew, the point was precisely *not* to assume a unitary and agreed-upon correspondence between style, aesthetic, and culture. The point was in the process of contest-ing and negotiating, through objects and discourses, just what these catego-ries were. It was also to mobilize the categories for particular purposes and to see whose delineations of them would gain the power of truth. Thus, making modern art from this location meant *not* taking the concepts, categories, and values of European-derived modernisms for granted. It meant reckoning with them through processes of translation. Once again, I take my theoretical cues

from my informants. For example, I analyze how different groups of people claimed certain styles as evidence of either a good or bad aesthetic. I show how this construction of good or bad was intimately linked, not to shared values, but to competing ideas of national identity or progress. As the reader will see from the images of art included in this book, local participants also discursively framed as completely different artworks that appear stylistically or aesthetically similar. Thus, it is how these aesthetic understandings were constructed and mobilized that is important to analyze, not some essential aesthetic that we imagine Egyptian artists might share that is different from our own.[19]

One more point on the aesthetic: Eagleton's argument about the specificity of the European aesthetic rests on explicating its oppressive nature. By appearing pure and solely about the senses, the aesthetic works by being "conveniently sequestered from all other social practices, to become an isolated enclave within which the dominant social order can find an idealized refuge from its own actual values of competitiveness, exploitation and material possessiveness" (Eagleton 1990:9). Eagleton also argues that the aesthetic emphasis on "habits, pieties, sentiments, and affections" (20) creates an individual autonomy that is "self-regulating and self-determining . . . provid[ing] the middle class with just the ideological model of subjectivity it requires for its material operations" (9). Given this loaded history of the concept of the aesthetic, it makes sense that we should be very careful when using it—particularly in the case of arts from the Middle East, which, as I have suggested, are presumed to be a space of autonomy from the "strictures" of Middle Eastern societies or Islam. We should always be attuned to the potentially oppressive nature of the aesthetic as constituted in particular cultural contexts and configurations of the modern, and the contests contained within the category. I explore this issue in my discussion of various Egyptian collectors, whose different aesthetics are not only assertions of the superiority of their particular class fractions and visions of Egypt but also "idealized refuges" from the results their own activities have wrought on Egypt's citizens.

A final, related reason that I do not concentrate solely on art objects is that such a project runs the risk of objectifying or even mystifying the art object and, by extension, the artist. These processes of objectification and mystification are related to the concept of autonomy, and are thus bound up with Euro-American modernisms. It is the particularities of these processes in Egypt that we should be trying to understand, instead of engaging in aesthetic theorizing

that uncritically reproduces them. Furthermore, Bourdieu has made it clear that to "explain" artworks, particularly formal properties of them, is itself an activity made possible by "the historical genesis of the pure aesthetic" that privileges a disinterested gaze (1993). This act of "explaining" itself is what should be studied. The meaning, it seems to me and to Egyptian artists, lies in the explaining, not in the object. Anthropologists, as cultural translators, compete with others (especially critics or curators) for the authority to explain artworks, and this space of contestation is part of what produces art and its meaning (see Myers 1991, 1994b). In the artist interludes that follow, I contribute my voice to the interpretive conversation about the meaning of particular artworks, but try not to foreclose other interpretations. Meanings of the visual are inherently multiple, as Roland Barthes wrote long ago (1977). The work of Christopher Steiner (1994) and Fred Myers (esp. 1991) has shown that the meanings that artists attribute to the objects they make do not necessarily remain attached to them as they move outward into other arenas of display and purchase. Given these considerations, Kenneth George clarifies what constitutes the useful anthropological perspective to take in dealing with the art object. In an article that examines the various meanings attributed to one Indonesian painting, he writes that to "come up with a settled or corrected account of the painting's 'meaning' . . . seems at best a fruitless and preemptive curatorial move that dreams of restraining an open-ended interpretive future for the work in question" (1997:607). Thus, to focus on the object without studying how it attains meaning through discourse, practice, and through its circulation amongst other objects can, as Steiner has suggested, "[attribute] far to much 'power' to it." Such a focus takes away from "the significance of human agency and the role of individuals and systems that construct and imbue material goods with value, significance, and meaning" (Steiner 2001:209–10).

In this book, then, I take a cue from the social art historian Michael Baxandall, who said, "We do not explain pictures: we explain remarks about pictures" (quoted in George 1997:603). I deal with artworks as they entered into systems of signification, which were distinctive and transforming "regimes of value" related to genealogies of the modern (Myers 2001). In this way, my subject is *people*, the multiple ways in which they dealt with various genealogies to give objects meaning and value, their arguments over how value and meaning were assigned, and how these practices became part of the larger processes of "culture-making" (Marcus and Myers 1995; Myers 1994b). Given that Egyptian artists often spent more of their time remarking about

art than making it, my approach also more accurately reflects the actual range and concentration of their social practices. It also allows for the recognition, shared between anthropologists and Egyptian artists, that we all participate in making art and culture, and that our ways of doing so are multiple, deeply social, contested, and change over time.

GENEALOGIES OF THE MODERN IN POSTCOLONIAL EGYPT

Recent anthropological work has countered the idea that the arts are epiphenomenal, decorative features of social life. Like sociologists of art, many anthropologists are now concerned with the ways in which the arts are completely intertwined in some of the most basic processes of signification, boundary making, and the production of hierarchies. Yet because it does not usually consider self-described modern artists living and working outside Euro-American metropolitan centers, this work has yet to shed light on certain dynamics of postcolonialism. This also means that it has not yet fully explored cross-cultural intellectual relations. The literature on modernity, especially that engaged with postcolonial theory, helps us understand some of the enduring questions of non-Western elite cultural production that the anthropology of art has only begun to consider: How do ideologies of modern art and artists, or artistic forms and media, move to, from, and through places like New York, Paris, London, and what were once called the "peripheries" of the international art scene? Do they mix with local ideologies or do they impose themselves, stamping out anything prior? Where the anthropology of art has often looked at what "we" do with "them," this book turns that question around, and ultimately, I hope, goes beyond the dualism underlying such framings.

Colonial and postcolonial theory has developed the concepts of translation, hybridity, and the interstitial to grasp the complex *interplay* (not imposition or imitation) of foreign and local forms, ideas, and practices that characterize modernity in (formerly) colonized places. As Dipesh Chakrabarty has noted, the concept of translation, especially, helps us go beyond stageist historicism (2000). Such historicism is endemic to Euro-American theories of modern art, whose reproduction depends upon notions of progress and development, including the idea of "the shock of the new" (Bürger 1984; Hughes 1991). The most dynamic renderings of translation in postcolonial theory (e.g., Bhabha 1994; Chatterjee 1995; Niranjana 1992; see also Liu 1999) go way beyond earlier notions that read the power relations of translation as being simply the West

imposing its values and aesthetics on the rest, or as a simple transference of forms, ideas, and so forth, to non-Western contexts. Now, translations are not judged as aberrations of or equivalents to an original, but rather are seen as productions of power, meaning, and difference through global circulations. Translation, then, also complicates the notion of "alternative modernities" that has arisen to explain the different forms that modernity took in the colonies. As Timothy Mitchell (2000) has cogently argued, this concept implies cultural variations to a singular, universal modernity that is Western-driven and originary, when it is the appearance of the universal through the construction of variation, difference, or the nonmodern that must be explained.

The alternative modernities concept, and the historicist stage theory to which it might unwittingly be related, would explain certain phenomena in this book in a different way than I have tried to do. For example, some Egyptians' penchant for the figurative and/or suspicion of conceptual installation art (see especially Chapters 2 and 5) could be seen as evidence that they are "not yet" interested in avant-garde art, since modern art was introduced to Egypt a few decades after its emergence in France. Or, the emphasis on the nation could be seen as merely a variation of "Western" concepts of modern art, which positions art as autonomous from, or more universal than, the nation. Instead, I try to show that artists in Egypt were not concerned with the figurative, the "traditional," the "international" (often coded as "Western"), and the "national" because they were introduced to modern art late, or simply because they have "adapted" it from a supposedly Western original to meet their own circumstances. Rather, these concerns reflect the actual reckoning with the legacy of universalism and its constitution of difference. Thus, instead of adopting a universalist narrative of progress in modern art, this book looks at how this narrative persisted among foreign curators in Egypt, and the translation of this narrative among Egyptian interlocutors, whose notions of progress had different valences, often connected to ideologies of national liberation.

If I were to expand this multidirectional process of interaction and translation into a historical study along the lines of Ann Stoler (1997) or of the contributors to Jill Beaulieu and Mary Roberts's edited volume *Orientalism's Interlocutors* (2002), I might likely be able to show further the ways in which colonial experiments in the arts in Egypt, or elsewhere in the Arab world, fed back into notions of modern art and progress in, say, Italy or France. My point here is that even though Europeans introduced a certain practice of modern art to Egypt, its genealogy for Egyptians was not reducible to or wholly

determined by that moment. There were other genealogies, such as that of Pharaonic art and values associated with it in the modern period, of Arab socialism and its logic of modernization, of theological reform movements and religious practice, and of the specific history of elite formation in modern Egypt, among others. The dominant concerns among Egyptian arts interlocutors arose from a continual process of reckoning with specific social actors, ideas, and forms within the Egyptian art scene and historical canon, as well as between this scene and those in the Arab countries, the former Soviet Union, western Europe (especially Germany, Spain, Italy, France, and Britain), sub-Saharan Africa, southeast Asia, and the United States. Drawing out these particularities is important because it gets us beyond East/West dualities and also universalist narratives of progress, yet at the same time enables us to see how such dualities and narratives were reproduced by all the parties involved.

This is where the concept of "genealogies of the modern" is helpful. Academics, like Egyptian arts interlocutors, are often enjoined to define exactly what they mean when they invoke the concept of the modern (or modernism, modernity, or modernization). Although wary of the prejudices, hierarchies, and naïve assumptions of progress contained within the concept of the modern, particularly when it is used in a prescriptive or normative sense, academics and arts interlocutors are nonetheless drawn back to it again and again. For the concept, in all of its etymological forms and the shades of difference between them, remains an indispensable means of capturing and analyzing the social and cultural phenomena and political projects that accompany industrialization and the spread of capitalism. The singular "modern" I use here points to the claims to universality embedded in the concept in its Euro-American versions, and to how Egyptian arts interlocutors see Euro-American modernisms and their claim to universality as partly indispensable.

The plural "genealogies" nods towards the inadequacy of the singular "modern" for academic analyses and Egyptian interlocutions wishing to highlight the many twists and turns that the concept has taken over time. "Genealogies" capture, in fact *are*, the many branches that both led to the concept's constitution and to its different formations, and they always push against the sense that geographical Europe is its source. I am thus using genealogy in a way inspired by Foucault (and Nietzsche)—as a nonteleological, nonuniversalist, nontotalizing way of understanding the relationship between the totalizing forces in the world and the fragmentary, detailed, and particular struggles against them (1984).[20] In many ways, Egyptian arts interlocutors

lived in this space between universality and difference and struggled to make sense of its various vectors.

The complex interplay between genealogies of the modern in Egypt created something akin to what Homi Bhabha (1990, 1994) has called a "third space" that is neither old/traditional/backward nor new/Western/imitative. To see Egyptian art and artists in this way gets us around accusations of backwardness and imitation that plague the art-critical literature on much non-Western art. The focus on translation, like the anthropology of art's focus on circulation, allows us to see how cultural value and difference are produced through the global processes of capitalism. As Bhabha argues, this "cutting edge of translation and negotiation, the *in-between* space . . . carries the burden of the meaning of culture" (1994:38; emphasis his). By examining the embattled processes of translation in the field of artistic production in Egypt, I reveal it to be an intensified in-between space that, for the actors involved, very much carried that burden. It was the burden of constructing a difference, an artistic uniqueness, but also of claiming inclusion in the universal march of modern art. The ideals of difference, uniqueness, and progress are well-known aspects of European modernisms. But in Egypt they were translated in such a way that the nation served as the primary basis of difference, and it was through this nation-based specificity that Egyptian artists aspired to be part of universal progress. Thus, a kind of modernism was produced that was similar to what George (writing about art in Indonesia) has called "a set of local dilemmas rather than . . . a set of globalized certainties." In Egypt, these dilemmas included how to make art showing Egypt's specificity while avoiding its appearance as provincial. They also included making art that commanded the respect of elites but was not elitist. The struggles to resolve these challenges and others might also be seen, then, as "an attempt to inhabit and domesticate the modernist legacy" (George 1999:216–17).

They were certainly an attempt to domesticate. As I indicated earlier, Bhabha's formulation of a "third space" is particularly useful for understanding how these processes of translation can produce hybrid forms that defy essentialist understandings of identities and their formation. However, despite the obvious advantages to such an approach, there are two potential pitfalls of this theorizing that emerge when I try to apply it to the data herein. First, although scholars like Bhabha are justifiably concerned to go beyond binarisms (such as tradition and modernity), the terms "hybrid" and "in-between" both index a duality that is ultimately insufficient for understanding the historical

shifts and contemporary dynamics that contributed to Egyptian art practice. It is not an accident, I think, that the concept of hybridity has been very useful to analysts examining non-Western artists "in exile" in the West, seen to be negotiating between *two* cultures. But for artists living in Egypt, the processes of intercultural translation have always occurred, not through an East/West duality only, but more precisely through multiple axes, which have included at various times the Eastern Bloc, France, Italy, Spain, Germany, the Gulf countries, and, most recently, the United States. That said, Egyptian artists used these East/West dualities to categorize the world. I examine the causes and productivity of this categorization among artists, rather than merely deconstruct it.

This persistent East/West dualism brings me to the other problem with the concepts of hybridity and liminality for the Egyptian case. Grounded ethnographic study of Egyptian artists shows that they did not experience the world as liminal or think of themselves as hybrids. Unlike the minority and/or exilic artists in the United States or Britain who populate Bhabha's texts, Egyptian artists actively resist what he calls "unhomely" or "border" lives (1994).[21] They did not negotiate the in-between spaces (e.g., between universality and difference) in which they found themselves by reaffirming or celebrating that in-betweenness. Rather, they tried to resolve it. They did so by reproducing nation-oriented discourses that were, most of the time, comfortable with binary categories and essentialisms. Even those artists I knew who advocated an internationalist perspective, or eclecticism, saw internationalism and borrowing as essentially Egyptian traits (e.g., part of the "Egyptian personality," or *al-shakhsiyya al-misriyya*). Are we to read this persistence of the nation as a naïve primordialism, as a holdover or "ghost" of Nasserist socialism, as a "construction" that is completely determined by the colonial encounter? Or are we to see this reformulation and reproduction of the nation as itself a "third space," a way of engaging with past and present global forces?[22]

I think it is the latter. I arrived at this conclusion by a fairly traditional model of ethnographic inquiry. It is much easier, I think, to dismiss essentialist assertions of nationhood than to understand, through ascertaining the "native's point of view," the productivity of those assertions for those who speak them. I have found that discourses and art centered on the nation were a productive way for many Egyptian artists to negotiate universalism and difference, and to engage with past and present global forces, especially those that presented challenges to national sovereignty. While neoliberal globalization has broken down barriers (e.g., Egyptian artists have more access to art

images, curators, and buyers from elsewhere), it has also led to inequalities and discriminations (see Chapter 6). To many Egyptian arts interlocutors, these changes, as well as U.S. military and economic intervention in the Middle East, signal a new form of imperialism. They also call forth memories of colonialism. Although informants recognized significant differences between British rule in Egypt and what was happening during my fieldwork, their lingering suspicions as members of a formerly colonized society direct us to connect some of the dots.

The struggle to partake in a universal modernity while exercising nation-based sovereignty from the oppressive, imperial aspects of that modernity is the core source of what many theorists have identified as the "ambivalence" or "anxiety" of postcolonial elite life. Writing about India, Partha Chatterjee describes this ambivalence as stemming from "on the one hand, a persistent complaint at being excluded from or discriminated against in the matter of equal access to the supposedly universal institutions of knowledge; and on the other hand, an insistence on a distinctly Indian form of modern knowledge" (1995:14–15). This situation was very much constituted through the colonial encounter and the persistent sense of the world as being divided into metropoles and peripheries. In the period of neoliberal globalization that coincided with my fieldwork, this sense among Egyptians was reproduced, not broken down, as some readings of Bhabha or Arjun Appadurai might indicate. Hierarchies and ambivalences were clearly reproduced in the actual transcultural encounters between people, and flows of ideas, art, and money documented in this book.[23] Furthermore, the nation remained an important frame through which the ambivalences were reconciled and international hierarchies were resisted.

I do not approach the nation here as a category of analysis, a given entity, or a fictive invention of my interlocutors. I analyze how the nation gets constructed, but the point is not to show its falsehood or realness, but rather to reveal its power as a "category of practice" in the ways outlined by Rogers Brubaker (1996). As I have discussed, the nation was an important frame for the working out of postcolonial ambivalences, anxieties, and international hierarchies.[24] By "frame" I mean that which "come[s] to structure perception, to inform thought and experience, to organize discourse and political action" (Brubaker 1996:7).[25] Throughout the book, I shall detail the ways in which the nation was a primary frame for perceiving and evaluating artworks, for articulating one's understandings of history and social change, for making

sense of one's experiences, and for making, staking, and organizing political claims. As I show, each of these nation-oriented practices did not exist always and everywhere, nor did they always take the same form. Rather, they were contingent on relations with other social actors in particular contexts, on political and economic changes, and on the contextual presence of other frames and practices. Thus, the nation is also approached as a "contingent event" (Brubaker 1996). In addition, I do not analyze nationalism as knee-jerk patriotism (it did not usually take that form among artists anyway), but rather as "a heterogeneous set of 'nation'-oriented idioms, practices, and possibilities that [were] continuously available or 'endemic'" in Egyptian cultural life (Brubaker 1996:10). Finally, I show how nationalism, and indeed the nation-state itself, were produced by a particular cultural field, and therefore "its dynamics [were] governed by the properties" of that field (Brubaker 1996:17; cf. Bourdieu 1993).

This approach to the nation, and my focus on artists as some of its "artisans," helps us understand it (and the nation-state, for that matter) as categories and institutions that are created and contested by human agents (Boyer and Lomnitz 2005). I seek to go beyond facile understandings of the elite as homogeneous, as all-powerful and exclusivist, and as mere tools of the state. As Kenneth George's sustained collaboration with the Indonesian painter Pirous has shown, elites sometimes spout state-sanctioned discourse and criticize it within the same sentence. In the Egyptian case as well, artists were not "merely or wholly . . . agent[s]" of the nation-state (George 1998:708). George Marcus's early compilation of ethnographic work on elites began to conceive of them as differentiated and as belonging to different groups that "crosscut institutional and regional boundaries" (Marcus 1983:19). This conceptualization has been greatly enhanced by Bourdieu's analysis of social capitals and his delineation of a relational theory of elites within fields of cultural production (1984, 1993). Bourdieu's work provides a model for tracking precisely how categories of elites are constituted in specific historical and cultural locations, and how that may influence people's reckonings with genealogies of the modern.

However, as much as I see the nation as a major category of practice in Egyptian artistic and intellectual life during my fieldwork, I make no claims as to its current sticking power or future death or resurrection.[26] I write in the past tense precisely because Egyptians' relationships to the nation and the nation-state (especially) appeared to be undergoing a major structural change related to the larger transformation from socialism.[27] I focus on this

change itself, rather than attempt to predict its outcome. I do so by examining Egyptians' engagement with the new economies, but also, more broadly, by attending to generation—both as a very important form of Egyptian social organization and as an analytic category.

Jean Comaroff and John Comaroff highlight generation (youth especially) as a primary social site for the workings out of neoliberal globalization (2000). In her work on post-socialism in China, Lisa Rofel also looks at generation as a social category, and further highlights it as an analytic category that reveals "the dynamics of temporality and history" (1999:22). By examining how Egyptians themselves conceived of social change through the discourse of generations *and* by discerning patterns of generational difference in how people worked through social change, I aim to capture both the meaning and nature of the transformation from socialism. It is important that generation not be seen as a biological category. Generations broadly share "modes of behaviour, feeling, and thought" shaped by the political and social circumstances present during the formative years (whenever those might be for a person) (Mannheim 1952). Rofel's insistence that generations are not homogeneous and that experiences of political moments can produce "multiple positions, paradoxes, ambivalences, and dilemmas" is an important one (1999:169).[28] My account of generation, then, draws out both the broad patterns *and* different positions within generations, as I saw them and as they were articulated by arts interlocutors. In this way, I show both the historical constitution and the dynamism in how groups of people within generations made sense of culture, nation, and nation-state in post-1989 Egypt, often through the discourse of generations itself.

MAKING ART AND CULTURE IN THE "FIELD"

Anthropology has gotten very good at critical analyses of the Western consumption of so-called primitive art. It has pointed out the various ethnocentric ways that Westerners use objects to construct certain ideas about primitive others, especially in contrast to a supposedly modern and civilized self. It has expanded from a focus on the aesthetics of different cultures to look at how boundaries and hierarchies are constructed and resisted through practices of representation, and through the circulation of objects.[29] This literature has the advantage of showing how art worlds are extremely useful sites for understanding how categories and hierarchies are constituted through transnational processes. However, some of the work in this vein still does not question the

implicit boundary being drawn between anthropology and other modes of knowing or representing culture. And some of it unwittingly denies agency to cultural others by focusing largely on what "we" do with "their" objects.

Sally Price's otherwise brilliant 1989 study *Primitive Art in Civilized Places* is a case in point. The author criticizes Western "high culture" for erasing colonial relations of exploitation in its use of art to figure "primitives" as simultaneously superstitious, fear-inducing, and a vestige of the West's lost innocence. The anthropological perspective is implicitly positioned as more informed and less ethnocentric than art criticism or history in the text, while Western collectors are largely dismissed out of hand. Meanwhile, the perspective of the objects' makers on what Westerners do with their work appears in just a few lines of the book.

Critiques of primitivism and representation can unintentionally reproduce the image of homogeneous, passive Others, as well as the image of all-knowing, savvy anthropologists. They do so by not examining what "they" do with our forms/objects/ideas, what "they" think of our consumption/representation of their objects, or how we all work to create art and culture. Such critiques also reproduce primitivism itself by ignoring self-described modern artists working in non-Western countries. The meaning of the objects, and the lives of the people that produce and consume them, are thus reduced to the story of cultural domination—which is an important one to tell—but the problem is that everything gets subsumed within the tale of Western modernism (which includes its own critique). We foreclose the possibility of analyzing the diverse ways in which people reckon with different genealogies of the modern in complex, overlapping social fields.

The fact that significantly less ethnographic attention has been paid to elite artists (and intellectuals, for that matter) who self-consciously view their work as bearing some relationship to Western modernisms primitivizes the primitive and cements Western intellectual superiority even more. When such social actors are ignored, the effect is to lock them, and their societies, out of modernity—although this is certainly not to say that having modern art or intellectuals brings a society into modernity. If "they" do not have modern art like "ours" or as "good" as ours, if "they" do not have intellectuals, or if "their" intellectuals are not as critically aware as "we" are, then essential, hierarchical cultural divides can still be imagined. We are back to the critiques of primitivism that Molly Mullin has warned "inadvertently . . . reproduce such binary structures of thought" (1995:167).

It is still worth repeating that scholars need to take seriously the ways in which they themselves are implicated in creating the very boundaries and hierarchies they criticize, and that they, like artists and intellectuals, do much of the work of making "art" and "culture" (Abu-Lughod 1993; Boyer and Lomnitz 2005; Marcus and Myers 1995; Suny and Kennedy 1999). Granted, anthropology has often been plagued by a "casual dismissal of 'high culture,'" which is likely in part due to anthropologists' continued "uncomfortableness" with elites (Marcus and Myers 1995:8; Marcus 1983; Nader 1974), and "native" intellectuals in particular.[30] But ethnographic practice should not fall into the "easy identification with anti-elitist or mass-culture positions attacking the boundaries of convention" (Myers 1994b:33). Rather, we should extend our discussion to examine how such boundaries get constructed, and why we (as intellectuals ourselves) seem consistently to identify with the anti-elitist side, while unwittingly silencing it. The fact that anthropologists sometimes dismiss art as an elite or epiphenomenal activity makes it an especially interesting area through which to ponder how hierarchies, cultural differences, and "fields" of study are constituted.

By engaging in an ethnographic study of the variety of sites where Egyptian arts interlocutors produce meaning and value through objects, this book joins recent work that recuperates the various agencies that are lost in the primitivist paradigm, and that takes the contested production and representation of culture as its subject.[31] I resist the urge to privilege anthropology as the most "informed" discourse in that process. For example, rather than only using my academic tool kit to debunk my interlocutors' assertions of national history or authenticity, I start by asking how and in relationship to what institutions these assertions were produced, and what their productive value was for those who promoted them. In other words, I start by looking at how the art world (Becker 1982) was constituted and reproduced in Egypt and consider my own role within that.

Like Egyptian artists chatting at coffee shops and fighting with each other in public forums, I focus on competitions and debates in my own anthropological analysis. It is not solely the competing values and meanings that were ascribed to art in specific institutional contexts that I am/we are after. I also examine how ascriptions of value were related to various subject positions (middle-class intellectual elite, state actors, rich collectors, foreigners, etc.)

What these ascriptions of value both constituted and indexed was a larger arena of cultural politics that, in effect, "makes culture." Any casual observer

of the intense debates over "culture" in Egypt, particularly among artists, would find it difficult to use previous notions of the concept to understand what was happening. Not only is the older anthropological definition of "culture" not appropriate for understanding the so-called object of study, but competing ideas about "culture" itself were continuously being formulated by participants themselves. A variety of social actors dealing with Egyptian art from different institutional locations were fighting over definitions and representations of Egyptian cultural identity, and of what counts as valuable Egyptian art. This is the process for which Fred Myers, writing about discursive struggles around Australian Aboriginal art (1994b), adopted the term "culture-making." Therefore, as a specific kind of activity that purports to define, represent, and hierarchize difference and value, art-making (broadly defined) is a key arena in which to examine the debates over culture itself, which have intensified in the Egyptian public sphere as the society moves away from the goal of socialism.

The artists with whom I worked used art-making to assert certain claims *about* Egypt and to subvert and reproduce power relationships in order to embolden their own claims *on* Egypt. These maneuverings were, at every level, connected to their subject positions in relationship to institutions and political and economic transformations. As I discuss throughout, different groups promoted insular or cosmopolitan definitions of Egyptian culture depending on their closeness to state institutional distribution of economic and symbolic capital. These definitions then served as a larger critique or support of the state's economic reform policies. I have thus used the term "cultural politics" as a way to analyze how culture in Egypt was "a contested category and ... a site of ideological and political struggle" (Mahon 2000:470) to define the nation in particularly unsettling times. Combining the concepts of cultural politics and culture-making in a study that includes social actors from a range of locations both within Egypt and abroad allows me to examine how "the categories and hierarchies of value ... reveal the outlines of an intercultural space" (Myers 1994b:94). Such intercultural spaces have become a primary interest of contemporary anthropological inquiry and require new kinds of fieldwork that conceive of "the field" as a set of global circulations and disjunctures rather than a bounded site (Appadurai 1996; Marcus 1998; Mazzarella 2004).

Rife as they are with battles of cultural politics, local instantiations of such spaces might also be productively analyzed through the lens of "the field" as inspired by Bourdieu (1993).[32] The field of artistic production is constituted

and defined by struggles—to obtain or conserve power, to define value and legitimacy, to delineate boundaries. In the chapters that follow, I highlight some significant differences between the field of cultural production as described by Bourdieu and the field of artistic production in Egypt. Nonetheless, I find Bourdieu's general concept of the field to be an intriguing way to think about the "field" of fieldwork on intercultural spaces. I have no doubt that my Egyptian interlocutors would see the concept as incredibly apt, as they themselves conceived of their activities largely in terms of struggles and often spoke about "playing the game"—a phrase that evokes the rich meanings of *le champ* in Bourdieu's French-language formulation of the field (as a playing field, a battlefield, etc.). It was not only Egyptians who played the game, with its struggles and high stakes. All non-Egyptian consumers of Egyptian art were drawn into it as well, myself included.

In various ways, I argue that the struggles within the field of artistic production worked to reproduce it. I also see this as the case in the international field of art, if such a thing can be delineated. Ever since the beginnings of modern art in Egypt, Egyptian arts interlocutors have been part of international circuits of artistic production and consumption. For Egyptians, participation in this enormous field has brought issues of Egyptian identity, past glory, and present backwardness to the fore. They have both resisted and promoted internationally circulating ideas about Pharaonic artistic achievements, Western modern art superiority, backward Egyptian imitation, and liberatory and repressive Third World nationalism. Western art critical frameworks for understanding art from postcolonial societies, particularly ones with famous ancient civilizations (such as Egypt, India, or Mexico), have thus been reproduced by different groups of arts people who find them useful, reprehensible, or a mixture of both. I focus here on Egyptians, but I would include everyone, including myself, who engages in the international circulation of art from postcolonial societies. I do not think it is a stretch to say that our interlocutions also reproduce the international field of art and its hierarchies and teleologies, not to mention the "discovery" of new markets that it depends on for its operation (e.g., Latin America, then East Asia, now the Middle East).

My fieldwork was on all of these different "fields," and on their interfacing. It was also part of them. Therefore my "field," in the anthropological sense, both consisted of these fields and was part of their constitution. It took me awhile to realize this point, as I struggled to conduct fieldwork in urban areas on disparate groups of people in a variety of locations, and in the process to

balance broad historical and sociological views of the art world with intimate, everyday experiences with my interlocutors. During my research trips, I resided in different neighborhoods in Cairo—the center of the Egyptian art world. Most Egyptian artists lived and worked in Cairo, and those who lived elsewhere came through Cairo regularly to see or participate in exhibitions. With my home base in Cairo, I also traveled to Alexandria and Aswan for extended periods of fieldwork. Alexandria is a distant second to Cairo in the volume of artist activity, and Aswan hosts an annual international granite sculpture symposium, which I attended. At other times of the year, Aswan is a provincial center of art-making. In Alexandria, I was lucky enough to be hosted in two different artists' homes, while in Aswan I lived amongst sculptors in a wing of a hotel for one month. In Cairo, I was fortunate to have two artists as close neighbors for several months. And for much of my fieldwork, I resided with my spouse, who is also an artist.

My main method was participant-observation in the major sites of artistic production and consumption. Initially seeking to cast a wide net, I conducted research in many different locations and with a large variety of art world people. I attended exhibitions, went with artists on expeditions to find and buy materials, socialized in studios, attended art lectures and conferences, and sat in living rooms and coffee shops. I also visited galleries and curators' offices, talking with them and observing daily business. I went to college classes and open studios. I also collected art publications (catalogues, brochures, books, journals, and newspaper articles), and regularly recorded radio and television programs on the fine arts. This work was supplemented by ethnographic interviews with a variety of artists, curators, critics, and collectors of different ages, institutional locations, artistic persuasions, and nationalities (with a focus on Egyptians). Although these days, much interviewing and textual analysis passes as ethnography, I would say that in this case (at least), these activities were an essential part of the ethnographic research, because discourse itself was such a privileged practice among my subjects—so privileged that I came to see them, and myself, as arts "interlocutors."

Nonetheless, I did not want to give up so easily the intense, sustained relationships with certain people and contexts that such multi-sited research and focus on discourse sometimes entails. So I also developed ongoing relationships with a small number of people. These individuals graciously accepted me more fully into their social lives. We invited one another over for meals, went to movies together, did art together over cups of tea, chatted on

the phone, shopped, watched television, and went on small vacations. Although there were some notable exceptions, I was mostly drawn to in-depth relationships with artists of an age close to my own (approximately 25 to 35, the "younger generation" in local parlance). Through them, I learned the importance of generation as an organizing framework, as a positive source of identification, and (for them) as a negative source of social hierarchy. Partly, I felt a kinship with those of my own age because we were at similar stages in life and therefore could share thoughts about starting careers and families. My husband and I forged friendships with other couples—one or both of whom were artists—and it was in these friendships that I really learned how much Egyptian artists value having a family and living a good spiritual and material life. In a way that suggests how Karl Mannheim's theory of generations (1952) could have transnational dimensions, I felt closer to the younger generation because we often shared interests in certain kinds of ideas, politics, popular culture, and because we had come of age in a similar geopolitical moment. I also empathized greatly with their struggles to become artists in their own right in a system dominated by generational hierarchy and by national and international prejudices and pressures. I hope to have captured some of their efforts, successes, and frustrations in these pages. If there is any imbalance in my analysis, it is a consequence of my partiality to their position and my greater familiarity with their perspectives, or perhaps of my attempt to compensate for this closeness by being too attentive to their critics' perspectives.

My recounting of fieldwork thus far does not reckon (I mean this in the same sense) with the West/East power dynamics that have characterized the fields of power and cultural production in Egypt, as well as the international art field, and that were inevitably to affect my relationships in the field of fieldwork. Westerners in Egypt often saw me as an equal—someone who, by virtue of my cultural background and language, shared their views about Egypt and Egyptian artists. They confided in me things that they would have been too embarrassed or discreet to say in mixed foreigner/Egyptian situations, such as their personal struggles in Egypt, their critiques of the art, or their frustration "with Egyptians." There was an assumption that I thought the same way, and, I think, a hope that I would translate some of these views into scholarly critique that might legitimate their projects in Egypt, or that might reach Egyptians' ears. In hindsight, I can say I let this assumption go unchecked a bit too often, which resulted in what I understand to be their senses of betrayal upon reading my written critiques of their positions. I discuss this

issue more in Chapter 6, but here I make the point that my relationships in the field were structured by people's perceptions of my allegiances, in both the local and international art fields.

My relationship with Egyptian arts interlocutors was also influenced by our positions in these interlaced fields. It is not an exaggeration to say that nearly all artists, critics, and curators were extraordinarily welcoming of me, partly because generosity and hospitality were major cultural values, partly because I was the spouse of one of their colleagues, and partly because I was from the United States. As a researcher from a major international art capital (New York), I was often accorded what I perceived to be overwhelming and unjustified importance and prestige. I was known to be "working on a book" about Egyptian artists for American readers, and many artists undoubtedly saw in me an opportunity to gain "advanced" critical views on their work, and to have knowledge spread about them and their work among audiences to whom they usually did not have access. This situation created an undeniable power dynamic that was, I sensed, only slightly overcome by long-term bonds with those in my generation and, in a different way, by some men of the older generation who had the tendency to talk down to me the way they did to my generational peers. Although, like most anthropologists trying to "fit in," I was uncomfortable with the status and prestige accorded me, and often displayed awkward self-deprecation as a result, Egyptians kept "putting me in my place." On several occasions I was told to just "quit it" and deal with how "important" I was. Not only did I begin to realize something about power in Egypt—that elites (and Westerners especially) are often expected to act according to their position, and if they do not, the social order can be disrupted. I also learned that by making me accept my higher position (which I was never quite able to do), they were demanding that I use it to represent them in a way that would help their careers. This was not just modernist thinking that posited Western superiority; it was also one that asserted Egyptian agency and worldview.

This point was made especially clear early on when the Metropolitan Museum in New York asked me to write a catalogue essay for an exhibition of contemporary Egyptian art that was to coincide with the opening of a large exhibit of Pharaonic art. I accepted. I was a graduate student at the time, enticed by the prestige of the Met, but also by the prospect of communicating something meaningful about the artists I knew to the American public. At the time (before 9/11), there had been very few exhibitions of contemporary

art from the Middle East,[33] and even though I was annoyed that, yet again, the minister of culture, Faruq Husni, was getting a major museum show, I thought it was important that I do the catalogue. Husni and his friend Adam Hinayn, who exhibited with him, spent hours explaining their work to me. I translated their ideas into English semi-academic, semi-American art criticism language, with an eye to what Americans might want to know about art from Egypt. The two artists later asked for an Arabic translation of the text. Artists expected me to mediate in a way that was advantageous to them, whether by writing or just by acting as a translator in meetings between Egyptian artists and foreign curators (which I also did).

When word of the exhibition reached art circles in Egypt, many artists were upset, because they thought that the minister was guilty of extortion. I was never able to ascertain whether or not he had actually, according to their accusations, told the museum that it could borrow Pharaonic sculptures from Egypt's collection (which he oversaw) on the condition that it exhibit his work. But it was clear that the accusations had their effect, for the minister felt obliged to defend himself in the national papers with a story that exemplified even more the ways to which my position as an American could be put to use. In a published interview,[34] the minister said that I was a famous professor at New York University (my alma mater) and one of the most prominent art critics in America, and that the Metropolitan had sent me to choose which Egyptian artists to exhibit. Because I was so prestigious, the argument went, and because this prestige could not be questioned, given that I was an American, my choice of Husni and Hinayn had to be legitimate. By this logic, they were the best artists in the country, according to the American arbiter, and therefore they should represent Egypt abroad.

Thus, my position as an American was used not only to translate these artists and their work to a potentially influential Met audience, but also to defend them against accusations of serious impropriety at home. My attempts to correct the story, if only to prevent people from thinking I had represented myself dishonestly, were usually met—by everyone from the minister's assistant to my closest acquaintances—with dismissal. This also revealed something about ideologies of power and resistance among elites. I was told that it was not worth it to take on the powerful minister, and/or that it was not too much of a stretch to say I was an art critic and professor. Responding to my pleas of "but I'm just a grad student," one of my closest friends told me, "Listen, Jessica, a graduate student in America is like a big professor or critic

here. You have to accept that." I was impressed by Egyptians' confidence in their own narratives, which ultimately denied me (the Westerner) any agency whatsoever. But I was also livid at the brute display of elite, in this case ministerial, power and what I thought (based on an ideal of the artist as resister) was artists' too-quick submission to it. (This was not the first or the last time I felt this way, as you will no doubt sense in the chapters that follow). And, more important, I was shocked into recognizing my own complicity in the reproduction of local and international fields of power.

I mean complicity in the negative sense, of course, but it took many different forms in fieldwork. Marcus has insightfully discussed "the uses of complicity in the changing mise-en-scène of anthropological fieldwork" (1998). In fieldwork that was ever aware of transnational connections in the intercultural space of multi-sited cultural production, it was impossible to be "merely" an outside observer of internal cultural logics (if that was ever possible). My outsiderness and my relations with informants were markers of those wider connections. We were all complicit in our anxiety and curiosity about "major transformations [that were] under way [that were] tied to things happening elsewhere," but we did not have "certainty or authoritative representation of what those connections" were (Marcus 1998:118). Egyptians were interested in my outsiderness as a marker of these changes and connections; I was interested in them for the same reason. To recognize this complicity was to begin to grasp some of the intercultural processes, such as differential reckonings with genealogies of the modern, that they and I were both trying to understand.

The example of the Met shows that anthropologists are inescapably implicated in the processes of culture-making in the art worlds that they study— whether they like it or not. This implication is part of my subject of study; it is also the basis for any reciprocity or activism that anthropologists might engage in. This text is my own representation, an interpretation among many, of these processes. While for me it is an ethnography of some things I experienced in Egypt between 1996 and 2004, for many artists, it is expected to be much more. It is expected to be like a Met catalogue, or a critical view that artists can use to "develop" their art scene, or a mediation that tells an influential curator that a certain artist is so good that he or she should be given a show, or a book that focuses international attention on the contemporary Egyptian art scene. I wish that it could do all of the things that Egyptian artists would like it to do, and more.

INTERLUDES AND CHAPTERS

The chapters in this book each explore a dimension of the cultural politics of artistic production and consumption. Through chapters on art education, art evaluation, state cultural policy, public art projects, art collecting and display, and private sector internationalization of Egyptian art, I show how different groups of artists, critics, curators, and collectors reckoned with historically constituted genealogies of the modern in Egypt. Interwoven between the chapters are "interludes" that feature individual artists. These interludes provide a way for the reader to get closer to these people and their work, and to get a sense of how an individual might work with or struggle against some of the frameworks dominating Egyptian art practice and consumption that I discuss in the chapters. While the chapters loosely follow the move from socialism to neoliberalism, the interludes are organized so as to resist the interpretation that this change necessarily implies "progress." They begin with a younger generation artist whose life and work deals with the capitalist ties between Egypt and the United States, and they travel back in time to feature artists working in different sets of circumstances, ending with one of the "pioneers" of Egyptian art, who worked mostly in the colonial period on nationalist topics. While these interludes cannot suffice for a more sustained historical investigation of the Egyptian art world, I hope that they will impart a better sense of the deep and different genealogies of the modern. I also hope they will alert the reader to the intellectual connections between artists and other culture producers, notably writers: each interlude pairs the artist's work with a novel (another modern art form) that shares similar concerns.

All but one of the artists I feature in the interludes were trained in Egyptian art schools, like thousands of others. Indeed, art school was such an important factor in shaping what it means to be an artist in Egypt that I devote Chapter 1 to it. In this chapter, I examine how thousands of Egyptians from modest backgrounds came to be artists in a society where little was known about the visual arts, and how this process resulted in the production of categories of the artist and of art that were not completely autonomous from, but were rather affiliated with, craft, family, and nation. Ideologies of "free-thinking" artist individuals were refracted through the history of colonialism, socialism, and class change in Egypt, resulting in art being viewed not only as a means for creative individual expression but also as an avenue of upward mobility, a way of creating and maintaining families, and a social/national obligation. This analysis of how people entered the visual arts and became

part of a secular intellectual elite, and of how the relationship between art and society was differently positioned than in many European-derived modernisms, sets the stage for the rest of the book.

Chapter 2 follows art school students into their careers as artists, and examines how they found both pleasure and difficulty in creating work in a cultural field shaped by the modern dilemma of authenticity, which took a particular form because of Egypt's colonial and socialist histories. I show how the intertwined concepts of individual and cultural authenticity drove much artistic production. And I analyze how these concepts were bases for the evaluation of artworks and, by extension, social changes wrought by the transformation from socialism to capitalism. In this chapter, I show that the anxieties of Egyptian modernism were located in debates over definitions of what constituted cultural authenticity, rather than in the existential angst about what constituted the authentic individual. I also detail how Egyptian artists did not reject the past (sometimes conceived of as "tradition"), so that the "uncomfortable dislocation" present in European modernism was absent, as Walter Armbrust has also noted of Egyptian film modernism (1996:194). Chapter 3 then looks at how discourses of authenticity, combined with concepts of generational difference, became part of strategic battles in the field of artistic production. It focuses on how this process contributed to the development and reproduction of the caretaker state ideal such that the state ended up, through cultural policy initiatives beginning in the 1990s, becoming a key player in the globalization of the culture industries and the rise of the neoliberal elite. Chapters 2, 3, and 4 complicate the Bourdieuian notion of artistic fields pushing for autonomy by highlighting actors' different conceptions of autonomy's importance or relevance depending on context and historically constituted identifications with family and, especially, nation. These chapters also challenge the idea that the laws of artistic fields are (or always strive to be) those of the "economic world in reverse."

Chapter 4, on an embattled public art project, begins the inquiry into non-artist evaluation and consumption of art. It examines artists' constitution of various "publics" and their strategic jockeying in the larger field of power that included new economic elites and politicians. I analyze artists' struggles to curry favor among them while maintaining artistic integrity, and also their attempts to legitimate their field by claiming that art can play a civilizing role in uplifting the taste of the society. We see how changing ideas about the creation of "cultured persons" reveal the tension between socialist ideals and the

reproduction of significant class hierarchies in a liberalizing economy, and how this tension was experienced by artists of the younger generation trying to make a living while apprehending the changes through both older and emerging taste sensibilities.

Chapter 5 extends the discussion of taste to the realm of private collecting and display. Through a detailed study of the kinds of art purchased and its contexts of display in homes, the chapter shows how art collection and display have been key ways in which elites have come to think of themselves as a distinct group and orient themselves to the larger collective of the nation. It also shows how the seemingly benign practice of art collecting was a central way in which elites both justified their domination of other Egyptians and criticized the effects of capitalism on Egyptian society. Through art collecting, they could imagine an idyllic Egypt where their capitalist activities have had no negative effect. Art collecting had another national component as well. Egyptian collectors countered the Western narrative of their inferiority by displaying their own expertise in and possession of *Egyptian* high culture. The creation of an idyllic Egypt through art was therefore related to the creation of a high Egyptian canon.

While Chapter 5 looks at the recent surge in Egyptian art collecting, Chapter 6 investigates the growth in European and American interest in contemporary Egyptian art, concurrent with the influx of capital accompanying the Mubarak government's economic liberalization program. The chapter examines the resulting tensions between state cultural policy and private sector markets, as they became manifest in battles between foreign curators, Egyptian artists, and Ministry of Culture policymakers. It highlights the tenacity of colonial-modernist logics and of nation-based attachments as Egyptian art becomes globalized along the circuits of capital.

I am part of this surge in foreign curatorial and Western institutional interest in contemporary Egyptian art.[35] Like curators, critics, and artists, I create discourses that define art and culture. This has consequences for how I shape my work and how it will be read. I came to Egypt the same year that Egyptian artists won the grand prize at the Venice Biennale. It would take a couple more years for the art scene at home to create a huge buzz in the expatriate community, and by the time I concluded the fieldwork for this book, Egyptian art was being included in major shows in Europe and all over the world. As I document in Chapter 6, this process caused new kinds of competitions, and no small amount of anxiety at home—especially among artists

who were ignored by the jet-setting curators and were struggling to figure out why. Some asked me to explain why (presuming that as a Westerner I could tell them), and some tried to get my attention in the futile hope that someday I too would be a powerful curator. I have no doubt that artists will scrutinize this book to see who I mention and who I do not, especially in the artist interludes. I can only hope that they will at least appreciate the spirit of my selections, but I fully expect that this book will generate another set of interlocutions, in which we shall all be participating.

I created the interludes in part because I want to challenge Western curatorial chauvinism, which promotes very specific ideas about what counts as good art and shows very little interest in the context or history that Egyptians find so important. Thus, most of the artists I feature are those who either have local social and historical importance or whose work might not fit into certain Western curatorial frameworks, precisely because these frameworks do not account for the local circumstances that the artists work with every day. Or, rather, they favor very specific local circumstances, such as the detritus and kitsch of urban life, public religiosity, and pre-independence colonial or Islamic architecture. Throughout the book, I have selected artists whose work articulates with other kinds of histories and circumstances, which were in fact those that were more commonly drawn upon by the majority of artists in Egypt. As an anthropologist, I was interested in showing the patterns in the ways that people reckoned with genealogies of the modern. And as a fellow arts interlocutor with artists, I was interested in taking seriously all of the art that I saw. As an interlocutor with foreign critics and curators, I was interested in revealing their hierarchies of value, their exclusions.

It is a challenge to write about artists in a way that captures the poetics of their practice and their individual artistic paths and explorations, while at the same time attending to the broader political and economic processes that have shaped them. Attaining this balance is particularly difficult in the Egyptian case for two reasons. First, one risks transferring certain ideologies of the artist (e.g., as individual hero), which underlie some theories of poetics, to a context where they do not always make sense. And second, Egyptians themselves placed such an emphasis on the relationship between art and society that it can be easy to overlook the importance of individual paths and struggles. And because they emphasized broader issues and conflicts and only rarely discussed individual artworks, it is also difficult to consider the meaning of individual artworks in any substantial way. So, how to communicate

the individual aspects of artists' lives and understand the significance of individual artworks?

My solution has been to use my own artistic preferences and my relationships with individual artists as a vehicle. I select individual artists whose work I find compelling, and I try to weave my own perspective on it together with theirs. I have tried to write the interludes in a less "social sciencey" style to convey my own personal attraction to these artists and their artistic explorations. I cannot claim to be completely free from, or opposed to, some of the ways of valuing art that I myself have learned in Western institutions, which includes thinking of artists as unique individuals with distinctive (often critical) views on the world. The interludes are partly my way of reckoning with this history, and of showing how such constructions of the artist were not completely alien to Egypt either. I have selected artists whose work deals with locally significant histories and circumstances, but that does so in ways that I, along with some Egyptian interlocutors, find particularly innovative. I have also chosen these artists because I find them exceptionally interesting individuals. I like the fact that their work pushes against the major trends and understandings of the times in which they work(ed), but is still in conversation with those trends and assumptions. The values of "pushing against" and "being in conversation with" have, I think, different emphases in our respective artistic genealogies. By bringing these together in the interludes, I hope to have helped readers from other locations to engage more closely with individual artists and their work. And I hope that through these interludes and chapters, we can all mutually create meanings for this art that extend beyond the boundaries and hierarchies that have traditionally divided us.

AMINA MANSUR
The Map of Love

I first met Amina Mansur in Alexandria in 1997. She was among twenty or so young Egyptian artists who had gathered for a series of meetings to discuss how they could collectively build the art scene in Egypt. Most of these artists had gained the attention of the Ministry of Culture in Cairo and had received prizes, exhibitions, and residencies. Many of the Alexandrian artists, Amina included, had also been given the careful attention and tutelage of an art professor of the older generation, Faruq Wahba. In the afternoons and evenings, Amina joined other young artists at the Alexandria Atelier, where Wahba had set up a workshop and schooled his students in the benefits of wild experimentation. (They learned a lot about Joseph Beuys and other German artists, because Wahba had spent many years in Germany.) While other young women from her background were attending private universities and prepping themselves for society life, Amina was questioning the boundaries of the material and visual culture taste that she had grown up with. At the Atelier, she met artists from many different backgrounds, who spent late nights smoking cigarettes, talking about ideas and criticizing each other's work, and mucking around in art materials. She was not living the kind of life that had been set out for her as the daughter of one of Egypt's most famous business families. But she wasn't "slumming" either. She was participating in a broader art-making community with members of her generation. They were trying to take advantage of all they had learned from their predecessors and really make their mark on Egyptian art.

Amina's comments at those meetings struck me for their incisiveness, commitment, and sensitivity. She had clearly observed the art scene in Egypt

very closely and had developed specific ideas for how she, along with the others, could develop their art in certain ways and find the means to do so. These ideas acknowledged the specificity of the Egyptian experience but did not lock it into a nationalist frame. Given her half-American background (her mother is from Alabama), fluency in English, and general international experience, she could have very easily put down the entire art scene in Egypt, or dismissed everyone else's ideas and asserted her own as the best or most advanced. But unlike many other artists from privileged or mixed backgrounds whom I've met, Amina did not treat the others as lesser artists or intellects. She was friends with many of them, and even though she often disagreed with their ideas, she respected their opinions and was sensitive to where they were coming from. It is this seriousness, intelligence, generosity, and modesty that have in large measure enabled Amina, in turn, to gain the respect of artists and critics who might otherwise see people like her as alienated from Egyptian society.

I also think it is these qualities that have enabled her to create some of the most compelling works being done in Egypt today. I admit that they are particularly intriguing to me because they deal with the relationships between Egypt and America, and between Egyptians and Americans. And so, in a way, they teach me new perspectives—some analytical and some sensory—on my own experiences as an American anthropologist working in Egypt.

Her current project, which has been evolving since the mid 1990s, is a series of installations, mixed media objects, and films exploring different aspects of the relationship between the antebellum U.S. South and the cotton-growing Nile Delta. Like my account of my encounters with Egyptians, Amina's is also arranged in chapters. But hers are revealed at different times and in no particular order. They are part of an interlinking series in a tale of wealth, gender, and nostalgia that spans two centuries and two continents. The tale is akin to that told by Ahdaf Soueif in her novel *The Map of Love* (1999). It is both personal and collective—an exploration of the love affair between the American and Egyptian sides of Amina and her background, as well as a recollection (and calling forth) of the troubled links between the two societies. By excavating her two pasts in a nonliteral and nonlinear way, Amina reveals the overlaps and disjunctures that this linking produces on both personal and collective levels. She both reckons with various pasts, and reckons the present and future by visually calculating the relationships between those pasts in a way that denies cultural hierarchies and notions of progress.

The beginning chapters (1–5) of Amina's project were first exhibited in 1999 in one of the well-lit rooms of a downtown Cairo gallery, which had previously been a colonial era residential apartment. A major theme in these chapters was the restraint and domesticity that came with the cultivation of elite women in both the antebellum American South and the nineteenth-century Nile Delta—women linked through the arts of embroidery, weaving, and flower arranging, as well as through the international cotton trade and development of capitalism. Amina mimicked the manual arts of these elite women by forming cotton into intricate flowers (fig. A.1). She therefore reproduced elite feminine taste through the very material—cotton—that had served as the basis for their wealth (see also Zurbrigg 2001).

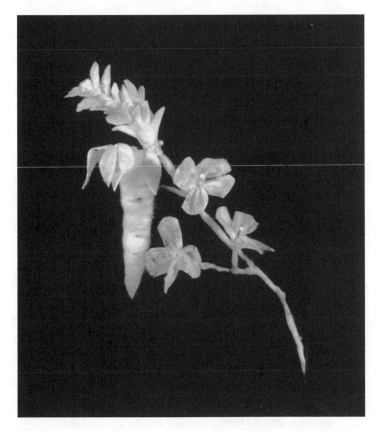

Figure A.1 Amina Mansur, floral detail from *Chapters 1–5*, cotton, 1999. Courtesy of the artist.

Yet even in these seemingly blissful chapters, we see clues to the unbridled future that will unfold later. Some of the seemingly meticulously constructed cotton flowers threaten to spin out of control.

There is an interesting contrast between the fragility of the cotton forms and the solidity of Amina's *Vitrine*, which clearly references the eighteenth-century French "Louis" style of furniture so popular in the salons of the international elite class at a certain time, and still popular among many elites in Egypt today (fig. A.2). The activity in these salons was characterized by polite conversation and china tea services; the furniture itself—as the *Vitrine* shows—was unbelievably extravagant in comparison to the simple furnishings of those who did the labor that made these people so rich. The porcelain plaque on the piece

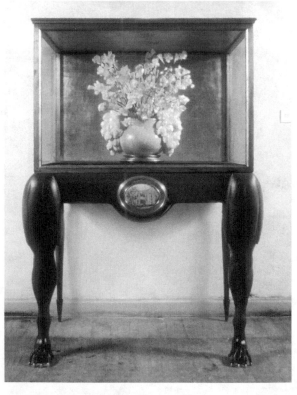

Figure A.2 Amina Mansur, *Vitrine: Chapters 1–5*, mixed media, 1999.
Courtesy of the artist.

bears the names of Egyptian and American plantation families. Yet even in this early chapter, Mansur gives us a glimpse of the underbelly of wealth. The legs of the *Vitrine* are modeled on muscular, laboring human legs but end in the fancy nail-polished hands of an elite woman. Caught in both dominant and submissive positions, the elite woman simultaneously directs the servants and holds up the house. The piece of furniture thus embodies the complicated power relationships between social classes and genders—relationships that are often maintained through a system of oppressive restraint but that always threaten to explode beyond their accepted boundaries.

The explosion is on the verge of happening some ten chapters later in *Chapter 15: A Failed Contemporary Attempt at Being a Modern Day Ophelia* (2003). Or perhaps it has just happened. We don't know yet. But the tensions that were suggested in the earlier chapters become major, almost belligerent, contrasts here. *Chapter 15* is like a drama, taking place in a massive, less contained gallery space that once housed factory workers—the urban equivalent of the rural laborers who make a fleeting appearance in the earlier work.[1] The artist darkened the space for the installation—a common method used in the theater during the major dramatic climax of a play, or at its ending.

Spotlights highlight some parts of the work, while others are left in the dark. Here the furniture is a heavy, black, lacquered table. It does not have the quaint porcelain plaque or delicate gold leaf that the *Vitrine* does. Rather, it is covered with a thick and imperious piece of bronze. The expensive material is no longer ornate and delicate. It forms a hardened seascape that serves as Ophelia's sacrificial bed. The elite woman's hands have reappeared on the walls. This time, they are the artist's manicured hands digitally manipulated into forms that are dichotomously both delicate and submissive and grotesque and aggressive (plate 1).

The lyrical romanticism of the earlier chapters has been transformed into something verging on melodrama. The title of the work is even announced in a domineering and assertive way on one of the walls. The restrained speech of the earlier works has become "unshaped," as the Gentleman in *Hamlet* says of Ophelia. Ophelia's madness as referenced in this work can be seen as a metaphor for transgression out of the restrained female, elite spheres. But whereas literary critics have often read Ophelia's transgression as primarily sexual (thereby linking female sexuality to insanity), in this work, the transgression operates on multiple levels. The sexual is certainly one of them. There is also material and class transgression. But most important, Ophelia's

madness results from the inevitable unraveling of the attempt to weave to-
gether two histories and cultures. To an extent, this weaving works in the
realm of restraint (Chapters 1–5), where it is all about elite correspondences
and appearances. But it becomes explosive in other contexts—presumably
those just prior to or after Chapter 15. The subject's (or work's) aggressive
refusal to speak in the languages of patriarchy, of elitism, and of cultural
boundedness breeds madness on both personal and collective levels. The at-
tempt to be a modern-day Ophelia is, from the beginning, doomed to failure.
Perhaps that is what Amina is saying about U.S.-Egyptian relations in gen-
eral. After reading Chapter 6 of this book, you may agree.

For me, the value of Mansur's work lies in her sophisticated examination
of the interwoven themes of wealth, taste, gender, and nostalgia in this long-
standing traffic across cultural boundaries. Mansur refuses to reduce cross-
cultural issues to identity politics, declarations of radical alterity, or simplistic
critiques of tradition. Rather, she reveals a story filled with complicated, and
often contradictory, alliances and dissonances. I try to do exactly this in my
own chapters here, but the written form has limitations that Amina's visual
language does not. Through Amina's work, I (and I hope you) can access other
ways of knowing and experiencing the story I am trying to tell.

What I also like about Amina's work is that it addresses her privileged
background directly. It recognizes and explores the oppressions and potential
of this history—not through didactic critique or embarrassment, but through
careful exploration of its personal effects and how these are linked with the
social. Other younger artists from similar backgrounds, doing art that is quite
different from that produced by the majority of artists in the country, have
emerged in recent years. Their work is different in that it does not fit easily
into nation-oriented themes and narratives, which to many viewers (myself
included) is often like a breath of fresh air.

But Amina still stands out among them. Rather than elide privilege, she
takes it as her subject. In fact, I see her as one of very few artists in the whole
history of modern and contemporary art in Egypt who has been able to break
the objectifying gaze. She does not paint peasants, sculpt veiled women, or
photograph difference. She does not create installations or videos with an
easy-to-deconstruct narrative about Egypt or Cairenes, and her visual lan-
guage does not fit easily into Western avant-garde desires and expectations.
Nonetheless, some aspects of her work do not translate well to her friends—
those artists who attended the meetings back in 1997. I think this is because

it references (often in English) histories with which they are unfamiliar. Furthermore, the reasons why I and other Euro-Americans like the work are often specific to our own notions of what "interesting" art is, and they may not be shared by the kind of "vast middle" of Egyptian artists I discuss in this book. It remains the case that Amina has opportunities that most Egyptian artists do not have—to travel, read and communicate in English, study abroad, and produce expensive art. This will inevitably continue to shape her concerns and her work in ways that diverge from the concerns and work of other Egyptians. I imagine that in the future, her art will increasingly have an international presence, which will be well deserved. And I hope it will counter what I find to be the new objectifications and self-orientalisms of contemporary Middle Eastern art favored by Westerners abroad. However, it may not. There are local specificities to Amina's work that foreign audiences ignore or do not recognize. The problem of translation goes the other way too. I worry that these specificities will be lost and that her work will be warped into a framework that limits it.

At the same time, I wonder what trajectory the other young artists will take, including those from the 1997 roundtables less well versed in Western internationalism and more deeply rooted in Arab and Egyptian intellectual histories and trends. I ruminate on that in the next interlude.

1 BECOMING AN EGYPTIAN ARTIST

"Freethinking" in the Mainstream

Education opened the door for many things. Education is like an old man. His son cannot reach the handle of the door. So the old man opens the door for his son and lets him go. In this way, the college I went to opened the door for me, and I just ran through it.

Sami Zahran, artist and graduate of the College of Art Education, Cairo

NEARLY EVERY DAY, with a bag full of books and art supplies slung over her shoulder, Manal Amin walked to the subway station from her family's brick and cement apartment building in a crowded Cairo neighborhood. After a twenty-minute trip and another ride on a packed microbus, she arrived at her arts college in Zamalek—an elite neighborhood in the center of the city dominated by neoclassical Italian and French architecture. At the college, she often met with her many friends. Like her, they were graduates of the college later appointed as teaching assistants while working on their Ph.D.'s. In the faculty room and out in the courtyard, they laughed, gossiped, and had heated debates over cups of tea. Someone often made a run for fava bean or falafel sandwiches to feed the crowd.

Manal's day did not end after classes. She regularly criss-crossed Liberation Square, the center of downtown Cairo, for various meetings, events, or errands related to her career as an artist. Sometimes she had appointments with reporters or gallery owners. If she was not giving an interview, dropping off pictures, picking up her cut of a sale, or arranging a date for her next gallery show, one might find Manal running to drop off a piece of art for a government exhibition deadline or picking up an application to enter a state-run competition. She also made trips to the big market in 'Ataba, where an artist could get just about any supplies needed. If there were no evening roundtables on art being held at the galleries, or no opening receptions, she might head back to

the coffee shops near galleries downtown, or to the studio of a friend. Again, with a tea and a few laughs, they would catch up on the latest news. I often rode home with Manal on the subway after these long days. Glancing at her watch frequently, she would often joke that she was going to get in trouble because she was expected home by ten. My stop was just before hers. As we kissed each other's cheeks to say goodbye, I would worry that she would have to deal with her brother's rebuke when she stepped in the door—envious as he was of her education and success. But I would also be completely amazed at her energy. For I knew that she was also going home to help out with the household chores, and then she would stay up late into the night doing her art—only to wake up the next morning and run from place to place with her heavy bag again.

To be an artist in Egypt was not just to make art. It was, fundamentally, to be part of different sets of social relations. It was to discuss with friends matters such as the best way to glue paper to wood, who received the latest government prize, who was selling work to foreigners and rich Egyptians, and what made some art "Egyptian" and some art not. It was also to spend significant time meeting with critics and curators, documenting one's work and buying supplies for it, preparing for shows and entering competitions, and teaching and studying. And it was to be a contributing member of a family whose members often knew very little about the visual arts.

How did someone like Manal Amin become an artist? She comes from a family of laborers and craftspeople, who possess vocational degrees at most. Her father makes decent money, and they live well enough, but they are not rich, and she was not brought up with knowledge of the art world. She grew up in a "popular" (sha'bi) neighborhood of petty traders, mechanics, drivers, and the unemployed. When I met her, most young Egyptian women her age were already married with children.

Like Manal, the vast majority of practicing artists in Egypt at the time of my fieldwork came from modest backgrounds in which they had little or no exposure to modern art. Egypt's population was nearly seventy million. Of that number, a mere 5,000 were members of the Syndicate of Plastic Artists, and there were a small number of artists who were not members. How, then, did one come to such a unique career in a place like Egypt, and from backgrounds like these? How did an individual find out about the arts, and then decide to pursue art as a career, amidst a population primarily preoccupied with making ends meet? And how did one learn what it means to be an artist in such a place?

To begin answering these questions, I start this study with an analysis of how the categories of art and artist were constructed, legitimated, and reproduced in Egypt. As sociologists and anthropologists of art have long argued, becoming an artist anywhere, Egypt included, is not solely a matter of doing art (see, e.g., Firth 1951; Forge 1967; Myers 2002; Wolff 1981; Zolberg 1990). A person has to learn what art is and how to do it. What an artist makes has to be considered as art by a larger community of artists and critics, and the art and the artist usually have to be integrated into this community and credentialed by its institutions. Howard Becker (1982), drawing on Arthur Danto (1964), has described this constellation of groups and institutions as an art world and showed that it is the art world that classifies certain objects as "art" and certain persons as "artists." Pierre Bourdieu (1993) also writes against the "transhistoric or ahistoric essence" that is often used to explain what art is or to assign it value. Instead, he argues that both art and artists are produced through a field of cultural production that strives towards autonomy (within the larger field of power), which emerged in late nineteenth-century France.[1]

These insights into the production of the categories of art and artists can be applied to places other than those usually studied by such prominent theorists. In this book, for example, I find the concepts of the "art world" and the "field" extremely helpful for understanding how Egyptian art is made through constellations of social groups and institutions, and through the struggles and battles that characterize fields in the Bourdieuian sense (*le champ*). But the specific content of Euro-American-derived theories of art and artists—about how art worlds work, how artistic fields are constructed and reproduced, what counts as art, and who is considered an artist—does not always fit my material, because the historical development of artistic fields differs from place to place (even within the "West"), and, as studies in ethnoaesthetics have shown, cultural understandings of what constitutes art and artists also vary (see, e.g., Carpenter 1971; d'Acevedo 1973; Fernandez 1971). Although there were some similarities between certain Egyptian and Western ideologies of the artist, and between the field of artistic production in Egypt and that analyzed by Bourdieu in France, there were also key differences, which need to be explicated here so that the rest of this book makes sense. These differences raise serious questions about the imposition of Euro-American-derived concepts of art's autonomy and related ideologies of the individual artist as genius and/ or rebel. These questions are particularly important in contexts, like Egypt,

where the field of power has been permeated by colonial and feudal relations, patronage relations of a (quasi) socialist state, and struggles for advantage in the hybrid command–free market economy among military and bureaucratic elites, nouveaux riches, and the old aristocracy. At some level as well, the disjunctures between my analysis and those working on western European or American contexts should cause us to question how the concepts or mechanics of autonomy, as well as ideologies of the individual artist, come to be assumed to be true or universal in the first place, even in the "West." To what extent are autonomy and the oppositional artist ideals in London or New York, for example, and just how much and when are these ideals realized?[2]

Partha Chatterjee (1995) and others writing about the formation of disciplines in colonized or formerly colonized places emphasizes the disjunctive processes in which certain concepts and practices (like modern art) were or are translated—through specific institutions—in ways that produce(d) "difference" and claims to difference. As I show in this chapter, the idea of the modern artist as translated in Egypt was one of a freethinking individual, but also a member of mainstream society—*not* an oppositional or critical malcontent. Thus, Egyptian artists have not emphasized the "rebel artist" strand in Euro-American ideologies of the artist, which is related to concepts of individualist personhood that are the hallmark of capitalist societies (see, e.g., Clark 1984; Guilbault 1983; Zolberg 1990). Artists in Egypt did cast themselves as especially inquisitive, cultured, and productive. For them, art was a means of individual expression, but it was also a way to become respectable elite members of their society and contributors to their nation. They have thus largely eschewed the idea that artists should adopt unorthodox lifestyles. Furthermore, they have not positioned art as totally divorced from utility or from the "praxis of life" (Bürger 1984), thus countering those Euro-American ideologies of art that depend heavily on Kantian formulations of an autonomous aesthetic characterized by disinterest. Finally, the process of becoming an artist in Egypt was also one of acquiring a middle-class subjectivity that embraced religion in private life, the acquisition of consumer goods, and a heterosexual, married lifestyle. In Europe, the rise of bourgeois society may have spurred artists' public derision of such subjectivities and catalyzed the concept of autonomy in general (Bourdieu 1993; Bürger 1984; Eagleton 1990), but in Egypt—where capitalist relations have been differently intertwined with colonialism, socialism, and neoliberalism—there has been no such one-to-one correlation between the bourgeois and autonomy.

It is important that the different formulations of autonomy and the artist in Egypt need not necessarily be read as a kind of incomplete modernization, contradictory modernity, or as evidence that Egyptians are working towards notions of complete autonomy and the oppositional artist in the first place (cf. Canclini 1995).[3] Indeed, the categories of art and artists were not subject to wholesale transference from Europe to Egypt, and European-derived notions of the progress to autonomy were not the only ones available. Rather, in both locations, they have been the result of ongoing processes of translation, in which arts interlocutors reckon with locally and globally circulating genealogies of the "modern artist" and "modern art."

This chapter examines the various ways in which certain Egyptians, like Manal Amin, came to practice art in this culturally specific way. It analyzes how they became functioning, productive members of a society in which little was known about their careers, and in which there were certain expectations of them as adult men and women. I focus on art education because art colleges were the most common contexts in which the categories of art and artist were produced and learned.[4] I consider a number of educational themes, including the history of higher education in Egypt; entrance to art school; peer activities; curricula and pedagogy; student aspirations; and relations between students and teachers. Each of these aspects reveals a crucial part of how one became an artist, as well as an Egyptian, in the latter half of the twentieth century, and my analysis of them thus lays the groundwork for understanding the major dynamics in Egyptian artistic life that I discuss throughout the rest of the book. This chapter also introduces the reader to remarkable men and women who devoted themselves to the visual arts and intellectual life, despite its virtual promise of continued economic struggle and social invisibility, after starting out as the sons and daughters of homemakers, factory workers, craftspeople, minor civil servants, small shopkeepers, schoolteachers, or even farmers.

By taking the reader through the trajectory of how a person becomes an Egyptian artist, I hope to convey a sense of these artists' social lives and the kinds of things that were important to them as artists in a particular place and time. For example, becoming an artist was inseparable from becoming an adult middle-class member of Egyptian society and a good Muslim or Christian, yet one who did not advocate religious bases for politics. Similarly, being an artist meant recognizing the national space and place of Egypt as a source of artistic inquiry, and individual and cultural authenticity as a framework

for evaluating art. Ultimately, I suggest that art-making in Egypt contributed to the creation of secular-oriented national subjects.

Being both an artist and an adult member of Egyptian society were not always easily reconcilable. To be an Egyptian artist was to manage a set of values (and tensions) produced through the history of colonialism and nationalism. Most artists wanted to be true to themselves and to their cultural background while pursuing a career in a field that was widely recognized to be a foreign import. They also wanted to be useful members of a society in which technology and science were valued over art. And many artists wanted to be connected to or participate in everyday life, while pursuing a career with elitist associations. The effects of these tensions, and how artists tried to resolve them in a post–Cold War world of neoliberal "reforms," are the subject of this book. Here, I examine how these dominant values that structured artistic practice were developed and inculcated, and how models for resolving specific postcolonial intellectual dilemmas were imparted to young men and women as they learned to become Egyptian artists.

BEFORE ART SCHOOL: THE ARTS IN EGYPTIAN SOCIETY

I began my first interview with Manal Amin with a question that I asked many artists when the tape started rolling: "So how did you become an artist?" Like many others, Amin began by telling me about her studies in art school: "I am a graduate of the college, and now I am a teaching assistant there, in the painting department. This gave me a chance to be directly in the art field." The focus on state higher education in these interview responses signals its centrality to artists' presentation of themselves, and to the process of becoming an artist in Egypt. That state higher education was the main avenue by which most Egyptians became artists was likely due to the fact that, outside of school, there was very little exposure to the visual arts in Egyptian society.[5] Indeed, nearly half of the artists I knew said that they had not known what the visual arts were until they attended art school. If one did not have a parent who was an artist or taught art, there were limited opportunities for exposure to or training in the arts. Indeed, many Egyptians gained their primary, if not sole, exposure to modern art through their enrollment in a state-run art college. This enrollment was determined by a tracking system, as described below.

Television was one place where those with no other connection to the visual arts might learn something about them. There were two half-hour art

programs on the Cairo stations every week. But at the time of my fieldwork, one was on during the late afternoon, when people are usually having lunch or taking naps, and the other often aired at the same time as the extremely popular early evening soap operas. These soap operas and some films occasionally had artist characters,[6] and artists sometimes appeared on talk shows. Arabic-language newspapers had arts pages or columns, but many Egyptians were illiterate or did not regularly read newspapers.

Outside of these occasional media appearances of art and artists, the main avenue for exposure to the visual arts was elementary and secondary school education. Sometimes students in Cairo or major provincial towns were taken on field trips to museums or cultural centers where there were paintings on the walls. But more often, exposure came in art class. Drawing was part of the national public school curriculum, and elementary children took it yearly either from a specialized art teacher or from an instructor of another subject who doubled as an art teacher. The classes focused on drawing techniques, and artists informed me that discussion of art as a career or of modern art as a movement was rare. Those children that made it to the eighth grade were tracked either into a three-year high school or into a vocational school, depending on their grades and interests. Those who attended industrial vocational schools were sometimes required to take drawing courses, particularly if they concentrated in mechanical drawing or in decoration (*zakhrafa*, e.g., decorative wood carving, calligraphy, Islamic designs). Alternatively, those who were tracked into high school were steered into either science (*'ulum*) or the humanities (*adab*), with the science track requiring higher grades. Art classes continued only for those tracked into the humanities. Thus, after the eighth grade, the majority of the population (who had continued after elementary school) ceased to learn about art in any formal way. People who did continue on and became artists, then, were choosing an especially unusual career in their society. Manal Amin's words convey the distance that many people came to feel when they chose this career, little known to their families:

> My family feels that art is something they cannot grasp. Now I am doing my Ph.D., and my relatives do not understand how I did not finish studying yet. They do not realize that this is my job. They cannot grasp the concept of a girl who is still studying and has not started a home and family yet, and who attends conferences and meetings until 10 at night. They ask why I can't do this in the morning. It is very hard to explain to them. When I try to explain modern art

to some people, they think that I should be drawing a portrait of them. All they think about is gardens, trees, or flowers. This is their way of thinking. You cannot explain everything to them.[7]

In a similar vein, her colleague Ahmad Mahmud said that his father had not understood his son's profession until he went to the latter's first exhibition. Seeing the crowds of people, cameras, and ribbon-cutting, he said to his son, "I had no idea that what you did was so important!"[8]

THE PATH TO ART SCHOOL:
MODERN EGYPTIAN EDUCATION AND THE CATEGORY OF THE ARTIST

Not only was the path to art school an unusual one, especially for Egyptians from families who were less formally educated. It was also highly regulated according to a centralized and ranked testing and college admittance system. This system also shows us the middling status accorded to the visual arts in Egyptian society at large. In the final year of high school, students across the country prepared for a comprehensive nationwide exam in either the sciences or humanities. Exam scores corresponded to a ranked list of colleges of different specialties (e.g., pharmacy, commerce, law) and largely determined the career that one would be trained for. In addition to preparing for the big exam, students could choose to take smaller skills tests that they might need to enter a particular college, such as a skills test in drawing that was needed for admission to the arts colleges. Artists told me that students often took as many of these skills tests as they could to maximize their college choices.

Ministry of Higher Education college rankings clearly suggest which professions carry the most social status and which are deemed most beneficial to the nation. Medical and engineering schools are ranked the highest overall, followed by other colleges related to science and technology.[9] At the time of my fieldwork, art schools were ranked just below the national median and shared their rankings with other faculties. The College of Applied Arts in Cairo, with its focus on technology, required the highest score out of all of the art schools and was usually ranked near the levels of the schools of engineering. The colleges of fine arts (in Alexandria, Cairo, and Minya) were ranked behind applied arts and shared their rank with colleges of commerce. The College of Art Education was ranked just below the fine arts schools, at the same level as other faculties of education (*kuliat al-tarbiya*).

This system of centralized exams and ranked entrance into secondary

school and university is intertwined with the history of European colonialism and Egyptian nation-building. British and French test-driven and ranked educational systems were developed in the nineteenth century in large measure to feed the ranks of the civil service of the colonial government. It is not incidental, then, that this system "took root" in Egypt during the tenure of Lord Cromer, the British consul-general and agent in Egypt from 1883 to 1907 (Reid 1991:111). One of the explicit aims of the educational reforms of the British-controlled local government was to staff the local civil service (Starrett 1998:31).

The emphasis on techno-scientific education in the testing and ranking system is also part of the history of nation-building. In the mid nineteenth century, some forty years before the British cemented their occupation of Egypt, the Ottoman ruler Muhammad Ali opened many technical and scientific schools, including a school of arts and industry, which at various times taught draftsmanship, machinery, and instrument-making (Heyworth-Dunne 1938). His aim was to develop the Egyptian province by making it on par with Europe both militarily and industrially (see Hourani 1983; Starrett 1998:26–27). This educational emphasis on science and technology received another boost nearly one hundred years later, when Nasser sought to build an independent, modern state after the 1952 revolution. Professionals in these fields were in high demand as the government embarked on many technological projects (such as the Aswan High Dam) in order to "modernize" the nation. The Coordinating Office was set up to distribute students among various faculties according to their scores on the new national exam. Donald Reid's history of Cairo University (1991) indicates what happened to the liberal arts in this period of technological development. The liberal arts ranked ninth in prestige out of twelve major fields in 1957 but had fallen to eleventh by 1976.[10] The high social status given to doctors, scientists, and engineers, which translated into the high rankings of their colleges, thus went hand in hand with the techno-scientific nature of the state's post-independence nation-building.

The prestige and government support accorded to techno-scientific fields throughout modern Egyptian history has not developed unopposed, however. Reid (1991) discusses the development of a major tension that has continued to dominate educational philosophy and policy. It is found in a set of debates among educational theorists over whether or not universities should produce technicians or liberal humanists. Well before the revolution, major thinkers such as Taha Husayn (at one point the minister of education) had argued for an emphasis on liberal humanism in education, and the first Egyptian uni-

versity was based on this philosophy. These thinkers were highly influenced by French liberal thought and by European high culture in general, and they were criticized after the revolution for belonging to the ancien régime. They countered by arguing that the Nasserist reforms, especially the emphasis on technical pedagogy, were throwbacks to the educational policies of the British. Despite the accusations that he was an elitist, Taha Husayn had long supported the establishment of free and open education in Egypt, and this idea was implemented by Nasser in 1962, when he declared university education "a right, not a privilege." [11]

The complex history of education that I have abridged here is reflected in the historical development of art colleges. Accounts of the beginning of modern art in Egypt often open with the founding of the School of Fine Arts in Cairo in 1908 by Prince Yusif Kamal, who was greatly impressed by the fine arts schools that he had visited in France and Italy and decided that Egypt also needed an art school in order to be a modern, civilized nation, according to 'Asim al-Disuqi (1995). A French sculptor resident in Egypt is said to have persuaded him to open the school. [12] Prince Yusif paid for everything (including tuition) until 1927, when he turned the school over to a government ministry. This school eventually became Cairo's College of Fine Arts, making it the oldest institution of its kind in the Arab Middle East. It was also very much ahead of its time, offering free higher education fifty-four years before the rest of the colleges in the country. The prince's philosophy—that arts were necessary for a civilized society—was in accordance with the liberal humanism of the intellectuals I have discussed. Later, in the 1930s, colleges and institutes of applied arts and art education began to be formed, representing the techno-scientific emphasis of the growing nationalist movement.

While interaction with Europe influenced Egyptian art education, the colonial experience did not completely determine how the category of "the artist" would be constructed at the end of the twentieth century. The history and structure of education in modern Egypt helped shape this category in three main ways. First, choice played a limited role in determining which Egyptians went to art college. Experiences like that of the accomplished painter and installation artist Hanan 'Atiyya, who had known very little about art until she placed into the rank of the art colleges, were quite common:

> In all honesty, I didn't know anything about the fine arts at all. I liked to draw in grade school [like everyone else]. But I wanted to go to the College of

Engineering and study electrical or mechanical engineering. I loved that a lot! But of course, the score on the exam, and the ranking, and these things . . . my score wasn't high. I scored into the College of Fine Arts in Alexandria. OK, I liked drawing and everything, so I matriculated. I didn't even know anything. I entered because of the ranking system, like everyone else. I didn't know anything in the world. At all.[13]

'Atiyya, like many others, decided to become an artist only while attending art school, which is where she gained her first substantial exposure to and interest in art. As the epigraph to this chapter also shows, in artists' narratives, art school "opened the door" of knowledge.

Most artists indicated that they had loved to draw when they were children, and some said that they had had an early interest in attending art college and had thus aimed for a particular score.[14] Significantly, the majority of artists who said that they had always been interested in art mentioned, often in the same sentence, that someone in the family had done art, or that the family as a whole was artistic. For example, Hanan 'Atiyya's colleague Nadia Gamal said that she came from a "typical" middle-class family that was "uninterested" in the arts, but that her mother used to draw once in a while, which piqued her interest.[15] A few artists also had relatives who exhibited and sold their art, so they had grown up with the knowledge that art could be a career. An Alexandrian artist showed me the sketchbooks he had kept as a child and spoke fondly of conversations with his uncle, who was a known painter.

As these examples show, the formation of Egyptian artistic identity did not depend on artists claiming that they had always wanted to be artists, had always loved art, or had chosen to pursue an arts degree, although their narratives might contain such elements. Rather, the system created the possibility for artistic talent to be seen (and respected) as learnable, not entirely innate. Furthermore, relatively arbitrary placement in art colleges actually enabled people to discover artistic talents and interests that they otherwise would not have recognized. Thus, this system resolves a contradiction inherent in Western art pedagogy (one cannot teach something that is supposed to be innate; see Bourdieu 1984:74) and demystifies Western romantic notions of the artist as a natural genius whose talents have existed since childhood (see Zolberg 1990). It also calls into question Bourdieu's theory (1984) about ultimate social distinctions being based on capabilities seen as innate or inherited, rather than learned.

The history and structure of modern education in Egypt shapes the category of artist in a second important way. I have shown that since the inception of secular education during the Ottoman period, and particularly since the rise of the socialist state after independence, the system has been geared towards the scientific, industrial, and technological development of the country. The ranking of colleges to correspond to scores on the national exam underscores this point. The place of the arts in this hierarchy is in the middle; therefore their state-accorded role in nation-building is ambiguous. Furthermore, the liberal arts were accorded a higher place in education before the revolution, which, among other things, led them to be associated with European colonialism and elitism. This middle space undoubtedly reflects the long-standing tension between liberal humanism and techno-scientific skills in Egyptian educational philosophy and social prestige (see Reid 1991). This tension, as I shall show, produced a situation in which people who went into the arts had to legitimate their career choices within a nation-based idiom. In other words, to increase the social value of what they did, they continually asserted its usefulness to society and to the nation.

The third important point of this overview of higher education is that it is open and free.[16] The 1962 decree that abolished tuition and instituted open admissions has led to a consistent growth in the college population, which is now dominated by students from the lower and middle classes. Not only were the majority of students at the Egyptian art colleges during my fieldwork from these groups, but many were also part of the first or second generation in their families to receive higher education. Before 1927, thanks to Prince Yusif Kamal's largesse, lower- and middle-class youth wishing to study art free of charge could do so at the School of Fine Arts in Cairo, but between 1927 and Nasser's decree of 1962, only those who could afford to study art did. During most of this period, the arts were very much an elite activity. It was quite common, for example, for society women to take up drawing and painting. But Nasser's educational reforms created a situation some forty-five years later where people from lower and middle classes came to attain a college degree in the visual arts, where many family members first encountered artwork during visits to student exhibitions, and where students had to explain to their families (with some difficulty) what exactly it was they were studying and planning to do with their lives. Just as they showed art's usefulness to society and nation in some contexts, in others, they asserted its value for the family.

THE DAILY LIFE OF ART STUDENTS:
LEARNING TO BE AN EGYPTIAN ARTIST

At art schools, students were taught how to become members of the intellectual community of artists *and* adult members of the large urban middle class within Egyptian society. Relations with family, peers, and professors, as well as academic studies, all contributed to this process of becoming Egyptian artists. My discussion here will illustrate that the cultivation of a distinct art student identity was a less important part of this process than was the acquisition of skills, knowledge, and, most important, a degree. These were what prepared individuals for adulthood at home and in a career. Art students were not focused on opposing mainstream society, as might be expected. Rather, they aimed to be productive, but especially freethinking, members of society. This artistic subjectivity represents the amalgamation of different genealogies of the modern, including (but not limited to) those that position the artist as having an especially inquisitive role in society and those that work to create nuclear families and national citizens, as well as a strict separation between the religious and secular. The importance accorded family and nation was taught well before the college years, but here I am concerned with how students learned to reconcile these important aspects of their lives with potential careers in the visual arts. It will become clear that art school life taught young people how to frame their artistic practices and aspirations (to themselves and to nonartists) with the socially recognizable image of freethinking individuals who also recognize their commitments to family, religion, and Egyptian society. More specifically, students learned the particular contributions that an individual career in art can make to these larger entities. Furthermore, it was in art school that students gained a sense of the cultural politics that define their field, and the dilemmas they would face if they pursued a career in it. In different ways and to varying extents, artists later came to criticize aspects of school socialization, particularly the more blatantly patriotic pedagogical discourses. But they also continued to agree with other things that they had learned.

Students began learning to be Egyptian artists on the first day of school. When they matriculated, they were given a student guide that officially explained the goals of their education. The lessons in the guide were repeated in many other educational settings and served as models with which students could, with some personal revisions, articulate to themselves and to their friends and families exactly what it was they studied and what the benefit

of their education would be. These models were also attempts to resolve the historically constituted dilemmas of visual art practice in Egypt—dilemmas they would encounter in art school and face for the rest of their professional lives. Artists drew on, critiqued, and manipulated them in a variety of ways, which will become apparent in the rest of this book. Here, I shall analyze what those models consisted of.

The very first paragraph of the 1999–2000 guide for the College of Art Education instructs the student that the college years are the time to define one's "practical role in building our society and its service."[7] In a short message, the provost then welcomes the students to the university community, where, he says, "we work towards elevating the nation." Next in the guide is a list of educational goals. The first goal is to produce art educators. The second and third goals clarify the national benefit of these art educators: they are to make Egyptians cultured (tathqif). Tathqif was not just a goal stated in the official students' guide at the art education college. It was a topic at many art school colloquia and conferences and became an official course topic. Indeed, one of the first lessons that students at all art schools were taught—whether or not they read the college guide—was that they could play a key role in building Culture (with a capital C) in Egyptian society.

Students were also taught that they could benefit the country by beautifying it through their art. "Beautification projects" ('amaliyat al-tajmil), intended to diminish the effects of urban decay and overpopulation, were quite popular in the 1990s, as discussed in Chapter 4. The formal curriculum of the College of Applied Arts was especially geared towards beautification, because it trained students who would later become industrial designers, public art producers, window dressers, and the like. Additionally, professors at the colleges of fine arts told their students that their training in painting, drawing, architecture, and décor could also be used to beautify Egyptian cities, workplaces, stores, and even homes. Indeed, educating the population in matters of Culture, in part through beautification projects, was one of the major ways that art students learned to articulate their role in society and their potential contribution to national progress. Some went on to participate in such projects, as I show in later chapters.

The importance of having larger societal goals for their work, and indeed the importance of the nation to artists, is one of the major subjects of this study. As I showed earlier in this chapter, nationalist discourse, and more specifically the clear display of nationalist aims, played a key role in the develop-

ment of modern pedagogy in Egypt. But here we can see particular institutional settings where art students were taught how to contribute to society, and where most came to believe that they should. I suggest that the strength of this conviction arose in part from their introduction, in art school, to the problems inherent in the practice of modern art in a postcolonial society.

How to be true to oneself and one's culture while pursuing a career in a field that had foreign and elitist connotations was the primary problem many art students encountered. Students in the colleges of fine arts (as opposed to applied arts and art education) were the most exposed to the dilemma of how to maintain Egyptianness, because instruction at these schools focused on techniques, styles, and media that came out of classical European academy curricula. For example, one common assignment was to copy the work of European masters (mostly from the Renaissance) or work done in European styles. On any visit to the College of Fine Arts in Cairo, for example, one will find students gathered around the various Greco-Roman or neoclassical statues and busts in the courtyard, carefully sketching or painting them (fig. 1.1).

Additionally, at this college and at others, professors introduced techniques (such as shading and color use) and composition by showing students

Figure 1.1 Students at the College of Fine Arts, Cairo.
Photograph by Muhammad 'Abd al-Ghani.

pictures from European art books. For example, students were often shown Cézanne reproductions before beginning a still life assignment. Lessons in drawing and painting were geared towards teaching students how to draw three-dimensionally, with examples from the Renaissance. Sculpture professors also used examples from the Renaissance or the romantic period in their teaching. Skills were seen as the core, or the basis, of much art education. And European art examples served as the model; only occasionally did a professor use an example from modern Egyptian art history.[18]

Alongside the consistent use of classical European representational techniques, Egyptian fine arts students were also required to take courses in art history during their first three years of college, in which the European classical canons were emphasized. But these were taught alongside other "great" traditions closer to home. For example, the first year's lectures dealt with the art of ancient civilizations, with the focus on Pharaonic, Greco-Roman, and Assyrian art. In the second year, students learned the history of Islamic art, with a small section on Coptic art. During these years, Pharaonic art especially was framed as part of the history of the nation. The third year was devoted entirely to the history of European art up until cubism. Writing about the translation of canons to the Indian modern art movement, Tapati Guha-Thakurta has observed that European art historians first included ancient Indian or Egyptian art in their canon as an attempt to locate European art's own lineage, whereas Indians included this art in their canon as part of the project of building a glorious national past (1995:67–71). Similarly in Egypt, students were taught the (often nationalist) value of other artistic traditions, particularly those related to the history of their region (i.e., Islamic, Coptic, and Pharaonic art). Nonetheless, the European canon took up an entire year of coursework (more than either of these traditions took individually), and the model for *doing* art remained European. It was not until 1999, when the art history department was founded, that students at the Cairo College of Fine Arts could major in non-European art history.[19]

At the same time, professors in the College of Art Education's Department of Art Appreciation primarily taught (and wrote on) Western theories of aesthetics. This department was heavily influenced by the writings of Mahmud al-Basyuni on issues of art education and aesthetics. A prolific writer, al-Basyuni had been instrumental in formulating the curriculum of the entire college. He had a Ph.D. from Ohio State University and had held several visiting professorships in the United States. His writings, as well as those of the

chair of the Art Appreciation Department, Muhsin 'Atiyya, have educated generations of students in Western aesthetic theory and art education techniques. They helped students graduate from the College of Art Education well versed in John Dewey and Herbert Reed, as well as Schopenhauer and Kant. They were either required to read these authors in translation, or Arab art theorists' discussions of them. Sometimes, the latter contained some philosophy on non-Western theories of aesthetics or discussions of how Western theories of art education could be adapted to a Middle Eastern context, but the starting point was nearly always Europe and the United States.

But just as students were learning how to reconstruct Cézanne's color schema and composition, and to cite Dewey's theory of modern art education, they were also learning from some of their professors that it was important to create work that was "Egyptian" and did not imitate Western art. There was an explicit attempt to include "Egyptian" artistic traditions in the universal category of fine arts. Not only were there required courses in Pharaonic, Islamic, and Coptic art (and in folk arts at the art education college), as I have mentioned, but certain professors encouraged the use of these traditions and drawing scenes from contemporary Egyptian life in the execution of some assignments. In the College of Art Education, for example, there were required classes on art and the Egyptian environment (al-bi'a), in which students were often asked to create objects from locally found, natural materials. Several professors complained to their students that the curriculum did not teach them about modern or contemporary Egyptian art; and they told me of their failed attempts to change it with the administration. To rectify this situation, they sometimes interspersed their mainly European class examples with images of art done by the pioneers of modern Egyptian art, and discussed the "Egyptianness" or the nationalism of that work.[20] Some of the younger professors even took their students to exhibitions of contemporary Egyptian art.

Many of the same faculty members who harped on the importance of creating "Egyptian art" complained that no modern Western art after cubism was formally integrated into the curriculum at Egyptian art schools. Some showed images of, or discussed, post-cubist American and European art, and junior faculty bought books on their trips to Europe or the United States and donated them to the school libraries. So, yet again, these professors used European and American art as primary examples in their teaching. After the paintings of Cézanne, for example, students were shown the work of Joseph Beuys, Donald Judd, and Robert Rauschenberg.

But other faculty objected to including such art in the curriculum on the grounds that students would be tempted to copy the latest in Western art when they became practicing artists. In Chapter 3, I discuss the debates surrounding the annual young artists' exhibition, or Salon al-Shabab, in which these professors and many critics attacked young artists for imitating contemporary Western art. Faculty who wanted to see more instruction in post-cubist ideas and techniques argued that their critics contradicted themselves, because while they opposed teaching Jackson Pollock because he was "Western," they also advocated copying European Renaissance masters as a pedagogical tool. One student of the Cairo College of Fine Arts, herself already a successful artist, commented that the "anti-Westernists" actually ended up encouraging young artists to imitate Western artists, because copying was their primary mode of instruction. In her logic, because students learn to copy European masters in art school, they then go on to copy American and European contemporary artists in their professional lives. Because examples from European and American art were held up as exemplars by both camps, accusations of copying and lack of cultural authenticity were prevalent all around. Such accusations persisted into adult artists' lives and work and had to be constantly negotiated, as discussed in the next two chapters.

Many faculty were also opposed to teaching contemporary Western art on the grounds that students needed to be immersed in basic technique, and that by teaching post-cubist trends, students would be drawn away from the basics. One day, in the Cairo College of Fine Arts faculty room, I witnessed an argument between two advisors for a student who wanted to do a concentration on images of the Messiah in art history. One professor wanted the student to look at contemporary treatments of the Messiah in Western art and made a larger argument for teaching post-cubist art trends at the college. His colleague (at that time the department chair) scoffed and said, "What can they learn from that? They learn all they need to know in the current curriculum." His comments were part of a larger position, which held that most post-cubist European and American art trends are naïve and silly (sazig), and that students needed to be taught how to distinguish serious art from silly art before they went and wrongly copied the latter.

These kinds of curricular tensions and arguments were imparted to the students during technical instruction, art history lectures, and in professors' criticisms of their colleagues in the classroom, as well as by arguments between their advisors that they overheard. I suggest that the majority of students

learned that there was something called modern Egyptian art, and that many of their professors made it and talked about the importance of cultural identity in it. Furthermore, they learned about artistic traditions from their own region of the world and that these were a part of world art history. At the same time, however, the practice of doing art, and of theorizing aesthetics and art education, were all taught primarily through Western sources and models—many of which were the same as those taught from the 1910s to the 1930s, during the reign of the European professors and the first and second generations of Egyptian artists. Yet they also learned that Western art was not to be wholly accepted. Art school taught students to experience *as tensions* the issues of Egyptian authenticity, European and American influence, and the uncertain value of Western art. It also taught ways for solving them.

Aesthetically, students learned from their lessons, and by looking at their professors' art, that they could use European techniques and styles to create forms and images that were distinctly Egyptian. For example, they were sent to draw mosques and old homes in the medieval part of Cairo. They were assigned to go to the Museum of Modern Egyptian Art and copy pioneer Egyptian artists' realist paintings of peasants, and they were sent to the Nile to draw the old houseboats among the palm trees. Additionally, sculpture and ceramics students, along with advanced students experimenting in assemblage or installation, were taught that the use of local materials, such as local clay, mud brick, or palm fronds, would root their work in the Egyptian environment. In critiques, students learned the language of evaluating and claiming artistic and cultural authenticity—a language analyzed in depth in Chapter 3. A professor, for example, would tell a student to be "sincere with himself" in doing art. Teachers also lectured on the importance of "searching for Egyptian identity" or "Egyptian roots" while working. Finally, those professors who introduced students to post-cubist European or American art told them that they could take from Western art what they found useful, as long as they mixed it with local understandings and produced something that was true to themselves as Egyptians living at a particular time.

Students were not only taught some aesthetic solutions for resolving the dilemma of how to make Egyptian art in a field with European roots; they also learned to frame what they did in terms that emphasized the benefit of art to family, society, and nation. Yes, they were studying a topic that was a Western import, they were told, but they could use it to help make the masses more cultured, to decorate the home, or to beautify the decaying city. A few profes-

sors even told students that art had originally been invented by Egyptians (i.e., under the Pharaohs) and was not a Western import at all. They showed students how to claim that, by making art, they were continuing, or even reviving, a great national tradition. Particularly since the revolution, with the rise of the socialist state, and with the socialist leanings of leftist intellectuals, it had become very important for artists to be able to step away from the elitist connotations of their work and to claim a connection to the people. Teaching the goal of bringing culture to the masses, although paternalistic, offered one way for future artists to claim interest in the masses in the face of claims that they were elitist. Here, modern art was linked to modernization. In a national educational system that valued science and technology over art, and in a society where the purpose (and profitability) of art was doubted or unknown, the models given to students at art school were useful on a very practical level. As the rest of this book will show, students drew on them frequently after graduating.

The European concept of modern art as a field of practice explicitly distinct from craft was introduced to Egypt during the colonial period, and this was one genealogy of the modern, one kind of autonomy, that artists generally advocated. Yet the distinction between art and craft needed constantly to be maintained, particularly in a place where the word for "artist" (*fannan*), to many Egyptians, implied a skilled craftsperson.[21] While artists wanted to be placed higher in the social hierarchy than craftspeople, craftspeople had more legitimacy, because their field was at least socially recognized. And Egyptian artists' notions of authenticity depended on some relationship to craft, an issue discussed further in the next chapter. Therefore, the distinction between art and craft became muddied in the art school context, where students were taught to do folk arts and crafts as part of their training in Egyptian or Arab art traditions. Classes such as woodwork, metalwork, decorative arts, weaving, and cloth printing, among others, were mandatory at colleges of applied arts and art education. And in further contrast to the pure gaze or disinterested disposition that Bourdieu sees as characterizing fields of cultural production and bourgeois engagements with art (1993, 1984), artworks were subject to frequent manipulation and touching by professors and viewers. Artworks (like artists) were not objects to be sacralized and set aside from everyday life. To really appreciate art, one had to touch it—a practice that artists later brought to their gallery visits. Given these similarities between art and craft, and between artists and craftspeople, both in the schools and in society at large, how did art students learn to distinguish themselves?

In part, the way in which art students learned the "proper" place of craft in their work, and their identity as artists and not craftspeople, was rooted in their relations with professors. In the centuries-long tradition of craft production in Egypt, apprenticeship to a master continues to be the primary mode of learning. The apprentice (*sabi*) is expected to obey and copy the master (*mu'allim*) in order to learn the craft; masters, not apprentices, are responsible for any innovation (see Koptiuch 1999). Many professors explicitly contrasted their own pedagogy with the master-apprentice system. For example, a former student of a famous sculpture professor fondly recalled his professor's way of teaching and began to quote what he called "the classic lines" the professor had spoken: "Here we are not apprentice and master. I show you the path, but you go down it by yourself. Don't take my word as indisputable."[22] Another professor told me that in his teaching, he "opens the window" for students, but they look out of it and see what they will. He went on to say, "I steer them, but I don't put restrictions on them."[23] In the classroom, I heard him emphasize to students that he "doesn't have the final word" and tell them to form other opinions if they wanted to. This professor and others said that the early focus on technique gives students the "basics," which is akin to opening the window or showing them the path, and then they are free to choose their way. Many teachers also argued that if students copied them (*taqlid*), they would not understand the curriculum, but if they "followed" (*itba'*) them, they would. A famous quotation from the Islamic legal scholar Imam al-Shaf'i was sometimes used: "Follow me, do not copy me" (Itba'uni wa la taqalladuni).

This pedagogical practice explicitly showed students that they were not craftspeople, and that part of being an artist was to explore one's own path and to have some freedom from one's teacher. The value of this approach for professors was also related to the anxiety over copying mentioned earlier. As one artist told me, "The worst thing for a professor is to be accused of churning out artists just like him."[24] Indeed, while evidence in students' work of a professor's influence could be a form of flattery, if it too closely resembled the professor's art, it was considered copying. And the professor was blamed: on several occasions, I was given the negative example of a famous teacher who allegedly turned out tens of students who did work just like his. Such charges taught students the limits of copying and the value of "freethinking" (*hurriyyat al-tafkir*).

This pedagogical discourse was based on the concept of "freedom of the artist" (*hurriyyat al-fannan*), which was a translation of Euro-American ideals of artistic autonomy, but with some important cultural emphases and limita-

tions. Students heard that artistic freedom was a right, and that as artists, they needed to think for themselves. They were told that they could differ with the professor and were encouraged to not let the professor have the "final word." Freethinking also applied to society. Some professors openly questioned religious tenets and other social values in front of students—not necessarily to get students to abandon their ways, but to get them to reflect on their beliefs. Several professors indicated that they tried to make students realize that there are other ways of living in the world, and that they therefore had a choice in how they wanted to live and do their art.[25] Religion and gender were two areas in which professors aimed to teach freethinking to their students. For example, as I discuss elsewhere (Winegar 2002), most professors were against the headscarf because they thought that it oppressed women, and because they saw it as extremist. One artist recounted her experience with her mentor, who disapproved of her veil. He challenged her ideas about it, but in the end, she said, he respected her decision to wear it. I shall return to the point of religion in a moment, as well as to the value placed on inquisitiveness and flexibility.

Certainly this pedagogical emphasis on "freedom" was inculcated, as evidenced by the fact that practicing artists went on to espouse the value of artistic freedom in adulthood, often to distinguish themselves from other Egyptians. For example, Manal Amin said, "There is a big part of society that doesn't understand what art is, and that an artist requires a lot of freedom. You find people who think that this freedom could lead a person to do something wrong. You have to start explaining to people that more freedom means more creativity, and that each person is then responsible for his life and choices, *in return for a good life*" (emphasis added). Art school professors sought to counter the idea that "free thought" was risky or disobedient and emphasized that it was *good for Egyptian society*. But they also taught that there were limits to this freedom. In the process, students learned to espouse "freedom" while learning their place in Egyptian society.

This "place" was partly in an age hierarchy, in which older people commanded the most respect. Egyptian artists constructed generational divisions amongst themselves in myriad ways, which reflected similar divisions in society at large. These stemmed not only from a shared cultural value placed on elders, but also, I would argue, from the sedimentation of a gerontocracy through state institutions. In art school, emerging artists learned the meanings attached to different generations of artists and how these divisions were regulated in the art world. They saw how the majority of Egyptian visual

artists classified themselves into two primary generations. First, there was the older generation (*gil al-kubar*), ranging in age from the late forties to the eighties, many of whom held important positions in the state bureaucracy. Students learned to refer to their professors by using this category. They also learned that once they chose art as a career, they would be classified as part of the younger generation (*gil al-shabab*).[26]

Generational divisions were reinforced not only by aesthetic proclamations but also through behavior. Like students in other faculties, art school students deferred to their professors of the older generation and their teaching assistants. For example, they always used honorific titles with them, and when they disagreed with them about something, they did so in a matter-of-fact or even shy tone and never with anger. This deference was akin to what they would show their parents, aunts, uncles, and other older relatives, and was part of a larger social value of showing respect for elders.

Deference was also cultivated through patriarchal means. The professors whose classrooms I observed were often formal and sometimes quite stern with their students. They frequently shamed those who exhibited any wayward behavior, such as not following the professors' instructions, gossiping or horsing around, or being careless about their work or their art supplies. In such cases, they would loudly criticize the student in front of the class, making an example of her or him. Many professors spent the majority of class time at their desks, ordering students to bring their work up to them, as well as to do various things such as open and close windows, move desks and easels, and summon the tea server. In these classrooms, a very clear hierarchy of order and obedience obtained.

Students who later became career artists found themselves in the same field with older artists who had once been their professors in such classroom settings. The deference of young artists towards older artists continued through the same practices of contained and measured disagreement and extensive use of honorifics. Even though it was not socially acceptable for an older artist to shame a younger adult artist in public, deference was still cultivated through small acts of what I call "putting young artists in their place." For example, on a panel, a well-established young artist would be referred to as "the young artist" and not by his or her name. Or, they might be spoken down to or interrupted by an older artist. Indeed, the construction of generations of artists and the regulation of behavior between them learned in art school continued after graduation.

However, while art students were expected to obey their professors' assignment instructions and classroom rules, they were not expected to be completely submissive or to copy their professors in all things, as I have shown. Although I never heard students complain about their professors' stern disciplinarian teaching style (probably because it was expected, given the formal teaching style of many grade school educators), young artists frequently criticized their ex-professors for being too controlling of their "freedom." However, these same young artists went on to repeat the teaching style of their elders once they were appointed to the faculty. In them, we see proof of the successful inculcation of both the language of "freedom" and the generational hierarchy. The importance of intergenerational deference and the limits placed on it also show how students were taught that artists should be especially inquisitive and flexible, but members of mainstream society nonetheless.

Like their professors, and in accordance with conventional Egyptian urban middle-class norms, students dressed modestly and conservatively and were well groomed. Men and women usually wore pressed slacks or skirts, with dress shirts and blouses. Approximately two-thirds of the women wore a simple yet fashionable headscarf. Even though their dress usually conformed to social mores of modesty, as young adults they were also attracted to the latest fashions. At the time, these included platform shoes, flared jeans, and headscarves whose fabric around the face was stiffened by inserting a thick piece of paper or plastic between the layers. There were hardly any unusual dress styles, however, and one found the same attire on other campuses in Egypt.[27]

In addition to dress, students' activities, demeanor, and religious practice were also well within the bounds of mainstream Egyptian society. On the whole, they were quite serious about their studies and getting their degrees. They flirted and talked about marrying first loves, living in a nice apartment, and raising a family. Students also generously treated one another to snacks and small meals. At prayer time, the school mosques were filled with men and women, and most Muslim students fasted during Ramadan. Christian students were equally modest, respectful, and pious. Drinking was rare; taking drugs, even rarer.

Rejection of religion was not at all necessary for the Egyptian ideology of the freethinking artist that I have been describing. While some students had long been aware of the injunctions against image-making in some Islamic texts, others said that they had only learned of such things in high school or in art school itself. Nonetheless, because religion was important to students, and because there was some question about whether or not Islam bans

images, students had to be shown ways to reconcile their religious piety with their potential careers. First, they were exposed to several reform interpretations of the religious texts in question and, by the time they graduated, the majority had come to terms with the issue. The main injunction against image-making comes from a particular saying, or hadith, of the Prophet Muhammad: "Those who will be most tormented on Judgment Day are the image-makers [al-musawwirun]." This is variously interpreted to mean either that man-made images (or idols) might be falsely worshipped or that it is vain for human beings to emulate God in the creation of things. For centuries, scholars have worked to determine which sayings can be legitimately attributed to the Prophet and which are false; many artists argued that the one about image-making is of questionable veracity (d'aif). Some professors countered this hadith with another, one of the very few that is in the special category of "holy sayings" (ahadith qudisiyya), which has been determined to be authentic: "God loves beauty, so how can his servants not desire it?" This hadith, in their view, supports art-making. Another argument for the acceptability of image-making held that the injunction against it applied only to the early days of Islam, when the danger of graven image worship actually existed. This argument was backed by a fatwa issued by the famous Islamic modernist Muhammad 'Abduh, Grand Mufti of Egypt at the founding of the College of Fine Arts in 1908 (see Nagib 2000:28). Professors taught their students these interpretations and, in the College of Fine Arts, an imam was also sometimes hired to give lectures on why image-making was not forbidden (haram). In art history class, students sometimes learned the common theory (in the Egyptian art world) that Islamic art was the original abstract art, so to do abstraction in any style was to follow in the Islamic tradition. Thus students were given ways to resolve any tension that might arise between their religious beliefs and their artistic practice.

These were inculcated to the extent that the conflict an outsider might expect Muslim artists to experience in this connection was just not an issue. Not once in my fieldwork did I an encounter an artist who felt any anxiety in this regard, or who even found the injunctions against art in Islam an interesting topic of discussion. Manal Amin was one of many artists I met who was deeply religious and also committed to art that involved images and representations. Actually, it was only when Westerners started to be intrigued by the fact that she was veiled that she felt a tension: she did not want people to become attracted to her art because of her attire.[28]

This discussion of the student population reveals it to be very different from what an American reader would expect. One of the major aspects of American art student identity, often cultivated by professors, is to go against the grain of social trends and mores (see Adler 1979). Although there were certainly Egyptian students in art schools who also defied some social values (e.g., by drinking, dressing shabbily, and insulting religion), the vast majority of students did not. And the value that students placed on being part of mainstream society continued into adulthood.

ESTABLISHING A LIFE AND CAREER IN ART

Towards graduation, students began to consider whether or not they wanted to pursue careers as artists. Decisions were based on a variety of factors, mostly having to do with whether they felt really committed to doing art, and whether they felt they could "establish themselves" (*yikawwinu nafsuhum*) as adult members of society with whatever money and social respect they could acquire through art. If the figures for membership in the artists' union (approximately 5,000) are any indication, clearly only a small number went on to become full participants in the art scene. Many other graduates chose related careers, such as making and selling tourist art; becoming set designers for the stage and television; working at the Ministry of Culture (in jobs ranging from secretarial positions to exhibition coordinating); or painting small signs and billboards. A good number of the female graduates eventually made their careers in the home, perhaps using skills learned in art schools to decorate the home or to raise creative children. (Art professors often emphasized that art education could help the family in this way.)

What made the small percentage of art school graduates continue on to become regular participants in the Egyptian art scene? Were they so engrossed in making art that they could not stop? Were they the exceptional ones, the most talented and creative? Were they the ones who were socially well positioned, who were able to capitalize on the art world resources necessary to make "successful art?" Or did they perhaps just fall into it, the way many of them had ended up in art college without really choosing to go there? I suggest that Egyptian art school students became practicing artists for all of these reasons, each to varying degrees.

The issue of "what makes an artist" has long stumped art theorists. Writing primarily of artists in the West, Becker (1982) has deconstructed the romantic idea of the modern artist as innately talented—a creative genius driven by

an inner force.²⁹ He does so by calling attention to the routine labor in which artists are most often engaged (e.g., meetings, buying supplies, framing). He also shows how works of art are not the products of individual geniuses but rather the result of the collective activity of persons as diverse as critics, art handlers, buyers, and art supply distributors. Vera Zolberg (1990) has likewise questioned the underlying assumption of many aestheticians and psychologists that the artist is some sort of unique, alienated heroic genius. But she also takes to task theorists such as Becker and Bourdieu for entirely negating the individual artist as author. She argues that such theories cannot account for the rarer "innovative" or "unusually gifted" artists, why individuals are drawn to art as opposed to other employment, or how artists are to be distinguished from other professionals (129). Zolberg suggests that some artists become mavericks because they possess unusual charisma.

Indeed, some sociological approaches are so overdetermined as to deny any possible recognition of the role of individual creativity, even if culturally constructed. At the same time, it seems that the overriding desire to see artists as inherently different from other professionals (who may also be drawn to their fields or fall into them as a more prosaic career move) clouds analysts' understandings of who becomes an artist and why.³⁰ Furthermore, as this chapter has sought to make clear, the reasons for becoming an artist differ from one society to another—a point often missed in some American and French sociologies of art. In Egypt, there were a number of answers to the question "How did you become an artist?" The same individual might have several answers.

As I mentioned earlier, artists' narratives sometimes included statements such as "I always loved to draw" or "I started drawing at the age of three." But in so many of my interviews in which I elicited this kind of "artist's life history," this statement was often followed by a discussion of a person who had pushed them. Such mentors (most often fathers, mothers, maternal uncles, or grade school teachers) told these artists early on that they had good drawing skills, and in many cases encouraged them to keep doing art. Rana 'Amir, a painter from a fairly well-off, educated family, explained:

> I used to draw a bit when I was young, and teachers used to say that my drawings were beautiful. So I started drawing more. And then my father noticed that I was good at that. So he brought a drawing teacher to the house. . . . Of course I got my artistic talent from my father and mother. My father was a lawyer but

he himself had an artistic bent. My mother loved the piano very much. So when they found out that I had some talent in drawing, they encouraged me.[31]

Muhammad al-Laythi, from a significantly more humble background, had a similar experience:

I got into art when I was three or four years old. . . . Like all young children, I wanted to be a doctor. I still did not understand [*mastaw'ibtish*] that I could do art. Then I wanted to be an army sergeant. Then I wanted to enter a vocational school and finish quickly in order to take care of the family, because my father was sick. But my father refused. He insisted that I go to the university. He had dreamed of going himself. He was uneducated. He used to take me to libraries and buy me books. He made me love to read. And he was illiterate.[32]

Even though these artists said that they had "always loved" drawing, the encouragement and confirmation that they were "skilled" seems to have been key to their artistic development as well. These examples also show the importance of kinship in the construction of artists, which is likely also the case in western Europe and the United States, despite theorists' focus on other factors.

While many relatives encouraged these budding artists, not many urged them to try to get the score that would put them in art school. It is quite likely many (except people like al-Laythi's father) did not know that such colleges existed. And, as discussed earlier, many Egyptian parents and relatives of college-age youth did not know very much about art, if they knew that it existed at all. Those that did were more likely to support a college major that guaranteed a more stable future. On the other hand, there were several cases of high school art teachers encouraging their students to take the skills test for the art colleges.

Individual desire, combined with other factors, continued to push people into art at the college level and after. For example, I asked a very successful younger generation artist how he got addicted to doing art and he said, "It's not really an addiction. I was good at it as a kid, and I think that just having lots of people tell me I was good, and then later in college the same thing, that it just happened. I don't know. You just find yourself doing it."[33] Indeed, just as there were those who "were told" that they had talent in grade school, many artists discovered or were told that they had what it took to be an artist only after they began college. If they got high marks, then they were awarded a university teaching position, which often cemented their entry into the art field. For example, when I asked another artist how he had got into the field,

he echoed the words of Manal Amin quoted earlier: "I was hired as a teaching assistant the same year I graduated. This was about 60 percent of the reason why I became an artist. Plus, during my undergraduate studies in art, I had started to realize that I have a style, and I started to like the field itself. So the minute I was hired I started to take part in the art movement."[34]

Zolberg (1990:135) writes that systems of rewards and opportunities influence what kinds of people become artists and how. This seemed to be the case in Egypt, where people were drawn to the field because of teachers' compliments, the possibility of getting government grants or ministry contracts, or of being a respected art professor. As these two artists' statements show, it was the experience of art school that finally pushed them into art careers.

They also had the model of the professor, who by virtue of her or his occupation and institutional status commanded much respect. Although teaching salaries were low, they gave some stable income. Getting an advanced degree and becoming a professor was a primary way to legitimate one's career choice, because professors enjoyed tremendous prestige in Egypt, no matter what the field.[35] To the average Egyptian who had very little (if any) exposure to the arts, the word "professor" or "doctor" was much more dignified than "artist." (This is partly because the term for "artist" is associated not only with craftspeople but also with entertainers, whose morality is regarded as suspect [see Van Nieuwkerk 1995].) Professors often told their students of the prizes they had won, the prominent work they did for the Ministry of Culture, their associations with famous businessmen and intellectuals, the art they sold to collectors, and their exhibitions in fancy places. These examples of success showed students that one could earn money and acquire status as an artist. As one junior professor put it, "I show them that being an artist is indeed a respectable profession," contrary to popular ideas about it. He added that he aimed to give the students a "sense that what they're doing is important."[36] It is significant that after art school, many practicing artists either continued to work toward a doctorate, with the aim of being appointed as a full professor, or got jobs in the Ministry of Culture.[37] Many exhibiting artists were also faculty members at art colleges.

The draw of academic careers for Egyptian artists, most of whom came from modest backgrounds, is illuminated by Bourdieu's perception that "those who owe most of their cultural capital to the educational system . . . are particularly subject to the academic definition of legitimacy" (1984:87). Indeed, for most artists, cultural capital was not inherited. Rather, it was acquired through education and other institutions. But in contrast to Bourdieu's argu-

ments about distinction, particularly in the field of cultural production (1984, 1993), acquired cultural capital in Egypt was not less legitimate than innate or inherited capital when it came to the arts. It was legitimate not only among arts interlocutors but also well beyond their circles—even, I would argue, among those whose forms of capital were inherited. The galleries that cater to old money elites nearly always feature the work of art professors and ministry officials very prominently, and they sell well to this group. Beyond the circles of arts interlocutors and elites, the acquisition of social, economic, and political capital, even through the arts, was nearly always accepted. As Amin told me: "In Zamalek [the upscale neighborhood where her college is located], it is so common that everyone is educated and goes to universities to become doctors and engineers. This is normal to them. But look at the people from the 'popular' [sha'bi] neighborhoods like mine. When one of them becomes a doctor or a professor, this is a big thing. Their families become so happy and ecstatic about it, after all their struggles, and they show their kids off happily."

It is clear that a career in art was a path towards upward mobility for many graduates—a point that was originally learned in art school. In Bourdieu's terms, they were not moving vertically within the same field as their parents' occupations. Rather, art provided a way to move in "transverse"—into another field, in which they were not only able to increase the economic capital they had inherited, however limited, but also to acquire other, educational and cultural capital. Those who came from modest middle-class backgrounds were often able to make more money than their parents had by selling their art or their artistic expertise to state institutions or private businesses and individuals. Manal Amin, for example, began to contribute significant sums of money to her household from sales of her work, which helped gain legitimacy within it for her career in art. She said, "My family is adapting to the fact that I am considered crazy by their standards . . . they have understood that I am different. But this difference has led to success, and they can see how fruitful it has been, so they are accepting it."

Because the Egyptian state had a significant arts budget, and because the Egyptian art world was so small, it is my impression that the percentage of artists who could raise their economic status through art was higher in Egypt than in many other places (especially the United States). Still, many artists were not able to get such rewards consistently and experienced financial difficulties, particularly when the economy was faltering. Even so, the times when their work was acquired or commissioned brought in large sums of money, which allowed

them to generate the cash necessary to buy apartments, cars, and luxury items. Manal Amin also liked to buy expensive art supplies, quality frames for her work, fashionable clothes, and fancy food for her parents from one of the new upscale supermarkets that had opened in the 1990s.

Certainly the possibility of upward mobility and other social and structural factors "made" artists in Egypt. Major "credentialing" devices included a college degree in art and membership in the artist's union.[38] Not only were all of these factors crucial, as sociologists of art have shown, but they took center stage in Egypt, where artists were less inclined than Western ones to adopt the romantic ideology of the artist, I suggest, in part because art was not a well-known activity, in part because the educational system was hierarchically ranked, and in part because such an ideology would compromise social obligations that promoted relations they valued. As choice did not play the sole or even a primary role in deciding who went to art school (the main path to being an artist), romantic ideologies of the artist were also significantly demystified.

There is another intriguing possibility why some people were drawn to the arts while others were not. Several artists, like 'Aliya' al-Giridi, whose story opens the next chapter, talked about a fascination with objects or loving to do things with their hands. The artist Huda Lutfi speaks of an early attraction to "old and beautiful objects" and how, later, the clay she was using to build a second home "invited" her to "play with it" (Mehrez and Stone 1999). Artists sometimes described this love of things and working with their hands as coming "from inside." I remember at least two occasions when this sort of love was described in a forceful, excited, and very animated voice. Additionally, several artists mentioned that they had always had an unusual power to "notice" (*yilahiz*) or to "be amazed" (*munbahir*) by things both tactile and visual. In a very clear example, the sculptor Adam Hinayn described an elementary school visit to the Egyptian Museum during which he could not stop staring at the Pharaonic sculptures in utter amazement. Clearly, some individuals possess certain other capabilities or qualities that attract them to art.

AFTER GRADUATION:
ORDINARY STUDENTS TO MIDDLE-CLASS LIVES

Living a mainstream sort of life was one way in which artists' unusual careers were made legitimate and through which they were able to manage all of their different commitments and desires. Most artists married and had families, were close to their extended kin, deferential to elders, generous with

friends, dressed neatly and modestly, and were well-groomed. Indeed, it is striking that at most public art events—openings, conferences, lectures, and so on—the majority of male artists wore ironed dress shirts and slacks, and many donned jackets and even ties, especially if they were attending an opening of their own work (fig. 1.2).[39]

Female artists also dressed up according to the norms of their social class— usually in skirts or dresses, with good jewelry and polished shoes, and, if veiled, a silken headscarf. This formality in dress, as I have mentioned, was consonant with the larger societal value placed on a well-groomed appearance.

Visual artists were also much like the rest of the "nonintellectual" population in their aspirations for better material and spiritual lives. In the context of searching for apartments with their prospective spouses, many artists in their twenties and thirties said they hoped to find a nice apartment in a clean, well-paved neighborhood. Most artists could not afford apartments in the fancy neighborhoods closest to the arts venues, and several said that they found these neighborhoods too snobby and Westernized (*afrangi*) for their tastes. At the same time, most did not want to live in "popular" (*sha'bi*) neighborhoods, where sewage frequently flooded the streets and where, two artists

Figure 1.2 Art opening at Cairo's Gezira Center for the Arts, 1999.
Photograph by Muhammad 'Abd al-Ghani.

complained to me, "your business is everyone's business." Many artists actually lived in such areas with their families before marriage, and spoke fondly of the residents' friendliness and "true Egyptian" spirit, and of the bounty and inexpensiveness of the markets. Nonetheless, they wished to move to cleaner neighborhoods that afforded more privacy. In their desire to find a suitable apartment in which to build a family, artists were very much like other young, urban Egyptians, for whom the search for an affordable marital apartment is a major preoccupation and can take years, the only difference being that artists also needed studio space.[40] Artists' ongoing searches for spouses and marital apartments represent a "selective" adoption of one genealogy of the modern: that which emphasizes bourgeois couples, "love" marriages, and nuclear families (see Abu-Lughod 1998; El Shakry 1998).

Artists also sought to buy fancy consumer goods, a desire that was congruent with dominant values in Egyptian society (even if the kinds of objects desired differed from group to group). For example, when sitting in coffee shops, my friends compared their mobile phones and spoke enviously of the foreign cars on the streets. They tried to buy quality furniture for their homes, and many who did not have satellite dishes or computers expressed a desire for them or told me that they were actively saving up for them. They especially wanted material possessions that would advance their artistic practice, such as computers, still and video cameras, kilns, and so on. Clearly, Egyptian visual artists did not subscribe to the tradition—or is it an ideal or a stereotype?—of renouncing consumerism that is found in intellectual and artistic communities in Europe and the United States. While most artists did not appear to be completely absorbed by consumer desires, the opposition to material goods was not an articulated position. Artists' economic backgrounds were part of what shaped an intellectual identity that criticized rich people and conspicuous consumerism but not the possession of the goods themselves. Manal Amin clarified this point for me: "I can tell you that the middle class tries to dress even better than the rich class. We have to dress very well. This is how my class thinks. I believe that you can spend money on more important things, such as books, computers, and so on. For them, it is important to buy a fridge, and more than one television, and four telephone sets in one house."

In addition to their material lives, many artists, again like most Egyptians, also wanted to improve their spiritual lives. The majority of artists that I came to know well, both men and women, did not pray regularly, and sometimes did not fast for every Ramadan or for every Coptic fasting period. Some enjoyed an

alcoholic drink once in a great while, but excessive drinking was extremely rare (although cigarette smoking was ubiquitous). Yet there were very few atheists, and most artists practiced at least some (if not all) of the requirements of their religion at different periods in their lives. Religious practice tended to be greatest during the teenage years, and then declined, only to increase again from the mid thirties on into old age. It was not uncommon to hear artists in their twenties and thirties say during Ramadan that they had not fasted in years but intended to do so regularly in the future, if not the next year. Lapses in religious practice were not attributed to opposition to religion, then, but rather to a spiritual insufficiency, or even weakness, on the part of the individual. Additionally, these lapses were sometimes seen as a natural and necessary period of one's life, when a person should experiment and try new things. Aside from a few prominent, and at times flamboyant, atheists, most artists self-identified as Muslims or Christians, and their religious background was an important part of their identity. Even though they might not always practice their religion to the fullest extent, most wished that they had the strength to do so.[41] Even those who were not interested in abiding by religious tenets or practice had a deep respect for the history of their religion and its philosophical aspects.

Alongside this private piety and respect for religion was a significant suspicion and criticism of dominant Islam and its institutions (e.g., state mosques and religious schools). Echoing the words of their professors, artists said that they were against the blind devotion to religion that they believed these institutions engendered, and that they were particularly suspicious of religious influences on the state. They were committed advocates of secularism and were particularly concerned about the rise of Islamist political opposition in Egypt. I suggest that this combination of private piety and public secularism reflected their position as artists who shared many values of mainstream Egyptian society but who saw their careers as threatened by an Islamism that they were sure would make image-making a dangerous, if not illegal, endeavor. Furthermore, because the spirit of inquiry and freedom of expression were cornerstones of their identities as artists and intellectuals, they were concerned about the institutionalization of religion, and even more about the convergence of religion and politics.

Another reason that artists did not experience a tension between their private piety and their artistic practice was that many found in religion a fruitful model for artistic exploration. As discussed in the next chapter, artists were particularly interested in Sufi thought and, to a lesser extent, Christian

mysticism. These traditions are filled with artistlike figures who attempt to gain enlightenment or closeness to God through experimentation or altered states of consciousness. Furthermore, some artists were particularly attracted to the history of philosophical debate within Islamic thought and found there a spirit of questioning akin to their ongoing artistic inquiry.

The dominant stance towards both material consumption and religion among artists, then, was one in which excess or rigidity was criticized, but in which participation and desires were within the urban middle-class norm. The same held true for other aspects of social life, notably marriage and politics. Getting married and starting a family were widely shared values and practices. Male artists in their mid thirties, and women in their late twenties, who were not yet married were often subject to criticism or pity. Shortly after an artist married, his or her friends began asking about plans for children. Two married artists I knew who informed friends that they did not want children were told that they would eventually change their minds and were encouraged to start trying before it was too late. There were also men and women who said that they did not want to get married, but these were a small minority. Even though artists largely adopted the ideal of marrying for love, they were not blind to the problems of modern coupledom. At times, they were highly critical of marriage, because they thought that it could be limiting to one's artistic practice. Women were particularly concerned that the demands of family and home would compromise their artistic careers, and both men and women sought partners who would understand their unusual schedules and need for creative freedom—hence the tendency for artists to marry one another. Some male artists, however, translated their desire to find freedom within marriage into a search for a woman who would be willing to take complete care of the home and children, leaving them free for their artistic pursuits. And some female artists I knew were angry to find themselves in this position with men who had, in one divorced artist's words, "made themselves out to be liberal" before the marriage. Thus, while most artists wanted to get married and have children, and did, they (especially women) did not want family life to be so conservative or rigid as to impose restrictions on their careers.

Similarly, artists had political views that were well within the range of opinions held by many Egyptians. They were primarily critical of American foreign policy in the Middle East, especially as regards the Israeli/Palestinian conflict. They also criticized their own government, particularly its pretensions to democracy and its corruption. Like many Egyptians, my interlocutors

told endless jokes about prominent Egyptian political figures. They were generally on the left of the political spectrum but derided those who had gone too far left as "old communists." The latter were people whose political ideology had so taken over their lives that, in many artists' opinions, they had become unthinking demagogues. I shall return to this point in subsequent chapters. But here we see again that artists were located within the mainstream, while rejecting any rigid adherence to certain positions or to any political extreme.

Of course, there were artists who were outside these norms or who opposed these values. There were men who grew scraggly beards and did not get regular haircuts. There were artists who dressed shabbily (e.g., in paint-splattered jeans and work boots), despite their economic means. There were male and female artists who slept around, rejected the idea of marriage, did not want children, drank alcohol, or used illegal drugs. Some openly derided religion. However, these were all in the minority. Other artists did not ostracize them, but if they exaggerated these practices and seemed to take great pride in them, their colleagues spoke of them derisively as being trapped in a Western stereotype of what an artist should be. Sometimes they were even perceived as suffering from psychological problems and became the objects of empathy or pity.

In this short description of adult artists, I have suggested that they often followed the models they learned from peers and professors in art school. In such models, artists can and should be productive members of society, but they should not subscribe blindly to its values or mores. They should be particularly wary of social conventions that limit their freedom to practice their art. Rigidity and extremism in all of their forms should be avoided. This is why artists were suspicious of artistic identities (such as those found in the West) that reject, oppose, or attempt to wholly revolutionize society. In their logic, artists who adopted these identities were just as rigid and extremist as the pulpit preacher calling for an Islamic state.

CONCLUSIONS

In this chapter I have attempted to set the stage for the rest of the book by showing how the categories of artist and art were differently translated in Egypt due to historical, economic, and cultural specificities. It is clear that these categories were produced through a field of artistic production that operated differently than that presumed to be the case in Bourdieu's work. In his concept of the field of cultural production, the "ideal" field is that which is most autonomous, and autonomy involves a "systematic inversion of the fundamental

principles of all ordinary economies: that of business (it excludes the pursuit of profit . . .), that of power (it condemns honours and temporal greatness), and even that of institutionalized cultural authority (the absence of any academic training or consecration may be considered a virtue)" (Bourdieu 1993:39).

Once we try to apply this concept to another social context, and particularly if we attend more carefully than Bourdieu to the agency of specific social actors, as I have done here, we see that the ideal field of cultural production involved a very specific formulation of autonomy vis-à-vis craft, mainstream values, the pursuit of profit and prestige, and academic training. Acquired economic capital or the pursuit of profit and high honors did not necessarily compromise one's position in the Egyptian field of artistic production. They usually enhanced it. Indeed, a respectable career in art did not usually correspond to a rejection of economic or political interest.[42] Autonomy and its limits were thus calculated through a complex reckoning with European-derived ideas of art for art's sake and art's distinction from craft, along with the nation-oriented and culturally and religiously inflected ideals of art having significance beyond the individual. I have shown that art school was the primary site where students learned the tensions that artists experience as practitioners of a career with European and elitist overtones in a society with an anti-colonial, nationalist, and socialist history. Furthermore, art school was where artists learned the models that they used throughout their lives for resolving these tensions—models that stressed their roles as members of families, generations, religions, society, and the nation. Art contributed to society: it enabled artists to make money, gain prestige, raise their families, and beautify public spaces, among other things.

Those students who went on to become the practicing artists whose experiences fill these pages are certainly extraordinary. They have chosen to pursue a career about which they, and their families, previously had very little knowledge. They understand that art will probably always be marginal in Egyptian society, and that they will therefore continually have to legitimate their place in it. But they love doing art, and most say that they cannot imagine life without it. At the same time, they enjoy doing most of the things that other middle-class city dwellers do. Therefore, these men and women have chosen to occupy a place that is both inside and at the margins of society. This in-between place, and the societal contours it reveals, is the subject of the remaining chapters.

MUHAMMAD MUKHTAR, AL-GINUBI
Season of Migration to the North

BEFORE INDEPENDENCE, Alexandria was considered by many to be the center of Egyptian cultural life. Its cosmopolitan flair is unforgettably captured and nostalgically remembered in the poems of C. P. Cavafy, the novels of Lawrence Durrell, and the films of Youssef Chahine. Then Cairo became the center—of a distinctly Arab cosmopolitanism. It still is. Artists come from all over the country to live, work, and exhibit there. Meanwhile, the south of the country, stretching approximately 700 miles from Cairo to the Sudanese border, has been figured as a cultural wasteland for all of Egypt's modern history. For many Cairene elites, Al-Sa'id, or Upper Egypt, conjures up images of poverty, ignorance, and filth. In the same breath, however, they talk about the south as "authentic" Egypt. The implication is that modernity has missed the south, thereby rendering it simultaneously authentic and backward.[1] For Westerners, the south (outside of Luxor and Aswan) often represents the "unknown"—a place where the authorities prevent them from going, ostensibly to protect them from Islamist activity and sectarian strife, but also to prevent them from encountering "backwardness."

What is an artist from the south to do with the simultaneous nonpresence and stereotyped presence of the south in the northern cultural consciousness? Some intellectuals from the south do their best to erase their backgrounds and perform northernness. Others take the path of 'Abd al-Rahman al-Abnudi, an older generation intellectual who "plays up" his southern identity to spice up an interview, get a laugh, or to make a point about authentic Egypt.

A third alternative is that offered by Muhammad Mukhtar, born in 1965

in Qina, a city nearly 500 miles south of Cairo. He has decided to address Egyptian regionalism directly in his work, by reflecting on his own experience coming to the north, on southerner stereotypes, and on alienation and nostalgia. I would say that he, more than any other artist in modern Egyptian art history, has challenged the standard narrative of Egyptian territorial nationalism by calling attention to its centralizing force, which depends on the delegitimation and erasure of other nodes of belonging, other networks of place and time. He has done this in part by creating an alter ego, an artistic identity that farcically objectifies the southerner—throwing the image back in the face of northerners when they use it as a basis for interacting with real southerners such as himself. The artist from the south, Muhammad Mukhtar, has now become The Southerner: "Al-Ginubi." All of his friends now call him by that name. We are forced, with each utterance, to recognize the structures of objectification that reproduce the contradictory prejudice towards, and valorization of, people from the south.

It is easy for me to see how Ginubi has accomplished this unusually reflective stance, which in turn informs his art. He is an anthropologist's delight. He is generous with his time, willing to sit for hours at a coffee shop, smoking his cigarettes, discussing and clarifying his ideas about art, politics, and life. We email frequently, agreeing and arguing about political events in the Middle East. Unlike many of the artists I have come to know, he is not didactic. He has none of the ready-made discourses about Egyptian authenticity or backwardness that I have learned to expect as answers to certain queries. He looks at issues from every angle, even entertaining unpopular ideas (depending on who's listening) such as Arabs' culpability for the problems in Middle Eastern societies, the benefits of the American invasion of Iraq, Western curatorial imperialism, and the charades of Egyptian nationalists. Ginubi has an incredible breadth of literary, philosophical, and theoretical knowledge, all acquired in Arabic, which far surpasses that of most visual artists in Egypt. Most of his friends are writers and journalists, and he himself has written numerous thoughtful articles on art, as well as a book analyzing the paintings of Egyptian artist pioneers. His southern inflections and accent slip unconsciously into his speech, which is a natural mixture of the colloquial Arabic spoken where he is from and where he lives now. Ginubi just makes you feel comfortable in his presence, and meeting with him offers an escape from didactic lessons, a chance for significant mutual engagement.

Ginubi spent most of his childhood in Egypt's southernmost city, Aswan.

He graduated in 1988 from the College of Fine Arts in Minya (another southern city), which was opened partly with the intention of spreading arts education to the south. Ginubi could be considered a member of the "younger generation" of artists who started to gain attention in the early 1990s, but he is lesser known among them in part because he started his career exhibiting in the "culture palaces" of the south, before coming to Cairo in 2000. I remember meeting Ginubi at his first exhibition in Cairo, before he officially moved, and hearing him talk about how he felt he had to come north in order really to participate in the art world. And I remember visiting the Aswan Culture Palace and thinking it was a good meeting place, but also seeing why Ginubi felt the need to relocate.

Ginubi's move to Cairo proved to be fruitful, not only because he began to exhibit in more prominent galleries, but also because the transition itself became his artistic inspiration and archive. He began to work on south/north identities, relations, and disjunctures, as the writer Tayib Salih did in his famous novel *Season of Migration to the North* (1970). Ginubi's early works used spices—spices made into paint, spices placed in bowls on the ground (plate 2). These pieces were partially ruminations on the material associations that both Westerners and Cairenes have with Ginubi's home province. Aswan is known for its spices, which are piled into colorful cones and sold in street stalls all over the center of the city. Here the artist takes a material—spice— that iconically fixes and represents a place yet also calls forth the historical transnational connections and movements of the spice trade that extended beyond the nation's territorial boundaries. I'll never forget smelling the work too. I think that this most unusual enticement of the viewer's senses of taste and smell could bring audiences into an Orientalist exoticizing mode but then force them to consider other ways of knowing and remembering—ways that are less locked into a set of preconceived iconic motifs or visual stereotypes of the south than those used by other artists. Ginubi works with smell as the sense tied most closely to memory, which has the power to conjure up shifting, hazy, and unfixed visual images that mix together different places and times. These works can evoke personal memory, the memory of emigrants, of old people, and of a society.

After this project, Ginubi embarked on a series of paintings in which he explored the figure of the southern man and his emigration to the capital city—a transition in which memory also plays a role. In these paintings, southern men are depicted in a variety of ways: clearly and iconically set against a

wash of color or set of color fields (some of these fields the same color as the southerner's clothing, so that it is his dark skin that is highlighted, which also references the racialization of southerners); unclearly receding into the background or emerging from it, often with the face covered by lines or otherwise manipulated and scratched fields of paint; in outline or in repeated series; in ghostlike forms (fig. B.1).

In a way, these works are a series of formal experiments with different kinds of modernism; in another way, they evoke various facets of the experience of the southern man in modern Cairo. The artist talks about this experience, and its artistic manifestations, as being one of alienation and displacement, of defense, of nostalgia and hope. For him, the southerner becomes what he describes as "an ambivalent figure, trapped within the contradictions of a modernity that is not of his own making, but that shapes his desires and aspirations." One painting in particular reveals how this situation might be akin to the kind of double consciousness that many black intellectuals, drawing on W. E. B. Du Bois, see as defining the black experience in America.

Although Ginubi does not fit the stereotype of the turbaned, mustached dark southerner in the painting reproduced here as figure B.2, he is aware of the gaze that sees him this way, that asks him to perform the role of the south-

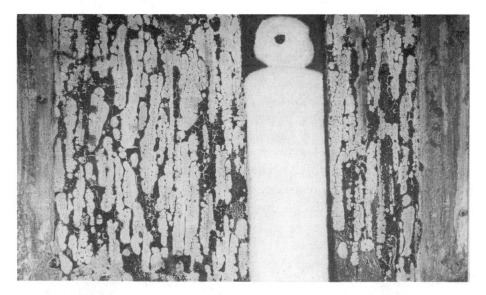

Figure B.1 Muhammad al-Ginubi, dyes, wax, and oil on wood, 2001.
Courtesy of the artist.

erner. He is also conscious of being a part of a southern community, with all of its relationships and histories, with its variety of men. The repetition of the word "me" (*ana*) at the bottom of the painting makes us wonder if Ginubi is calling attention to his double consciousness, showing how he is repeatedly put into the "southerner box" in Cairo and saying there are many different "me's" betwixt and between the framings.

Ginubi's own experiences lead him to humanize and give presence to the male southerner, but this focus also has the benefit of working against

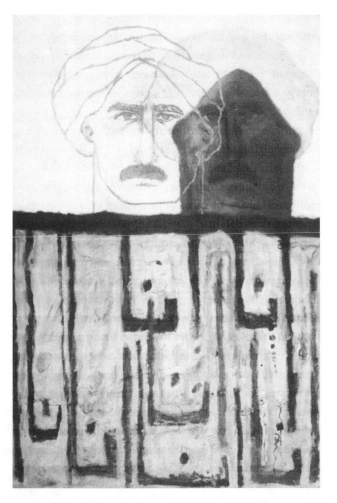

Figure B.2 Muhammad al-Ginubi, oil on wood, 2001.
Courtesy of the artist.

centuries of idealistic paintings of southern village women, whom national-
ists often use as icons of "authentic Egyptians," because they are presumed
to be least influenced by Westernization and modernization. The empathy
for men in these paintings, and the way in which Ginubi reveals their vul-
nerability, also works against the stereotype of southern men as ignorant,
violent, and domineering. He shows, sometimes all in one painting, their
fear, their pride, their hope, their sadness, and their weariness. These paint-
ings capture things I sense among relatives through my own marriage to a
southerner, and they also force me to rethink my own views towards south-
ern American men.

The paintings also make us recognize the structural oppression of south-
erners. Ginubi did a series in burned oil pastel that expressed his deep sadness
at a massive train fire in 2002 that killed hundreds of southerners and also
called attention to the government's neglect of southern-bound trains and
everything else in the region.

In 2003, after three years in Cairo, Ginubi explored the theme of the south-
erner in the city from a different angle—that of the material relationship be-
tween the individual subject and the metropolis of seventeen million. He cre-
ated an installation in which he covered the walls of a gallery with scraps of
paper accumulated through his first interaction with the city and its people.
These included bus tickets, newspaper articles he had clipped, jackets of books
that he had read and that are only readily available in Cairo, medical records,
business cards, sketches, and so on. The sheer mass of paper scraps both em-
phasizes the anonymity of urban life that the artist experienced and opens up
the most intimate details of his daily life to intense scrutiny. Here again is the
split self of modernity, but refracted through a series of papers that reveal the
agency of a southerner in Cairo who rides the bus with everyone else but also
has an individual interest in art books and novels. We see how the artist, and
presumably many other newcomers to Cairo (including, in a way, myself),
both love the city and find it exhausting, and how it gives certain freedoms
while also presenting a range of new, sometimes confusing, constraints.

One of these freedoms and constraints involved the arrival of Western
curators in Cairo in the late 1990s, of which I provide an anthropological anal-
ysis in Chapter 6. Ginubi's work often did not translate to these new audiences
for a variety of reasons (e.g., it deals with issues unknown to foreigners or not
particularly compelling for them; it is executed in a style that is mistaken for
romanticism or old modernism). An Italian gallery owner in Cairo, by virtue

of her long experience in Egypt and linguistic skills (Ginubi communicates only in Arabic), has supported the work. But overall Ginubi is among the majority of locally well-respected Egyptian artists who have been passed over in the mad international rush for those whose work is more easily translatable outside the country. Ginubi remains anxious to gain different critical perspectives on his work. As he struggles to "read" these new social circles in Cairo, he recognizes his own personal limitations as well as structural ones. A couple of years ago, he tried to attend one of the many important and interesting symposia offered by one of the new arts organizations in Cairo. He was very excited by the topic. Upon arriving, he found that all the lecturers were to speak in English, with no translation into Arabic. He asked for a translator, and the organizers apologized profusely that they weren't able to get one. Ginubi recognized that they had the right intentions, but also that the mere organization of an English-only event reveals a broader system of exclusions. He ended his telling of this story to me in exasperation: "I felt like I was living back in the days of the British."

2 CULTURAL AUTHENTICITY, ARTISTIC PERSONHOOD, AND FRAMES OF EVALUATION

ON MANY EVENINGS in the winter of 1999, I sat with the artist 'Aliya' al-Giridi, sipping tea and smoking cigarettes in her apartment just upstairs from mine. While we gossiped endlessly about the latest goings-on in the art world, I watched her make the jewelry that she sold to support her art. She formed metal wire, small metal scraps, and little stones into different designs, held each up in front of her eyes, and welded her final selection together. Later that spring, preparing for a solo exhibition at a major arts center in Cairo, she gathered found objects—huge metal scraps and larger pieces of stone and tile. 'Aliya' and her husband had been lucky enough to find an affordable rental apartment that had enough studio space for each of them. Just outside the door of the apartment, on the expansive rooftop to which they were delighted to have sole access, 'Aliya' spent hours cutting and bending copper strips, rearranging rough pieces of tile in different colors, and wrapping steel wire in thick circles.

One night that winter, we finally sat down to do an interview.[1] With tea made, and her pieces for the upcoming exhibition laid out on the counters in various states of completion, we sat down at her kitchen table. I asked her to talk more about her personal history as an artist. 'Aliya' explained that her tactile relationship with materials had begun ten years earlier, when in her early twenties, she had decided to join the Alexandria Atelier to train under Faruq Wahba, a professor at the Alexandria College of Fine Arts who had done his Ph.D. in Germany. She remembered the days at the Atelier, when (like Amina Mansur, see Interlude) she was trying to figure out what exactly art is, what it does in the world, and who she was as an artist: "Is art just a beautiful thing

to hang on the wall? . . . If that's it, then in the end I'm just a craftsperson. . . . There must be something besides techniques." Her teacher had no answers, she said, except to say that she should keep on working.

It was a period of great introspection for her, which was reflected in her intimate exploration of materials. Playing with materials was better than standing at a distance looking at an oil painting, she said, "because I didn't feel that oil paintings were close to me, or that I had anything to say in oil." Explaining her growing interest in experimenting with used objects, she said, "at that time I was interested in things [ashya'], almost in a spiritual way . . . I was trying to see the outside world from a place deep inside myself." As she sat with herself, she also sat with "simple things" and tried to "see them as if they were the whole world." She explained that she was interested in "silly things, like [pointing to a piece of brick on the table] this thing in front of us"—details in everyday life that people might not pay attention to. She tried to highlight them in her work, because she felt that one needed to see these details in order to see the person beside oneself, and indeed to see oneself more fully. In this period, she read profusely. She explained, "I always take theories and philosophies and apply them in a very special way that benefits me. It's like they enter into an internal mill [mathana dakhiliyya]."

As the call to evening prayer from surrounding mosques wafted through the window onto the background of my tape, mixed with the incessant sound of car horns, 'Aliya' continued: "Then I got a Goethe Institute scholarship to Germany. . . . I thought that [German] society would understand me more, that life would be better there. But then I discovered that it has its problems, just like anywhere else. [Living in Germany] also gave me the feeling that I am deficient [naqis] in every respect. That my education was deficient and my culture was deficient. . . . It was a crisis [azma]."

Her experience confirmed feelings she had had before traveling—that just as Egyptian society did not understand her, she did not understand it, or the purpose of her art in the larger world. Even though she had won several prizes at the Young Artists' Salon in Egypt, she felt that they were all based on appearances, not on reality: "I didn't get prizes because my work was real [haqiqi], but because it looked nice." Indeed, she began to doubt whether she was a "real" artist. In Germany, she compared herself to her counterparts:

I tried to see what interests artists there. I discovered it was completely different. Here we practically have an open air museum—ancient monuments but also

old, broken homes. There, everything was clean. The shapes were all even. I said to myself, "How can anyone do art in this country?!" Everyone was doing things with tools. I was used to making everything with my hands. The Egyptian artist especially makes everything with his hands—we even make our own tools! My first impression was that these people aren't artists! Then I thought that maybe that was really art, and I wasn't the artist.

But then, she said, she realized that her intimate, tactile, and nearly nonindustrial relationship with materials was part of her—not just as an individual artist, but as a person from a particular place: "Then I discovered I'm from a different place, a different artistic system. I realized that I needed to more deeply understand the system of the place where I was from in order to use it better."

Her teacher and her then-fiancé both urged her to return from Germany, which she did. They informed her that she was one of the few young artists chosen to represent Egypt at the International Cairo Biennial that year. With her experience in Germany, and after reading the Lebanese poet Khalil Gibran, she began to consider the idea of human beings having different dimensions, and different spirits, depending on their place in space and time. She thought more about spiritual birth and death, and the relationship of time and history to this process, and returned to exploring used materials.

At the kitchen table, she showed me a picture of one of her works from this period (plate 3). She explained that by handling the sheets of cardboard and looking at them in different ways, she discovered that there was a whole inner world, akin to the spiritual world, contained in the small circles between the two sheets. She combined these sheets into layers of circles, and carved them in a way that recalled geological layers of earth and, thus, the passage of time. As we sat talking about this and related works, it was clear that they represented both her own personal artistic development and her growing understanding that the deep history of her cultural background—embodied in materials—was the richest source for her artistic practice. Indeed, the two were inseparable.

As we continued talking late into the night, conversation turned to her frustrations with the Egyptian art scene, and in particular with some critics' reactions her work. This part of 'Aliya''s story continues in the next chapter, where I discuss the world of critics, galleries, and power struggles. Here, I place her vivid description of how she developed her particular artistic perspective alongside that of many other artists in Egypt. Each of these stories

is unique in its specificity, yet they are similar in their emphasis. The themes of self-exploration, cultural rootedness, and doing something "real," appear side by side. Often, artists paired these themes with an in-depth discussion of their relationship to materials. As I sat in kitchens, studios, coffee shops, and classrooms, talking with artists about earlier periods in their lives, and about their current practice, it became clear that they constructed their artistic paths as a search for authentic personhood. In the course of this search, artists found that their cultural background and the material context of Egypt were crucial to who they were as people, and therefore as artists. Thus, recognition and exploration of specific cultural roots and contexts was necessary to being an artist who was "true" to her- or himself and who did "real" art that was "good." As this chapter will show, artistic production and consumption were primarily motivated and shaped by discourses of authenticity. Yet the ideal of authenticity common to some Enlightenment-based ideologies of the artistic life, which insist on the individual artist being "true" to her- or himself despite social mores (the rebel artist), was translated to emphasize the *link*, rather than the rupture, between the individual and society. Just as art was not set apart from the praxis of life, so artists did not, for the most part, conceive of themselves as wholly set apart from society.

In the previous chapter, I discussed the role of the education system in making artists as both individuals and members of Egyptian society. The process of "becoming Egyptian artists" did not end in art school, as I show here. Practicing artists continued to hold individual and cultural authenticity as a primary ideal, and the individual and cultural remained very much intertwined. Furthermore, these ideals shaped many aspects of artists' work—from choosing subject matter and materials and theorizing about those choices, to evaluating art, to representing themselves to their colleagues, critics, and the anthropologist. Thus, artistic production and consumption (including processes of representing and evaluating) were dialectically related.

Even though artists shared a conceptual framework centered around the ideal of authenticity, they fiercely debated its cultural component. In Germany, 'Aliya' al-Giridi asked herself what was specific about her as an artist from another place. Most artists, usually as a result of exposure to art or people from other countries, asked themselves the same question. The myriad aesthetic responses were reflected in the sheer variety of styles, themes, media, and references in contemporary Egyptian art. What they shared was an emphasis on the national space, place, and past of Egypt. But it was the nature of that

entity that was debated—in paint, steel, cardboard, paper, and clay, as well as in the various discursive contexts of the art world. These were their reckonings with the genealogies of the modern that involved Kantian, Islamic, and secular nationalist visions of authenticity, the individual, and "culture." The emphasis on Egypt indicates that the nation, and nation-oriented notions of culture and society, were the primary frames of reference for arts interlocutors as they made and evaluated art. The nation was in fact the main "classificatory scheme" and "cognitive frame" (Brubaker 1996) for arts interlocutors, and, as such, it was continually reproduced through the authenticity debates.

It is crucial to note here that the emphasis on Egypt was not necessarily nationalist in the patriotic sense. Or, to put it another way, when Egypt appeared in the discourses of artists and critics, it was not necessarily to signify that they were advocates of nationalism. There were artists and critics who would probably consider themselves adherents of nationalism in one or other of its Egyptian forms. These people were often the ones who would ratchet up the stakes in public venues through insults, yelling, and picking fights. Even though their style was seen as extreme, and thus not socially sanctioned (see Chapter 1), they often ended up sparking debates that reverberated through the rest of the Egyptian art world.

Artistic debates over the relationship between Egyptian culture and art, whether motivated by patriotism or not, were strikingly similar to those in other countries on the margins of the western European and American centers of the international art scene. Such debates have been particularly common in places where modern art was introduced through colonialism, and especially where there exist remnants of ancient civilizations that have been co-opted into national histories (e.g., Olmec, Mayan, Assyrian, Hindu, Hellenistic). Given modern art's European history and elitist connotations, its indigenous and populist credentials were shaky in Egypt, where artists struggled continually to define themselves and their work vis-à-vis both Egyptian society and the West. This struggle became manifest through a set of arguments over how and how much artists should engage with Western artistic trends, as opposed to artistic traditions from their own region.

Debates and decisions over artistic sources in Egypt and other postcolonial art worlds have often been made through historically constituted discourses of authenticity. Anti-colonial thought in Egypt and elsewhere was geared towards creating a territorial, nationalist modernity. As Partha Chatterjee (1986, 1993) has shown for India, nationalist thinkers often proposed

a mixture of Western institutional structure combined with the "preservation" of local "culture" in particular domains. Whereas Chatterjee focuses on the preservation (through construction) of a spiritual sphere as the place for authentic culture, I suggest here that the arts constituted another domain where such culture was to be constructed, preserved, and developed. The parallels in postcolonial art worlds, then, must be seen within this comparative historical context, despite vastly different colonial experiences. To attain authenticity, artists in these art worlds have (sometimes willingly, sometimes not) negotiated a set of seemingly dichotomous concepts formed through the colonial encounter: Eastern and Western, local and international, traditional and modern, backward and progressive, and authentic and imported. These dualities do not only exist in Egypt; they have concerned artists in places as diverse as India, Senegal, Mexico, Ghana, Indonesia, and Syria (see Kapur 2000; Harney 2004; Bakewell 1995 and Canclini 1995; Svašek 1997; George 1997; and Shannon 2001, 2005, respectively). As the work of Ian Burn et al. (1988) on modern Australian art suggests, they could emerge in any art world peripheral to Paris and New York.[2] In Egypt, as in these other examples, these dualities have been mobilized into competing frames of evaluation and hierarchies of value, all centered around the question of what makes a "real" and "good" artist and art. Colonization and peripherality pushed authenticity forward as a major theme in processes of postcolonial artistic reckoning, but they did not completely determine these processes or render them the same in all art worlds. In Egypt, different dimensions of the concept emanated from different genealogies, each of which had its own imperatives, possibilities, and limitations to be discovered and dealt with.

Egyptians' concerns with authenticity articulated through competing nation-oriented discourses should not be read as an affliction, or obsession, of the postcolonial periphery only. Genealogies of authenticity circulate through western Europe and the United States as well. Indeed, authenticity has often concerned Western artists. One thinks of romanticism in its various European forms (particularly the German), of French modernism between the two World Wars (see Golan 1995), American abstract expressionism (see Guilbault (1983), and even, in a way, the Young British Artists phenomenon (see Home 1996).[3] Thus, while the interest in authenticity I noted during my fieldwork was most surely related to Egypt's postcolonial, peripheral position in the international art arena, it was also at some level an act of translation via European and American art movements as well.

Egyptian artists' deliberations over cultural authenticity were not limited to the art world, as any casual glance at newspapers and television in Egypt in the 1990s would indicate. As the country stepped up its neoliberal economic reforms and became more integrated into the global financial, technological, and communications networks that characterized that period, many Egyptians were asking hard questions about what might change in their society, and whether or not these changes would be beneficial.[4] Would Egyptians finally become modern? Would that mean that they would lose their traditional heritage and become Americanized? To better understand the cultural stakes of this transformation from a command to a free market economy for Egyptians, it is useful to examine visual art practice, whose historical dilemmas lent a particular urgency to these questions for artists. Because the practice of modern art inhabited the space between East/West, traditional/modern, local/international, and so on, it is possible to read artists' various deliberations over cultural authenticity as particularly illuminating examples of larger debates over the future of the nation in a period that seemed especially unsettling to Egyptians.

Although many of the discourses of cultural authenticity that I examine here are obviously "inventions of tradition" (Hobsbawm and Ranger 1983), and artists' national visions are clearly "imagined" (B. Anderson [1983] 1991), it is not my interest here to debunk artists' claims about their culture and history, or advance my own assertions about what is and is not "Egyptian." Such a project would undoubtedly entangle anthropological and national concepts of "culture."[5] As such it would also push me into the local debate in an unhelpful manner, because to discredit one perspective in the debate is often to take sides with another. Therefore, in order to avoid these possible pitfalls, and to grasp the different meanings of the concept "Egyptian culture" to arts interlocutors, I analyze artists' evaluations and art critical writing as sites of cultural production. As Fred Myers (1994b) has argued, anthropological writing should move from judging art criticism to analyzing it as a form of "culture-making." While I do break down the cultural components of authenticity to show how notions of Egypt are effectively "made" by artists and art writers, I also take into account Jocelyn Linnekin's cogent reminder that however much scholars deconstruct authenticity, it remains "entrenched in popular thought and is an emotional, political issue, for indigenous peoples" (1991:446).[6] In the next chapter, I examine the implications of artist elites' promoting certain exclusionary and idealist nation-oriented visions from

different positions in the institutional power structure in Egypt. But my discussion here is first and foremost an attempt to understand the potency of authenticity in Egyptian artists' reckonings with genealogies of modern art and artistic subjectivity.

REPRESENTING EGYPTIAN ART

It would have been hard to miss the importance of authenticity among Egyptian artists. From my very first days of research, it became clear that its discourses were used to filter and represent Egyptian artistic production to outsiders, including myself, in ways that ensured the integrity of Egyptian "culture" alongside the international aspirations of most artists. My status as an American, and as a researcher, elicited strong declarations about what was authentic and what was not. For many Egyptians, the United States represents the pinnacle of wealth and progress, as well as the negative aspects of globalization perceived as threatening to Egyptian society.[7] Artists were no exception. To them, I was a researcher who was going to represent Egyptian art abroad. New York gallery owners might well read my work and choose artists based on it. People might form opinions of the whole Egyptian art scene according to what I wrote. But I was also a reminder of the potential dangers of opening up to Western aesthetics, morals, and capitalism. Thus, my position as an American researcher afforded me the opportunity to see the dimensions of the authenticity debates with greater clarity, because artists were especially interested that I "get it right."

Upon meeting me for the first time, most artists asked about the nature of my research. I would begin by saying that I was interested in the social aspects of the art scene in Egypt. This basic explanation usually prompted strong opinions about just what "Egyptian art" is, and what about it I should study. During these initial encounters, I received a considerable amount of advice from many different kinds of artists. They wanted my research to be "sound" (salim), but they also did not want me to write about Egyptian art abroad in a way that they found embarrassing or untruthful. Some artists were concerned that I would focus on Egyptian art that was "too Western" and ignore what they believed were the truly indigenous forms of artistic expression, thereby giving the impression that Egyptian artists "imitate" (biyiqallidu) the West. Others were afraid that I would include artists whose work was "too Egyptian" or "too folkloric." They were concerned that by writing about such artists, I would make Egyptian art seem "backward"

(*mutakhallif*) to Western readers. Artists' advice helped me to understand how they perceived my role as an American anthropologist and writer and how they categorized and evaluated the work they and others produced. Both of these dynamics—my relationship with them and their varied ways of categorizing and evaluating work—were permeated by concerns about Egyptian authenticity and Western influence, and more generally by the debates over the particular relationship Egyptian artists had with their own cultural patrimony, on the one hand, and with the Western-dominated international art scene, on the other.

When I was meeting my interlocutors for the first time, and getting revealing contradictory advice, I was also surveying the gallery scene to get a sense of the audiences for Egyptian art. I learned that they were also concerned with authenticity. On these first forays into the galleries, I noticed that the guest books were often filled with comments about the perceived Egyptianness or Westernness of the works. At one sculpture exhibition, for example, I found that a visitor had written in enormous letters, filling almost an entire page: "WHERE IS EGYPT IN YOUR WORK?!" In contrast, Usama al-Baz, political affairs consultant to President Mubarak, wrote in a guest book at another gallery: "I am pleased to visit the exhibition of [these artists] and touch the depth of the Egyptian environment and national culture in their works." That such an important figure in Mubarak's government would laud the "national culture" in an art gallery was not incidental. In the past century, intellectual production in Egypt has often been shaped with one eye on the state and nationalism but the other trained on Europe, and, more recently, the United States.

GENEALOGIES OF MODERN EGYPTIAN AUTHENTICITY

The importance of authenticity for artists such as 'Aliya' al-Giridi is directly related to the history of modern Egyptian nationalism, which played a central role in the development of the visual and literary arts in the country. From the beginning of the anti-colonial movement in the early twentieth century, Egyptian politicians and intellectuals were concerned with making a society that was "modern"—a nation among the nations of the world—but that still retained its specificity. Nationalist intellectuals offered different visions of what a modern, independent Egypt would look like. With the decline of the Ottoman empire, secularists by and large advocated building a governmental system based on a combination of British and French models, while also preserving and nurturing what was perceived to be an Egyptian cultural and

historical specificity. Those working in the arts (e.g., visual, music, or literary) were especially keen to "preserve" or "develop" what were seen to be authentic cultural traditions.[8]

Several variants of nationalist discourse in this first half of the twentieth century show us how the idea of an authentic "Egypt" was conceptualized and developed. Prominent nationalist thinkers such as Salama Musa and Muhammad Husayn Haykal argued that contemporary Egyptians were the direct descendents of ancient Egyptians, and that this spiritual and cultural link should be explored. Such political writings and discussions have been characterized as "Pharaonicist" national discourse, and it has reappeared in cultural debates in subsequent periods (see Colla forthcoming; Hourani 1983; Gershoni and Jankowski 1986). Some of the very first works of modern art made by Egyptians in this early period used ancient Egyptian themes. Although Pharaonic references in modern art waned a bit with the popularity of surrealism before independence (see Gharieb 1986), and socialist art after independence, they reemerged after the post-1967 crisis of socialism and Egyptian identity in general. Pharaonic influences in art became increasingly popular in the late 1970s and 1980s and continued to be during the time of my fieldwork.

Other nationalist intellectuals, like the writer Tawfiq al-Hakim, contributed to another major trend in nationalist thought that has also endured. Many writings from 1915 on focused on the countryside as the authentic Egypt and the peasant as a kind of noble Egyptian, unpolluted by Western influence. In some writings, the peasant even appears as a descendent of the ancient Egyptians. In al-Hakim's famous novel Return of the Spirit, for example, the peasant personifies ancient Egypt (1933; see also the Raghib 'Ayad interlude in this book). At this time, the peasant woman was singled out as being particularly authentic, a kind of "mother of the nation" (Baron 1997). Visual artists socialized with these writers in the various literary salons of the 1920s and 1930s, and the frequent inclusion of pastoral themes—especially peasant women—in their work indicates that there was considerable exchange of nationalist ideas. It is also very likely that Egyptian artists were influenced by their European professors who painted Egyptian countryside scenes in their own Orientalist search for an authentic Egypt. Since the early twentieth century, then, pastoral scenes and peasant figures have been popular themes in modern Egyptian art and, for many, have represented the "authentic Egypt."[9]

With independence in 1952, and throughout the socialist period of the 1960s, the interest in defining "Egyptian culture" was further catalyzed, and

we see the development of other nationalist themes that have been reflected in art. During this period, the concept of *asala* gained currency in art world definitions of Egyptian culture. The noun *asala* comes from the Arabic root *a-s-l*, meaning "to be firmly rooted." Another variant of the root signifies nobility of descent or lineage (*asl*). *Asala* itself often means pure or noble descent or roots, and its adjectival form, *asil*, most directly corresponds to the English "authentic."[10] Silvia Naef (1996) writes that the concept of *asala* began to be used in the visual arts during the 1950s and also gained currency in art movements elsewhere in the Arab world—particularly Iraq (see also al-Bahnasi 1997). It is no accident that in Egypt, the artistic concept of *asala* developed during the height of Nasserist nationalism, when art collectives (such as the Group of Art and Life) formed with the intention of bridging the gap between art and the local environment, spirituality, and folk arts (see Karnouk 1988; Naef 1996).

At this time, the ideal of *asala* was frequently paired with the nationalist and anthropological concept of the "Egyptian personality" (*shakhsiyya misriyya*). The components of this "personality," which can also be translated as "character," have been the subject of many studies since the 1920s and 1930s.[11] Many of the proposed characteristics of the Egyptian personality, such as loyalty, fatalism, and an agricultural mentality, were attributed to peasants in particular. Many artists and other intellectuals have continued to see peasants as embodying the true "Egyptian character" and have therefore created images of the countryside and peasants in literary and artistic works. Intellectuals have also portrayed the residents of centuries-old urban neighborhoods in Cairo and Alexandria as possessing true Egyptianness as "sons and daughters of the country" (see El-Messiri 1978). Artistic representations of Egyptian authenticity thus also include "popular" (*sha'bi*) urban quarters and their residents.

The concept of *turath* goes hand in hand with that of *asala*. *Turath* is translated literally as "heritage" and likewise refers to the composite of traits, practices, and objects that have been passed down, inherited through many generations. For the arts, the term can include images, techniques, and behaviors from ancient Egypt through the Coptic and Islamic periods to contemporary folk arts. Heritage is a key element of the "roots" associated with *asala*. Thus *asala* is a consciously historical perspective. It is also primarily insular and significantly nostalgic.[12]

Variations of the tradition/modernity axis have been articulated throughout modern Egyptian art history, most notably in the artists' collectives that formed in the 1940s and 1950s, which produced manifestos on how artists

should be "contemporary" or "modern" in relationship to both the history of visual culture in Egypt and various trends in Western modern art (see Iskandar et al. 1990). The intellectual concern over the state of Egyptian culture vis-à-vis the West took on a certain prominence in the 1970s and was filled with arguably even more anxiety than is found in earlier nationalist writings. Sadat's abrupt reorientation of the country towards the United States and free market capitalism, combined with the decline of Arab nationalism after the loss of the 1967 war against Israel and Nasser's death, catalyzed a series of intellectual discussions about Egyptian authenticity and identity that questioned the wisdom of secular nationalism as it had been practiced, as well as the effects of capitalism on culture. In addition, the 1967 defeat, Sadat's subsequent encouragement of Islamist groups to counter the communists, the Iranian revolution, and the massive social and economic upheaval caused by Sadat's open-door trade policy with the West all contributed to the rise of political Islam in Egyptian public life. There was a corresponding increase in the number of artworks inspired by Islamic calligraphy, and artists became more interested in Islamic aesthetics in general.

At this time, the counterpoint to *asala* was articulated as *mu'asira*, which means "modern" or "contemporary." The term often referenced "the West," but Egyptian thinkers were trying to break out of the tradition/modernity, or *asala/mu'asira*, dichotomy. The Islamic philosopher Hasan Hanafi (1980) and others wrote about the possibility of "renewing" heritage for the contemporary era (*tajdid al-turath*). Hanafi argued that rather than being *mu'asira* and blindly accepting the West and refusing tradition, and rather than advocating *asala* and rejecting the West outright, Egyptians should look critically at their heritage, choose what is useful, and renew it, while taking what is useful from the West. This idea of "picking and choosing" had its roots in the first philosophical writings to emerge from the period in which Europe began to exert tremendous influence in the Middle East and North Africa. In the early nineteenth century, for example, Butrus al-Bustani wrote that the East could develop if it borrowed judiciously from European knowledge (Hourani 1983:100). And the idea of renewing heritage gained full force in the thought of the Islamic modernist *salafiyya* movement at the turn of twentieth century. The reformer Muhammad 'Abduh, for example, argued that while Islamic civilization had decayed, Islam in itself contained certain principles (e.g., rationality) that could be resurrected in a new renaissance (*nahda*) that would modernize Islam (Hourani 1983:131–60). Thus, the first phase of economic liberalization

in the postcolonial state, along with the growing worldwide attraction to po-
litical Islam, spurred the (re)invigoration of other genealogies of the modern
for artists to consider.

By the time I began my fieldwork in the mid 1990s, the second major phase
of economic liberalization had begun in response to U.S. and international
donor pressure. State industries were privatized and other incentives for pri-
vate sector growth were created. The new forms of consumerism arising with
these developments, coupled with the flourishing of new media technologies
that brought American pop culture into people's homes, spurred national dis-
cussion about Egypt's cultural (and even moral) integrity vis-à-vis the West.
In the art world, the *asala/mu'asira* debate as articulated throughout the 1970s
and 1980s had become hackneyed to many people. Yet the questions raised
in that debate remained important for Egyptian arts interlocutors and intel-
lectuals more generally, especially in the context of these changes, which also
made access to Western art much easier. Just as countless newspaper editorials
focused on the unsure future of Egypt, Egyptian artists reflected on the rela-
tionship between their work, the nation, and the international art scene. They
attempted to reconcile the uncertainties of this relationship with their values
about what an artist should be, and about what constitutes good art. While
many arts interlocutors criticized the *asala/mu'asira* dichotomy, and some
stopped using those terms, they also regularly fell back on the dichotomy in
assertions about what makes good, authentic art.

THE CONCEPTUAL COMPONENTS OF ARTISTIC AUTHENTICITY

The importance of authenticity as both a value and an ideal among artists and
critics was virtually undisputed. It was a concept with two mutually constitu-
tive parts—the individual and the cultural. An artist had to be an authentic
individual, which meant that she or he had to have originality, honesty, and
sincerity in life as well as in making art. But the referent of these qualities was
largely cultural. That is, to be an authentic individual, one had to be honest
(*sadiq*) and sincere (*mukhlis*) to oneself, and this necessarily entailed being
honest and sincere to one's cultural constitution, which was cast in national
terms as "Egyptianness," "Egyptian personality," or "Egyptian identity."[13] To
make good art, an artist had to transfer this cultural constitution to the artis-
tic product in an original way.

Arts interlocutors' concepts of sincerity and authenticity resolved many
of the tensions between and within these concepts in European philosophy.

Hegel and Kierkegaard conceived of authenticity as emerging from the individual's solitary search for "genuine selfhood in isolation from the common world." In their view, once authenticity is achieved, it must be protected from "the inroads of society" (Golomb 1995:99). For Hegel especially, "sincerity" and "honesty" were both diametrically opposed to authenticity, because they imply submission to prevailing social mores. The problem with sincerity and honesty in this view is that they are proven in a social domain, whereas "true" individual authenticity revolts against the social, because society is seen to inherently limit individual freedom. Nietzsche is also well-known for his hostility to social mores, which in his view limit sincerity. Sincerity and authenticity thus sometimes refer to the same thing in this general strand of philosophizing that emphasizes breaking with the social. There is another strand in which sincerity and authenticity are likewise slippery terms, but in which what is desired is attained through significant intersubjectivity. Heidegger, for example, conceived of individual authenticity as necessarily achieved through what he called Being-in-the-world. In the later writings of Sartre, individual authenticity carried with it a social responsibility and could only be achieved in an ethical and authentic society. For Lionel Trilling (1971), sincerity and authenticity were opposed, with authenticity representing the negative abdication of all social and moral responsibility.[14]

These tensions in Western philosophy parallel, and probably produce at some level, the tensions in modernist ideologies of the artist, some of which I discussed in Chapter 1. On the one hand, the artist is conceived of as a romantic hero-genius on an individual quest for selfhood (see Williams 1958; Wolff 1981; Zolberg 1990), an image perfected by the American abstract expressionists. On the other hand, the artist consciously engages with society in her or his work and behavior. This is the move of the European avant-garde and much American art classified as "postmodern"—to "reintegrate art into the praxis of life" through a criticism of art's autonomy (Bürger 1984:22). There are significant tensions in these ideologies of the artist surrounding the role and identity of the individual and his or her relationship to culture and history. In contrast, although Egyptian artists may have gone through periods of self-doubt and questioning regarding their roles and identities, as did 'Aliya' al-Giridi on her trip to Europe, these did not usually translate into alienated angst and a desire to break with history. Furthermore, artists did not doubt the components of individual authenticity and the necessity of their relationship to Egyptian culture and history. As I shall show, the key tension in Egyptian concepts of artistic

authenticity lay elsewhere. Rather than worrying about how to reconcile no-
tions of authentic individuality with society, artists were more concerned with
figuring out just what defined Egyptian culture and society.

. . .

One evening in September 1999, I visited Husam Amin at his exhibition in
a small gallery on the grounds of the government-run Cairo Opera House,
where the Museum of Modern Egyptian Art and the newly built Palace of Fine
Arts are also located. Amin, like many other artists, worked for the Ministry
of Culture and was also a practicing artist. His work in the exhibition—mixed
media paintings and sculptures—was an amalgam of many different trends
in contemporary Egyptian art. As we walked from piece to piece, Amin ex-
plained that he combines the three important components of Egyptian heri-
tage (*turath masri*): Pharaonic, Islamic, and Coptic, and also includes some
elements of popular, or folk heritage (*turath sha'bi*). These elements, he ex-
plained, are stored within him as an Egyptian, and as such they come out
spontaneously (*tilqa'i*) when he works. Looking for political motivations, I
asked him if he ever drew on this heritage "deliberately" (*bil-qasd*). Amin
maintained that he did not. He said that he "absorbs" (*yimtas*) heritage but
doesn't "copy" (*yiqallid*) it. If he brought out these elements of artistic heri-
tage deliberately, he said, his work would be "artificial" (*mufta'al*). He would
not be working with "honesty" (*sidq*), which he described as "the most im-
portant element in the success of a work." His Egyptian colleagues of every
ideological persuasion would agree. They consistently used the value-laden
terms "sincerity," "honesty," "artificiality," and "copying" both to articulate
their self-identity and to evaluate others through a distinction between the
authentic and the inauthentic. Indeed, these values, and others I shall discuss
shortly, structured the artistic field of production in Egypt.

By the 1990s, the noun for authenticity—*asala*—had come to mean a po-
litical and aesthetic position held by certain artists. The term was used with
pride by its adherents but derided by opponents (who spoke, e.g., of *al-nas bitu'
al-asala*, "those asala people"). However, the adjectival version of the word,
asil, is more neutral and retained great potency. As Amin indicated, *asil* artists
and art had honesty and sincerity. Inauthentic artists and art were defined by
the concepts of artificiality (*ifti'al*) and superficiality (*sathiyya*). Artificiality
referred to the artistic expression of a feeling or idea that an artist did not sin-
cerely hold, and it was therefore executed dishonestly. The concept was related

to that of imitation or copying (*taqlid, naql*), in that imitation was one way that a viewer could recognize that artificiality had occurred. Superficiality was another way that one could recognize artificiality or imitation. It referred to the insincere use of particular symbolic elements or styles, which belied the artist's ability to comprehend the cultural context from which such elements or styles emerged. Therefore their "true" meaning was lost on the artist.

A good artist had to pair these cultural concerns with individual ones. Picking up the idea of individuality central to western European ideologies of the artist, many artists believed that a good artist was one who did work that was "specific" to them (*khass bihum*). When describing how they work, artists like 'Aliya' al-Giridi and Husam Amin said that their particular experiences, introspection, and outlook led them to create work that was very specific to them. Any work that could be seen as derivative or influenced by another artist or artistic trend could compromise the claim of an artist to specificity (*khususiyya*). But this specificity *had* to take culture into account. An artist who displayed a sincere and honest relationship between him- or herself, Egyptian culture, and art was the one who truly avoided being artificial, superficial, or an imitation.

People generally agreed that a large degree of "awareness" (*wa'i*) and "understanding" (*fahm*) were necessary in order to avoid the negative traits of artificiality and to be truly authentic.[15] "Understanding" was largely interchangeable with "awareness." Both described a person's capacity to comprehend art or issues of importance to artists. Artists used phrases such as "he doesn't understand" or "they don't have awareness" to pass judgment on one another.

A more common way that arts interlocutors judged one other, and therefore distinguished themselves, was to make accusations of inauthenticity. Obviously, the inauthentic artist lacked the qualities of sincerity, loyalty, awareness, and understanding outlined earlier. He or she created work that was deemed inauthentic by other artists and critics, who based their claims on a range of any number of the following perceived faults: the piece is an imitation of another work or another style (usually that of an older Egyptian artist, or of Europeans and Americans); the work, or elements in the work, are directly transferred (*manqul*) from another work; or the art presents its ideas too directly (*mubashir*) or superficially (often directed at artists who use symbols from Pharaonic or folk art, but also at artists who take on political topics).[16] Accusations of imitation or Western influence were quite common and were often targeted at the younger generation, a point discussed further in the following chapter.

The effect of living under constant threat of such accusations became apparent on one of the most exciting nights in a long time for many young artists. The week-long al-Nitaq arts festival was being held in Cairo, and that night a rock band from Alexandria had a packed audience in a downtown restaurant dancing, clapping, and singing along with the music. A group of artists who had produced installations for the festival decided to get a bite to eat and sit at a nearby coffee shop. Conversation was animated and cheerful, but one artist seemed distant and preoccupied. I asked him what was wrong, and he said, "Apparently, I've been stealing work." He said he had overheard people looking at his festival contribution asking one another when he was going to quit "copying things." His friend tried to console him by saying that these comments are commonplace ('adi). She shared a story of how her work had been set to receive a prize at one of the Young Artists' Salons, but she had been accused of copying someone else's work. The committee was given extra time to find the original piece in books or magazines, but they did not. Nonetheless, her prize was retracted. However, this story did not comfort her colleague.

It was indeed the greatest slight to charge an Egyptian artist with copying someone else's work, for several reasons. First, artists distinguished themselves from craftspeople on the basis of originality, according to one Euro-American genealogy of modern art, which they had learned in art school.[17] But there were also local intellectual traditions that discouraged copying. In Chapter 1, I noted a saying by a famous Islamic jurist that artists liked to quote: "Follow me but do not imitate me." And as indicated earlier, Islamic reformist thought influenced the discourse on the proper uses of heritage in art. In this thought, "blind imitation" at the expense of interpretive reason (*ijtihad*) had led to decline of the Islamic *umma*, especially in comparison with post-Renaissance Europe (see Hourani 1983:127, 150). Similarly, artists said that the pervasiveness of copying proved that Egyptian art was more backward. The art critic 'Afif al-Bahnasi has advanced a similar argument about the arts in the Arab world as a whole (1997). Thus, not only was imitation seen as the sign of an unoriginal individual; *it also indicated a regressive culture.* Furthermore, if someone was accused of copying, his or her individual artistic authenticity was not the only thing being challenged. Because individual and cultural authenticity were so wedded to each other, one's cultural belonging was in question. Therefore, to Egyptian artists, most of whom embraced nation-oriented notions of identity, the stakes were quite high.

As a result, many artists engineered careful responses to accusations of imitation. In one poignant example, two artists told me that they had been looking at a large compendium of American art and had stumbled on some paintings by Georgia O'Keeffe. Having never seen her work before, they were shocked by its resemblance to the work of a distinguished and well-established Egyptian artist. Coincidentally, this artist, during a talk accompanying an exhibition of his, spoke about how an American visitor to his studio in Paris had once remarked that his work looked like O'Keeffe's. He shrugged off the comparison, saying that American artists were not really known in Europe, and that whoever this artist was might likely be copying *him*. But then he learned that she was much older than he, and so he explained that his work is very different from O'Keeffe's in composition. He said that he would leave a book of her work in the gallery so that people could compare for themselves this "insignificant American artist" (*fannana amrikiyya sughayyara*) with himself, "a very important Egyptian artist" (*fannan masri kabir*). As this suggests, artists sometimes defended themselves from accusations of Western imitation in ways that reinforced their legitimacy as Egyptians and attempted to subvert Western (especially American) dominance in the arts. It also shows that to be an artist in Egypt involved constant risk and the necessity to arm oneself with carefully prepared defenses, which might have to be invoked at any time. Finally, the incident suggests that processes of evaluation influenced how artists did art and how they represented it to others.

While artists struggled to maintain individual authenticity against such accusations, they engaged in serious debates over the nature of cultural authenticity. The intensity of these debates was rooted in the colonial history of artistic practice in Egypt and the continued dominance of western Europe and the United States in the international art scene. The specific context of late 1990s neoliberal globalization added a particular urgency to the issue. Arts interlocutors were asking a variety of questions: Just what would an artistic expression of cultural authenticity look like, when Egypt itself had never been hermetically sealed and would not stand still? Are artists who paint on canvas, work in installation or video, do still lifes or abstract expressionism, or produce images of televisions and Coke bottles inauthentic because all of these things are foreign imports? Are artists who use nonindustrial materials, paint images of the countryside or the desert, or construct works according to strict Islamic aesthetic principles inauthentic because they do not engage with certain things that, although originally foreign, have now become

regular parts of contemporary Egyptian life? What about artists whose work combines any number of these trends? Do they lack understanding, awareness, and sincerity? For Egyptian participants in the art world, the defining tension of authenticity lay neither with individual artistic identity nor with the individual's relationship to society, as is the case in much European and American aesthetic philosophy and artistic practice. Rather, it was the idea of Egyptian society itself, embodied in the cultural component of authenticity, that was rife with anxiety.

The tension inherent in defining authenticity resulted from the fact that there has never been an unadulterated nation or culture of "Egypt." Even if some artists and critics constructed an idyllic, pure past, the situation in the 1990s made *any* attempt to define and express "Egyptianness" open to criticism from some angle. In the following section, I follow local convention and group the various attempts to formulate a cultural authenticity into two major camps. These were the contemporary instantiations of the *asala* and *mu'asira* solutions, centered on the nation, to making authentic art that was neither backward nor lagging but modern—and modern on its own terms. This imperative to be both modern and authentic has always dominated Egyptian artistic practice. But the different means of accomplishing it have been shaped by sociopolitical and economic factors specific to certain moments in Egyptian history, which pushed certain genealogies of the authentic, modern nation to the fore. What follows can be read as competing reckonings with competing genealogies. They are also ruminations on Egyptian identity, and the future of the Egyptian nation, in a period of substantial uncertainty.

VISIONS OF THE MODERN NATION

For an entire week in January 1999, some private, largely foreign-owned galleries in downtown Cairo held an unprecedented arts festival, named al-Nitaq, which brought several important European and American curators to the country. The curators went to the exhibitions, spoke with artists, visited their studios, and examined their slides. For the most part, artists were eager to build international contacts, but they were nonetheless wary of them. In this context of unprecedented (since the colonial era) Western presence in the Egyptian art world, debates over the cultural aspect of authenticity reached a heightened pitch.

It was the opening night of the festival, and I was standing with three young Egyptian artists outside of a popular new gallery. Crowds of Egyptians and

foreigners, including a representative of the Tate Gallery in Tokyo, streamed in and out. My friend Manal Amin (with whose story Chapter 1 opened) introduced me to Hadi Labib, a painter in his thirties who was a colleague of hers from the Ph.D. program at the College of Art Education. Like the artists sitting at the adjacent coffee shop, we all started talking about this concentrated foreign presence in the local art scene. Labib launched into a heated critique of American art and Egyptian artists who imitated it. He turned to me and, in a very animated voice, started explaining that Egyptian artists copied Western art in an attempt to be *riwish*—a relatively new slang term meaning something between "funky" and "cool" (often used negatively). He said that globalization (*al-'awlama*) was to blame for local identity being "wiped out" (*mash al-hawiyya*) and went on to compliment artists of the older generation whose work he felt expressed their "Easternness" (*sharqiyyithum*) because it used Pharaonic themes. This statement provoked an angry response from Ahmad Mahmud, a colleague of the same age who worked at a state-owned gallery. Mahmud argued that Egyptian artists did not have to resort to such themes to prove their identity. Labib retorted by insulting a well-known older generation artist, 'Aliya' al-Giridi's teacher Faruq Wahba, for using metal in an installation of standing mummies, the effect of which was to make them look like men in spacesuits. Labib claimed that metal was not an *asil* material. At this point, Manal Amin entered the fray, arguing that Labib's criteria were skewed, because the ancient Egyptians had also used metal. Labib dismissed the comment and insisted that "real" Egyptian artists did not copy the West.[18] When I asked him what "real" meant, he responded with the explanation that I had heard often: that the real Egypt is a mixture of different civilizations and peoples—Pharaonic, Islamic, Coptic, peasant, and *sha'bi* (a term referring to residents of the oldest city neighborhoods). This unique mix, with its historical roots, is what gives Egypt its special character; a good Egyptian artist is one who uses any or all aspects of this heritage. Ahmad Mahmud was very irritated with Labib's focus on the past and said that he and his friends were "artists of today." He looked angry and exasperated and left abruptly. Later, he told me not to pay any attention to what Hadi Labib had said.

This episode highlights the two major ideological poles that held up the conceptual framework through which most artists represented their own work and evaluated that of others in contexts of heated debate. The first position was a contemporary version of the *asala* philosophy previously discussed, and a great many artists expressed adherence to this philosophy. For them,

to find and express authentic Egypt, one had to deeply examine the various historical periods that converged on the particular geographical area of the Nile Valley and the surrounding desert. One was more likely to find traces of this history in areas assumed to be less affected by technological and social change—namely, in the countryside and in centuries-old urban areas.[19] Their work tended to be more figurative (though not exclusively) and consisted largely of paintings and sculptures executed in the conventional materials of oil, pastel, clay, bronze, or granite. Its subject matter was almost always related to Pharaonic, Coptic, Islamic, folk, or peasant concepts or practices. Sociologically, these artists were either lower- or middle-level art professors, their students, or those in middle-level positions in the Ministry of Culture. A great number of them were not connected with the government at all. Indeed, most Egyptian artists aligned themselves with this perspective; and while they enjoyed the patronage of most of the private galleries, their perspective was in the minority in the chambers of power at the ministry.

The opposing group included many artists of the younger generation, high-ranking professors at arts colleges, public sector curators, foreign private gallery owners, Ministry of Culture committee members, and the minister of culture, himself a painter. Because they held significant power in the art world, and because they did not like labels (especially "nationalist"), they categorized themselves only when they had to distinguish themselves from others whom they considered not "modern" or "contemporary." They believed that their art "naturally" conveyed a cultural authenticity by the mere fact that they were Egyptian. This group found some inspiration from historical research and from studying rural areas and old urban neighborhoods. Thus, subject matter could be similar to that of *asala* artists but was also frequently inspired by aspects of contemporary, middle-class urban life such as commodity consumption, mass media imagery, and pollution. In contrast to *asala* artists, they also did work that explored individual states of being or emotions, or that was purely aesthetic (e.g., relations between organic and geometric forms). These artists also tended to use more industrial materials than the other group, were more influenced by painterly abstraction, and were more likely to experiment with assemblage, video, and installation.

Even though there were some very general differences in subject matter, media, and styles between these two groups, the arguments between them were not so much over particular artistic elements per se. Rather, their core disagreements concerned the "authentic" use of these elements and the con-

sequent visions of the nation that different uses implied. And although these groups by and large occupied different institutional positions in Egypt, I do not intend to present them as wholly separate. As the episode at the al-Nitaq festival described above shows, two teachers at the College of Art Education might have opposing opinions. Artists could be friends and associates with those who advocated a different perspective. And some artists straddled both groups, or even switched allegiances. Furthermore, there were artists who resisted these categories all together. But even artists who claimed to be weary of the debates about tradition and modernity that dominated intellectual life in the 1970s found themselves defining, and defending, their aesthetic stance against what they were not.

RESISTING THE WEST: THE *ASALA* PHILOSOPHY

Two months after the argument during the al-Nitaq festival, I attended the opening reception for a joint exhibition of the works of Hadi Labib and his colleague Hazim Mustafa. Labib greeted me warmly when I entered and, smiling, gestured towards his work and said, "Here you go, here is the East." Then he threw his hand in the direction of Mustafa's more abstract and gestural work and declared, "And over there is the West." We joked about his reference to the argument of that night, and then Labib took me around to view his works, which were fanciful representations of Arab legends. Remembering his comment about "Easternness," I asked what was Eastern about them. He explained that they were filled with the "magic" of the East and were done with a childlike "spontaneity" that was filled with "imagination and innocence."

Labib and many other Egyptian arts interlocutors have appropriated the language and ideas of Orientalism when they advance their claims that the "East" is more magical and childlike. In this respect, they resemble their intellectual forebears in the early twentieth century, whose discourses of nationalist self-identity were shaped by European Orientalism (see Hourani 1983). As in the case of modern Indian art, Western Orientalism was picked up and reconfigured locally to create a specificity that could be harnessed for constructing the nation (see Guha-Thakurta 1995:78).[20] Here we see the potency of ideas about Eastern spirituality for the artist in distinguishing his work from that of others whom he believed lacked or were losing cultural authenticity in a time of globalization. It was this concern with Western influence that formed the basis of the *asala* perspective, which emphasized artistic inspiration from a specific set of indigenous sources. These artists thought that the

way to reach both local audiences and universal standards of art was through deep exploration of Egyptian social life and traditional visual culture. If one did not do this, one would be imitating Western art and would therefore be identified as a fraud on the international scene. There was a phrase that was sometimes used to explain why some Egyptian artists gained positive international attention: "He reached the international by way of the local" (wasal lil-'alamiyya 'an tariq al-mahaliyya).

Labib explained that it was his professor, Gamal Lam'i, who had impressed upon him the importance of drawing on Egyptian artistic heritage in his work. Lam'i himself later told me that he had learned to appreciate Egypt's heritage while studying with the famed Wisa Wasif,[21] and he has written several articles exploring the problem of relating heritage to modernization and postmodernism.[22] He has been particularly interested in researching heritage because of his concern that Egypt is changing beyond recognition. Lam'i's work can serve as an introduction to the ways in which many artists articulate the *asala* position visually. In a meeting at the College of Art Education, Lam'i showed me a painting that he exhibited in Kuwait before the 1991 Gulf War (plate 4).[23]

He explained that this work, like many of his other paintings, combines symbols in a dreamlike landscape and attempts to merge ancient ideas and imagery with contemporary concerns. Though Lam'i did not mention it, this painting contains fragments of scenes that the artist probably sees out of the windows of his house, which he had built in the village of Dahshur near the pyramids in an effort to be further away from the overcrowding and pollution of Cairo.[24] Lam'i said that in this painting, he had tried to answer some of the questions that remain about the meaning of the pyramids by showing them with roots that support the people. With simplified symbolism that harks back to Pharaonic systems of representation, this painting is a visual reminder that a society can be supported by its history. "But sometimes," he said pointing to the tree growing out of the roots, "the tree dies." Lam'i depicts people with faces inspired by both Pharaonic and Coptic art, riding on fish around the pyramids and the tree. The fish, he explained, have two meanings that are useful for his message. In Pharaonic art, the image of the fish means "to arrive at a place peacefully." Lam'i, a Coptic Christian, said that in his religious tradition, the fish also conveyed prosperity. With this work, he argues that if people recognize that they are supported by their cultural and historical roots and work to protect them, they will prosper and live in a more peaceful world.

Many painters, sculptors, printmakers, and ceramists—indeed the major-

ity of artists who made up the 5,000-plus members of the Syndicate of Plastic Artists—found tremendous power and potential in this aesthetic perspective. To further develop it, some thirty of the most active artists formed the Asala Collective, whose founder and president, 'Izz al-Din Nagib, himself a painter, has systematically outlined the *asala* perspective in various writings over many years, becoming its virtual spokesperson (to much praise and derision.) Nagib is a committed leftist who came of age during the heyday of Nasserist social-ism, and this political intellectual tradition continues to shape his thought and that of many *asala*-oriented artists. Nagib has also been more politically active than others in his generation who spearheaded the opposing aesthetic per-spective. He has been involved in radical resistance against the state (particu-larly during the Sadat years) and was imprisoned several times for his political views and activities (most recently in the mid 1990s). He writes in a variety of forms (e.g., books, newspaper articles, and short stories) about class issues, the role of the intellectual in society, and Egyptian identity. Analysis of these writ-ings and interviews reveals three primary aims to his artistic agenda—ones that were shared by artists working with the *asala* philosophy in mind: closing the gap between art and society; preserving and innovating Egyptian heritage; and expressing Egyptian identity by "returning to," or "searching for" Egyp-tian "roots." Nagib was also always interested in analyzing the socioeconomic and political dynamics behind the *asala* philosophy and its emergence.

Asala artists were primarily motivated by what they said was a steady de-cline in artists' connection to society (and its history) since the 1970s. This theme is repeated in many of Nagib's publications, most notably his book *The Social Direction of the Contemporary Egyptian Artist* (1997), which argues that the 1967 Arab defeat by Israel resulted in the great majority of disillusioned Egyptian artists being "cut off" or "separated" (*munfasil, maqtu'*) from their own society, spurring the well-known exodus of a large number of intellec-tuals from conventional Nasserist nationalism, if not from Egypt altogether. Artists became further removed from their own society during the 1970s, Nagib argues, as a result of Sadat's honeymoon with America. He writes that the open-door economic policy (*infitah*), with its principles of free competi-tion, the law of the market, and supply and demand, "heightened the presence of limited individual objectives at the expense of higher social values and ob-jectives" (1997:136). In his book, Nagib discusses the repression of intellectual freedom in the 1960s, and in his interviews with me, he was not uncritically nostalgic for the Nasser years. Yet he does think that as a natural outcome of

the nationalist project, artists (and intellectuals more generally) were more interested in social issues and the lives of everyday Egyptians during the Nasser years. *Asala*-oriented artists repeatedly lamented that the turn away from society beginning in the 1970s had been given official encouragement in the 1990s by the minister of culture, who, they said, favored any Egyptian art that looked Western in order to put Egypt on par with art scenes in Europe and the United States.

Nagib argues that the negative effects of these larger socioeconomic and political changes can be found by looking at art. Contrary to what his detractors claim, Nagib does not oppose the incorporation of Western art styles into Egyptian art per se. Rather, he writes that he opposes their use in a manner that is merely "imitative," or that is without "awareness" or "understanding." Because "the West" has always been a model for many Egyptian intellectuals, artists are "dazzled" (*mabhurin*) by Western art and become overwhelmed by their blind attraction. It is this sense that they are always lagging behind the West that leads Egyptian artists to imitate Western styles without awareness or understanding—in short, without any authenticity.

Nagib echoed the sentiments of many *asala*-oriented artists when he suggested that this imitation of Western art leads to an unthinking adoption of Western individualism, which is what ultimately leads artists away from social concerns. He explained this point forcefully in one of our many discussions about an issue that was dominating intellectual discourse in the late 1990s—globalization (*'awlama*). Referring to an argument that I had witnessed at the 1999 conference of the artists' union between him and an Egyptian theorist of globalization, Salah Qunsuwa, he remarked:

> I later told him that he was adopting the Western concept of art and aesthetics, which is based on the individual and is directed towards the individual. . . . This perspective differs completely from the concept of Eastern arts, because Eastern arts are based on commonality, on shared culture. . . . on shared feelings, traditions, and values. It is impossible for me as an artist to destroy all of that and say, "I am a modern artist." The public will not understand that, not even the intellectuals, because they are also from the same ancient culture. So there must be something shared between the artist's work and society as a whole.
>
> The more I feel that an artist expresses something beyond himself as an individual, the more I am convinced that he is going in the right direction. And the narrower the aesthetic vision, especially to the degree that it is limited to the

individual, and the more superficial the artwork, the more the artist will not have a continuous relationship with the people. Maybe the artist can sustain this in Europe, and address the views of a very limited group of intellectuals or specialists in society, but the artist will never be a popular/public artist [*fannan gamahiri*]. . . . The artist should have public awareness and direct his work towards the public.[25]

Asala-identified artists, led by Nagib, were frustrated by what they perceived as a lack of public awareness among artists, caused by the massive socioeconomic changes in Egyptian society since the 1970s, and abetted by the state's complicity. In response, they joined with craftspeople in 1994 and formed the Asala Collective for Heritage Arts and Contemporary Arts. One primary aim of the organization was to encourage the development and proper marketing of handicrafts. In their view, crafts were Egypt's true "heritage" (*turath*), which was in danger of disappearing with modernization and needed to be preserved.[26] Another goal of the organization was to increase artists' awareness of and interest in craftspeople's work, so that they may then work to innovate Egyptian artistic heritage for the contemporary era (cf. Hanafi 1980). In this sense, the craftsperson, and the craft, represented "society," and by helping to support these people financially and initiating dialogue with them, *asala* artists thought that they were reconnecting to society.[27] As they learned in art school, however, a distinction between modern art and craft had to be maintained (see Chapter 1). As one member, 'Ismat Dawistashi (a close friend of Nagib's), explained in an interview, "One of our goals was that the artists could innovate, not imitate, the heritage."[28]

Dawistashi's prolific lifetime of work was rooted in this idea of renewing the heritage. I got to know him and his art during a month spent at the international granite symposium in Aswan in 2000, itself an event intended to encourage Egyptian sculptors to "revive" the use of granite, so important in ancient Egyptian art. He talked extensively about how he used images, forms, and materials from ancient Egyptian, Islamic, and folk arts in an attempt "to develop the popular/folk [*sha'bi*] artistic vision that stopped right after the revolution."[29] He said that growing up in an old popular district in Alexandria had allowed him to see and interact with folk art from a young age. Dawistashi usually worked in series that explored a particular theme, such as the palm tree (famous in Islamic and rural imagery) or parapets (wooden screens from the Mamluk period); and he often used bright colors inspired by folk

art or integrated found objects such as old textiles or hookah pipes into his assemblages.

In a February 2000 exhibition in Cairo, for example, he exhibited a series of drawings and paintings inspired by coffee cup fortune-telling. He described this work as "the realization of an aesthetic perspective and an evocation of inherited legends [*asatir turathiyya*] that are in dialogue with symbols from contemporary times and the future."[30]

The figures are reminiscent of Pharaonic, Greco-Roman, and African art, but also are playing out scenes from such popular local legends as those of the Beni Hilal tribe (fig. 2.1). Egyptian coffee cup readers divine secret events both present and future. Thus, like Gamal Lam'i, Dawistashi is suggesting that legends, and heritage in general, are the knowledge that should be uncovered for present and future. In his *Faces of the Old World* series (1998), he likewise calls forth associations with Pharaonic and folk art in technique, style, and theme. In the example from the series shown in plate 5, he uses calligraphy to announce that this is the "head of Egypt" and it is filled with goodness, and he uses symbols of ancient Egypt (e.g., the headdress, the face itself) and folk art (e.g., the flora) to express what Egypt is iconically.

As has become clear, *asala*-oriented arts interlocutors were reckoning with modern intellectual genealogies that represented the "West" as the pinnacle of modern progress and valued the individualist artist, as well as with those genealogies that positioned "authentic Egypt" as rooted in Pharaonic, Islamic, and Coptic history, and as most likely embodied in the peasantry or residents of the oldest neighborhoods in urban Egypt. They believed that colonialism had interrupted the development of Egyptian art, whereas contemporary European art had been allowed to develop without rupture from Greco-Roman times.[31] In their view, only by going back and mending that break with their visual history could they produce modern art that was not "superficial" or "artificial." Linking art, craft, and heritage again, *asala* artists hoped, would make modern art part of society rather than something "separate" or "cut off" from it.

In addition to nationalist intellectual genealogies, I want to suggest several other sources that arts interlocutors most likely drew on in arriving at their vision and interpretation of art and its purpose. First, state education from primary school through the university level teaches students that the Egyptian nation began at the time of the Pharaohs, and that Egyptian citizens are the contemporary descendants of the ancient Egyptians. The media and

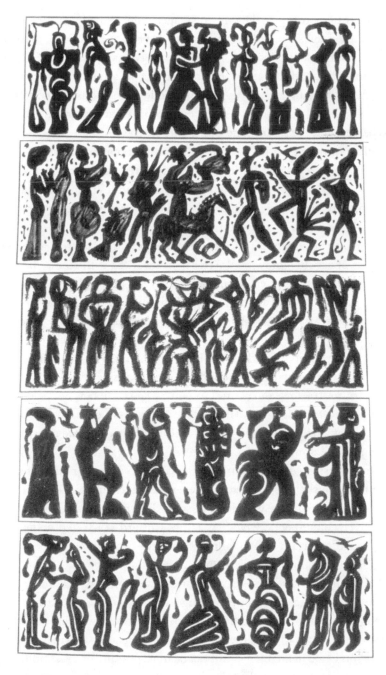

Figure 2.1 ʿIsmat Dawistashi, *Diwan Khayalat Finjan* series, ink on paper, 1998.
Courtesy of the artist.

literature often propagate the same message.[32] Educational texts, intellectual studies, television shows, films, and classic and recent Egyptian literature, as I have mentioned, also locate the authentic "Egyptian personality" in peasants.[33] In addition, the figure of the *ibn al-balad*, a "son of the country" who hails from old urban quarters, appears in public discourse as the model Egyptian.[34] Finally, although some were second- or third-generation city dwellers who belonged to the middle and upper middle classes, many of these artists took pride in their families' backgrounds in the "popular" districts or glorified their rural roots and identified their ancestry with particular villages. Their distance from peasants and lower-class urbanites in location and class position, I argue, allowed them to idealize these groups as representative of their "origins" (*usul*, also from the root *a-s-l*).[35]

The constructedness of their "authentic Egypt" was apparent at the minute levels of artistic production. Artists who worked with rural, Pharaonic, or urban folk themes systematically erased aspects of social life in those contexts in order to present an ideal image. Indeed, these works of art were just as revealing in what they *did not* contain as in what they did. The case of the painter Farid Fadil is exemplary here. His rural paintings were highly idealized portrayals of village life devoid of any markers of modernity, which by now are commonplace in the Egyptian countryside (e.g., electric wires, pickup trucks, tractors, and plastic). When I asked Fadil how he decided what to paint, it became clear why. He told me that he went out into the countryside, photographed scenes he found beautiful, and then painted only the parts of them that he wanted (see fig. 2.2).[36]

Other artists told me of similar artistic processes (either photographing, sketching, or just choosing certain images from their imaginations) that reveal a significant erasure of aspects of social life that would contradict their artistic view of authentic Egypt. As James Clifford (1988) and many others have argued, a certain idea of cultural "purity" is often necessary for these kinds of constructions of modern authenticity.

Although these discourses of authenticity were often employed by my interlocutors in struggles for power, prestige, or even money, their strategic uses did not detract from their truth value for *asala* artists. While it is nearly impossible to ascertain whether these artists *actually* believed that their authentic culture was based in Pharaonic, Coptic, Islamic, peasant, or folk traditions, to question their sincerity would not only strip them of their personhood (which is bound up with the presentation of sincerity) but also be to enter the fray

Figure 2.2 Farid Fadil, *Egyptian Village Scene*, oil on canvas, 1994.
Courtesy of the artist.

on the side of the other major position in the art world. Instead, I shall now discuss how those other artists and critics articulated their perspective, which they did in part by deconstructing the *asala* position.

ARTISTIC *INFITAH*:
THE "MODERN/POSTMODERN" PERSPECTIVE

Those who disagreed with the *asala* perspective dismissed 'Izz al-Din Nagib as a ranting old-timer, an "old communist" who was out of touch with reality. Older generation artists who held prestigious positions at universities and in the Ministry of Culture, as well as young artists who had won government prizes, said that unlike the *asala* artists, they (and their art) were "modern," "postmodern," or "contemporary." They peppered their speech with the English versions of these words, which implied a connection between themselves and the West, and suggested that it was this link that made them modern or postmodern. Since the 1970s, their artistic perspective, the conceptual opposite of *asala*, had also been glossed in Arabic as *mu'asira* (contemporary). However, by the late 1990s, they had gained enough power in the structures of the art world not to need to regularly use this word to signify themselves.

There was a way in which they criticized labels because they wanted to move beyond them, a luxury the *asala* artists (who had to name their struggle) did not have.

Although authenticity—both cultural and individual—was equally important to *muʿasira* artists, they constructed the cultural component in a very different way. While they agreed that the path to meeting universal standards (of high art culture) was through the local, they thought that *asala*, with its emphasis on idealized motifs, imprisoned the local in a fixed national culture that would forever render it provincial and second-rate. In their view, the local should be a free, fluid source for artistic inspiration. If the local was ossified or reified, the artist was inauthentic and just not good enough for the world stage. Thus, while their opponents fought Western dismissal of Egyptian art as imitative, these artists countered Western audiences' tendency to put their art in the box of "ethnic" or "Egyptian" art.

These interlocutors wanted to escape Western (and elite Egyptian) desires for art expressing some Orientalized notion of the "real Egypt." Thus, they advocated art that they thought reflected the social changes wrought by Egypt's engagement with the West. In their view, if art honestly reflected one's experience in the space and place of contemporary Egypt, with all its glories and problems, it was real and good.

Like the *asala* artists, these artists did not break with the past, a move common to many European modernisms (cf. Armbrust 1996). Rather, they argued that Egypt had always accepted other cultural influences and made them its own. It was this ability to "digest" foreign elements that was the true mark of Egyptianness, and to ignore it would be to deny Egypt's historically international and cosmopolitan nature. This group's different construction of the cultural component of authenticity thus reflects a competing understanding of Egyptianness in a time of tremendous flux. Although these artists abhorred the label "nationalist," theirs was also, in fact, a national ideology, and one promoted in the media by many politicians, intellectuals, and businessmen in Egypt in the late 1990s.

These artists' aesthetic position was shaped by their different conception of history. Although they agreed with the *asala* argument that the indigenous artistic trajectory had been interrupted (i.e., by the decline of ancient Egypt, colonialism, or socialist modernization), they thought that this break could never be repaired. Furthermore, the colonial basis of contemporary Egyptian art rendered any search for prior roots futile. To search for roots, in their view,

one would have to force a certain relationship with the past (or the rural pres-ent) that was no longer possible. Thus, the relationship would be "artificial." Moreover, they said, such a project would deny the European basis of modern Egyptian art and would therefore be "dishonest" or "insincere."

For them, the proof of this "inauthentic" relationship with history was to be found in *asala* artists' penchant for using symbols and figures from Pharaonic, Islamic, Coptic or folk art. *Mu'asira* artists dismissed such work as *motifat* (motifs), implying a lack of depth, awareness, and understand-ing of artistic elements. Images such as peasant women carrying water jugs, folk dolls, palm trees, the Sphinx, and camels, for example, were particularly despised if seen to be executed too superficially. Such "motifs" are employed according to the widespread "vulgar" (*suqi*) understanding of them among the masses, according to Ahmad Fu'ad Salim, the ex-curator of the Centre for Fine Arts in Cairo, often seen as the most influential and prolific *mu'asira* art critic (1999:90).[37] It was not that Salim and other artists denied that peas-ant women carrying water jugs, or the Sphinx, were part of Egypt. Many of them were also inspired by rural life, or by Pharaonic or Islamic art. Rather, these artists argued that it was the superficial use of these elements and preoccupation with them at the expense of other elements of Egyptian life that devalued the meaning of the noble term "heritage" (*turath*). They joked about the lack of value and understanding in the particular *turath* discourses of *asala* artists, changing the word *turath* slightly to form *turash*—which means "vomit."

The work of Mustafa al-Razzaz, then the influential Chair of the Fine Arts Committee of the Supreme Council for Culture, and one of Egypt's first instal-lation artists, shows that *mu'asira*-oriented artists were not necessarily against the use of heritage elements in their work, as their opponents often claimed. But they argued that such elements could only be included after long and serious research. I discuss Razzaz's work extensively in the interlude between Chapters 3 and 4, but here I want to note that the figurative nature of his work, and its references to Pharaonic and Sufi theories of transformation, made it more palatable to *asala* artists. His age and institutional position afforded him additional prestige. But when younger artists explored similar ideas in more abstract ways, they were often subjected to accusations of Western imitation and deviation from Egyptian authenticity. For example, Razzaz's former stu-dent, the painter and installation artist Shadi al-Nushuqati, also explored the concept of transformation but was often criticized for copying Western art.

The layout of an installation al-Nushuqati created for the 1999 Venice Biennale is reminiscent of certain Sufi ceremonial formations, as well as of ancient Egyptian temples, where transformations of men and animals into gods are often depicted. The lights are simultaneously points for ritual concentration and also formal references to mosque or shrine lighting. The gauze, as a material, suggests the Sufi idea of the bridge or thin veil between this world and the other world, or the state of enlightened consciousness (fig. 2.3).

Unlike his mentor Razzaz, al-Nushuqati departs from figural representation. The different reactions to these two artists not only illuminate the influence of generational difference and institutional position on the evaluation of art but also suggest that *asala*-oriented artists were often suspicious of installation (seen to be a wholly foreign medium) and of abstraction that did not seem (to them) to be derived from "native traditions" such as Islamic design.

Installation artists in particular felt compelled to counter the accusations that they imitated the West. Definitions of the category of art itself—and how much it was determined by the West—were at stake. They often said: "If *asala*

Figure 2.3 Shadi al-Nushuqati, mixed media installation, 1999.
Courtesy of the artist.

artists call our installations a Western imitation, then why are their canvases any more 'authentic'?" One installation artist complained to me,

> The idea of painting itself is a European idea. Why can't they understand that?! Even what we teach in the arts college—proportionality, rhythm, balance, shadows, light—these are European rules [cf. Chapter 1].
>
> JW: But there are still critics who keep telling you that the Pharaohs had sculptures and that the idea of art is originally Egyptian.
>
> Yes, we had sculpture, but we didn't have canvas painting. . . . They can't comprehend that the ancient Egyptian work of art was not in fact art but part of a civilization. . . . So there weren't artists during that time. There were skilled people who were used by the ancient Egyptian priests [to create objects] to serve the [ancient] Egyptian faith.[38]

Here we see a debate over the definition of "art" that is shaped by the colonial encounter. Whereas the *asala*-identified artists most often drew on the broad definition of "art" typical of general art history, artists such as this one more frequently defined art as "modern art" that starts in the late 1800s in Europe. These were different reckonings with the power of various canons.

Asala artists' broader definition of art enabled them to resist the Western canon by constructing their own parallel canon. Meanwhile, their opponents' narrower definition of art allowed them to resist the exclusivity of the Western canon by arguing for inclusion on their own terms. *Mu'asira*-oriented artists questioned the exclusive nationalist ownership that *asala* artists wanted to claim for artistic heritage, often by turning the tables on colonial pillory of ancient Egyptian objects and using the discourse of "rights." Artists frequently said that it was their "right" (*haqq*) to use forms, media, or other elements from the West, just as Picasso and Miró used African or Pharaonic forms. For example, a ceramist of the younger generation, Diya' Dawud, told me that when people asked him how he could look "abroad" when he had a "7,000 year old civilization" right in front of him, he countered that it was his "right" to do so. Referring to the West, his friend at the table added poignantly, "If you have a nice piece of cake in front of you, will you eat it or just look at it? We're hungry, so you can't tell us not to eat it!"[39] Dawud's own work was rooted in a long history of ceramic production in Egypt. Like the work of 'Aliya' al-Giridi, Mustafa al-Razzaz and Shadi al-Nushuqati, it was concerned with ideas of birth, death, and transformation (primarily through the use of forms breaking through eggshells and crossing over to the other side of the

wall). Also like their work, his took advantage of forms of installation developed in Europe (fig. 2.4).

This demand for inclusion in the give-and-take of world heritages did not preclude *mu'asira* ruminations on their own Egyptian identity. It was part of it. As Muhsin 'Atiyya, an art historian and professor at the Cairo College of Art Education, writes, "any artistic antiquity that was produced under the

Figure 2.4 Diya' Dawud, ceramic, wire, and foam installation, 1999.
Photograph by Jessica Winegar. Courtesy of the artist.

patronage of Egyptian culture will become a part of human heritage. In fact many of these antiquities have already become part of the heritage of the whole world—just as the authenticity of heritage in Egyptian art was always to be found in its openness [*infitah*] to all tastes and in its ability to satisfy the collective desire of different peoples" ('Atiyya 1998:64).[40] Many arts interlocutors used a version of this argument, made famous by the geographer and Egyptian personality theorist Jamal Hamdan, to prove that an authentic Egypt was one that was historically open to all cultures. Hamdan (1970) argues that Egypt's geographical position at the crossroads of Europe and Asia, on the Mediterranean and Red Seas, and its connection to sub-Saharan Africa through the Nile Valley, have made it a unique and fertile ground for the mixing of populations. In this view, the "Egyptian character" was built upon this mixing, which brought about an absorption and Egyptianization of other cultures in a "welcome acceptance"—as a writer at the Cairo Atelier once told me.[41]

Mu'asira-oriented people applied this logic to the increasing influx of Western ideas and products since Sadat's economic reforms, and especially to the processes that had recently been glossed as "globalization" ('*awlama*). Not only did they see no reason to oppose Western trends in art, but they thought that to do so would actually be culturally inauthentic, given Egypt's geographical location, its colonial art history, and the Egyptian character. They considered it dishonest to deny what they saw as already a part of Egyptian society. For example, the art critic Salim asks whether identity is to be found solely in "a peasant woman carrying a bundle of wheat along an agricultural ditch . . . or Pharaonic symbols . . . or Islamic aesthetics" (1999:50). He criticizes the use of such elements as implying that *asala* can only be found in the past (1999) or in scenes of poor people's lives (1998). Really authentic Egypt was about history and all the people in the country. But it was also about technology, consumer goods, pollution, and other things that characterized the contemporary era. Indeed, these artists believed that they were *more asil* than others, because, they said, they were not actively filtering out influences that were already there. Furthermore, they said that they did not have to "prove" their Egyptianness, because the mere fact of their being Egyptian would make the work culturally authentic.

These artists extended the metaphor of Egyptian geographic digestion of other cultures to themselves as Egyptians. In Hamdan's theory, Egypt digests foreign cultures to create its unique Egyptian character. Similarly, these artists believed that they (visually, mentally, and sensorially) digest all that is around them. 'Aliya' al-Giridi talked about her "internal mill" that processed everything

she saw and experienced. Artists talked about digesting such things as art theories and other ideas, local history, visual aspects of Egyptian life, their individual experiences, and contemporary art from the West. They said that these disparate elements interacted inside them, and then were brought out in a unique artistic product—one that was produced from elements specific to the present moment in Egypt, but that was also an expression of the individual artist's perception of these elements.

Sabah Naʿim, an artist of the younger generation, eloquently explained this perspective to me as we sat outside a state gallery one evening in the fall of 1999:

> I cannot say that to be *asila* [authentic] I should paint a picture of a peasant woman holding some green plant, or paintings of ancient Egyptians. I am living a condition. I cannot start making art of 1901.
>
> What does Egypt look like? Egypt is so open to the rest of the world. The traditional form of [artistic] expression of Egypt is a girl wearing a face veil and a robe. Well, I am not wearing that. We all wear jeans and eat at fast food restaurants. We don't all live a single identical life. . . . Globalization is not a monster that is going to force me to stick to the old and say "This is Egyptian art." That is our heritage, but not our current state. . . . You cannot build your future solely on your past. You have to include the present as well. [It's like] adding a few components to your VCR.
>
> This is *asala*. This is what is *asil*. I have to express the world I live in. I can have the old serve as a reference, but not as a basis for *asala*.[42]

Naʿim's assemblages show how this perspective shaped artistic production among many *muʿasira*-oriented artists. In an early series of works, she rolled Arabic, French, and English-language newspapers into small balls and placed them next to each other (as shown here in fig. 2.5). She explained the work as exploring what happens when the inner self (each ball) is placed side by side with others, entering into a relationship of social or global mixing, as referenced by the barrage of media images and texts in different languages.

Naʿim's discussion illuminates a particular understanding of the cultural component of authenticity, which, like ʿAliyaʾ al-Giridi's words at the beginning of this chapter, emphasizes a particularity within a universal:

> I was thinking about the issue of repetitiveness, and how from a distance we all look the same. Differences appear only at closer distances—differences in

Figure 2.5 Sabah Na'im, newspaper, 1999.
Courtesy of the artist.

the ways we look, our ways of thinking, and in our ways of dealing with other human beings. Inside each circle is a world that is so distinctive from the others beside it. Each circle of newspaper is a world that embodies other worlds . . . I have always been looking for something that is very shared but specific to me at the same time.[43]

These artists still faced the problem of how to ensure that the digestive process did not compromise their artistic sincerity and honesty. Again, "awareness" and "understanding" were the key discursive elements. One could not absorb just anything from the environment. Artists had to pick and choose from their surroundings what to digest, and this required considerable awareness—of the history behind things, of what had quality, what was substantive, and what was aesthetically interesting. As mentioned earlier, this idea of critical engagement with the West has a long trajectory, dating at least to the early nineteenth century, and draws on different genealogies of Islamic thought. During a passionate discussion with friends over tea, the painter Salwa Khadr echoed earlier Islamic reformers when she argued that critical engagement with the West, as opposed to refusal, was actually within the Islamic tradition—either in its historical openness to influence from other cultures (especially during the Abbasid period) or in its emphasis on scientific reasoning (see also Munir 1998).

These artists were less interested in constructing an unadulterated parallel history than in being "on par" with the West. Contrary to the *asala* camp's charge that they "run after the West" (*biyigru wara al-gharb*), these artists did not want to be the same as Western artists; they just did not want to be more "backward." The overwhelming perception among artists that Egypt lagged behind the West was an undeniable outcome of colonialism and modernization and was related to larger concerns among many Arab intellectuals that a so-called superficial turn to tradition promotes a kind of cultural retardation.[44] This perception evidences a partial acceptance of Western teleological thinking about modernity, and the impetus for many *muʿasira* artists to become aware of and use Western styles, media, and concepts in their work was indeed a concern about backwardness.[45] They lamented what they perceived to be the backwardness or "reactionary" nature of *asala* art, which in their view threatened to propel Egyptian art in its entirety into the dark ages. Some artists expressed embarrassment at the prospect of Westerners seeing this work and thinking that it represented all of contemporary Egyptian art.

For example, one audience member at an art college conference complained that the only contemporary Egyptian art he had seen in the United States were paintings of peasants playing the wooden flute. "Then the Americans ask me about camels. The work we show abroad is embarrassing!" he cried.[46] Furthermore, whereas *asala* artists almost never compared their work to Western art, their opponents continually judged their art scene in comparison with what was going on in the art centers of western Europe and the United States. In public lectures and debates, coffee shop discussions, and interviews with me, arts interlocutors repeatedly said, "We are so backward here." Often, an artist would return from a visit to the United States or a European country and tell his or her friends something like, "I saw this and that there, and I just thought, 'Look how far behind we are in Egypt.'" One older artist who worked for the state conveyed this sentiment in another way: "It is not shameful ['*ayb*] to say that the West is actually superior [*mutafawwiq*] and that Egyptians can learn from it. What matters is *how*."[47] What mattered was how to learn and take from the West with awareness and understanding, and with sincerity and honesty. These arts interlocutors' reckoning with Western dominance involved a critical engagement with the West, not a refusal of it or the construction of a parallel artistic canon.

In an example of this critical engagement, the critic Ahmad Fu'ad Salim turned the tables on *asala* accusations that he and others run after the West. In a public lecture to the artists' union, he claimed that the West had captured *asala* artists' minds by exporting the idea of "Egyptian identity," which he argued was basically a box imprisoning Egyptian artists, forcing them to paint camels and peasants.[48] Here, Salim overturns Nagib's accusation that *mu'asira* artists cannot maintain their identity in the face of Western influence. It is *asala* artists, in his view, who are deluded by Western curators and buyers seeking work that "looks Egyptian."

CONCLUSIONS

This idea of "the West" (*al-gharb*), a signifier for imperialism and globalization, has been a primary force in processes of artistic production and evaluation in Egyptian art throughout the twentieth century and into the twenty-first. In this chapter I have traced two of the primary reckonings with Western dominance, which shaped and were shaped by the concerns over individual and cultural authenticity. And I have shown how discourses of authenticity were one of the primary means through which Egyptians made art, represented

themselves, and evaluated the art of their colleagues. The crucial importance of authenticity derives from Egyptians' reckoning with the genealogies of the modern at their disposal, and from the impossibility of escaping location in a place and art world that experienced colonization and is marginal to the Euro-American centers of the international art scene. Individual authenticity, in its emphasis on originality, was in large part borrowed from Euro-American ideologies of modern art, and it continued to be extremely important to arts interlocutors because of the ever-present specter of backwardness, seen to breed imitation. Ideologies of cultural authenticity were shaped in nationalist, religious, and other responses to colonialism; in the late 1990s, they took on great urgency for artists debating the potential benefits and drawbacks, for themselves and their society, of neoliberal globalization.

The polarization of cultural politics into categories such as "traditional" and "modern," and their continued performance as a dichotomy (despite the best intentions of the framework's critics) is common in many art worlds far from the avant-gardes of London, Paris, and New York. For example, Romanian intellectuals, who share a similar history of socialism, are largely split between indigenists and internationalists, and this polarization dominates much intellectual life in Romania (Verdery 1991). Greek artists, who share a famous civilizational history with their Egyptian counterparts, have become concerned with how to build an identity rooted in ancient Greece, while still showing that they are part of Europe.[49]

But there were important specificities to the Egyptian context—particularly in what constituted "heritage," the history of socialist modernization ideology, the intellectual tradition as influenced by Islamic thought, and material and thematic aspects of the art itself. There is also a particular nature to the authenticity debates over "tradition" and "modernity" in places that are not only outside of the major centers of the international art scene but were also colonized. In Egypt, as in Mexico, India, and Ghana, the national modern art movement was created, and has developed in the context of, various European colonialisms and, now, American cultural dominance.[50] Despite Frantz Fanon's warnings, many anti-imperial nationalisms (and related modernization projects) adopted ideas of Western superiority and evolutionary progress, at least in some domains. For modern artists of the global South, the sense that the West (however defined) is the source, model, and ultimate arbiter for all they do has been a central impetus in the authenticity debates. How they orient their ideas about local or national culture to fantasies of universal

or high culture is key to understanding their struggle to gain legitimacy in a number of arenas without losing their sense of artistic integrity and personhood. The fact that anti-colonial resistance so often took place on the grounds of "culture" (Chatterjee 1993) has meant that these artists, who work in the domain of cultural production itself, must continually prove their "rootedness" when the threat of foreign domination feels particularly palpable—such as when the Egyptian government began bowing to U.S. and financial donors' pressures to liberalize the economy and politics, and when the United States invaded Iraq in 2003.

Egyptian artists' formulations of rootedness that inextricably linked individual and cultural authenticity and deemphasized the image of the lone, renegade artist were also rejections of the atomization of the individual that threatened to accompany the spread of capitalist social relations. Egyptian artists were taught in school that art was not merely for individual gain, and this nationalist pedagogy developed into ways of making, interpreting, and enjoying art that resisted alienation and foregrounded the nation. The dominance of national-cultural authenticity in discursive frames of evaluation contributed to forms of artistic personhood that emphasized social connectivity and collective enterprises.

This was not the happy collectivity constructed in some anthropological writings as an ideal opposite to capitalist society. As I have shown, disagreements and fights were common. Defining what was authentically "Egyptian" was a tremendously fraught affair for arts interlocutors, because cultural authenticity was defined almost exclusively in nation-oriented terms, and people were uncertain about the future of the nation, given the transformation from a command to a "free market" economy, intensified global circulation of commodities and technologies, and foreign intervention in the Middle East. Perhaps if there had been space for more artists to view authenticity through other lenses (e.g., region, religion, gender, class), the debates and dilemmas might have found some resolution, or authenticity might even have declined in importance. But the terms of the debate were formed through the colonial experience, and as such they constituted a useful analytic and evaluative framework for artists trying to come to terms with a postcolonial, post-Soviet world dominated by American-style capitalism.

Geeta Kapur's work on Indian artists (1993, 1998, 2000) has shown that they operate within a similar set of debates, in her words, "notations within the cultural polemic of decolonization," in which the nation has been the primary

frame. She argues that nationalism in art "helps resist imperialist hegemony; it also serves as an environmental testing ground for unheeding modernism" (2000:267, 292). When Egyptian arts interlocutors struggled to build an artistic identity that was on par with the West yet distinct from it, they were exemplifying what Chatterjee has called "the most powerful as well as the most creative results of the nationalist imagination in Asia and Africa," which were "posited not on an identity but rather on a *difference* with the 'modular' forms of the national society propagated by the modern West" (1993:5). Looking for and expressing "Egyptianness" can be emancipating (and protective) at many levels—from the social to the personal. 'Aliya' al-Giridi, the artist whom I introduced at the beginning of this chapter, was trying to find her own individual and cultural artistic specificity in a way that saved her from a negative comparison with German artists—a comparison that threatened to destroy her love for art. And looking to an artistic past (like the Pharaonic) that is well regarded in the world art canon could be a way of resisting the Western characterization of contemporary Egyptian art as lagging or backward (cf. Shannon 2001:281–82).

At the same time, however, nationalism is undeniably hegemonic. Kapur has described nationalism as a "burden" for postcolonial artists, even if some of them wish to escape it in their work and representations of themselves (2000). The importance of cultural authenticity places limits on artistic production, even as it offers certain possibilities. The ideal images of the nation that are constructed in art and its discourses either marginalize intranational differences such as class, gender, and religion or negate them altogether. When propagated by cultural elites, even (or especially) if they come from modest backgrounds, such nationalism legitimizes their own positions of power. And when these elites are as intertwined in the state cultural apparatus as they were in Egypt, their exclusivist nationalist vision is further buttressed in society at large. Furthermore, cultural authenticity and one's relationship to "the West" become the criteria by which state resources are distributed. It is to these topics that I now turn.

MUHAMMAD 'ABLA

Nile Sparrows

MUHAMMAD MUKHTAR, AL-GINUBI, is good friends with an artist from the far north named Muhammad 'Abla, who has become something of a mentor to younger artists—an alternative to professor and government mentors and someone closer to their age and disposition. In local categorizations, 'Abla would belong to the "middle generation" of artists (*gil al-wasat*) who came of age in the 1970s, when there was dwindling support for the arts and when the dominant ideologies of Nasserism and socialism were in serious disrepair, not yet rehabilitated objects of nostalgia. There are only a few artists in this generation—most budding ones entered other fields because of lack of support. Others went into exile. 'Abla also spent many years in Europe, then returned to Egypt, where he has since been a prolific artist, active intellectual, and coffee shop companion to the artists who are interested in cultural issues beyond art-making. He was also one of the first artists I met, and from my experience getting to know him, I learned to negotiate many kinds of relations in the art world. 'Abla has that rare combination of being incredibly diligent and relaxed, hardworking and sociable, successful and unpretentious. He and his work have thus gained the respect of many people—from the poor families who have been the caretakers of his various studios to writers, filmmakers, and many of his fellow artists.

Like Ginubi, 'Abla came to Cairo from the provinces. He was born in 1953 in the Nile Delta town of Bilqas, to a family that includes farmers. He has never once used his modest background to sell himself in the capital's art scene. This is one reason why he has become a favorite of many young foreigners

and Egyptians who do not like to romanticize roots, and also why he has had problems with other Egyptians whose only way of dealing with non-Cairene artists who do not objectify their rural roots is to tease them for being "country bumpkins." ʿAbla's background, unique personality, intellectual interests, and artistic vision have led him to produce a series of works that often stand out from the usual portrayals of Egypt and Egyptians. Instead of working on rural themes, which can easily fit into national authenticity narratives, ʿAbla has focused on the city and its people, including its new migrants. In doing so, he has helped me relate to Cairo in new ways.

In fact, he was one of the first Egyptian artists to explore the changes in urban life and space that accompanied industrialization and, later, free market reforms. Today, there are other artists in Egypt working on that topic, many of them using photography and video. Although ʿAbla has used these media in the past, his Cairo works from 2001 have primarily been on paper, canvas, or board and make use of collage, painting, drawing, and printmaking. I think that his use of more traditional media often makes a difference in the outcome. Some artists who use photography or video succumb to the gaze that the camera invites. There is an erasure of the artist as subject, which then enables objectification of urban life. Spaces and people are either put into Orientalist frameworks or become objects of wry commentary or even derision for artists featuring what they deem the kitsch of post-independence social change. But ʿAbla usually avoids all of these things in his works on the city, thanks to his particular background and intellectual outlook, his choice and use of artistic media, and his modest studio residence amidst the poor Egyptians living and working on one of the small islands (al-Dahab) in the middle of the Nile, in the middle of Cairo. This means that this series of works is less digestible to those desiring certain "images" of the city. It consists of complicated explorations of the hope, sadness, and absurdity of everyday life in Cairo, all the while respecting its subjects. In this way, his work is much like that of novelist Ibrahim Aslan, whose book *Nile Sparrows* (2004) captures similar aspects of life in Cairo from the point of view of another impoverished Nile island (al-Warraq).

ʿAbla's work on Cairo only starts to make sense when one steps out from behind the camera and "lives the city," as he says. ʿAbla walks the city, often with an old friend who points out details and tells him the history of how they've changed. Sometimes, he photographs things, *not* in order to "capture" them, but in order to *learn* what he calls the "city's secrets." And he is not a

flaneur. He talks to the city's people, interacts with them in streetside coffee shops, in stores, and on the bus. In a way, then, his art is akin to Ginubi's, which also attempts to grapple with the contradictory hope and desperation that is experienced in the city.

His paintings are of ordinary, often marginalized, people—traffic cops, government workers in safari suits or *higabs* (head scarves), merchants, children playing in the water near his studio, and people crossing the street, going to work, sitting at the coffee shop. Sometimes they are portrayed in strong, flat colors, which the artist says reveals them as "impressive and mighty" against the din of the city. At other times, they are like "phantoms," fading into their crowded, noisy surroundings. There's an in-between stage too, where the figures are just outlines—strong figures but nonetheless permeated by the city (see fig. C.1).

These are ruminations on people's relationships with Cairo and with one another in the city. For 'Abla, the city is about its people, and especially about the paths they take through it. It is not a depopulated city, painted up in idyllic fashion for a viewer who imagines a better past; nor is it a city consisting only

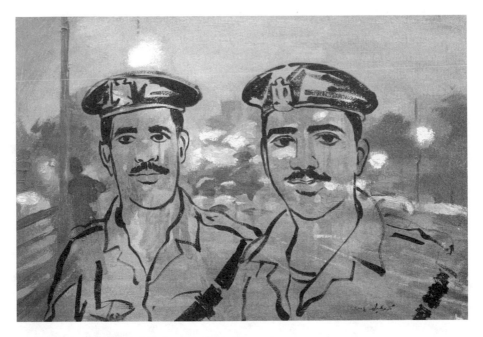

Figure C.1 Muhammad 'Abla, mixed media on canvas, 2004.
Courtesy of the artist.

of "traditional" craftsmen, magicians, or storytellers who inhabit the oldest neighborhoods, as if Cairo were locked back in time. It is a Cairo of social relationships and of movement, of the artist *in* Cairo, not gazing at it like a tourist. This is why images of 'Abla himself often appear in the works as well (see fig. C.2).

In this series, 'Abla also shows us Cairo as the capital of a country beset with problems. Like the writer Sonallah Ibrahim, whose use of headline clippings in his novel *Self* (*Zaat*) (2001) throw the insanity and desperation of postcolonial Egypt into full relief, 'Abla also incorporates the "news" into his work, achieving equally destabilizing effects. In one particularly evocative piece, he paints in (rather than clips) articles, headlines, and cartoons that one could readily find in any newspaper or magazine (plate 6). A headline on the right jokes about how international assistance doesn't reach ordinary Palestinians, or Egyptians (a comment on the government). At the bottom is a state newspaper declaration that the banks and currency are stable (this in a

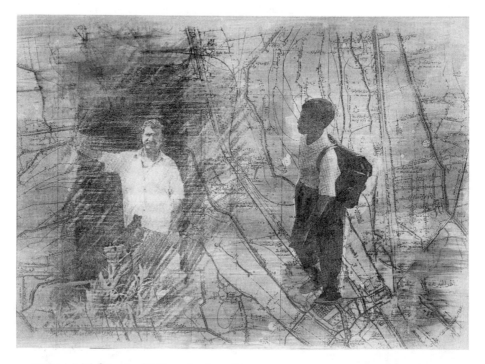

Figure C.2 Muhammad 'Abla, mixed media on canvas, 2004.
Courtesy of the artist.

period of intense instability). In the middle, in large red letters, it says, "How much is the life of an Egyptian worth?" This is a phrase 'Abla repeats in other works as well, including one piece titled *The Description of Egypt*—a wry reuse of the title of the huge volume that resulted from the Napoleonic expedition to Egypt.

'Abla loves his gestural process of painting, and the spontaneity of the brush, because he says they help him "capture the effect of radiant and optimistic faces notwithstanding the sea of suffering and pressure." He also says that the people "grant him the right" or "allow" him to portray them and their movements. He therefore conceives of his subjects as agents, participating with him in the process—just as we, at this moment, participate with 'Abla in the process of creating meaning for his work.

'Abla's fundamental philosophy is that art should be participatory. He regularly elicits comments from viewers of his work and is known for mixing the genres of art, openings, and social parties. During an arts festival, his "installation" consisted of a real wedding party, complete with tea served to guests and a throne for the bride and groom. He was also one of the main organizers of a major, unique public art project launched in 1996 in Kum Ghurab—a squatter settlement in Cairo close to 'Abla's studio at the time. He and other artists worked together to paint designs on the sides of the decrepit houses (see Afifi 1997). My first months of fieldwork were spent with the artists working on this project, and I got to see 'Abla's casual side in the coffee shops of the area. Later, when the project succumbed to in-fighting and outrageous accusations that one of the artists had stolen money through Kum Ghurab connections, 'Abla stood on the side of right and defended the artist.

But one event stands out in my memory for how it revealed 'Abla's philosophy, sociability, and values. In 1998, a fire destroyed his government-provided studio in the Ottoman-era Musafirkhana Palace in the old Cairo neighborhood of al-Gamaliyya. 'Abla loved this building's architectural and aesthetic beauty and its significance in Islamic history. Like many of us who had spent time there, he was crushed by the loss. Some blamed the government for being negligent, or for intentionally starting the fire so that it could sell the land to developers. For the one-year anniversary of the fire, 'Abla invited me and his other friends to a commemoration of the building on its ruins. We received handmade invitations, on which he wrote about the "deep wound" that this event caused for everyone who "loves beauty." So we all went on a Friday, the main vacation day of the week, when families gather. This was a family of

artists and friends, so to speak. As we talked late into the night about matters large and small, he served us *kuwari'*, a traditional stew of cow's feet, which many artists would either turn up their noses at or eat with such a to-do that you'd realize there was an element of slumming to it. But not 'Abla. He neither reifies his background and his current social milieu nor tries to escape them.

3 FREEDOM OF TALK
Cultural Policy and the Transforming State

There is an equation in Egypt, which is: The government, the regime, is saying now [to the writers], "You write whatever you want but I'm going to do whatever I want." And that's why we don't have the freedom of speech, we have the freedom of talk. And there is a difference. . . . You talk and you write whatever you want but this will never be influencing the decisions of the regime.

Egyptian novelist Alaa Al-Aswany

MAKING ART IN EGYPT was not just about putting brush to canvas or striving for authenticity, however defined. Artists not only needed to support themselves financially; they wanted exhibitions, an audience for their work, and recognition in the shape of critical reviews, awards, and other honors. They hoped to have some impact both in the art world and in society at large. These personal desires and artistic visions connected with larger social aspirations and political hopes, which were not only of the moment but were shaped by the various permutations of state activities and ideologies in post-independence Egypt.

This chapter explores the relationship between artistic practice and state cultural policy. It analyzes three interlinked processes: how the state came to occupy such a central role in artists' lives and imaginations by the mid 1990s; how and why artists within and between different generations viewed the state as responsible for supporting the arts, and held it accountable for perceived failures in that regard; and how art policy became a key part of the Mubarak government's stated goals of privatization and democratization. Through discussion of the debates surrounding an annual young artists' exhibition, I examine how the different discourses of ideal cultural authenticity discussed in the last chapter were linked with particular political projects and employed strategically in ways that sometimes challenged state policy and its attendant nationalism, but almost always reproduced the idea of the state as custodian

of art in Egypt. I argue that this reproduction of the socialist-inspired idea of the caretaker state ended up enabling Ministry of Culture programs and institutions to become vehicles of the transformation to neoliberalism.[1] It is well known that globalization has challenged state sovereignty (see, e.g., Sassen 1996), but less attention has been paid to the ways in which states actually produce and protect neoliberal policies, particularly in the cultural realm.[2]

To grasp these processes requires disassembling monolithic notions of "the state" and "society" as inherently demarcated and opposed sectors (Abrams 1988; Mitchell 1991). Such notions have obfuscated our understanding of political processes, especially in Middle Eastern and socialist contexts. As Schein suggests, such notions often reveal, more than anything else, Western desires for (and assumptions about) autonomy and to distinguish the West as superior to the East, perceived as totalitarian (2000:138–43). One way to avoid this pitfall is to go beyond simplistic presentations of elites as agents or dupes of the state (see Boyer and Lomnitz 2005) and to figure out how the field of cultural production was politically constituted in Egypt. I argue that the field is a rich concept, which enables us to see how the state can "[work] in tandem with cultural producers" who might or might not be state employees but "who share certain ideological stances with the state" (Schein 2000:164). It therefore enables analysis of how artists interacted with institutional projects (and the actors representing them) on a variety of levels, and how institutional processes were affected by or effected these interactions. In Chapter 1, I discussed Ministry of Education art schools as the most important medium for the production of artists and ideologies of artistic practice. Ministry of Culture institutions were also very important sites in Egypt's field of artistic production.[3] Here I continue the discussion begun in Chapter 1 to examine how social relations in and around the Ministry of Culture, and state-sanctioned ideologies both past and present, infused certain art with value, while delegitimizing other art and artists. I look at the way in which state actors' assertions and development of cultural policy continually engendered struggle around notions of value. The intense nature of debate and jockeying for power in the Egyptian art scene shows it clearly to be a field along the lines Bourdieu envisioned, because "the generative, unifying principle" is "the struggle, with all the contradictions it engenders" (Bourdieu 1993:34).

However, the autonomy of this field of artistic production from the political elements in the larger field of power was even more relative than Bourdieu's theory allows. In fact, as we shall see, forms of value and prestige that had their

bases in political institutions permeated the artistic field in Egypt, and there was not a large push for autonomy from them. Quite the opposite: the vast majority of Egyptian arts interlocutors saw state support for the arts as key and sought political value for art. Artists in high state positions were envied, if not respected, for they got to determine which art was politically valued and got financial support.

In this chapter, I separate Bourdieu's somewhat myopic claims about the value of autonomy dominating the field of artistic production from his insights into the mechanics of how fields work. Thus, I offer a fine-grained analysis of the field of artistic production as "a field of forces" and as a "field of struggles tending to transform or conserve this field of forces" (Bourdieu 1993:30). The key to understanding how these struggles worked is to examine the relationship between Egyptian arts interlocutors' positions in the field and their "position-takings"—assertions of particular stylistic or political positions, which were very often articulated through discourses of authenticity. Bourdieu argues that the space of contradictory position-takings in the field of cultural production is intimately tied to the space of positions (which is the space of capital possession and distribution). In the Egyptian art world, a clear connection can be discerned between different artists' positions in relation to capital and the kinds of arguments they made about the cultural policy that largely determined capital possession and distribution. For example, the leader of the *asala* movement commanded some symbolic capital as a member of the older generation. But he did not have control of the distribution of social capital in the major competitions, and thus he took a position opposing abstract or conceptual artists and the institutional processes that lent value to their work. At the same time, however, his socialist background and credentials in part led him to put faith in the state's ability to successfully build an art movement that was connected to "the people." As I shall show here, those opposing state cultural policy continued to privilege the nation-state in their discourses of opposition. They did so by using a variant of nationalism whose terms were set by state processes dating back to the Nasser era. Furthermore, institutional location, cultural capital acquired abroad, political credentials, and generation were all primary aspects of position that shaped position-takings. Such position-takings ranged from appeals for more resources or a change in cultural policy to asserting the validity of a particular aesthetic perspective.

I also reveal how discourses of authenticity were the most powerful tools with which artists enhanced their images or delegitimized their competitors

in order to get what they wanted from state actors and institutions. Discourses were the best means, in part because they were drawn from the shared ideal of artistic practice as analyzed in Chapter 2. Thus the position-takings largely consisted of arts interlocutors using discourses of authenticity to advance personal and group agendas, claim legitimacy, jockey for position, ensure loyalties, advance careers, and weaken competitors—primarily through state channels. And because "generation" was such a loaded category, for reasons I shall soon discuss, claims to authenticity were more powerful if justified by reference to it. Arts interlocutors on opposite ends of the age and aesthetic spectra both appealed to and criticized the state, depending on the context. They did so by claiming, often with reference to generation, that their authentic work would make the Egyptian art movement progressive or original (as opposed to backward or imitative).

It is important to note that these position-takings were not completely determined by people's different relationships to the space of capital. Therefore, it is not analytically useful to denounce some of the people discussed here as remnants of the old Nasserite elite or old bureaucratic hacks, or to dismiss others as tools of imperialism or immoral capitalists. While such characterizations might not be completely off the mark, I think it is important for the analysis here to recognize the extent to which arts interlocutors had serious emotional attachments and political commitments to certain genealogies of the modern—which included particular visions of art and the state's role in supporting it (cf. Abu-Lughod 2005 on television producers). These commitments also shaped people's position-takings as they reckoned with the fate of these genealogies or the power of others. Position-takings, then, were themselves acts of reckoning at some level. For many arts interlocutors, 1990s state cultural policy went against the ideals and frames of evaluation and meaning developed over a lifetime. This disturbed them at existential and political levels. For others, the shift in cultural policy aligned with their ideas about art and politics and alleviated personal and professional problems they had faced for some time. Not surprisingly, they responded enthusiastically. These kinds of attachments and commitments are less easily encapsulated in Bourdieu's language of "strategy" and "positions" but are extremely important to understanding the complicated place of state projects in artists' lives and worldviews.

In what follows, I show how arts interlocutors' contests to change or maintain the field of forces in cultural production (through nation-oriented discourses of authenticity) contributed to the hegemonic ideal of the state as

the caretaker of culture. The reiteration of the nation as a category of practice (Brubaker 1996) helped reproduce the state as an institution. It was through interaction with state actors and policies that consent for an ideal caretaker state was cultivated among diverse groups, including those who opposed state activities or were not necessarily patriotic nationalists. Ministry of Culture officials co-opted or gave space to the opinions of those opposed to certain policies, thereby helping to gain their consent as to the importance of state cultural policy in and of itself.[4] Thus, even though there were extreme differences in how artists conceived of "real" Egyptian art, the allowance for these differences in various state venues gave an appearance of pluralism that enabled the field of forces to be reproduced. Alaa Al-Aswany's characterization of writers' relationships to the state, quoted as the epigraph to this chapter, is supremely applicable in the art world as well: there was a "freedom of talk" that gave the illusion that there was actually free discourse, but the terms were largely set by state institutions. Therefore state officials did not really have to change their policy.

State institutions, through their processes and employees, played a key role in defining the set of position-takings available to artists. These position-takings, no matter what they were, helped reproduce the hegemonic ideal of the caretaker nation-state in part because they were articulated through discourses of authenticity that foregrounded the Egyptian nation. Writing about similar debates among Romanian intellectuals, Katherine Verdery points out that all sides "were engaged in a single potentially system-reproducing endeavor, in that through arguing, they further consolidated a realm of agreement about the importance of national identity" (1991:313). A similar process occurred in the intense debates that dominated artistic life in Egypt. Not only was there relatively little disagreement among artists about the enduring importance of the nation, but the state was continually held accountable against an ideal of it as the primary creator, nurturer, and protector of the nation. In what follows, I read arts interlocutors' debates for what they say as well as for what they do not. The assumptions underlying the debates are what lead me to argue that the ideal of a caretaker state had achieved a certain hegemony by the late 1990s. In a related way, so did the frame of the nation for giving meaning to much artistic practice. The debates that did exist, then, can be seen as "clashes of symbols . . . produced when tensions *within* the hegemonic . . . chafe for immediate resolution" (Comaroff and Comaroff 1991:24; emphasis added).

Richard Perry and Bill Maurer (2003) examine the changes that globalization has wrought to the practices and effects of modern governance, showing how modes of "graduated sovereignty" (Ong 1999) are emerging as nation-states cede control over some aspects of social life and global flows, while enhancing their surveillance of others. Here and in Chapter 6, I extend this popular line of inquiry into the realm of cultural production, and more specifically into the role of arts policy in creating visual and cultural components to neoliberalism and in engendering what might be called a neoliberal artistic subjectivity. Cultural studies scholars have only recently begun to consider how cultural policy in North America and western Europe is part of modern strategies of governance and the move to neoliberalism (Lewis and Miller 2003; Miller and Yúdice 2002; Stevenson 1999). However, there has been little consideration paid to non-Western situations—particularly in nations formerly colonized by European powers.[5] Yet, as Tony Bennett (1992) has argued, culture has become both an "object" and "instrument" of governance in such nations.

It is not merely coincidental, then, that an unprecedented expansion of government art activities and institutions accompanied the privatization of key industries in other sectors of the economy. This apparent contradiction actually fit with the government's plan (shaped by pressures from international donors) to enhance Egypt's status in the "new" global economy. This national arts policy was the cultural accompaniment to neoliberalism, stressing international progress, flexibility, and democratic openness as made manifest in "avant-garde" art. This example resembles others where nation-states have redefined some forms of nationalism as internationalist, particularly in realms of cultural production (cf. Ong 1999; Wang 2000). This was a strategy both to make Egypt's cultural goods more competitive internationally and also to create a friendly and progressive international reputation that would encourage foreign investment. Indeed, the promotion of art was, I argue, seen as creating a friendly environment for foreign investors skittish about political Islam. It was no accident that some Western businessmen I came to know talked excitedly about how Egypt was becoming more culturally avant-garde. Art—especially that made by young artists—was understood by foreigners as a marker of progress, in contrast to politicized religion.[6] State officials and arts interlocutors shared this assumption, and thereby aligned themselves with certain secularist and teleological aspects of genealogies of the modern. But they were not motivated by Western-derived stances of superiority and generalized fears of Islam as a "conservative religion." Rather, their reckonings were shaped by concerns that

the rise of specifically political Islam threatened both their hold on power and resources and their ability to create any work they wanted. Their reckonings were also shaped by the workings of cultural policy since the Nasser years, and in particular by its relationship to the ideologies of socialism and the nation.

ARTS POLICY FROM NASSER TO MUBARAK

Understanding how the state came to dominate artists' lives in Egypt at the turn of the twenty-first century requires analysis of the historical development, and hegemonic processes, of arts policy since the revolution, when the Nasser government instituted wide-ranging cultural initiatives in the service of the nation. The ways in which cultural policy was framed by the state and understood by arts interlocutors were systematically reproduced over the decades, and a pattern of constraining and conceding government support emerges. This pattern, the position-takings that brought it about, and the nation-based framework in which these position-takings took place formed the field of cultural production and made the state dominant within it. This specific aspect of arts policy is part of a larger history of the Egyptian state's uneasy relationship with its intellectuals, some of whom became its mouthpieces, while others became critical and threatening (see Ginat 1997; Gordon 1992; Mahmud 1998; Shukri 1990).

After Nasser came to power, the state took over as the largest patron and supporter of the arts. The sequestering of many private collections speeded the process (Karnouk 1995; Iskandar et al. 1991), but it was really the centralization of cultural production that led to this early dominance of the state in arts affairs. After independence in 1952, state officials became determined to show the world that Egypt was modern enough to have modern art. The government purchased a building on the grounds of the Venice Biennale to serve as the Egyptian pavilion.[7] In 1956, the same year in which the constitution that centralized power in the presidency was ratified, the government set up a Supreme Council for the Development of Arts and Literature. The responsibility of this council, which reported directly to the presidency, was to ensure that "culture" developed along with science and technology in the new modernizing nation, as well as to "protect" fine artists financially, morally, and spiritually (Iskandar et al. 1991:183–84). This council coordinated, instituted, and expanded arts activities and programs in several areas, including state acquisitions of art, grants for travel and study abroad, and national exhibitions inside and outside the country.

A Ministry of Culture was formed in 1958, and together with the council, expanded and centralized state art support even further. The nationalist nature of this move was clear: commissions and long-term grants were distributed to produce art within themes defined by the government. Also, new museums and exhibition spaces were opened (e.g., the Great Exhibition Hall at the Socialist Union headquarters, the Akhneton and Bab al-Luq galleries in downtown Cairo, and the Mahmud Mukhtar museum, built to honor Egypt's first nationalist sculptor). Construction began in 1960 on the Egyptian Academy of Arts in Rome, which continues to host artists, musicians, and writers sent by the government for long-term residencies. The government also took control of the press in which art critics wrote, and it took over the existing art colleges and created new ones. The new Ministry of Culture also began several programs to bring the arts to "the masses," which will be explained in more detail in Chapter 4. One of these, important for the discussion here, was to build "culture palaces" (*qusur al-thaqafa*) throughout the country. Each palace had an exhibition space, and artists visited them not only to exhibit their work but also to lecture about art. Artists were also invited to administer these palaces as a way to serve the new nation. It is indeed significant that two of the major figures in the 1990s art world took up this offer and started their careers at these palaces: Faruq Husni, the minister of culture, an advocate of internationalism, and 'Izz al-Din Nagib, Husni's main detractor, and head of the opposing Asala Collective of Artists.[8] Whether through administering culture palaces, getting grants or commissions, having work acquired by the government, or writing art criticism in state-produced publications, artists and critics who (prior to the revolution) had been supported in the private sector or who had had to support themselves through other means, increasingly found themselves on the state payroll in the 1950s and 1960s.

It is clear that cultural production under Nasser was centralized and expanded in order to create a vibrant cultural scene that supported the explicit and implicit goals of the regime. Liliane Karnouk argues that the Nasserist state supported art as a "propagandistic extension of the military regime" that catered to "the taste and ideology of the new class in power" (1995:6). Such art was often commissioned by the government in conjunction with various industrialization projects, such as the High Dam.[9]

Centralizing cultural production was also a way both to control and co-opt secular intellectuals whose communist tendencies the regime found threatening. As Joel Gordon (1992) has shown, the regime's interest in main-

taining military power over Egypt was infinitely more important than any ideological affinities that certain members of the junta had with Marxism. In what Gordon calls "the great deception," intellectuals—despite being arrested in droves and having other freedoms greatly compromised—justified their own persecution by accepting military rule as a necessary evil that would stabilize society and prepare it for true reform. In a related example, the painter Inji Aflatun was jailed for her leftist activities but continued to do art with nationalist themes upon her release, like the painting *Battlefield*, which commemorates Egypt's struggle to take back the Sinai from Israel (fig. 3.1).

One artist told me that even when the regime began to imprison various leftist writers and artists, there was still a sense that Nasser was the best possible leader for the socialist revolution. He only lacked appreciation for arts and culture. This sense that the state is the proper benefactor for art, if only its officials were "cultured," will be taken up in Chapter 4. Here it is important to recognize that this early faith in the Nasserist program and nationalist ideology, and the related suspicion, if not outright rejection, of the aristocratic and foreign elites that had previously supported the fine arts, kept artists looking towards the state more than to the private sector well into the 1990s.

This history reveals the seemingly contradictory nature of various cultural policy initiatives that continued through the period of my fieldwork. Speaking at the end of the 1990s, Egyptian artists often complained that the ministry was inconsistent and lacked systematic order (*tansiq*). Bureaucracy and stupidity were usually seen as the causes. Many turned to the new private sector hoping to find more organization there. But the effect of post-independence cultural policy, and of socialist ideology and the command economy in general, has been to reproduce: (1) the idea of the state as patron, promoter, and protector of the arts; and (2) the conceptual frame of the nation for evaluating artistic practice and policy. A pattern of concessions and constrictions began in the Nasser years that continued to string artists along decades later. It is not that artists were blindly manipulated. In a cultural economy of shortage (created by state socialism), favors, bargaining, bribes, and personal relations—the stuff of this pattern—were paramount (see Verdery 1996).[10] It was a game that characterized the space between positions and position-takings (Bourdieu 1993), and artists played it.

I have already documented the expansion and centralization of state-supported art projects and activities in the early 1950s. Even while imprisoning intellectuals, including some visual artists, the government was also build-

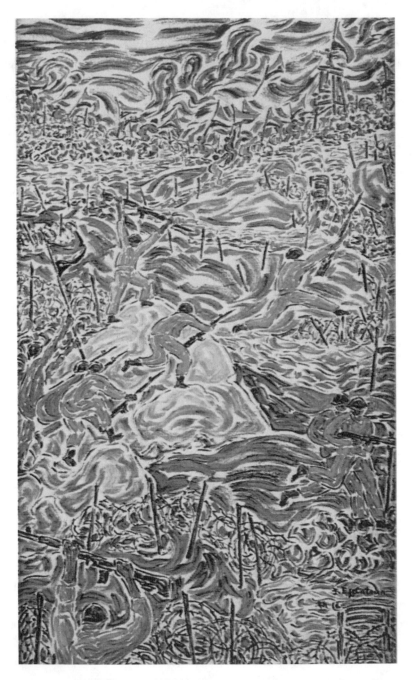

Figure 3.1 Inji Aflatun, *Battlefield*, oil on canvas, early 1970s.
Courtesy of the Museum of Modern Egyptian Art.

ing museums, opening galleries, and giving artists various forms of monetary support that were unprecedented in their number. More artists could make a living doing, administering, or writing about art than at any time prior to independence. In 1962, artists were pleased that the government opened the Bab al-Luq gallery for them to exhibit and sell their works. In 1963, however, the government tore down the Museum of Modern Art on Qasr al-Nil Street in downtown Cairo and built a tourist hotel in its place. Then, Tharwat 'Ukasha, who had at one time been exiled to Europe for being too much of a leftist, but who was later brought back into the fold as the minister of culture, announced a policy of bringing artworks out of storage to "see the light" (Iskandar et al. 1991:168). Paintings and sculptures that had been acquired over the years were distributed for decorating government offices, including the People's Assembly building, thus giving artists' work prominent display. In 1966, the government also reopened the modern art museum in a different building. But then, in 1967, the acquisitions budget was reduced by three-quarters, and the government-run residency program in Luxor was closed for financial reasons (presumably because state funds were being diverted for that year's war against Israel). In an act that countered these reductions in support, it was decided that artists would no longer have to do art according to a government-determined theme if they won the major state arts grant (*minhat al-tafarrugh*). The government also announced that it was going to build a massive Palace of Arts in Cairo. Construction began in 1969, with plans for exhibition halls, artists' studios, a library, a conference hall, and a store in which artists could sell their work or reproductions of it. It is likely that these actions mitigated some of the anger and disappointment caused by the reduction in state venues and support, and by the growing loss of faith in the Nasserist program, which was reinforced by the 1967 defeat in the war against Israel.

During the Nasser years, then, there was a centralization of the culture industries within the state apparatus, as well as an overall expansion of state support for the visual arts. Artists became more and more connected to and dependent upon state processes, primarily through employment, sales, and exhibitions. A similar process has been documented by Verdery in Romania, where "avenues of professional fulfillment" outside this state socialist model also began to "disappear" (1991:115). Even though many artists supported the revolution and the Nasser regime ideologically, when their faith was put to the test—because of arrests, the 1967 defeat, the closure of exhibition spaces, or the decrease in acquisitions—they were still compelled to seek state support.

Enticing new resources or art spaces became available every once in a while. These incentives, combined with artists' enduring hope in a national revolutionary future, laid the foundation for the consensual process that was to reproduce the hegemonic ideal of the state—even when the cultural apparatus was on the verge of being dismantled under Sadat, and even when cultural policy in the 1990s began to disfavor the most popular aesthetic perspective in the country.

Before turning to the Sadat era, I want to mention the deep disappointment in the government felt by a large number of artists after the Arab defeat in the Six Day War against Israel. As the 1960s wore on, they had seen that the military government was not moving towards democracy; instead, it was becoming bloated, inefficient, and more controlling. After 1967, some artists quit the profession. Others traveled or lived abroad for ten or more years, while still others stayed on in their positions as professors or as occasional recipients of grants and acquisitions, hoping for an improvement. Those who stayed eventually became some of the major figures in the government during the 1990s. They were joined by a new group who, in 1967, were just starting to attend art school. Even though these younger artists were not yet practicing during the heyday of Nasserist art support, they became attached to state nationalist ideology partly through compulsory military service in the Egyptian army in the 1973 war with Israel over the Sinai—service that they proudly mention as part of their biographies. It should be noted that the idea of artists being proud of military service is completely anathema to most Western genealogies of the artistic modern and Bourdieu's theories of autonomy.

In the 1970s, the Sadat government reversed much Nasserist policy by drastically downsizing the Ministry of Culture, its funding, and activities. But the practice of restricting or taking away support, followed by conceding it, continued. From the first months of the Sadat presidency, it became clear that cultural policy, along with economic and political policy, was to change radically. These changes could be seen as part of a larger attempt to create a new kind of neoliberal citizen subjectivity—one that did not depend on the government but was accountable to it, and one that was flexible and mobile but also allegiant to the nation. In 1971, on the same day as the "Corrective Revolution," in which Sadat replaced government heads who were allegedly planning a takeover, he also asked Minister of Culture Badr al-Din Abu Ghazi to hand over the newly constructed Palace of the Arts for his personal use as a presidential palace. When Abu Ghazi refused to give up *the* major art project

of the Nasser years, he was promptly replaced by a new minister, who surrendered the building (Iskandar et al. 1991:173). But at the same time, Sadat also released many leftist dissidents imprisoned under Nasser—a move that no doubt was welcomed by artists.

The back and forth effects of cultural policy moves continued. When a series of disputes between Egypt and the USSR occurred in 1971–72, resulting in the expulsion of Soviet technicians, many of the cultural centers of the Eastern Bloc countries closed down. These centers, with their cultural exchange programs and exhibition spaces, had been an important part of artistic life in Egypt. Acquisition budgets also decreased. The Akhneton Gallery space was sold and converted into a fancy restaurant named Arabesque.

With the loss of these spaces and resources came a few more concessions that also promoted a new kind of artistic subjectivity. In 1975, a National Creativity Prize for fine artists was created. In 1976, a presidential decree allowed for the establishment of an artists' union. And the same year, a private villa that had been sequestered after the revolution was converted into an exhibition space, which eventually became the Centre for Fine Arts in Zamalek and home to the annual Salon al-Shabab, or Young Artists' Salon. A former curator at the Czech cultural center was employed to manage the new space. Contemporary art was put in the bottom floor in a gallery named "Akhneton"—a clear sign that the government was attempting to compensate for the closing of the gallery bearing the same name downtown and to evoke the nation's artistic heritage (Iskandar et al. 1991:201).[11] The storage area of the closed Museum of Modern Art, the dilapidated state of which had been a constant annoyance to artists, was emptied out, and works were placed on the upper floors of this villa.

In 1977, Egyptian artists were mortified to learn that a Van Gogh painting previously owned by the art collector Muhammad Khalil, but now part of the state's patrimony, had gone missing while supposedly under the protection of state security. An international search was led by Interpol and made national headlines.[12] A Kuwaiti prince eventually returned the painting on the condition that charges would not be brought against him.[13] In response to the scandal, Sadat himself personally opened a space called the "Peace Gallery" in an old royal villa, which was to house the newly secured collection. The 1978 peace agreement with Israel inspired the name for this new gallery intended to appease artists concerned about the security of the national collection. Camp David also resulted in the Union of Arab Artists expelling its Egyptian

members. The same year, in a move that is highly symbolic of Sadat's courting of Islamists and capitalists to counter the leftists, the major exhibition hall at the Arab Socialist Union headquarters was turned into an Islamic bank. A year later, a second major exhibition space (in Bab al-Luq) was closed and another bank opened in its place.

Amidst these constrictions and concessions, there was also an attempt to radically change cultural policy in Egypt, which met with tremendous opposition. Sadat not only reimprisoned many leftist intellectuals and student activists but also called for dissolution of the Ministry of Culture under the slogan "Culture is for the Intellectuals" (al-thaqafa lil-muthaqqafin). Thus, in the 1980s, for the first (and only) time in the history of the Egyptian state, the idea that culture should be developed for the nation and the masses was almost abandoned. The plans to cut resources and leave artists on their own were to be implemented through an even more intensive centralization and downsizing of the arts administration. Plans were made to replace the Ministry of Culture with a smaller Ministry of the State (*wizarat al-dawla*), to be administered directly by the president's office. A Supreme Council for Culture that reported directly to Sadat was formed and charged with running any remaining arts programs, presumably to conform cultural policy to political policy (Iskandar et al. 1991:184). At the time of my fieldwork, artists remembered being very upset about this last in a series of actions under Sadat that threatened to erode state support for culture.

In the fall of 1981, however, shortly after these changes, Sadat was assassinated by Islamists, whom he had encouraged to counteract secular intellectual opposition to his regime. The Ministry of Culture was reinstated very quickly thereafter. Artists were to soon witness a significant increase in arts support that made up for the dwindling support during the Sadat years. Furthermore, state support was about to be slightly decentralized away from the presidency, giving an impression of more independence. Although the Supreme Council of Culture remained under the wing of the president's office, in 1985, a National Center of Fine Arts was formed as part of the ministry, which could accept or reject recommendations of the Supreme Council. The council, whose decisions had had the force of law since 1956, thus no longer had complete control over how arts were to be run in the country.

Without exception, the artists I came to know had negative memories or opinions of the Sadat years and frequently linked what they saw as bad cultural policy with Sadat's economic policy. Ahmad Mahmud was a younger

generation artist and had served as a government curatorial assistant for several years. As an insider to the politics that shaped art world decisions, he was an animated interlocutor on issues of state support for the arts. One night, before he closed the gallery he was working in, I asked him for the inside scoop on the powers that be. I had known him for over year and we had gossiped endlessly about the players in the art scene, but now I wanted to know more of his own personal thoughts. He said that he had a lot of criticisms of current officials, but that the art world was better for what the new minister had done. He echoed the words of many artists from different perspectives and generations when he exclaimed:

> The shutting down of fine arts in Egypt occurred in the 1970s and 1980s. The disaster during Sadat. He was a catastrophe [*nakba*] for the cultural movement in all of Egypt, because the political idea was *infitah* [literally, "opening up" to trade with the West] and consumerism. We changed to a consumerist society. We got chicken from Holland and butter and clothes from I don't know where. The most important thing became "what will I consume?"—not "what will I do?" There were no longer any substantive issues to discuss. The issue in the 1970s was money. Make money quick.
>
> JW: How did that suppress the art movement?
>
> The two biggest galleries closed in the 1970s! . . . You know from 1970 until 1990, only about ten artists came out [names seven artists in the middle generation]. . . . I cannot even think of ten names![14]

But something kept artists from completely turning away from the state throughout that period, such that when government money and resources were put back into art in unprecedented amounts in the late 1980s and 1990s, it was universally hailed as a positive development. Throughout the 1970s, artists would seem to have retained an ideal image of the state as a positive supporter of culture in the new modern nation. Even if faith in certain kinds of cultural policy eroded, the idea that the state was important remained, such that it could be harnessed by artists and administrators through the 1990s and later. By the time I began my fieldwork, state support became so diverse and vast that artists produced narratives portraying the 1970s as a catastrophe and the late 1980s and 1990s as a veritable renaissance for the Egyptian art world.

As this brief history suggests, the ideal of a patron state came to be taken for granted for several reasons. At a most basic level, previous forms of elite patronage had significantly decreased with the exodus of foreigners and the

dissolution of some private property after the revolution. Furthermore, aristocratic elites were not interested in buying the kinds of abstract and experimental art that began to emerge from the late 1960s onward. The nouveaux riches of the Sadat era did not constitute a significant market for art; it was not until their children came of age in the late 1990s that a noticeable interest in modern art could be detected among this group. But it was not just the fact that the state became the main patron of art that kept artists looking to and assessing the state over some fifty years. Many arts interlocutors drew heavily on postindependence ideology that asserted the role of the state in developing culture for the masses. Most argued that state support was better than the prerevolutionary aristocratic alternative. Critics on opposite sides of the aesthetic spectrum argued that the state protected artists from the capitalist art market. For them, potential censorship of a politically charged work of art was better than being forced to either adopt Western styles or cater to the local bourgeois preference for paintings of peasants and still lifes just to make a living off of art.

These views stemmed from the belief, shared by almost every artist who was part of my study, that the Sadat government had shown indefensible, if not immoral, disregard for the value of cultural activities in a modern, developed society. Not only did the anti-imperial, socialist history of their immediate predecessors influence their opinion that Sadat had abdicated an essential state responsibility. From this perspective, the alternative to state dominance in the arts—private sector support and development—bore an uneasy parallel to Sadat's economic reforms, which had wreaked havoc on their social class. In the context of neoliberal "reform," many artists feared the termination of state arts support and the prospect of being at the mercy of the capitalist market, in much the same way as they dreaded a return to the price spikes and long bread lines of the 1970s. Artists were not about to turn their backs on much-needed financial rewards and exhibition opportunities both at home and abroad—opportunities usually available mostly through the state in formerly colonized, poor countries. I discuss this issue further in Chapter 6. Government support of the arts was also seen to thwart political Islamists, whose ideal polity (artists presumed) would ban much of the work they did. Government attempts to appease Islamists by banning certain books had no parallel in the visual art scene, and thus siding with the government to combat political Islam did not have any obvious costs. (It is likely that Islamic activists and intellectuals did not target visual arts because artworks, unlike books, were not mass produced and thus could not have a broad influence on social

mores, and because visual artists—unlike writers—did not openly criticize or deride religion in their works.) For all these reasons, the government was able to maintain its central role in the field of artistic production well into the 1990s. And the hegemonic process that enabled this central role consisted, once again, of a pattern of restrictions and concessions that allowed "freedom of talk." Arts interlocutors tried to make their talk have the power of speech through various position-takings vis-à-vis the new cultural policy instituted with a new culture minister.

In 1987, President Mubarak appointed Faruq Husni to head the Ministry of Culture. In his appreciation for European arts, and in his refined Italian style of dress, Husni was ostensibly no different from famed predecessors such as Tharwat 'Ukasha, minister of culture during the Nasser years. But Husni was also an abstract expressionist painter. His goal of making Egyptian visual arts recognized on an international level was also coming at a different time—one in which Nasserist socialism had lost much of its credibility, and in which neoliberal open-door trade and privatization policies were causing great unease over globalization and Western influence. The new minister was not about to make the same mistakes as were made during the Sadat era, when cultural programs were cut and Islamist groups supported. This combination ended up tarnishing Egypt's image and creating religious-based opposition to the policy of market liberalization—to which Husni, as a minister in the Mubarak government, was supposed to at least give lip service. Shortly after his appointment, then, Husni began an ambitious campaign to expand the fine arts initiatives of the Ministry of Culture in an attempt to reinvigorate the art movement. This confluence of heightened state ventures in the visual arts and a shifting political and economic climate effectively made these ventures one of the primary arenas in which battles of cultural politics were fought.

The minister spearheaded the construction of several new arts venues, revamped old ones, instigated new arts programs throughout the country, started a series of annual exhibitions (including biennials and triennials) in a variety of media, and allocated more funds for government prizes and acquisitions. By 1999, the annual budget of the National Center of Fine Arts was almost 20 million Egyptian pounds (approximately $6,000,000 at the time), and nearly 1,500 artists exhibited annually in individual and group shows in state galleries and museums, many of them newly constructed.[15] During my fieldwork, two major exhibition halls, complete with auditoriums and research facilities, were constructed in Cairo alone: a new Palace of Arts (the old one taken by

Sadat now served as the offices of the National Center); and the Gezira Center for the Arts. Planning and construction had begun on several other major museums, some of which were to house fine art. In Cairo and in other parts of the country, small art centers were built and annual arts festivals, workshops, and symposia were established. Additionally, the international Cairo and Alexandria biennials grew in both size and fame as the ministry invited prominent curators from all over the world to participate on selection committees. Meanwhile, the artist's union (which depended on the state for a portion of its funds) was expanding its member benefits. These included retirement pay, health insurance discounts, and apartments for sale at reduced prices. In 2000, the National Center of Fine Arts was renamed the Fine Arts Sector, which gave it greater structural prominence within the ministry and highlighted the centrality of the visual arts to the new cultural policy.[16]

On the tenth anniversary of Husni's tenure, the ministry published a lavish catalogue replete with pictures and descriptions of the various institutions and projects built from 1987 to 1997. Entitled *Culture: A Light Shining on the Face of the Nation*, the catalogue contains an essay by the minister in which he outlines the cultural policy behind these initiatives. It is worth excerpting at some length, because it reveals how state actors proclaim the role of the state in cultural affairs, how they "prove" that the state is good for art, and how they imagine the role of Egypt internationally. It also shows the shrewd way in which the ministry wove together the ideologies of Nasser and Sadat to create a new vision of cultural policy. The post-1987 Ministry of Culture retained some socialist-oriented goals, but also made culture a virtual handmaiden of the resurgent open-door economic policy. The vision of this new cultural policy was based on several basic factors, listed in the book as:

1. The cultural riches enjoyed by Egypt among the countries of the world;
2. The Egyptian role . . . which is a leadership role that Egypt has captured from a number of sources: history, geography, people;
3. Cultural democracy: one of the main achievements for culture in the era of President Husni Mubarak . . . ;
4. Culture and society: cultural policy will not reap its fruits unless we participate together—intellectuals and cultural institutions—in assuring [our] belonging to the nation, and in [working towards] complete development . . . ;
5. The youth: they are the real soldiers of the cultural battleground. They possess the present and they are also those capable of creating the future.

These factors represent important aspects of the modern available for articulations of state policy. First is the idea that Egypt has a unique, historically constituted character that makes it a leader among nations. The goal of cultural policy, which artists also articulated, was to develop contemporary Egyptian art so that it lived up to this grandeur, and so that the rest of the world recognized it. The focus on the youth as a barometer of the art movement and its future became a hallmark of Husni's tenure, and a gauge by which artists claimed their own authenticity. Finally, the factor of cultural democracy was a claim repeated endlessly by higher-ups in the government arts administration, particularly when they gave small opportunities or platforms to those who opposed mainstream cultural policy.

After stating these factors on which cultural policy is based, the minister then outlined its specific goals, which are again worth excerpting in detail, for they show even more clearly the way that cultural policy was being reformulated:

1. Innovation and creation;
2. Non-centralization: Egypt has always suffered from the centralization of cultural work in the capital, to the extent that it did not reach the cities or villages;
3. Funding: This is the principal obstacle that any cultural work faces, especially in difficult economic times. Therefore, it is necessary to search for creative means of funding through cooperation with capitalists and national institutions;
4. Developing cultural and other sanctuaries in order to return to Egypt its creative vitality and to form a wall that will be the first [line of] resistance to any cultural threat that targets our youth and future;
5. Interaction: with the cultures of the world through cultural exchange and effective participation in international events and cultural opening [*infitah thaqafi*] onto the world, and to place Egypt in its pioneering place, both culturally and civilizationally.

Here we see the presentation of more "proof" that the new Ministry of Culture will continue in its socialist mission to modernize and democratically distribute the arts. Point 3 represents a shift: it attempts to link the cultural policies of Nasser and Sadat, arguing that both capitalists and the nation-state should support art. Point 4 could be read as a reference to the threat of Westernization, a threat prominently discussed in intellectual circles and the national media in the 1990s, and the main concern of *asala*-oriented artists. Here, art is

positioned as akin to the sanctuary of spiritual authenticity that Partha Chat-terjee suggests is characteristic of anti-colonial nationalisms (1993). Or, point 4 could refer to the threat of political Islam, which worried artists and the gov-ernment alike. There was particular concern that young people would turn to political Islam, as they were doing elsewhere in the Middle East. As I discuss further below, in Egyptians' discussions of cultural threats more generally, youth were seen as particularly vulnerable, and that is partly why they became an important "object" of cultural policy.[7] Point 5 takes Sadat and Mubarak's open-door economic policy and enshrines it in cultural policy. Using the same word that characterized the economy of the 1970s, *infitah* ("opening up"), the ministry here argues that "culture" should also be open; but in point 4, it is to be protected by a wall. The ancient glory of Egypt, so prominent in modern nationalist discourses and in the ideology of *asala* artists, is evoked as well. The next few paragraphs after these points (not cited earlier) are straight out of socialist cultural policy, because they discuss the importance of spreading "cultural awareness" to the masses so that they may "develop."

There are two important points to these "goals." First, they emphasize in-novation, creativity, opening, and democracy. This is the kind of rhetoric that still dominates U.S. foreign policy discourse about Egypt (and the Middle East more generally), and it is the rhetoric of neoliberal capitalism. Here we see a real shift in how Egyptian cultural policy is conceived and presented such that it aligned with what international donors were pushing for in the economic sector as well. I do not think it is too much of a stretch to say that in this formulation, young artists are targeted as a medium of social and eco-nomic liberalization. In the upcoming discussion of the Ministry of Culture's Young Artists' Salon, we shall see how these artists were often positioned as the ideal neoliberal subjects.

The second point about the goals listed in this publication is that they speak to ministry supporters *and* detractors. For the most part, artists saw most, if not all, of these points as very important. But many said that there was a gap between such proclamations and what the government actually did. For *asala*-oriented artists, the government was not executing these goals in the right way. Ministry supporters agreed with the general direction of cultural policy, but said that bureaucracy and personal interests often incapacitated the government. Despite the fact that artists on both sides often saw govern-ment pronouncements as propagandistic, then, they agreed with the general message. Furthermore, at a very basic level, they were tremendously pleased

with the spate of growth in resources, institutions, and activities. It lent live-liness to their art scene that many had found absent in the 1970s and early 1980s. The plethora of exhibition openings, roundtables, workshops, and con-ferences gave arts interlocutors much-needed opportunities for dialogue and camaraderie. And, of course, the opportunities for state support were entic-ing. It should not be underestimated how much state support was coveted, and not only for the money it provided artists. (As indicated in Chapter 1, most of them were from modest backgrounds and had few other ways to make art and a living at the same time, especially given the high unemployment rate in Egypt.) Prior to the burgeoning of private sector galleries (see Chapter 6), the state galleries were seen as the premier exhibition spaces. They were large and well lit. Catalogues and invitations were paid for, and as government spaces, they provided immediate links to the state-run television and Arabic print media. Furthermore, a government nomination to represent Egypt at inter-national biennials, arts festivals, or cultural centers abroad was the only way that most artists at that time had any chance of exhibiting outside of the coun-try—especially given their limited linguistic, financial, and social resources to hold shows in private galleries abroad. In a sense, the state leveled the play-ing field, thereby satisfying at least one of the remaining socialist-tinged aims of cultural policy.

Government channels provided a way past these obstacles and others pre-sented by the exclusivity of the European gallery scene. This support was the most obvious reason for state dominance in the Egyptian art scene into the 1990s, because artists continued to look to the state to meet their most basic needs. Even when an unprecedented growth in the private sector occurred in the late 1990s, many young artists maintained their ties to the state (as pro-fessors, exhibitors, etc.) while currying favor with the new galleries. Part of the reason lay in the material resources and channels to local audiences and prestige that the state continued to offer.

But these resources were not evenly distributed. As part of a larger state apparatus built during Nasserist socialism, the Ministry of Culture was an "official" purveyor of nationalist discourse. But because this apparatus bol-stered certain ideas about national culture through the tremendous support offered by arts institutions, it also created a competitive atmosphere—one in which exclusions based on national ideology, and by extension cultural au-thenticity, had the potential to seriously inhibit or even damage artists' ca-reers. Just as arts interlocutors believed that the Egyptian government had

a duty to support and promote the arts, they also wanted it to support the "right" art. Of course, all artists believed that their work had personal integrity and cultural authenticity (however they defined that idea), and that they should therefore receive state resources and accolades. I shall now turn to the ways in which arts interlocutors expressed these desires, doing so through the structural constraints and discursive frames set by state cultural policy in the decades since independence.

THE MINISTRY OF CULTURE CREATES A "GENERATION": THE YOUNG ARTISTS' SALON

One of the new minister of culture's projects caused tremendous discord. As stated in the ministry publication cited earlier, the government was focused on the youth as "soldiers" in the "cultural battleground." In cultural policy logic, the youth represented Egypt's future. Therefore, they needed to be the object of development, and any threats to them (from the West or from Islamists) needed to be contained. The Ministry of Culture, like other branches of government, instituted programs to this end. Foremost among the ministry's activities was an annual juried competition, begun in 1989, for artists under the age of thirty-five.[18] This competition, the Salon al-Shabab, or Young Artists' Salon, produced a dynamic set of position-takings, which can be read as struggles to gain or maintain control over resources and aesthetic vision—articulated through a shared ideal of the patron state, *an ideal that was reproduced in the struggle itself.*

Every year from 1989 on, artists on the Supreme Council for Culture, in consultation with higher-ups at the National Center of Fine Arts, selected a committee of distinguished professors, art critics, and government arts leaders (the majority of them also artists). This committee judged a pool of more than 1,000 artworks of varying media, styles, and topics.[19] Selected pieces (around 200) were exhibited for one to two months at a major public gallery in Cairo. Of those works, the committee selected around 45 to receive prizes ranging from 500 to 5,000 Egyptian pounds.[20] This amount was significant to many artists struggling not only to buy apartments so that they could marry but also to dress and feed their families.

In Chapter 1, I discussed how art school pedagogy divided the art world into two primary generations—old (*kubar*) and young (*shabab*). This division was reproduced throughout the institutions of the Ministry of Culture as well, and most notably in this annual exhibit. As I shall show, this institu-

tional construction, drawing on broader social values placed on elders, had enormous consequences for the production and evaluation of art. Indeed, "generation" became a central theme in the evaluative discourses of authenticity and therefore a key gauge by which assessments of Egyptian art as a national project were made.

The vast majority of arts interlocutors I spoke with initially supported the idea of the Young Artists' Salon, and the related activities of the ministry. There was a sense that, in ancient times, Egypt had been at the pinnacle of world art, and that providing resources and encouragement to emerging artists would help create a generation that could revive this earlier grandeur. While Pharaonic art had entered the world art "canon," contemporary Egyptian art was little known. It was widely believed that expanding the art scene by building institutions, holding competitions, or starting international biennials would bring international attention to the country. It would also create the conditions for increased and better artistic production that would make the art better known and more popular at home. In sum, encouraging young artists would ensure artistic progress—a value I have discussed earlier as historically constituted through the colonial encounter. Of course, too, evidence of a vibrant young art movement also served wider political and economic agendas.

But cultural policies always unfold in specific contexts. This one was filled with artists, critics, and administrators who had different relationships to the distribution of symbolic and economic capital in the art world, and different kinds of attachments to and views of the genealogies of the modern available in postcolonial Egypt. With each year of the salon, as certain patterns in selection and prize giving began to be perceived, these different positions shaped people's position-takings towards the salon, and by extension, the ministry. In Chapter 2, I presented the aesthetic positions of Egyptian artists as generally belonging to two different groups—one that emphasized indigenous sources of authenticity (*asala*) and one that emphasized international sources of authenticity (*mu'asira*). But the latter commanded significantly more institutional power, because its proponents were closer to the dominant center of capital distribution in the art world: the state. In contrast, advocates of the *asala* position occupied a position farther from the center, although nonetheless connected to it, which was important.

Those in the highest officials at the ministry, including the minister himself, the director of the National Center of Fine Arts, and the curators of the most prominent public galleries, were all associated with the *mu'asira*

position. So were members of the Fine Arts Committee of the President's Supreme Council for Culture. These individuals were responsible for choosing who would represent Egypt abroad at various biennials, triennials, and other exhibitions coordinated between national governments. They determined who would be offered exhibitions in the state galleries. And they were responsible for forming the committees that determined whose work would be acquired by the state and selected works and prizes for the exhibitions and competitions, including the annual National Exhibition, the Spring Exhibition, and the Young Artists' Salon. They often included themselves on the committees and usually appointed artists or art professors who shared their aesthetic perspective. More often than not, committee members were well over forty-five and thus belonged to the older generation (*gil al-kubar*).

Many of these artists had spent several years in Europe—primarily in Spain, Germany, and Italy. Their sojourns often included extensive arts training in European academies. While some of their detractors had also traveled abroad, they generally had not spent a few years living or studying there. This point is important, because experience in western Europe, and especially a degree in art obtained there, gave a person significant prestige in the Egyptian art scene. These trips also gave them in-depth experience of countries and art that did not have the same anti-colonial, socialist history. It was not just the prestige itself that translated into their being offered influential positions in the ministry. For some, it was their service to Egypt in cultural centers abroad that helped them garner a coveted government appointment at home. The minister himself, for example, had been the director of the Egyptian Academy of Art in Rome.

Artists and critics associated with the *asala* perspective did not hold any of these major positions. Thus, they were nearly always excluded from the decision-making process that determined what kinds of artists and art would be most valued or consecrated by the state. Rather than deciding who would receive what exhibitions, nominations, or prizes, they hoped to be chosen. They also hoped to gain entrance to this institutional cadre, to sit on committees, or to be hired as a major curator. The higher-ups in the state did occasionally accommodate them, but only in a limited way. As I shall suggest, the sporadic committee appointments, prizes or exhibitions given to *asala*-oriented artists, in addition to their ongoing attachment to socialist ideals, were part of the long-standing process that kept the ideal of the caretaker state alive among this group especially.

Another aspect of this process—the multiple position-takings, related to the positions of artists and critics vis-à-vis resource flows—also made up the field of cultural production. *Asala*-oriented artists, effectively shut out of the upper echelons of cultural policy and arts decision-making, found that their aesthetic perspective was not receiving the state support that they thought it should. Thus, they felt that their work was wrongly devalued. Not only that, but if the kind of work that ministry committees selected for the Young Artists' Salon was any indication of what kind of art Egyptians would be producing in the future, their aesthetic perspective might potentially be obliterated, and their entire set of political and social hopes might be dashed. For them, the annual salon represented not only the future of Egyptian art but the future of the nation. Therefore, this exhibition became the main focus of their position-takings. Every September, pro-salon and anti-salon forces gelled around their respective ideologies, using discourses of national-cultural authenticity to articulate their positions and register their complaints. The question was: "Are the young artists producing work with authenticity?" Interlocutors felt that the future of Egyptian art, and by extension Egypt's future as a nation, depended on the answer to this question.

The salon rapidly developed into a major event in the art world. Many art school students and professional artists spent their summers preparing entries, and the opening night was attended by all of the important critics, members of the Supreme Council, art school deans, gallerists, television crews, and artists' families. The minister of culture usually opened the event to much fanfare. Entering artists rushed to get the catalogue and the list of selected works and winners distributed at the door and went to stand by their works and talk to viewers. Families often stood to the side, looking on admiringly. Indeed, the salon became one of the most notable events in the art world every year. In the first few years, it was widely acclaimed as a promising initiative. It seemed to many that the Egyptian art movement was finally regaining its vitality after twenty years of decline, starting in the Sadat years.

But the more established the salon became as an art event, the more it became a key "tournament of value" in which imitation, influence, Egyptianness, and Westernness became strategic markers in competitions over the "status, rank, fame, or reputation of actors" and *more important*, over "the disposition of the central tokens of value" in society (Appadurai 1986:21). Every year, when the salon opened, the same debates took over much of the arts press and private conversation among art world participants of all generations

and theoretical orientations: Do the young artists imitate the West with their abstract art and installation pieces? Have they forgotten their own cultural heritage in their eagerness to make it to the world stage? Is their work devoid of sincerity, thought, and meaning? Does it evidence a simplistic idea of what Egypt is? Is the work bold and experimental, keeping up with the latest international trends in art? Or do artists just do big installations to please the Western-oriented committee? Should young artists get more prize money and general attention than older artists? The "forms and outcomes" of these questions, and of the exhibition and prizes, were "consequential for the more mundane realities of power and value in ordinary life"—not just artists' lives, but Egyptians more generally (Appadurai 1986:21). For what was being worked out through the salon debates over who had (or should have) power and what work was (or should be) valued were visions, fears, and hopes about the future of Egypt itself.

In 1992, the Nile Gallery on the Opera House Grounds, which had housed the Young Artists' Salon since its inception, was destroyed by an earthquake, and for the next seven years, it was held in a large villa that had been converted into a set of public art galleries, the Centre for the Arts, which was long regarded as leading the internationalization of the art movement. Its curators brought European critics and curators to Egypt, organized symposia on contemporary international trends, made Egypt a member of the AICA (International Association of Art Critics), and encouraged artistic experimentation.

But others, most particularly artists of all generations advocating the *asala* perspective, were very critical of these developments. They argued that the curators of the Centre for the Arts believed that "Western art" was superior and that only by imitating it would Egyptians gain acceptance in the international art scene. They charged that the Ministry of Culture gave the best public exhibition spaces, prizes, and nominations to international biennials to artists who adopted a "Western" aesthetic. Installation art was often singled out, such as the work of Wa'il Shawqi, who took the grand prize in the 1994 salon with a mixed media installation (plate 7). Critics also railed against nonfigurative conceptual works, especially those done in materials that they would normally classify as "trash." Examples include the works of 'Aliya' al-Giridi, who was given the moniker "'Aliya' garbage" for her use of found materials (see plate 3), and the works of Ayman al-Simari, who won many salon prizes for his pieces exploring visual transformation in rural towns through the use of domestic detritus (see plate 8).

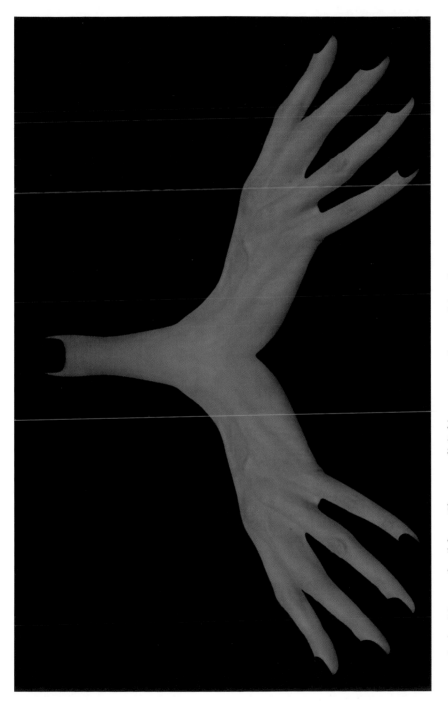

Plate 1 Amina Mansur, detail from *Chapter 15*, digital image, 2003. Courtesy of the artist.

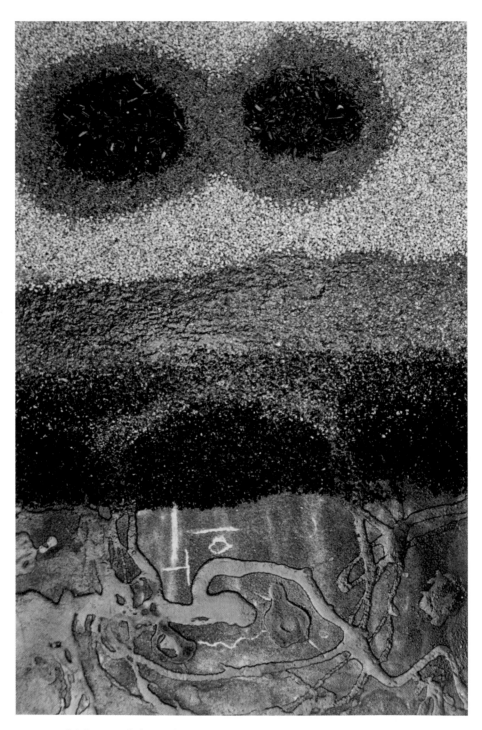

Plate 2 Muhammad al-Ginubi, spices on wood, 1999.
Courtesy of the artist.

Plate 3 'Aliya' al-Giridi, cardboard, 1994. Courtesy of the artist.

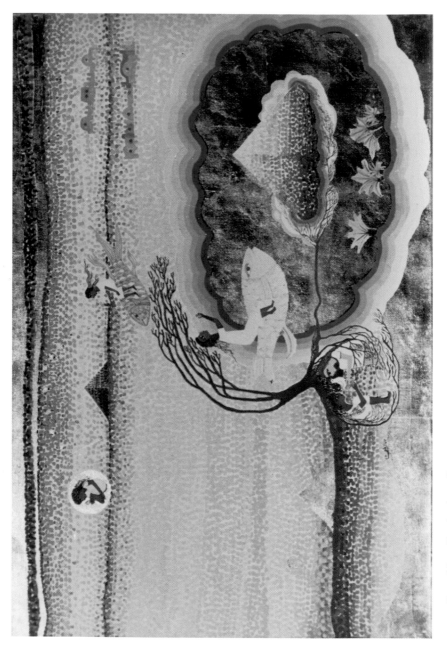

Plate 4 Gamal Lam'i, mixed media on paper, 1990. Courtesy of the artist.

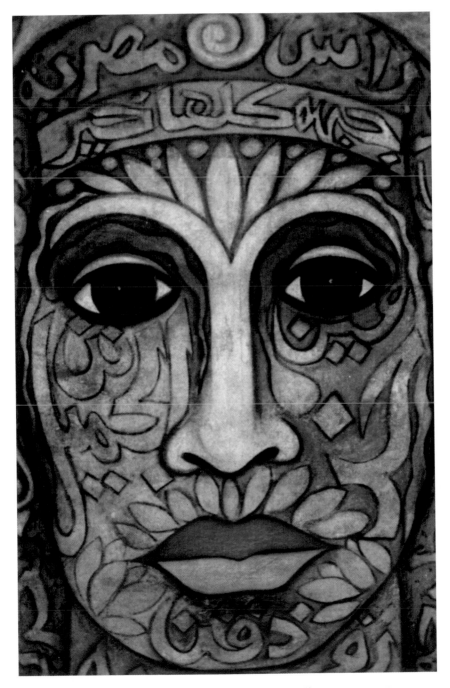

Plate 5 'Ismat Dawistashi, *Faces of the Old World* series, oil on canvas, 1998. Courtesy of the artist.

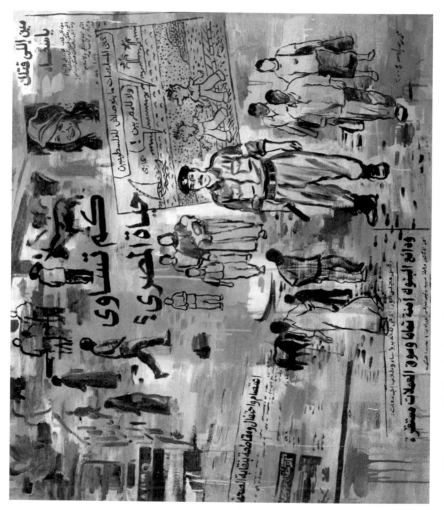

Plate 6 Muhammad 'Abla, mixed media on canvas, 2004. Courtesy of the artist.

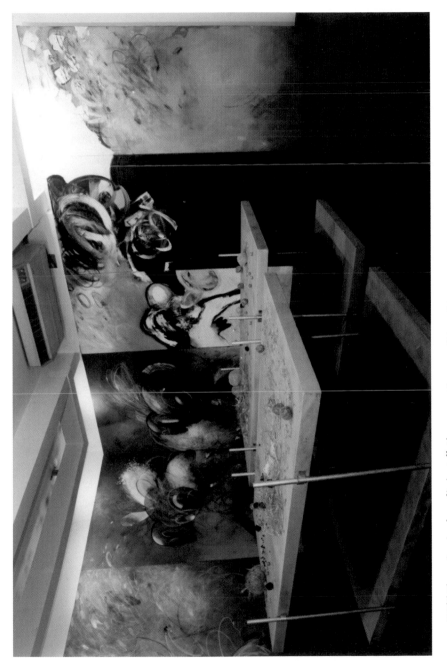

Plate 7 Wa'il Shawqi, mixed media installation, 1994. Courtesy of the artist.

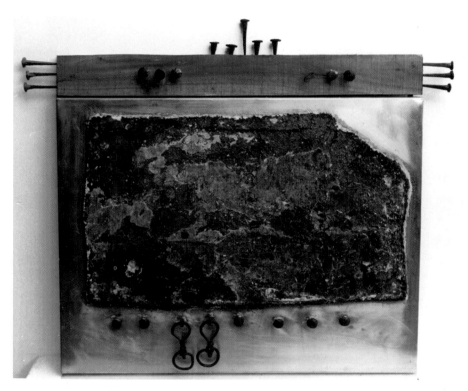

Plate 8 Ayman al-Simari, rural house remnants on aluminum, 1997.
Courtesy of the artist.

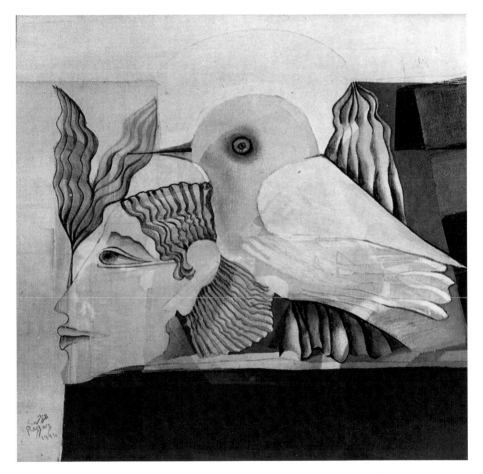

Plate 9 Mustafa al-Razzaz, *A Girl with a Horse* (detail of *The Big Bird*), oil on canvas, 1994. Courtesy of the artist.

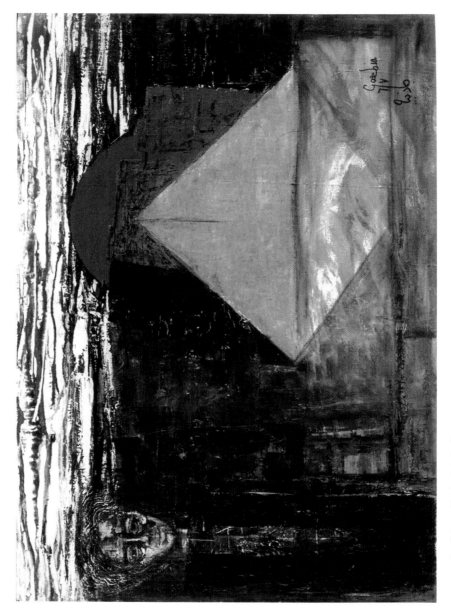

Plate 10 Gazibiyya Sirri, *Grief*, oil on canvas, 1967. Courtesy of the artist.

Plate 11 Interior of 'Abd al-Wahhab al-Misiri's home. Photograph by Muhammad 'Abd al-Ghani.

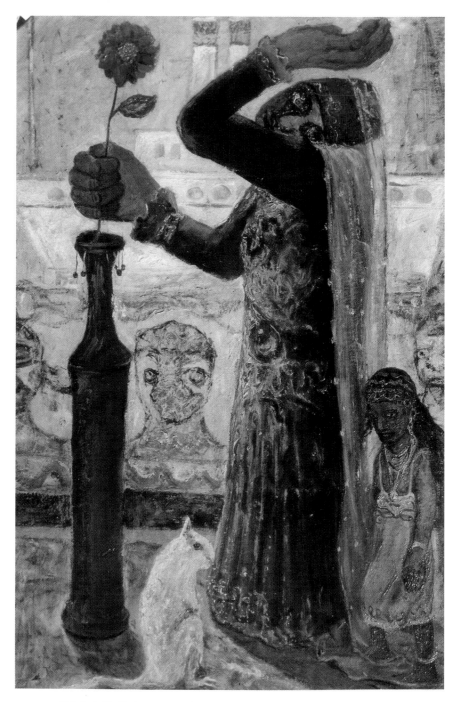

Plate 12 ʿAbd al-Hadi al-Gazzar, *The Story of Zulaykha*, oil on cardboard, 1948.
Courtesy of Laila Effat.

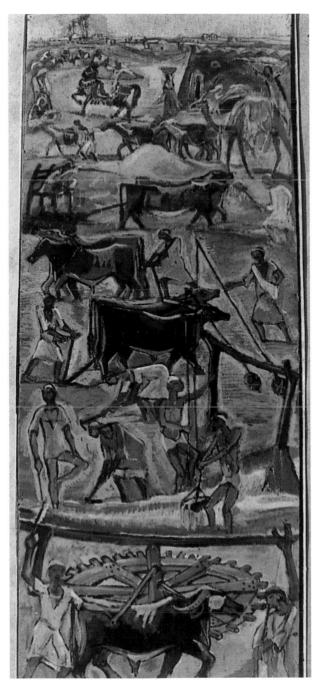

Plate 13 Raghib ʿAyad, *Agriculture*, oil on celotex, 1958.
Courtesy of the Museum of Modern Egyptian Art.

Plate 14 ʿAyda Khalil, mixed media on wood, 2004.
Courtesy of the artist.

Plate 15 Tariq Ma'mun, detail of untitled work, oil on paper, 2000.
Courtesy of the artist.

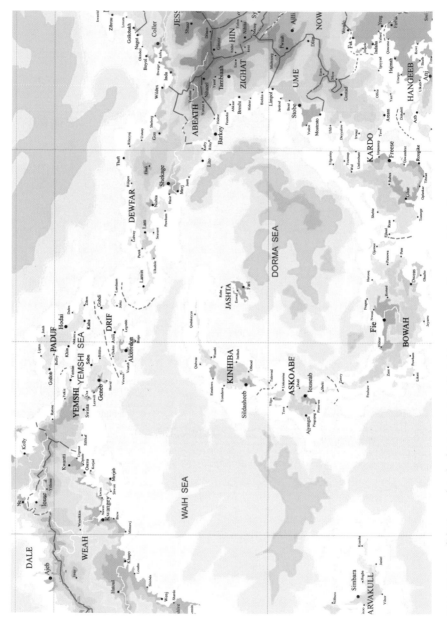

Plate 16 Hamdi 'Atiyya, detail of *Map Project*, digital image, 2004. Courtesy of the artist.

Although a different committee of fifteen judged the works in the salon each year, their appointment was said to be in the hands of the minister, whose abstract paintings *asala*-oriented critics regarded as "Western" (*gharbi*). Indeed, the minister's art was often cited in my interviews with these artists as proof that he preferred the "Western style" (*al-istayl al-gharbi*) and therefore encouraged it through the salon. Although *asala*-oriented artists appreciated the new art programs, then, they charged the minister and his colleagues with turning their back on Egyptian artistic heritage and leading the art movement down a treacherous path.

For these critics, the salon was the ultimate embodiment of what they perceived to be the misdirection of state arts administration, and the Mubarak government in general. The founder of the Asala Collective, 'Izz al-Din Nagib, articulated the problem in a way that reveals how *asala* proponents categorized certain art forms and values as belonging to Western genealogies of the modern, and other values as important to an emerging, yet historically rooted, Egyptian modern:

> I was on the committee to establish the Young Artists' Salon in 1989, which formed the foundations and philosophy of the salon. We gave the impetus to young artists to experiment in order to confirm their artistic identity through research on heritage and roots and contemporary trends at the same time.
>
> But we have to admit that these foundations were never executed. They were followed for a few years, but when the salon was transferred to the Centre for the Arts in Zamalek, it took a new direction. . . . There was no longer an adherence [to the idea of] looking at modernism through what we have in Egypt. The most important thing was to go beyond national art and search for modernity and postmodernity in the West, and any kind of innovation, and concentration on installation at the expense of other kinds of art. And the prizes were always given for these trends—either for installations or to postmodernity in the Western way. Thus young artists' attempts to give roots to Egyptian art decreased. After the salon moved to this Centre, there was more interest in choosing committee members who would go along with this direction in art.

Then, in an attempt to explain his own disfavoring, he said, "That's why I wasn't invited to serve on any committees during those years."[21] Nagib's comments should be understood in relationship to his position as an older generation artist who was rarely included in the major decisions that shaped the art movement in Egypt. Even though he was employed by the state as the director of a cultural

center, it was marginalized in ministry planning. Nagib had not attained an advanced degree abroad, and his major experience exhibiting outside of Egypt was in what were considered less prestigious places—like Yugoslavia, India, Tunisia, Kuwait, and the Emirates. Basically, the state committees did not ignore him, but rather sent him to represent Egypt in places outside of western Europe.

Another art critic repeatedly condemned what he saw as the tendency of the salon to encourage European art trends at the expense of Egyptian authenticity. In an interview, he argued that the problem rested with the art professors who had trained in Europe and had come back to teach Western art to their students. He thus tried to subvert the prestige accorded to the ministry higher-ups because of their experience in Europe:

> I'm sorry to say that, as a result, a large group of young artists continued along this path, and they aimed to figure out how they could win prizes. They took prizes because they follow these new directions in accordance with the views of some of the judges—who also studied in Europe and [this experience] is reflected in them. . . . I've written many articles about this, and some people got upset with me. . . . But in things like this you can't hide your opinion![22]

In my conversations with these older generation arts interlocutors, they often showed a range of intense emotions as they described what they thought to be the state's abdication of a whole range of responsibilities. There was a way in which their articulations were a way of making sense of the disintegration of a whole system of relationships and a political cultural ideology that, for them, was deeply linked to the history of colonialism and their coming of age in the heyday of independence.

They were particularly annoyed that there was a system of personal allegiances and relations that they were newly locked out of. One artist complained that the decision makers in the ministry were all friends and ignored those who were not in their inner circle. In a tone of deep frustration, he said that he was being pressured to imitate the West just to succeed in his career:

> JW: I remember you once criticizing the salon and the new direction of art here, and you said that the youth are losing their Egyptian identity, because there was encouragement to follow the West . . .
>
> BH: Yes, of course. I don't like to be just a chess piece. . . . I am rich with my culture, so why not feel it is part of our art history in Egypt? . . . And if I ignore it and start imitating something from France or Germany or Italy, or from the

States, it will be taking the results of their culture without understanding the process [of how they got to that point].

I feel like cultural activities are directed towards certain trends. . . . I mean art should be free from the minister's idea of culture. But the ministry owns culture. The ministry is running everything, including competitions. They set all the criteria as to what is art and what is not art, what it should be. The salon director gives prizes based on what they want.[23]

The view that the government was using prize money to entice young artists to copy Western art was articulated through accusations of inauthenticity in the press, public conferences, and endless private conversations. These evaluations, or position-takings, were couched in accusations of imitation, superficiality, immorality, and abandoning the nation. These critics were not only making a claim that their art was more "authentic" and should therefore be included as a major part of cultural policy and resource distribution. They were also calling forth a larger set of concerns about what they saw as the increasing lack of morality, sincerity, and national community in Egyptian society as it underwent economic reform.

Yet at no time did the state-run newspapers or journals stop running these critiques of the Ministry of Culture. On various public and private occasions, ministry officials said that these critics were "unaware," but they let them write anyway. I suggest that this inaction acted as a concession to their opponents, which then gave space for the continued articulation of the patron state ideal and for the reproduction of national discourses.

Some *asala*-oriented artists used age differences to lodge their complaints in another way, arguing that what was due them as members of the older generation was being wrongly given to the younger generation. The implication was that the Ministry of Culture was defying the moral social order. One older generation artist who had built his career locally revealed how generation, like discourses of authenticity, could be used to claim the right to more state resources. He focused directly on a key issue: money. He criticized the huge monetary prizes given to young artists, not based on the argument that money necessarily polluted art (Bourdieu's "economic world in reverse"), but because, he said, older artists should get more money than younger ones, and because more valuable prizes indicated higher artistic value:

Of course older artists deserve more. It's a career for them. I mean, if I'm twenty-two and I get a 15,000 pound prize, and Hussein Bikar . . . got the National

Achievement Award of 5,000 pounds, then I'd not think as highly of Bikar as I should.[24] . . . Just as [the government galleries] go out and make deals with some of the younger, practically worthless artists, they should seek the work of the older established artists as well. This is your job and your duty as an employee of the government. . . . Because what happens is that the government only exhibits the work of certain artists, certain genres and certain forms of art.

I mean, take the fact that I, for example, have not been offered 15,000 pounds for any of my paintings by the government, and you have twenty-year-olds receiving such big prizes.[25]

Such sentiments were repeated by many older generation artists, who felt that they had paid their dues only to be subsequently ignored by their generational peers at the ministry both aesthetically and monetarily. Part of their sense of having a right to these resources undoubtedly stemmed from decades of service in state institutions, in which salary and job level increase with age and experience. With the Young Artists' Salon, the ministry had unsettled the generational hierarchy of the art world. Previously, it had been inconceivable for someone to win more money or get better exposure than their teacher had. To these artists, it seemed that the entire system of state bureaucracy (built through Nasserist socialism but also shaped by pre-independence systems of patronage) was falling apart before their eyes.

In addition to resources, it was Egypt's relationship to the rest of the world that motivated many *asala* artists of different generations to criticize the salon. At a time when they saw Egypt succumbing to more Western-driven neoliberal reform, they worried about the ramifications for the culture industries. For example, one younger generation artist complained to me that most of his colleagues imitated the West. While chatting at the opening reception for an exhibition he was participating in at a private sector *asala*-focused gallery, he said that young artists should concentrate on exploring "local identity" (*hawiyya mahaliyya*) in the face of "globalization" (*al-'awlama*). He was expressing concerns found regularly in the national press over the possibility that the new influx of foreign capital would compromise Egyptians' ability to hold on to their past and determine their future. The fiery accusations that surfaced every fall during the salon should be seen in the context of larger societal debates about Egypt's changing relationship to the global economy, as catalyzed by the Mubarak government's economic "reform" program. Just as people were asking whether or not these reforms would put the Egyptian

economy at the mercy of Western-driven market forces, many artists (and not just those of the *asala* perspective) feared that they would also lose sovereignty over their art, a point I discuss at length in Chapter 6. In an article in the literary journal *Ibda'*, Nagib wrote that the Salon al-Shabab "threatened the future of the art movement by sliding in the direction of blind subordination to Western culture."[26] This threat of a new imperialism spurred artists' attempts to acquire government resources and recognition for themselves and their work, especially among those who had come of age in the Nasser era.

Nagib echoed his colleagues' view that the marginalization of the *asala* perspective extended beyond the salon in the magazine *al-Shumu'* (connected with the private sector gallery of the same name), writing: "In this ailing artistic atmosphere, and with the paucity of government support for serious artists and those who search for *asala* and identity, it has become difficult for them to find a place under the official lights. . . . They must find private or commercial galleries to show their work."[27]

Yet it is important to note here that the majority of private galleries in Egypt, al-Shumu' included, regularly exhibited artists who could not attain consistent government venues, grants, or prizes. Thus these artists' argument that they were marginalized in the art world in fact only pertained to the public sector, a point that strikingly reveals the higher value that was accorded to the state. Even though they had more private exhibition spaces willing to show their work and more private collectors willing to buy it than did artists who were favored by the government, none of this advantage could replace positive attention from the Ministry of Culture and the kind of political vision of Egypt such attention would imply. It was not just about their access to resources, then, but also about their ideal vision of the state and about the reproduction of the nation as the main frame through which art is to be understood, classified, and evaluated (cf. Brubaker 1996).

Artists and officials who bore the brunt of this criticism certainly had the upper hand. Their positions close to the distribution of various kinds of capital in the art world gave them a certain confidence that allowed them to dismiss the ideology of their detractors out of hand. They often distinguished themselves by brushing off a mention of *asala* with a sweep of the hand and a short remark like: "You know, those are just paintings of camels or peasants." Rarely was a specific artist mentioned, or differences among *asala*-oriented artists recognized. As I mentioned in Chapter 2, I was discouraged from taking these artists seriously.

In addition to what seemed to be calculated lack of interest, there were several other specific ways in which the artists who distributed or received ministry resources countered the ideology and position-takings of their critics. They used the shared value of authenticity to distinguish themselves as better artists with a more sophisticated perspective (e.g., *mu'asira*, or contemporary) to legitimize the fact that they reaped the lion's share of state resources and to argue that support of their art was better for Egypt.

Indeed, many of their defenses of the salon were cast in terms of state-led national progress—terms that appear in the ministry's book discussed earlier and that drew on the socialist orientation of art policy beginning since at least the 1950s. Along with the higher-ups in the ministry, salon supporters argued that the marginalization of trends associated with the *asala* perspective was necessary to develop contemporary Egyptian art such that it could find a place on the world stage, because *asala* art was internationally "backward." The arts committee chairman at the Supreme Council for Culture explained the rationale behind the salon as such: "Having an energetic youth movement means that the movement as a whole is progressing."[28] Supporting young artists through the annual salon was framed (to me, as an American, and to Egyptians) as good for the nation. Not supporting the salon, or insulting the young artists, was said to hold the art scene back. My point is that the framing of salon policy in nationalist terms, which were so potent for most artists, reproduced the hegemonic ideal of the state as promoter and developer of art at a discursive level.

For *mu'asira*-oriented artists, the "proof" that young artists' experimental work should be supported came in 1995, when the Ministry of Culture sent three young artists to represent Egypt at the Venice Biennale. Their installation took the prize for best country pavilion. This was the first and, to date, the only time in the history of the Biennale that a non-Western country had won the prize. That year's salon opened three months later, and the higher-ups in the government arts institutions used the occasion to defend their cultural policy. Taha Husayn, an artist of the older generation, wrote an essay for the exhibition catalogue that embodied the ways in which state committees justified their choices and marginalized their opponents, while also using a national discourse that appealed to them. Husayn's own position is important to understand the position taking in the essay. He was a prominent member of the Fine Arts Committee of the Supreme Council for Culture, which at various times appointed him commissioner for both the Cairo Biennial and the

International Ceramic Biennial in Egypt and head of the salon selection committee. He was also dean of the Faculty of Applied Arts and had spent many years living in Germany, where he had obtained a doctorate.

In the catalogue for this first salon after the Venice prize, Husayn began his essay by criticizing "the abundance of attacks" on the artistic experiments of the young artists "on the pretense of protecting traditions and heritage." In a passage that compliments the state more than the artists, he continued:

> At the same time that they were attacking the young artists and the prizes they won, and a petulant onslaught was also directed against the respectable judging committee—which was composed of artists and critics of different ages and artistic directions—the international response came. It was represented in the decision of the judging committee of the international Venice Biennale. [This decision] supported the young Egyptian fine arts movement and its creative experiments, which the state had nurtured and encouraged and provided funds for, and for which it had undertaken competitions and given large cash prizes.

Drawing on a "West above the rest" teleology of modern progress, he went on to argue that some of these critics of the salon were "still, to this day" discussing aesthetic issues that artists and critics "in the West" had surpassed, and that the kinds of aesthetic discussions that the salon committee had encouraged would not have been valued "under the shadow of [such] traditional and conservative concepts and styles." Here, Husayn uses "the West" and "the international response" to defend the government committees that judged the salon. In his formulation, the Venice committee affirmed that the Egyptian ministry had encouraged the right kind of art. The state is also given credit for building a whole generation, not just for choosing the right artists, who won the Venice prize. Finally, Husayn implies that the committee itself had members of different aesthetic positions and, indeed, one or two *asala*-oriented artists or critics were usually assigned to the committee. They never made up the majority, but it was important for this influential figure to point out that they were sometimes invited to serve. The pattern of minor concessions is emphasized once again.

In another move that worked to co-opt the opposition to the salon, Husayn concludes his essay by putting the Venice victory in a framework that emphasizes Egyptianness and heritage, saying that the installation that had won the prize "combined modern and contemporary concepts that were not just in line with the international art movement but also surpassed it

[because] the creative Egyptian carries deep heritage and fertile thought and imagination and expansive dreams for the future." Thus, he implies that the salon committee is not only able to choose artists who are really Egyptian and draw on Egypt's heritage, but that it is also able to do so in a way that looks to the future and is not backward. The ministry, then, is shown as interested in *surpassing* (not imitating) the "West"—and surpassing it through Egyptian national civilizational superiority.

This idea that *asala*-oriented artists and critics were backward was also picked up by young *mu'asira*-oriented artists to defend themselves against the vociferous attacks in the newspapers, and, by extension, to defend the cultural policy and their vision of an ideal Egypt they felt it embodied. One salon prizewinner explained that the kind of art that exhibited at the salon was poorly understood in the art criticism press, saying: "There has been a big attack on the new trends in art and, until now, I am insulted publicly in the main newspapers. We demanded to have art criticism for young artists that was more aware of their progress and their vision and the new dimensions open to them. But of course nothing happened."[29]

In this artist's view, young artists were progressive, while art critics were "unaware." Many other young artists said that they were seriously disadvantaged because they did not have open-minded art critics. The concepts of "awareness" (*wa'i*) and "understanding" (*fahm*)—key components in the constellation of authenticity discussed in Chapter 2—appeared again and again in these evaluations of critics.

Not only did young artists and their supporters among the older generation claim that they had more understanding and a consciousness able to build a great art movement as part of national progress. They also argued that they had more cultural authenticity, because they did not rely on "superficial" motifs to express Egyptian identity but rather looked around them and incorporated contemporary changes into their work. And they were doing so in a way that did not copy the West. When I asked this same artist, "If a critic told you that your work is Western and not Egyptian, what would you say?" he implied that it was not he but his critics who were not in tune with their society: "It happens a lot, and I always say, 'What is Egyptian?' What does the claim that this is not Egyptian mean?. . . . I am not copying the West, but I am part of a world that I cannot separate myself from. . . . I believe that an Egyptian artist is one that is concerned with the situation and issues of his society, and not with folk art, Islamic art, or ancient Egyptian art."[30]

The effects of various government actions and inactions seemed to contain or co-opt the opposition, whether or not concessions were actually planned.[31] This was especially the case when the gallery that had been destroyed in the earthquake was rebuilt as the Palace of the Arts in 1999 (fig. 3.2), and it was announced that the salon would be returning to its original venue, albeit with different curators.

Critics of the salon's former curators were hopeful that this would put contemporary Egyptian art back on track. Although some older *asala* artists had occasionally been appointed to the salon committee (in ratios of one to ten) in years past, that year the ministry brought several of them to serve. In addition, several of the early salon winners were also appointed to the committee, an action that helped appease some of the frustration that forty-year-old artists felt at being constantly categorized as "youth."

The result was debatable. Some viewers did not see much difference between the kinds of work selected for the 1999 salon and previous ones; others saw the difference only in the lesser degree of *mu'asira* curatorial control. And some argued that nothing had changed, with committee members still awarding prizes to their spouses or students. But Nagib and other *asala* artists saw an enormous change. In his words, we can see evidence of the hegemonic effect

Figure 3.2 The Palace of the Arts, Cairo.
Photograph by Jessica Winegar.

of this seemingly radical ministry maneuver. His extensive article in the state-sponsored journal *Ibda'* lauded the standards of judgment and the results of the 1999 salon. He claimed that the committee (on which he sat) had been able to rectify the mistakes of previous salons, in which young artists, seduced by prizes, had been "led astray . . . from their identity and authenticity." He was pleased to report that the committee had been able to bring the salon back into line with its original goals.[32]

In the example of the salon, not only do we see the perpetual small concessions that partly kept opponents looking to the state for more. We also see all parties using national authenticity as the classificatory scheme and cognitive frame (Brubaker 1996) through which art is evaluated. Even though the situation was reversed in the context of socialist Romania, where *asala*-like views dominated the state, a similar reproduction of the nation occurred there:

> Because . . . the Party leadership phrased the struggle in terms of national identity, and because of their own commitment to the national idea, [the opposition] too [were] compelled to argue their alternative values in terms of what was best for the Nation. The result was to reinforce the significance of the Nation at the center of culture, in the politics of intellectual production, and, consequently, in the discursive space of ideology and legitimation. (Verdery 1991:304)

Furthermore, those supporting the state's cultural policy made art incorporating the national ideology that served it (cf. Verdery 1991:309).

CONCLUSIONS

Some readers might be distrustful of the degree to which these artists engaged with state institutions and were committed to a socialist-inspired ideal of the state as a patron, nurturer, and protector of Egyptian arts. They might be especially committed to the ideal of autonomy, particularly when it comes to the arts, and see what I have described in this chapter as evidence of but one stage in the move towards that ideal, which, supposedly, all people involved with the arts inherently share. However, state art institutions, such as ministries of culture, are important supporters and shapers of artistic life in many formerly colonized and/or socialist countries and, indeed, in many European countries (including those visited by Egyptian artists and administrators). I know many artists in the United States who would give anything to see the budget for the National Endowment for the Arts doubled, and many intellectuals who deride Republican attacks on the NEA as plebeian.

My task has been to go beyond the assumptions that complete autonomy is a cross-cultural ideal, that these artists blindly subjected themselves to state power, or that the state controlled artistic production. Instead, I have examined how specific state actors, institutions, and practices created a system that was contradictory, exclusionary, and also productive of the nation—a system in which there was "freedom of talk" but not of "speech." Through analysis of the annual Salon al-Shabab, a tournament of value that spawned some of the most heated battles in the Egyptian art world, I have shown that cultural authenticity was not just the main ideal that guided artists as they sat in their studios making art. Along with generation, it was also the primary frame through which artists assigned artistic value, defended their own successes, explained their failures, tried to get coveted resources, assessed the current state of the Egyptian nation, and imagined its future. They did so in ways that cut across generations, even though the discourse of generations was used.

I come to the conclusion that the strategic use of discourses of authenticity ("position-takings") in battles over cultural policy, along with certain emotional attachments and political commitments, reproduced the centrality of the state in idealistic schemata about the way the arts should be in Egypt. Sociopolitical attachments and values also contributed to state power and governance itself, even as people criticized particular cultural policies. The battles within the field of artistic production that I have documented here could also "produce" or "induce" nationalism among people who were not otherwise blind patriots. The battles thus contributed to the reproduction of the nation as a "practical category, as classificatory scheme, as cognitive frame" (Brubaker 1996:16–17)—with consequences for artistic production. Moreover, battles in the field of cultural production, and everything they reproduced, eventually enabled the Ministry of Culture to assist the shift towards neoliberalism occurring in other sectors of the government and economy.

Serge Guilbault (1983), Fred Myers (2002), Katherine Verdery (1991), and Penny Von Eschen (2004) have all demonstrated the ways in which cultural policy can be made to serve different nation-states' political and economic goals, even in the case of the United States (see Guilbault and Von Eschen). The history of art policy in Egypt indicates that art has always been tied to genealogies of nationalist politics—whether it be paintings and sculptures commissioned for the "revolution," or installations chosen to show Egypt's cosmopolitan sophistication to the world and, perhaps, to create a new nonsocialist, neoliberal kind of subjectivity. The young artists who were the primary subject of the new

state projects ended up being courted by new groups of European and North American curators and critics whose arrival paralleled that of new businessmen, diplomats, and development workers. The problematic consequences of this development are discussed in Chapter 6. For the marginalized *asala* artists, the most dramatic sign of the political and economic underbelly to cultural policy came one August morning in 1999.

When I arrived at Wikalat al-Ghuri, the medieval caravansary home of the Asala Collective, for an appointment with 'Izz al-Din Nagib, I found a number of people waiting, the administrative aides running to and fro, and the telephone ringing off the hook. It was clear that something was afoot. When Nagib was finally freed up to see me, I entered his office and found him visibly upset. He apologized profusely for not being able to have our regular meeting that day, because he had just discovered that the Ministry of Culture, through its subsidiary the Supreme Council of Antiquities, had just ordered the local police unit to escort all of the employees out of the building. Operations were to be shut down and the caravansary was to be "renovated." Nagib had heard reliable rumors that "renovation" was in this case a code word for an investment project to turn the caravansary into a shopping mall.[33] He was infuriated at this turn of events, particularly because he had received assurances from the minister of culture two months earlier that the Asala Collective could stay. In what had become a classic government move, however, the threats to commercialize heritage and kick out the *asala* artists and craftspeople subsided. Nagib retired on his government pension, and the Wikalat al-Ghuri is not yet a shopping mall.

MUSTAFA AL-RAZZAZ
Book of Revelations

I HAVE SPENT many hours listening to artists complain about their colleagues in the upper echelons of the Ministry of Culture. Artists who hold prominent positions in the government arts administration are frequently criticized for bureaucratic malaise, petty corruption, and playing favorites with certain artists and artistic trends. Some have their intellectual capabilities questioned. Mustafa al-Razzaz, a major force in the government arts hierarchy, escapes this characterization. And through my discussions with him, I came to agree with my artist friends who found him much more likely than most administrators to give a thoughtful, historically grounded analysis of what "Egypt" means in contemporary art, even if it strayed a bit from the party line. And it is very notable that, despite supporting the government's internationalist trend in contemporary art, his own works are appreciated by even the most hard-core *asala* artists. Even though some younger generation artists see his work as too traditional, they will readily tell you that Razzaz (as he's known) is a "real intellectual."

I did not find Razzaz to be a particularly critical intellectual. He seems comfortable with the power he holds in the art scene. He lives in a fancy building on the Nile, in a luxuriously furnished apartment. He exhibits in some of the most elite galleries, which cater to rich collectors who are not really looking for art that challenges them. And he has never, like some artists of his generation, irritated government officials enough to be thrown off committees and the like. He remains at the center of power. But Razzaz is not arrogant. He's known for his friendliness and for being "decent" (the English word is often

used in Arabic descriptions of him). He certainly was with me, and was the most accessible top administrator I met. Razzaz is also very knowledgeable. He reads widely, has written interesting articles and books on Egyptian art, and articulately expresses his views on a wide range of political and cultural topics. He also has an impressive command of English, having earned a doctorate in the United States. He is a professor at the College of Art Education, an institution that, partly through his efforts, has produced some of the most conceptually minded young artists in Egypt (as opposed to the colleges of fine arts, which only emphasize technique and mastery of one subfield).

Razzaz was born in 1942, into a generation that came of age during the height of Nasserist socialism. It was partly through him that I learned what strong ideological commitments and attachments this experience could produce in a person. This history has given him a certain commitment to expanding art beyond elite circles. He has served as the director of the "cultural palaces" located in towns and villages across the country. He also worked hard to set up the first colleges based on a U.S. liberal arts model (*kuliat nuwuw'iyya*), which have educated young people who did not attain the scores to get into the other faculties. His background has also no doubt influenced his indictment of the Sadat years—when he says that the shift from producers to middlemen (who got very rich but bore no responsibility) ended up making cultural life "subsidiary" to the rush for money. This experience also motivated his efforts to get the government to support the arts, and young artists in particular.

I think that Razzaz's generational and personal background also influences his commitment to the use of folk imagery and themes in his work. It was through long discussions with Razzaz that I came to really respect this kind of work, which I had previously dismissed as superficial, too traditional, too trite. Through learning his personal history, I arrived at a fuller understanding of his and other artists' interest in these sources, and their projects to make something of them. Razzaz's father was the curator of manuscripts at the National Archives, and he told me with great nostalgia and excitement about how he used to go there after school. He would study and copy thousands of figures drawn on old texts dealing with witchcraft, astronomy, geometry, the animal kingdom, and so on. He also studied with two of the most prominent Egyptian artists of the time who were interested in folk art and magic: 'Iffat Nagi and her husband, Sa'd al-Khadim. He fondly recalls his yearly trips to Nubia in the 1960s with al-Khadim and the famous novelist Yahya Haqqi (known for writing about the interplay between tradition and

modernity)—trips that yielded works done by staining the canvas with paint, to give what he calls an "old" or "mystical" feeling. Razzaz speaks about these trips as contributing to his fascination, cultivated in the archives, with folk magic, imagery, and fantasy. Like many artists at the time who were commissioned by the government to go south and record Nubian life (especially folklore) before their ancestral lands were flooded by the High Dam, he was taken with, and helped to reproduce, an idealized view of the place and the people.[1]

He was also swept up in the fervor of modernization. Razzaz was keen to watch the building of the High Dam on every trip through Aswan to Nubia. He has a vivid memory of watching welders standing on scaffolding at night, and the sparks from the welding machines going on and off and illuminating the "animal-like" cranes and other machinery in a mystical way. Indeed for him, the whole experience of watching the dam being built was metaphysical. In 1966, he exhibited the Nubia works along with paintings that dealt with the dam metaphorically. In this show were the seeds of what would become his life's interest: the relationship between *turath* (heritage) and modernity. This celebration of both Nubian folklore and a major means of its destruction (the dam) reveals a significant contradiction in intellectual thought, common at the time, which Razzaz attempted to resolve by visually locating Nubia in the past and modernity in the present, thereby sidestepping the ethical issues of the effects of the dam on Nubian life. Later, he was to visually connect heritage and modernity, particularly through the idea of reinvigorating or renewing heritage for modernity.[2]

His theoretical and visual interests in heritage and modernity place him in the genealogies of both Sirri's Group of Modern Art and 'Abd al-Hadi al-Gazzar's Group of Contemporary Art (see the next two interludes), and indeed as part of a long line of Egyptian artists from the beginnings of modern art to this day. These relationships to the art of his predecessors are of the utmost importance to Razzaz, and it was partly through experiencing his work and thought that I also came to take seriously the importance of the different historical valences of the modern for artists working in Egypt, which are too often lost in Western critics' pronouncements about Egyptian art's "imitation" of European and American modernisms (quickly leading to dismissal of such work as superficial and traditional).

Razzaz gradually became more and more interested in mysticism. In the mid 1970s, perhaps as a result of the marginalization of cultural activities, which he still criticizes, he started reading heavily in Sufi literature. He became

interested in how in some forms of Egyptian Sufi thought, human characters can cross boundaries into other kingdoms, such as the animal and plant kingdoms. He found similar themes in Pharaonic religion as well, and he started to work with the idea of transformation and metamorphosis, with what is hidden and what is revealed. Working almost exclusively with the images of a girl, a horse, and a bird, he transformed them into one another. For him, these three images correspond to the human, animal, and plant kingdoms but also have symbolic weight drawn from folk mythology. This interest in the mystical, magic, legends, and Sufi philosophy was to become a lifelong obsession, and as Razzaz's work unfolds, we can see spiritual similarities to Egyptian novelist Gamal al-Ghitani's *Book of Revelations* (1990), which is metaphysical in both theme and method.

Razzaz and I share a history of sorts. He received his doctorate at SUNY Buffalo, where my mother also obtained her art degree. They did not know each other, but just thinking about another generation's set of interactions, potential and otherwise, places my own anthropological encounter with Egyptian art and artists in another kind of rooting history.

In Buffalo, Razzaz discovered an interesting confluence between the Sufi ideas of metamorphosis and transformation and the Gestalt theory of visual perception. He immediately did a series of black-and-white works on this theme (fig. D.1).

Gestalt came to influence his work quite deeply: in an installation he created for the Cairo Biennial in 1984, he worked out visually some ideas he had been discussing with an American filmmaker friend of his. I can imagine how avant-garde this project was at the time. He cut out parts of various panels and put them at particular distances from one another. From one angle, the installation looked like a square enclosing a circle; from another, it resembled a bird. He even compensated for the different perception of tone at a variety of distances. He developed these ideas further in a series of four installations that he did in the 1980s as part of the Mihwar [Axis] Group that he formed with four of his colleagues as a way to save the art movement from its progressive devaluation under free-market capitalism. Reckoning with the ideologies of individualism deriving from capitalism and Euro-American modern art, and with socialist-inspired notions of collective cooperation, they conceived of the works as experiments in the relationship between individual and collective expression. Razzaz explained that in their individual contributions, they had to account for both the perspectival, linear, and tonal relations em-

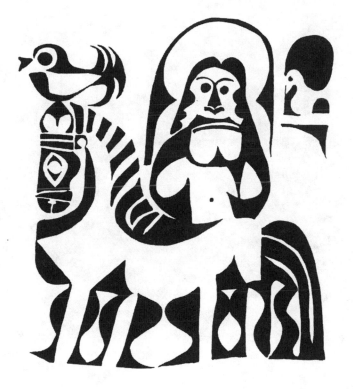

Figure D.1 Mustafa al-Razzaz, oil on canvas, 1978.
Courtesy of the artist.

ployed by other artists and the relationships between all of their own contributions as well.[3]

Perhaps as a result of his installation experiments, Razzaz's paintings have become more sculptural over the past twenty years. He has also started to explore his ideas in fairly traditional sculptural form, with varying degrees of success. He now adds other subjects, such as boats, fish, birds, and eyes. Sometimes, these new elements morph into one another; at other times, they seem to pull apart (see fig. D.2 and plate 9).

Unlike other artists who employ such motifs in their work, Razzaz does not use them to express a kind of Egyptian authenticity. He is not after "references to Egyptian identity," as he says, but rather a "sensibility"—the sensibility of someone who has spent hours at the National Archives with old Arabic manuscripts, who has studied Egyptian folk art with pioneering artists, who has read in Sufi Islam and Gestalt philosophy, who saw Nubia before it was

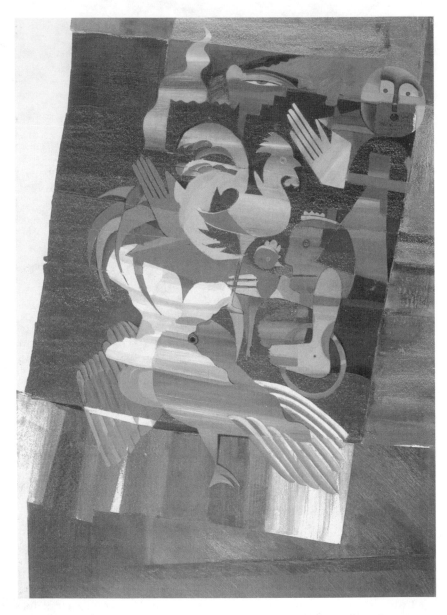

Figure D.2 Mustafa al-Razzaz, *The Golden Rooster*, oil on canvas on board, 1997.
Courtesy of the artist.

largely destroyed, and who witnessed the birth of the independent nation in his youth. Rather than trying to assert an Egyptian identity through work, he reckons with what life in post-independence Egypt, and in the United States, has presented to him.

There are many artists in Egypt (and all over the world) whose creativity is mercurial and spasmodic—moving from theme to theme, medium to medium, style to style, until they find their way. But Razzaz is the kind of artist who works deliberately, slowly making incremental changes within one theme. This may be because he is so busy, serving on selection committees of the Supreme Council for Culture and working in various capacities in university administration and teaching. It may be that institutional life suits him well as an artist who takes his time with his work. We may also see this deliberate prodding of his ideas, subjects, techniques, and styles akin to the Sufi meditation that he has studied. I would also say that this prodding is circular rather than linear, which might also explain why linear-minded Western-trained art critics might see this work as hopelessly "old-school."

Whatever the reason, Mustafa al-Razzaz will always be widely respected in Egypt as an artist and intellectual, bringing together what are usually antagonistic groups of artists and critics on the local scene. I personally thank him for showing me the importance of artists' histories and social ties, and for helping me to appreciate other reckonings with genealogies of the modern that were outside the realm of my own taste.

4 CULTIVATING CIVILIZED PUBLICS

FOR A FEW DAYS in October 1999, an unusual obelisk appeared in the middle of a major traffic circle in Cairo, not far from Liberation Square. It was quite unlike the granite obelisks inscribed with Pharaonic hieroglyphs that were taken from Egypt to adorn similar traffic circles, parks, and museums throughout Europe. This particular statue was constructed of polyester resin, and covered with reliefs of such images as the face of President Mubarak, a satellite dish, an atom, and other symbols of modernity. Then, suddenly, late one night, the obelisk was removed and replaced unceremoniously by a large plant in a shiny brass urn. The sculptor who created the obelisk was not notified prior to its removal. Later, while sitting at a café with a group of artists gossiping about the incident, another sculptor recalled that he and his friends "were driving by at about two or three o'clock in the morning. We saw a big crane pulling up what looked to be a statue or something. At the time, I had no idea what it was, but that must have been it!" He was excited to have been one of the few artists to witness the mysterious end to the sculpture that became the most embattled public art project in Cairo in some time.

Soon after its removal, word spread in the art world that the artist who had designed the obelisk belonged to the younger generation—a controversial figure who had made many public sculptures funded (lucratively, so the rumors go) by the Ministry of Culture. It seemed that everyone had an opinion about the obelisk, though many never actually saw it except in newspaper photographs.

Artists at cafés and art openings talked about it, and the weekly arts page in

the state-run newspaper ran a series of articles on the subject, using the episode to raise larger discussions about public art. The piece was even criticized on *Good Evening Egypt*, a popular television program. Most people thought that the mixture of national symbols on the obelisk was too blatant, and that the images were poorly rendered. Some critics also objected to the use of polyester resin to copy Pharaonic forms done in granite, seen as a more "noble" material. Almost no one thought it was a good piece of art. They said that it symbolized the problems of "public taste" (*al-zuq al-'amm*) and were glad it had been so quickly removed.

But the obelisk had been made to show the public the nation's achievements, and its aesthetics were intended to be celebratory. The official occasion for the commission of the obelisk was the sixth of October anniversary of the 1973 war, seen to have won back the Sinai from Israel—the most important state holiday in Egypt. This anniversary also coincided with the national holiday of the Giza governorate, where the obelisk was erected. Like previous public art, the sculpture was a symbolic mixture of various facets of contemporary Egyptian nationalism, executed through the use of forms and designs from Pharaonic art, which artists claimed as part of their national patrimony. Artists agreed and government decision-makers often said that original ancient Egyptian statuary was the most appropriate art for public spaces. As one artist declared to me, "Egypt should look like Egypt." This iconic relationship between Pharaonic art and the Egyptian nation, expressed in the choice of the obelisk to celebrate a national event, had recently appeared with greater frequency in visual culture and public space. For example, government buildings in the new "Mubarak City for Scientific and Applied Technological Research" were being designed in the shape of pyramids. This mix of Pharaonic symbolism, contemporary technology, and presidential accolade was also found on the obelisk. It drew on art trends from the Nasser period, in which symbols of technology signified a modernizing nation.[1] And it is clear that this aesthetic combination of a glorified past, hagiography of the president, and technological progress was part of the larger project of promoting secular nationalism to negate or co-opt the growing Islamic identifications of Egyptians.

There was another related set of politics behind the obelisk—the politics of what was happening at the intersection of a bloated socialist state and capitalist enterprise, and of how the kinds of patronage and corruption inherent in these systems both overlap and chafe against one another. In many ways, the obelisk

affair was symbolic of the rocky road of economic "reform" in Egypt, where ways of living in and understanding the world were turned upside down, and where the destination was unclear. The lack of clarity led to all kinds of gossip around the obelisk affair. No one knew what had really happened, in part because no one could yet accurately read the broader political and economic changes in Egyptian society, and the story was therefore subject to fabulous exaggerations (cf. J. Anderson 1996). Through these, artists launched critiques of their (potential) publics and asserted their autonomy and legitimacy to them. Such exaggerations were also an important means by which arts interlocutors commented on the shift to neoliberalism and how it was affecting artistic production and consumption, and visual culture more generally.

Made increasingly visible by the economic changes, art became a prominent public part of this shift, serving variously as the window dressing of reform, a prominent vehicle for moneymaking, and a pawn in battles for political power. It was central both to the government's cultural program to initiate and "prove" reform and to Western and Egyptian neoliberal elites' project to "develop" Egyptian culture and market it to the world.

The obelisk was erected in the same month as President Mubarak's referendum to renew his six-year tenure. Like most Egyptians, artists joked about the pretense of democracy and knew that the referendum had been engineered to pass. They were more interested in which provincial governors and cabinet ministers the president would keep in office. There was particular interest in whether or not the minister of culture would be reinstated, because he had come under fire for allegedly ignoring the preservation of antiquities and planning lavish projects like a five-star hotel in the historic Citadel area of Cairo. Writers and other intellectuals thought he gave too much preference to the visual arts, his own field. The artists I knew said that the governor of Alexandria would likely remain in office, because he had become a kind of star as a result of having given the city a "new face," in part through a number of large mosaic murals (which also included symbols of ancient Egypt and modern technology) and other works of public art. Many commentators said that this upstart governor's activities had made the other governors anxious, so the Giza governor had decided to hire a young artist to quickly create a celebratory piece of public art just in time for the holiday and elections. But these were not the heady days of earlier periods of nationalist art, motivated by anti-colonial sentiment and the dream of building the newly independent nation. Although controversies had occurred around the execution of earlier

works of public art, they had not been serious enough to cause their swift removal under cover of night.

Although the obelisk episode was over in a matter of days, its effects took on a life of their own, becoming part of already popular debates among arts interlocutors. The story was told over and over again, through jokes, rumor, and argument. The most common telling of it began with the governor of Giza summoning the favorite young artist of the Ministry of Culture, Tariq al-Kumi, who had been hired a few years earlier to do public sculptures of the renowned Egyptian music stars Muhammad 'Abd al-Wahhab and Umm Kulthum for the Opera House grounds. The governor had offered the artist anywhere from 50,000 to 500,000 Egyptian pounds (depending on the rumor).[2] It was said that this money had either come out of the budget for the Giza governorate or from private businessmen hoping to secure a quid pro quo from the governor in some other realm (probably real estate licenses). Many young artists speculated that the governor himself had received a kickback of at least half of the cost of the project. Al-Kumi was given approximately ten days to design and construct the sculpture before the elections. Unfortunately for the governor, the overwhelming criticism of the obelisk and its cost further damaged his reputation. Some said that he had had it removed to save face. Others gave the story a juicier ending: someone had called President Mubarak and informed him that the rendering of his face on the obelisk was unflattering, and that the ring of figures with their hands raised around the bottom of the obelisk looked as if they were worshipping him, which was particularly offensive, given Islamic injunctions against the worship of false gods. Hence, the statue had been promptly removed by presidential decree. Some art critics of the older generation believed that it was their persistent writings condemning the obelisk that had prompted its removal; on the arts page of the national al-Ahram newspaper the following week, a congratulatory article appeared entitled "The Power of Critical Pens." Perhaps, however, as one young artist later suggested, passersby had objected to the obelisk. Needless to say, the governor of Giza was not reinstated (though the minister was). According to the artist who made it, the obelisk had been taken somewhere near the desert on the Fayyum–Sixth of October Road, to be reerected at a later date. And he was granted another commission, this one to construct a large gateway to one of the entrances to Alexandria.

This story was not so much about a particular artist's talent or skills as it was about the ways that artists interacted with and imagined their publics in

the transformation to neoliberalism. This controversy reveals artists' ambivalent and fraught relationships with state bureaucrats, private businessmen, and the general populace, and the ways in which artists tried to carve out a sphere of relevance and legitimacy for themselves, in part through the discourses of taste—all in an atmosphere of uncertainty. By looking at how artists constructed this event as an exemplary failure of their relationship to these various publics, I seek to show here how the "ideal" public was conceived and how "ideal" relationships to it were strategized in various ways, depending on artists' different historical experiences of the contrasting regimes of Nasser and Sadat and how they reckoned with their legacies. Artists' debates over the obelisk controversy signified their various attempts, largely distinguished by generation, to define themselves as the legitimate arbiters and distributors of taste and "culture" in society. Their key arguments drew on popular topics much discussed in the art press, in public conferences, in studios and coffee shops. These included: public taste (al-dhawq al-'amm); aesthetic appreciation (al-tadhawwuq); visual pollution (al-talawwuth al-basari); the importance of awareness (wa'i); the meaning of "culture" (thaqafa); the role of the state in contracting works of public art; the role of private sector business in supporting public art; and the importance of recognizing artists as cultural authorities and specialists (mutakhassisun).[3]

As arts interlocutors positioned themselves in the debates by discoursing on these topics, different ideas about their relationship to their publics emerged among them. These differences signal a shift over the past fifty years that, I suggest, is largely explainable by the fact that the older and younger generations of artists began their careers in very different political and economic circumstances, with different relationships to genealogies of the modern. The older generation came of age when Nasserist socialist ideology and its accompanying modernization rhetoric dominated political discourse and much economic activity, whereas the younger artists were most affected by the market liberalization, new wealth, and conspicuous consumerism that dominated social life under Sadat. Karl Mannheim's seminal theory of generational differences in "certain definite modes of behaviour, feeling and thought" (especially political consciousness) as emerging from formative experiences (Mannheim 1952) helps to explain why the artists generally under the age of forty, whom I discuss in this chapter, constructed new images of the relationship between themselves, the state, businessmen, and the general population through generation-specific articulations of what modern art should or could

do. This construction did not have the force of ideology yet, and it was thus more a "structure of feeling" (Williams 1977) that was emerging with neo-liberalism. It was a "particular quality of social experience and relationship, historically distinct from other particular qualities, which [gave] the sense of a generation or of a period" (Williams 1977:131).

Attention to generation reveals that the role of artists in society was always defined and redefined, asserted and legitimated, depending on political and economic changes and different generations' experiences of them. Put another way, artists' delineations of their social roles was part of their reckoning with the possibilities put forth by different genealogies of the modern produced under socialism and neoliberal capitalism. Artists' fraught relationship with their (imagined) publics stemmed from the problem of how to read the trans-formation from socialism in relationship to these genealogical trajectories.

Their fraught relationship was also related to their position in what Pierre Bourdieu calls the "dominated dominant" section of the field of power in society. In general, artists were economically and politically dominated by those in other sectors of the field of power, especially businessmen and politi-cal elites. The field of cultural production, then, was marked by struggles for legitimation and attempts to keep in check the economic and political val-ues or principles that characterized the other dominant sections of society. Bourdieu has written at length about these struggles in the French field of cultural production (see, e.g., Bourdieu 1993).[4] But Egypt is another cultural, political, and economic context, where the field of artistic production was pro-duced through colonialism and socialism, where the position of the artist did not develop in complete opposition to the market or state bureaucracy, and where the relationship between cultural and economic capital was not neces-sarily the fundamental opposition that structured all conflict in society. If we also take actors' agency into greater account than does Bourdieu, we see that such a field did not necessarily have inherent laws or mechanisms that pushed it towards autonomy. It was not just that people acted according to their own interests and sought legitimacy outside the field, which then compromised its autonomy (a phenomenon Bourdieu acknowledges). It was also that from the early 1900s until the time of my fieldwork, Egyptian arts interlocutors con-structed the field as autonomous only in certain ways and only in certain cir-cumstances. As I have suggested in Chapters 1 and 3, the model of artistic pro-duction around which the field was reproduced usually allowed for artists to acquire economic and political capital. Such capital actually enhanced artists'

reputations, as long as it is was seen to come on their own terms, and not those of nonartist businessmen or nonartist state actors who, it was claimed, do not understand matters of art and culture.

The obelisk episode is a particularly rich example of how artists struggled for autonomy, but not necessarily for a completely autonomous field of artistic production. They sought to be respected (not dominated) by the economic and political elites, and to make art that would not be overdetermined by money or politics but in a definite positive relationship to these things. These were context-specific struggles for relative autonomy, then, shaped by different generational experiences of particular post-independence political and economic circumstances, and visions of the modern. At the very least, they should alert us to the problem of assuming that there is an independent engine of autonomy operative in all art worlds, specifically in cases like this one, where artists actively tried to resolve the European modernist tension between art and money or politics. Furthermore, assumptions about the drive to autonomy run the risk of confirming certain teleological notions of progress regarding the art of non-Western people (e.g., that their art world has not evolved enough yet to become completely autonomous).

George Marcus (1995) and Andrew Ross (1989) both argue that the anxious pursuit and defense of highbrow taste reveals middlebrow origins. Indeed, the preoccupation with matters of taste in the obelisk controversy seems to have arisen from a combination of artists' dominated position in the field of power, and from their backgrounds as sons and daughters of the petite bourgeoisie. Unlike literati of aristocratic origins, the majority of Egyptian artists did not inherit their cultural capital; it had to be acquired through formal education (see Chapter 1). Furthermore, artists did not fit society's literary definition of the "intellectual" as someone "with culture" (*muthaqqaf*), which connotes expertise in reading and writing. I suggest that this dually ambivalent position continually led them to engage in defenses of themselves as cultural elites by creating a new field for their knowledge and expertise known as "visual culture" (*al-thaqafa al-basariyya*). The specific ways in which middling origins were transferred into constructions of cultivated taste in Egypt reveals an added anxiety shaped by the history of anti-colonial intellectual nationalism. Artists sought to create a new highbrow artistic taste that was not aristocratic (a leftover from the colonial era) and that did not completely alienate the general population (a goal of Nasserist socialism)—but at the same time was not contaminated by their popular taste. To achieve this particular elitist-

populist modern, they engaged in strategies of "containment" of the lowbrow and especially of the middlebrow (cf. Ross 1989). The obsession with "public taste" in and beyond the obelisk controversy reveals the middlebrow source of artists' claims to high culture, in that many artists used discourses of taste to distinguish themselves from those of similar economic origins. In these ways, the obelisk affair represented one of many attempts to construct and police the boundaries of art and taste, thereby placing certain aspects of visual and material life into a "hierarchy of value" that objectifies a hierarchy of social groups and persons (see Bourdieu 1984; Clifford 1988; Myers 2002). It was one of the main exercises of power in which artists engaged, and was in large part shaped by their own ambivalent position on the margins of the petite bourgeoisie and intellectual life, and by their subordination to economic and political elites.

The obelisk and other public art initiatives were attempts to cultivate a public from a population that had little knowledge of or interest in art. Nowhere was this more evident than in the discussions of "enculturation" (*tathqif*, also meaning "cultivation"). Bringing culture to the people, or making them "become cultured," had been a prerogative of the government and of intellectuals since the Nasser years (and even to some extent before). As Lila Abu-Lughod has convincingly shown for the world of Egyptian television, intellectuals frequently cast their culture projects in a pedagogical framework, and such a framing contributes to elite domination more generally (2005; cf. E. Smith 2006).[5] Here and in Chapter 5, on collectors, I discuss how the construction of a "public" with no taste or culture gives shape to and justifies the activities of art producers and consumers. I comment on the consequences of this construction in my remarks concluding the book.

By lamenting the poor taste of businessmen or government bureaucrats, but especially peasants, or the urban lower classes, artists could assert their own legitimacy. If these other groups were made to recognize the need for "culture" and "art," then more artists would be employed and the basis of their legitimation (knowledge of "visual culture") would be enhanced. If bad taste could be contained, then artists would be distinguished and their field of cultural production would attain the kind of autonomy they wished for. Thus, in their attempts to silence and distance these other voices and their aesthetics, artists tried to open up a space for themselves to colonize in which they could claim superiority (cf. Verdery 1991:57–58). As I shall show, this process became especially clear in the construction of a need for "specialists." This

production of specialists, as Bourdieu has suggested, "satisf[ies] their group interests by deploying the legitimate culture with which they have been endowed by the education system to win the acquiescence of the classes excluded from legitimate culture, in producing the need for and the rarity of their class culture" (1984:153). For decades, artists had struggled to be recognized as specialists, and indeed to be recognized at all.

THE HISTORICAL RELATIONSHIP BETWEEN EGYPTIAN ARTISTS AND THEIR PUBLICS

The Nasser and Sadat periods were central to shaping how different generations of Egyptian artists viewed their relationship to the state, the private sector, and the general population. This centrality was immediately visible in the historical narratives I collected, which were usually divided into four parts: before the 1952 revolution; the Nasser years; the 1970s under Sadat and the 1980s under Mubarak; and 1989 until the present, a period defined for Egyptian art by the tenure of Minister of Culture Faruq Husni. These narratives especially illustrate how Nasserist cultural policy continued to influence how artists conceived of their roles in Egyptian society and in the nation, just as it influenced how prestige and other resources were distributed (see Chapter 3).

Many artists said that prior to independence in 1952, most of the "intellectuals" or those who "had culture" (muthaqqafin) were from the upper classes. Unlike the "masses" (al-gamahir, al-sha'b), these elites had access to and appreciation of the fine arts. Artists saw their predecessors in this period as creating works that celebrated Egypt and its people, particularly peasants or the "popular" (sha'bi) classes, but they mostly argued that modern art never reached the broader population—in large part because of its colonial-era elitism.

In contrast, the vast majority of artists usually characterized the Nasser years (1954–70) as the pinnacle of artists' effectiveness and their status within society. They said that during that period, artists were becoming increasingly interested in social issues and in reaching their society through new kinds of modernism that "reintegrated" art into life (cf. Bürger 1984).[6] Furthermore, in their view, the general population was becoming more knowledgeable about art. Artists between the ages of 40 and 65, many of whom would never have received their degrees had it not been for Nasser's free education reforms, were particularly inclined to extol this period. This was not only because these reforms afforded them opportunities previously reserved to the aristocracy, and not only because Nasser built many art institutions that then employed them,

along with an increasing number of arts graduates. The widespread praise of this period during my fieldwork reflected a renaissance of Nasser nostalgia among large numbers of educated Egyptians dissatisfied with free market reforms. This nostalgia also elided the repressive and decidedly unsocialist aspects of Nasser's rule (see Gordon 2000).[7]

Indeed, artists credited the education reforms, along with the development of state-sponsored art programs and television coverage, with developing awareness and appreciation of the arts among the middle and lower classes during that period. Whether or not they had been alive during the Nasser years or were old enough to remember them, artists often talked about the days when working-class men (sometimes their fathers) could afford to take their families to the theater or the opera, and when artists like Salah Tahir became household names. For example, one painter who had received an annual state grant first instituted in the Nasser period (*minhat al-tafarrugh*) that had allowed him to take time off from his work at an iron and steel factory to do art, talked at length about this democratization of culture. Joking about the abysmal state of the arts in Egyptian society, he told me: "My co-workers at the factory used to ask me to do paintings for them as wedding presents to decorate their new apartments. It was just a very regular thing. It was well known that you have a painting of fruit in the dining room, a painting of a nude in the bedroom. Now no guys at the factory ask me for those things."

Thus, the ideology of "cultivation" or "enculturation" (*tathqif*) of the masses that artists expounded in the late 1990s was narratively linked to the Nasserist period.[8] In the 1960s, the Ministry of Culture initiated a "mass culture" division, whose goals were both to employ artists and to spread cultural awareness and knowledge of art to the masses through cultural centers throughout the country (Iskandar et al. 1991:161–63). Some artists reminisced about this program or about their employment at these centers.[9]

In their narratives, visual artists, like many Egyptian novelists, poets, playwrights, and musicians, often portrayed the 1970s in stark contrast to the Nasser years. That decade was seen as the beginning of a decline in "public taste" that continues to this day.[10] Artists often blamed President Sadat's open-door trade policy and rapprochement with the United States for enticing the public away from cultural activities and towards consumerism. Moreover, in tandem with Egyptians' loss of interest in art, artists had become less interested in social issues, according to Ahmad Mahmud, a painter of the younger generation. The critic 'Izz al-Din Nagib (on the opposite side of the aesthetic

spectrum from Mahmud) has written that the increased interest in social is-
sues like poverty and oppression during the revolutionary years had begun to
fade even in the mid 1960s, because artists were falsely convinced that the rev-
olution was on its way to success (Nagib 1997). Furthermore, Egypt's shocking
defeat by Israel in 1967 was understood by many as a failure of the socialist
experiment, which caused artists to seek artistic inspiration outside political
ideology or national culture. For visual artists in particular, the 1970s repre-
sented a particularly painful period, when the arts had also been marginal-
ized by dwindling state support. As will become clear, older artists were more
nostalgic than their protégés about the "old days" when ordinary people were
supposedly interested in buying paintings for their living rooms. They aimed
to erase what they saw as the negative effects of Sadat's open-door capital-
ism on cultural life and to reinvigorate ideologies from the Nasser years. In
contrast, younger generation artists who had come of age during the 1970s
saw themselves as caught up in a general, and likely irreversible, decline and
malaise in artistic and cultural "awareness." Both groups, however, preferred
the Nasserist model of state support and encouragement for public art and
public art programs, as long as the government did not completely dictate the
form of the art.

Thus it came to be that by the turn of the twenty-first century, artists pos-
sessed historically constituted (but often generationally different) ideas of the
relationships between artists and the state, private business, and the general
population. In general, they were pleased with some of the changes under
Mubarak, especially the increase in funds for the Ministry of Culture and the
massive public outreach and art support programs. Indeed, it seemed that the
government was providing more opportunities for public art contracts than
at any time since the Nasser years. First, the governor of Aswan started spon-
soring the international granite symposium and purchasing statues made
there for the city's parks. The governorate of Port Said commissioned several
works, the governor of Alexandria embarked on his massive renewal of that
city, and the governor of Giza followed suit. Meanwhile the Ministry of Cul-
ture and the National Center of Fine Arts were sponsoring large numbers of
new projects.

The brief economic boom of the mid 1990s also improved artists' outlook
on their relationship with private business. Many became optimistic that they
could combine leftist-nationalist principles with capitalist gain. Artists were
hired to decorate new shopping centers, hotels, tourist villages, and amuse-

ment parks. Their art and their decorating skills were also sought after by the new and "renewly" wealthy for their new luxury homes.[11] Companies began to hold competitions, complete with large cash prizes, for the best advertising designs or for public art to decorate their new or expanding offices. They even began to team up with the government and helped to sponsor certain projects, including exhibitions in government art centers.

As a result of these changes in both the public and private sectors, artists at the time of my fieldwork thought of their situation vis-à-vis society as improving, with more demand for their work and more arts institutions in which to exhibit. Young artists were particularly happy about the growing number of private sector galleries catering to their work. And the arts were slightly more visible in the public media. A full page on the visual arts began to appear weekly in *al-Ahram* in 1996. Yet despite all of these changes, artists still argued that they had no substantial audience for their work. They thought that their roles in the state and in business were not being realized to their full potential or were being controlled by economic or political interests not of their own making. They also warned that economic "reform" could lead to an uncontrolled explosion of distasteful visual culture. The obelisk incident exemplified this predicament and the ways in which different generations sought to resolve it.

GIL AL-KUBAR: THE OLDER GENERATION AND THEIR "PUBLICS"

Immediately after it was erected, several prominent older generation art critics vociferously attacked the obelisk in the national papers. Their attacks on the young artist who had made it demonstrate the negative side of the generational hierarchy, and also a vision for fixing the "problems" of public taste in Egypt. The numerous aesthetic criticisms often focused on how far Tariq al-Kumi's obelisk had strayed from the ancient Egyptian originals. The obvious nationalist symbols emblazoned on the obelisk were seen as vulgar compared to the noble national history represented by Pharaonic obelisks. An article on the *al-Ahram* arts page criticized the obelisk for "weak design" that did not "rise to the level" of the event that it represented (the October 1973 War, in which many older artists had fought) or to the level of the Pharaonic sculptures it had "supposedly" been inspired by. The writer focused on the rendering of the president's face, saying that the artist was guilty of "naïveté" and "weakness."[12] The same day, the critic Ahmad Fu'ad Salim appeared on the popular talk show *Good Evening Egypt* calling for the obelisk's immediate

removal on the basis that it was "an insult to Egyptian civilization and an insult to the Egyptian obelisk." He went on to discuss the need for better public sculpture to beautify Cairo's prominent streets.

The nationalist tenor in the older generations' critique of the obelisk was obvious. Just as Salim termed the obelisk an insult to Egypt, a journalist in *al-Ahram* called it "deformed" and an "affront" to the country, to art, and to the taste of the Egyptian people. This critic argued that art makes society civilized (*mutahaddir*) and that the poor quality of the obelisk raised the issue of how art could better elevate the taste and aesthetic appreciation of the masses (*tadhawwuq al-gamahir*).[13]

Indeed, the obelisk controversy was not merely the story of a criticized work of art. It became part of a larger set of debates about the decline in public taste and the role of artists in either contributing to or potentially reversing that decline. Such debates had taken center stage at a major conference held by the Syndicate of Plastic Artists just six months earlier, in April 1999, and at the National Exhibition held one month after the obelisk affair, in November 1999. Articles on public taste also appeared with more frequency in the popular press and in the intellectual weekly *Akhbar al-Adab* after the obelisk incident, which galvanized already intense discussions on public taste and the role of artists and art in society.

I first became aware of the relationship between the obsession with public taste and its connection to political and economic changes when I attended the syndicate's conference. The great majority of the speakers and most of the audience were over fifty. Many of them held distinguished positions in the National Center of Fine Arts of the Ministry of Culture, were full professors in the arts faculties, or were the major art critics in the country. This conference was only the second in the twenty-three-year history of the union. The first was held in 1989, and the special magazine printed about that conference indicates that the syndicate was just beginning to think about the role of the arts in society and how it could act as a representative body to increase that role. At that time, a major panel discussion was titled "The Responsibility of Connecting Art to Society: Between the Artist, the State, and the Syndicate."

By 1999, both the syndicate and the National Center of Fine Arts had more than doubled in size. Yet artists still felt that they, their work, and art in general were underappreciated in society at large. They also saw the increasing problems in their visual environment as a result both of the public's igno-

rance of art and of their own powerlessness to do anything about the changes that accompanied rapid urbanization, population growth, and economic liberalization. Thus, by the time the syndicate convened its second conference in April 1999, the role of the arts in correcting bad public taste became an even more pressing topic than it had been twenty-five years earlier. All seven sessions explored a particular aspect of art in Egyptian society, such as the importance of cultivating audiences and collectors, the responsibilities of art education, and the goal of establishing a cultural policy of beautification for urban areas. In fact, the last issue had its own special session, and the heated discussion that came out of it bled into other sessions. The official topic was "Reviving the Architectural Beautification Law and Methods of Its Enforcement." This law had been passed under Nasser in 1960 and required that 2 percent of the total expenses of any architectural project be spent on its beautification and surrounding public art. The law, however, had never been adequately enforced. The session was convened to address this particular problem but ended up debating the larger issue of the relationship between artists and the general population and the role that the state and private business could play therein.

The keynote speaker, Ahmad Nawwar, then director of the National Center of Fine Arts, began by expressing his criticism of the current state of affairs by drawing on the same nation-based discourse that would become important in the obelisk affair six months later: he lauded the ancient Egyptians for their aesthetic achievements in the field of architecture and said that contemporary Egyptians had lost that special "sense" (*hiss*). He talked about the new "degree of ugliness" in an urban architecture that had strayed from artistic principles and values. Nawwar then warned that the problem was even spreading to village Egypt: "The beautiful, simple villages that were built with mud brick have been polluted by [the use of] cement and red bricks."[14]

Following Nawwar's speech, *al-Ahram* art critic Nagwa al-'Ashary gave a laundry list of urban problems that she said needed the attention of the government, in addition to enforcement of the beautification law. People constructed buildings according to their own taste, without regard to other considerations, she said, and two major traffic arteries in Cairo—Liberation Square and Pyramids Road—lacked coherent design. She implored the government to take responsibility.

In response, Nawwar exonerated the government arts sector, saying that solving these problems was the responsibility, not only of architects, but of the

society as a whole: "The issue is an issue of the people [*al-sha'b*]. It is not easy. To develop anything requires the awareness and the culture of the society. We cannot forget that the culture of the society has an effect on the building of society. As artists, we want to do something, and the society is against it. So what do we do? There has to be a raising of awareness [*taw'iya*]." Employing the older generation's common tactic of comparing Egypt with Western countries, Nawwar then contrasted Egypt with Spain, giving several examples of Spanish cities, where, he asserted, aesthetics laws were enforced. His call for Egypt to follow the European model was subsequently echoed by his predecessor at the National Center of Fine Arts, Mustafa 'Abd al-Mu'ti, who noted, among many examples, that residents of Rome could not paint their houses without official permission.

Civilizing discourses and comparisons with the West were also very popular in the arts press, where most of the writers were from the older generation, and they appeared with even greater frequency after the obelisk affair. For example, two weeks after the sculpture was removed, an article on the scandal began with the declaration that "a people that practices art and has aesthetic appreciation for it is a civilized people."[15] A later editorial in the same paper argued that Egyptians were an artistic people by nature, given their Pharaonic history. The author asked how the contemporary "grandsons" of the Pharaohs could neglect this history and neither "know anything about art" nor "appreciate it." He asked how a people with this history could turn the streets into a "carnival" filled with "tasteless advertisements" and "garbage."[16] Critics proposed art as the "cure" for such urban problems of public taste: "Public works of art play a strong role in elevating the aesthetic taste of the millions that see them generation after generation. Everywhere in Cairo, we find much neglect of the public work of art," one writer in *al-Ahram* declared.[17] "In order to develop a love of beauty and aesthetic appreciation among our people, we must recognize the important role that art galleries can play in elevating the appreciation of beauty among them," another added.[18]

At a major conference held at Cairo's College of Art Education that same year, participants also stressed the importance of art education in raising the taste and culture of ordinary Egyptians so that they could be full national citizens. Such pronouncements made strategic use of elitism, Western teleological modernism, and populist nationalism to advocate for a special role for the arts in society.

As I have made clear, there were several major themes that emerged in the

obelisk affair that were repeated frequently by older generation artists in other contexts: visual pollution, awareness, culture, Egypt's history versus its contemporary situation, and the West as a model. These themes suggest significant ways in which older generation artists conceptualized society and their relationship to it. Their ideas and claims about the role of the state, and their roles within the state, were necessarily embedded in this conceptualization, in which artists blamed "the masses" for bad taste and claimed that they, as intellectual specialists in "visual culture," could uplift them.

"Visual pollution" (al-talawwuth al-basari) was the key term favored by older generation artists to describe the low- and middlebrow taste they sought to contain and overcome. Seeking to create a legitimate role for themselves, these artists argued that just as politicians and the public were starting to care about environmental and even aural pollution (al-talawwuth al-sam'i) that had proliferated since the 1970s, attention should also be paid to visual pollution, which in their view was both the result and the cause of bad public taste: ugly cement buildings, billboards, neon advertising, tacky store windows, and so on. These critiques were much like those of art collectors that I discuss in the next chapter. Underlying them was a deep anxiety about the effects of "free market" capitalism on Egyptian visual culture, as well as on their attempts to acquire economic capital on their own terms.

The destruction of historic buildings and the sale of the property to developers were favorite examples of what was perceived as the decline in public taste and proliferation of visual pollution. There was a kind of colonial nostalgia here that "reconstruct[ed] the past as a means of establishing a point of critique in the present." Colonial nostalgia, then, was a reckoning, a way of creating a political "space of possibility" (Bissell 2005:239). Art critics and other intellectuals strongly defended the value of old buildings, particularly palaces and villas, in contrast to the new high-rise apartment buildings that were being built to house Cairo's growing population. For example, a lengthy article called "Crimes of Ugliness" in the weekly literary journal Akhbar al-Adab documented famous buildings, palaces, bridges, and streets that had been destroyed or altered in recent years such that their beauty or historical importance had been "forgotten" or "ruined."[19] The destruction of historic buildings, particularly of the colonial era and in upper-class neighborhoods like Zamalek, was a favorite topic of the prominent poet and journalist Faruq Guwayda. He and a number of other intellectuals worked to pressure the government to issue a military order to stop such demolitions and to save what he

called "aesthetic, architectural, and civilizational values."[20] These individuals spoke with much nostalgia of the way Cairo "used to be" and referred especially to the recent visual "pollutants" in old elite neighborhoods—neighborhoods many of them had not been able to afford to live in until quite recently (if indeed they could do so now). Thus, even though they were the "sons and daughters of the revolution," so to speak, they still aspired to protect and produce high-class aesthetics. After all, Nasser himself had ended up living in a palace.

The focus on pollution also points directly to the fears of contamination that produce intellectuals' strategies of containment. This is the boundary-making practice examined by Andrew Ross (1989) for American intellectuals, and also theorized by anthropologists working on notions of order and disorder in society, especially in the construction of nations (e.g., Douglas 1966; Malkki 1995). In Chapter 5, I discuss its operation among collectors. Here, in the intellectual scene, strategies of containment were linked with the discourse of awareness. As these examples show, older generation artists argued that visual pollution and bad public taste resulted from a general lack of awareness in the segments of Egyptian society that they were trying to contain and dominate, and from which they wanted to distinguish themselves. As noted in Chapter 2, "awareness" is a rough translation of the Arabic wa'i, which could also mean "attentiveness" and "consciousness."[21] Just as it was found in discourses of authenticity that shaped artistic production, the concept also dominated discussions of public taste. Among older generation artists, "awareness" was something that they had and that the public did not—awareness of one's surroundings on a general level, and of aesthetic principles and what constitutes good taste more specifically. Those defined as "unaware" were thereby denied consciousness, distanced, and silenced. The act of defining a lack of awareness and a visual pollution that results from it was one way in which older generation artists tried to assert a more central and relevant role for themselves. Framing the general population as responsible for bad public taste not only distinguished artists from their origins and legitimated their claims to a dominant position in the cultural hierarchy. It also created an object upon which they could work (cf. Verdery 1991).

A key contradiction clarifies this process. While these older artists distinguished themselves as intellectuals who were aware of aesthetic issues and the problems of general public taste, they criticized individual expressions of distinction among the public. They made fun of storeowners for their window

displays or marble façades, and apartment owners for painting the external façades of their apartments a color distinct from the rest of the building. As artists who valued individual freedom of expression for themselves, they denied the same value to the public precisely because they believed that members of the public did not have the education, awareness, taste, and culture to express their individual identities aesthetically. Thus, they saw themselves as the only ones who had a right to claim aesthetic distinction.

Finally, I should note that the criticisms of the obelisk and the comments made during the artists' union conference indicate that these older generation artists credited both the ancient Egyptian public and contemporary Europeans with having artistic sense and taste; meanwhile, their fellow citizens were portrayed as lacking these qualities. Such artists represented themselves as a select few, like ancient Egyptians and Europeans, who had the culture and awareness to understand if there was a problem with public taste.

As this evidence suggests, older generation artists framed the general public as responsible for the decline of taste in Egypt, and themselves as the appropriate parties to civilize the public and cultivate better taste among its members. In this way, they adopted one strand of the European elitist idea of the modern artist as having superior artistic taste and ignored competing ideologies of the artist as living (often in poverty) amongst the people. There was a kind of "selective repudiation" of borrowed cultural elements that served them in their efforts to claim and maintain positions of dominance (Abu-Lughod 1998). I argue that the strategies of silencing, distancing, and containment that they employed were shaped by their deep anxiety over economic reform, and, in a related way, by their history as artists who came out of petit bourgeois backgrounds and moved into the cultural elite through a formal education and early employment steeped in Nasserist socialist ideology.

Social class backgrounds and generational experiences also shaped the older generation's positioning with political elites. The framing of this other "public" was most apparent in a full-page article in the daily newspaper *Akhbar al-Yaum* entitled "Who Is Responsible for Beautifying the Face of Cairo?!"[22] Several key figures in the art world were interviewed about the obelisk and a coinciding incident in which a public sculpture of a popular musician came under fire by art critics.[23] These artists, as well as state administrators, blamed such incidents on four groups of factors: the behavior, lack of awareness, and cultural illiteracy of the people; the lack of a coordinated urban design plan to improve the face of the city; the lack of local officials' understanding of art;

and the need to hire art specialists to assist in all stages of urban development. Here we see the reiteration of the ideal that the state and its artist-specialists should bring culture to the masses, but we also see the idea that political officials cannot plan or understand artistic practice. In this article, National Center for the Fine Arts Director Nawwar proposes the creation of a government committee called "Art and the City," to be composed of all kinds of visual artists and specialists in architecture, landscape, and sociology, among other fields. This committee would then implement international urban design standards in Egypt to bring Egypt "up to par." This attempt to stake out a field of expertise for artists was a common strategy used by the older generation to gain some autonomy from other political elites and to distinguish themselves from them in matters of taste.

In the same article, the minister of culture reiterated the need for specialists to design traffic circles and solve other design problems in Cairo, such as the proliferation of billboards and "ugly" building façades. He said that he was "surprised" by the specific characteristics of another much-maligned sculpture in Fatimid Cairo that had been made with his encouragement. Another comment more directly reveals that the minister was publicly placing responsibility elsewhere:

> I asked that there be a national bureau to define the features of beautification and how they are to be implemented. The job of this bureau would be general coordination among offices and visual planning, so that there would be unified taste. But the decision for establishing such a bureau for cultural coordination remained a suggestion and has not been realized for the past ten years. If there were currently such a bureau, the absurdity [al-'abath] in our public squares would not have happened.

The deans of Cairo's three art schools and the general director of Egypt's museums all said that they were not in the position to make decisions, and those who were—like local officials (al-mas'ulin)—had no aesthetic awareness or understanding. Therefore, they argued, specialists in art should be consulted. The museums' director and a professor of art education complained that these officials ignored artists or thought they could do artists' jobs.

Thus, the men in these highest positions of administrative power in the art world all placed responsibility for the obelisk affair and other urban design problems on political elites as well. It is evident that either they did not see themselves as fully capable actors in this system or (more likely) that they

were passing the buck. They argued for their legitimacy as specialists so that they could gain a more prominent role in the new circuits of decision- and moneymaking that were emerging.

The older generation of artists imagined their relationship to the state and the role of the state in addressing matters of public taste in ways that were significantly different from the younger generation. In the same way that older artists understood or portrayed themselves in a separate, hierarchical relationship to the public, and not contributors to poor taste, they also saw their activities in the arts sector of the state as better than, and not subject to the same criticism as, those of other state actors and institutions. And while they thought that they should have a role in raising public taste and aesthetic appreciation, they also presented the state as the main instrument with which to achieve this role. Of course, older generation artists saw these roles as unfulfilled, largely because, in their view, artists were underappreciated. But they still believed that the state was capable of doing something. This latter viewpoint contrasted with that of younger artists, whose generational experiences of the state led them to discredit its capabilities much more quickly.

Indeed, generational differences between Egyptian artists were produced and reproduced in many ways through events like the obelisk affair. In that particular case, it is important to recognize that older generation artists were inclined to blame the artist, Tariq al-Kumi, because he was younger than they were. Indeed, it became apparent that many of them objected to a young artist being granted the contract for this work because it disrupted the generational hierarchy, which benefited them most directly. On *Good Evening Egypt*, a Ministry of Culture official denigrated al-Kumi by referring to him vaguely as "an artist from the youth and what not" (*fannan min al-shabab kida*). He further diminished al-Kumi's stature by saying that Egypt had "great artists that are capable of executing a great work" (*fannanin 'azam*: implying older, well-established artists). Similarly, the critic Muhammad Salima wrote that those in power (implying those at the Ministry of Culture) encouraged young artists to "destroy the most beautiful heritage" of the country.[24] In a climate in which young artists were often criticized for doing work only to get prizes, another critic in the *al-Ahram* newspaper attacked al-Kumi for "thinking that art is a quick way to a fast income."[25] That older artists found themselves in financial competition with their juniors, and that young artists saw a colleague getting contracts they could only dream of, were undoubtedly two of the reasons that catapulted the obelisk to such opprobrium. Not only had established modes of

power and privilege in the art world been flouted and group boundaries transgressed, but al-Kumi had made a lot of money doing it.

GIL AL-SHABAB: THE YOUNGER GENERATION AND THEIR "PUBLICS"

Tariq al-Kumi and his cohort had significantly different understandings of themselves in relationship to the various publics imagined for art, and their formulations of relative autonomy were thus differently positioned. Young artists' positionings were also shaped by their own reckonings with the genealogies of the modern that were put forth by Egypt's colonial and post-independence political and economic situations. As will become evident, they did retain some paternalist ideas about the masses, a middlebrow valorization of high culture, views of themselves as experienced specialists, and a desire for the state to step up to its ideal role as the purveyor of culture. But their generational experiences coming of age in a time of increasing wealth disparity, government corruption and incompetence, and population growth (especially in urban areas) led them to formulate an altered perspective on the relationship of artists to political elites and to ordinary people.

Like the older generation, they too held their Pharaonic artistic heritage in great esteem and often remarked that the arts had held a more prominent place in ancient Egyptian society. And while they shared with their elders the opinion that contemporary Egypt was not living up to this historical standard, that view did not lead them to value an original obelisk as inherently better than an artistic innovation. They might criticize al-Kumi's obelisk on aesthetic grounds, usually finding fault with the images on the surface and the proportions of the obelisk in the space; but they supported an artist's right to experiment with such a Pharaonic form, even in polyester resin.[26] "Europeans stole our granite obelisks so it is our right to make new ones as we wish. It is our right as Egyptians to give obelisks a new, contemporary style . . . and polyester resin does that," al-Kumi declared.

A more striking difference between the generations existed in their evaluations of Western publics. Whereas the older generation tended to believe that the general population in places like France, Spain, or the United States had a much higher aesthetic sense than ordinary Egyptians, young artists—particularly those who had traveled outside the country—saw only relative differences between Egyptians and Europeans or Americans. I was often told how an artist had got on the plane expecting to find a place where people understood art and artists, only gradually to discover that the same prob-

lems existed there too. In contrast to the older generation's captivating tales of Europe's beautiful architecture and clean streets, younger artists spoke of filthy canals in Venice, dilapidated buildings in London, and crime in Rome. They often said that they had found out that "the differences were only a matter of degree." For example, an Alexandrian installation artist compared his visits to New York and Cairene neighborhoods: "One could say that the difference between Manhattan and Bulaq al-Daqrur [a poor neighborhood in Cairo] is huge. But when you think about it, Manhattan is like Zamalek [a rich neighborhood]. And the Bronx is like Bulaq al-Daqrur. There's good and bad everywhere."

Most young artists were also unlike those in the older generation in that they considered themselves regular people in matters of public taste, not completely above them. While they felt that they had more aesthetic sense than their co-citizens, they believed that they too often suffered from deficiencies in taste and awareness. Whereas the older generation distinguished themselves from the general public, the younger generation sometimes saw themselves as part of general publics everywhere, with all their problems. This was still teleological thinking, but it had a different orientation. Thus, a shift in perspective emerges that reflects the larger change from an idealistic, socialist-inspired political program to one that increasingly emphasizes the inevitable spread of capitalism and its effects. What I document here strikes me as a case of what Raymond Williams has termed an emerging "structure of feeling" key to the formation of generations (1977). Among young artists, there was a "tension between the received interpretation [of publics, of taste] and practical experience" that was experienced as an "unease, a stress, a displacement" (Williams 1977:130). It could not yet be called an ideology, however, as the assured pronouncements of the older generation arguably could.

The contrast between generations in their conceptions of the relationship between the artist and the general public is clear in several striking examples. The first is a series of meetings held in the spring of 1997 by approximately twenty-five young artists from Cairo and Alexandria. They gathered with the dual aims of establishing their identity as a generation and of increasing their knowledge and awareness of art from around the world. Their first meeting was dominated by discussion of what they felt they were lacking. As each artist spoke, they repeatedly used phrases that used the verb "to lack, or to be deficient in" (naqs): "we all lack awareness," "we all lack information," "we lack education."

A specific complaint was that they did not know enough about art history and contemporary art production. Some artists talked about the need to study Egyptian history and contemporary life to gain a sense of their artistic roots and to understand the context from which their work emerged. An Alexandrian installation artist suggested that the group begin by doing an exhibition on "Increasing Awareness" in which each artist explored the meaning of that concept in her or his work. He said that such an exhibition would help *them* become more educated.

In these meetings, and in casual gatherings, artists of the younger generation almost never discussed the beautification debates or visual pollution—except during the height of the obelisk controversy. Only rarely did they use the term "visual pollution" to describe the problems they saw in their urban environment. More often, a group would be walking down a street or riding in a car when someone would point something out—like a new pink high rise, a flashy marble and fake gold store façade, a big tree planted right in the middle of a narrow sidewalk, or a group of huge mosaic urns in the median of Liberation Square—and make a joke that had everyone in stitches or shaking their heads in amusement. These jokes were often an expression of bewildered amazement at the new styles that people employed. They were also a sarcastic comment on the general situation in the country that was enabling these things to happen. Young artists implicated the public, themselves, and Egypt as a whole in this situation and often did not elaborate more than to say, "Egypt is this way" (Masr kida), "This is how we are" *(Ihna kida)*, or "Look at what's going on!" (Shufu ayh illi biyihsal).²⁷ In their jocular comments on their surroundings, artists usually did not specifically blame a particular class of people or even the general public. Rather, they called attention to what was happening and lamented (or made fun of) the entire situation that the country was in. Whereas with the older generation, one got a sense of desperate indignation, with the younger generation there was more a feeling of being resigned and overwhelmed, which was often expressed through dark humor.

Wa'il Shawqi's prize-winning installation at the 1994 Salon of Young Artists dealt with vulgarity and consumerism in Egyptian society (plate 7). He later explained to me that he "was not criticizing society. It was an attempt to capture the situation." This "capturing of" or "calling attention to" the situation is what young artists were doing when they joked with one another about sights seen during their daily commute, or about new building projects they had read about in the papers, for example. Joking took precedence over wor-

ried discussion about visual pollution. Yet when an art critic asked Shawqi to write something about his installation, he wrote about visual pollution. Later, when I asked him to explain his artist's statement to me, he started laughing and said sarcastically, "You mean that masterpiece of writing I did?!" After a good bit of snickering to himself and shaking his head, I asked him what was so funny. He said that there is a belief in the art world that "[puffing up his chest] we have to *do something* about visual pollution." He regretted having felt, when he put his ideas down on paper, that he had to use that same discourse, or to use "big words" (*kalam kabir*), as he put it. When I asked if he actually thought there was something called visual pollution, he was silent for a few moments and seemed at a loss for words. Then he mentioned hesitantly that he thought that Egypt's problem was that it could not define its own visual features, the way Cuba or Mexico could, because it did not have enough "confidence in itself." I asked him what he thought the causes of this situation might be, and he said that there were many, like the media, but that it was "very complicated." Then he started to say, "it's natural in Egypt . . ." and stopped. Indeed, framing a serious question about the idea of visual pollution was unsuitable for a young artist. "Visual pollution" was a bloated, funny term used by the older generation, but that did not necessarily mean that young artists were unconcerned about the changes in visual culture that accompanied economic "reform."

Despite their reluctance to use the categories of the older generation, young artists were sometimes forced or entreated to by the circumstances. For example, the National Center of Fine Arts organized a program of roundtables to accompany the 1999 National Exhibition, which opened one month after the obelisk incident. One of the roundtables featured three prominent young artists, who were asked to talk about a variety of topics—from freedom of expression to the idea of the rebellious artist to public taste. At that time, public taste and public art were on the minds of many arts interlocutors because of the obelisk controversy. Yet only one of the three artists chose to speak about this issue. When the sculptor 'Ali Yasin presented a stinging critique of artists who complained about public taste without examining how they were implicated (as middle-class artists, as government officials) in reproducing this taste, he received a terse thank you from the government moderator, and there were no comments from the audience. The other two artists chose to speak about topics unrelated to this issue. In private, one of them rhetorically asked the other, "What would *I* say about public taste?"

In another poignant example, the obelisk artist Tariq al-Kumi was practically forced to frame his discussion of the incident as an issue of public taste, because that was the term used constantly by his critics. I met him on a windy evening in May 2000, a few months after his obelisk was removed in the middle of the night without his knowledge. He was still very affected by the incident and brought it up almost immediately; and even though I asked him several questions about his recent exhibition, he was much more animated when discussing the issues raised by the obelisk affair. When I asked him to tell the story from his point of view, he began with two themes that continued to drive our discussion that night: public taste and the shortcomings of state actors. These two points provide a useful bridge between this section and the following one on the state, because they reveal how young artists included the state in their complaints about public taste more than they expected the state to have the capacity to improve public taste (though many held onto the ideal that it should do so).

Like the big art critics and administrators, al-Kumi discussed a number of urban design problems in Cairo and gave many specific examples—from cement walls blocking visual access to parks to busy roadside advertisements that block views and disturb drivers. Yet he described these examples, not as "visual pollution," but as "psychological barriers" that prevent "visual comfort for the people." When people are waiting in the heat in the middle of a crowded road for buses at rush hour, he said, they should not have to be subjected to such visual assaults. Instead of directly holding the people accountable for the problems of public taste, al-Kumi suggested that they deserved attention and care:

> Look at the whole world around us . . . Egyptian commodities, Egyptian products, clothing, the colors that are used, even the way of joking . . . these are the things that make public taste. The little things that we are careless about . . . these are things that might make up the man of the street, the stratum [*tabaqa*; also class] that will really define the country, or that will give it a civilized appearance [*shakl hadari*] or not . . . those crowds of people that walk in the streets, the regular stratum. . . . There should be attention paid to them on many levels. But that doesn't happen. What happens is we create propaganda and spend lots of money in order to show that we're doing something.[28]

Here, al-Kumi first uses "we" to refer to himself as part of the public and then uses it to refer to himself as part of the art system that he thinks prevents the improvement of public taste. This usage was common among young artists,

who tended to think of themselves as both part of the public *and* as slightly more versed in the importance of visual aesthetics. They considered all artists and critics responsible for not successfully imparting this knowledge to their fellow citizens. I suggest that this sense of inadequacy arose from their marginal position in relationship to various groups who produced and consumed visual culture. It also exhibited a trace of the paternalism of the older generation, as the "man of the street" is not given the power or awareness to change his own circumstances. It is the artists who have the agency to uplift him.

As al-Kumi's words also indicate, young artists also held state actors particularly accountable:

> The problem is those who control public taste in the country and the people that wrote that the obelisk corrupted public taste. First of all, they should write on the denial of artists' rights to work on the issue of public taste, and push for the appointment of artists to positions where they can do something. Or else other people are going to keep taking their places and controlling the taste of the Egyptian street. Like the neighborhood heads, for example. They have the power to beautify (put a small tree here, a big tree there), and they don't understand a thing.

This remark leads us into an examination of how young artists understood their relationship to political elites, and the general role of the state in improving public taste. Here there are some similarities with the older generation, as well as some key differences. Instead of defending his sculpture, al-Kumi blamed the Giza governor, the local neighborhood leader (*ra'is al-hayy*), and Cairo's Beautification Board, whom he called *al-mas'ulin*, a word commonly used for officials in power that, literally translated, means "the responsible ones" or "those who are accountable." He condemned these men for their aesthetic shortcomings and complained that decisions had been made without his knowledge, that no one on the planning committees had listened to him, and that he had been given no power. In his explanation of the event, we see a common way in which artists of all generations tried to create roles for themselves as legitimate bearers of visual cultural knowledge in a general milieu in which their relevance or importance often went unrecognized. But al-Kumi's explanation also reveals the way in which the younger generation increasingly saw the state as part of a whole failed system, which suggests that perhaps some fissures were forming in the traditionally held expectation that the state could be the dominant purveyor of culture.

Al-Kumi was particularly angry about the politics behind the placement of his sculpture in Midan al-Gala'. Originally, he had been told that the obelisk was for a different location, and that it was to be a temporary work for a carnival celebrating the Giza National Holiday and the Sixth of October 1973 War. When he later found out, after completing the work, that it was to be permanent and installed in such a prominent place at the entrance to the Giza governorate, he was annoyed that he had been compelled to miss such an opportunity: "If I had known that the governor [had] the ability to put the obelisk in that place, or if he had told me [that it would be in] that place, and [had given] me the ability to do any work that I wanted, the whole thing would have been different. Quite the opposite—it would have been quite an opportunity to get. And that's what irritated me about the whole affair."

Al-Kumi protested this decision by calling into question the artistic expertise of those who had made it. This challenge turned accepted power relationships (between young and old, between government officials and ordinary citizens) on their heads, embroiling the artist in a battle to define and defend himself and his field. He told the Giza governor and the neighborhood leader that the new location had a different set of aesthetic problems that had to be taken into consideration. For example, the visual factors of the Sheraton Hotel and the big gas station in the background needed to be dealt with. Al-Kumi objected to the fact that a retired army sergeant had been appointed head of Cairo's Beautification Board and been put in charge of the landscaping for the traffic circle, despite his lack of artistic or architectural experience. He was further frustrated when this man neglected to inform him of his plans:

> I was surprised that they had already done the plan. I was surprised that they had produced an order to clear the space, and that the man was doing his landscaping. And when I went and found that the neighborhood leader had done these plans, I asked him what right he had to do those drawings! He got very angry and sensitive as if I had attacked his honor—like how could *I* attack *him* . . . [laughs incredulously]. He did not understand that he had deprived *me* of *my* right.

The feeling that his rights as an artist had been denied was compounded by his lack of power over the future of his work. When he further voiced his objections to the *mas'ulin*, he was ignored:

> They presented it as if it were already done—a political decision. I felt that those people who are in control have no background. . . . Can you imagine the

person in charge of landscape is a sergeant who has spent his whole life in the army?! . . . All of these people in important positions are *not specialists*. . . . They are all retired politicians or army people. This has been our problem from the days of the revolution.

Indeed, al-Kumi's complaints that his artistic expertise was not respected, and that he was given no power over basic aesthetic decisions, were always paired with criticism of the taste and artistic experience of the local officials, implying that the military nature of the Nasserist revolution had not been so ideal for intellectuals and cultural policy (cf. Abdel-Malek 1968) and suggesting that the growth of capitalist markets resulted in major problems in visual culture.

It is significant that al-Kumi argued not only that it was the poor taste of these local officials that contributed to the decline in public taste, but that this trend was representative of the times and of the public in general. Meanwhile, in his view, artists contributed to the problem by focusing on their own exhibitions instead, thereby marginalizing themselves even further. State officials and the society at large had no concept of art, he said; they thought that artists just did "silly" or "crazy" things. Even other intellectuals, he added, might not be "cultured in art" (*mish muthaqqafin tashkiliyyan*). Here again we see the attempt to construct a sphere of relatively autonomous artistic expertise. "Artistic" or "visual" culture was positioned as equivalent to "literary" culture in importance and relevance. Artists of all generations shared al-Kumi's view that artists had been unable to affect the way urban areas were beautified or developed for a variety of reasons—they were "busy with their conferences and private exhibitions"; the general public had no idea about art; economic changes had overwhelmed any attempt to manage visual culture; and officialdom did not recognize artists' specialized expertise.[29]

At the end of our discussion, al-Kumi echoed the benevolent paternalism of the older generation towards "the people," but in a way that did not completely dismiss their potential: "If we can just gain a presence, generation after generation, and have the persistence to reach the people [*al-nas*], then they will have [a] passion for art, in addition to it easing their eyes . . . if people live in a good environment, that then gets reflected in their behavior." In a separate discussion about the incident that I had with another young sculptor, he went beyond this and gave credit to ordinary people for having more artistic sense than the government officials: "Totally ordinary people [*al-nas al-ʿadiyya*] don't comprehend what modern art is. They want to see figurative

sculpture. . . . But still they know what an obelisk is, and when they say, 'Why don't you put up a real obelisk?' sure, they don't have a real understanding, but they sense that something's wrong. . . . It was a very nice thing that regular people objected to the work."[30] Even though elitist paternalism appears in this statement, it nowhere near approaches the kind of negation of "regular people's" agency evidenced by the older generation.

The majority of young artists readily held the Ministry of Culture partly responsible for the obelisk controversy. But instead of singling out the ministry, young artists saw it as part of a whole system—including the rest of the government, private business, the general public, and even themselves. This system (referred to as *al-nizam, al-system*) was seen to be both a cause and a result of the general situation in Egypt (*al-wad', al-hala al-'amma*, or even *al-'akk*). As the next examples show, artists tried to separate out the parts of the system in order to keep the constantly changing, uncertain, and undesired economic and political factors from completely determining artistic value.

A few months after the obelisk was removed, in January 2000, an intense discussion occurred one night at a coffee shop between a group of five artists. The most outspoken of this group, Nabil 'Ashur, who had been involved in several successful art business projects in recent years, said that there was no such thing as public art in Egypt. What was called public art was actually "public business," because everyone was just trying to make money. And because such business in the private sector was limited, everyone sought work with the government. What had happened, with the governor giving very little time to the artist to produce a work of blatant nationalism for purely political purposes, was par for the course when one mixed art, business, and government. "Any artist put in that situation," he said, pointing to and naming each of his friends sitting around the table (including me), "would end up producing a piece like that." But, he argued, in the end the artist wins financially and he can still put on an exhibition to redeem himself artistically. That was how the faulty system worked.[31]

At a sculpture symposium in Aswan, al-Kumi's colleagues expressed a similar view and cast it as a larger problem, not specific to Egyptians or to socialist or capitalist systems. When I asked one sculptor how a young artist could get such major contracts, he responded: "This is not an Egyptian thing. It is international. The most successful artists always have private relationships with authority [*al-sulta*]. This is everywhere." Like other young artists, he was more interested in the system of connections and decisions that had led

to the obelisk debacle than in blaming the individual artist. Another sculptor eloquently captured the sentiments of many of his peers when he said that the obelisk was a "testament to the times" (*shahid 'ala al-'asr*). He was particularly critical of the minister of culture, saying that "this is what happens" when a ministry that has lost all standards of value brings up a young artist. This critic sardonically hoped that Egypt would be filled with more works like the obelisk so that people could see "the truth" (*al-haqiqa*) of how government officials were turning their back on important issues and just running after money, connections, and political power. Indeed, the appearance of new government-business relationships propelled a search for, and declarations of, the new "truth" about how things were operating. It also motivated new struggles for artistic autonomy and legitimacy.

THE GENERATIONS AGREE:
ART MAKES GOOD BUSINESS, BUT BUSINESSMEN CANNOT BE ARTISTS

The fact that it was unclear whether the obelisk had been funded by the Giza governorate or by private businessmen was significant, and the rumor that the work had been contracted for a large sum caused a great deal of envy. Competition for well-paying work was on the rise, especially between artists of the young and old generations. It was also fierce—largely because artists depended on such contracts to supplement their incomes.[32] Government officials were using their prestige and connections to capture some of the most lucrative contracts in the private sector. Indeed, the line between state and private business was often blurred, as it often is in neoliberalism (e.g., in the case of the Halliburton Company). Artists were trying to make sense of this situation, and the ways in which they did so further elucidate the context-specific, relative nature of Egyptian assertions of artistic autonomy.

Planners of the 1999 artists' union conference sought to take advantage of the increased corporate demand for artists and designers. Some of the biggest names in Egyptian business—Ahmad Bahgat, Muhammad Nusayr, and Muhammad Farid Khamis, among others—were billed as chairs or key speakers of sessions. Clearly, the aim was to build a stronger bridge between the arts and business, and this aspect of the conference had attracted many members of the audience. Not one of these important businessmen actually attended, however. Significantly, the director of the National Center of Fine Arts and other government artists filled the vacancies in the program. Some audience members understood these absences as proof of the enduring ignorance of

art in business circles. Yet it was very novel that the conference organizer, a Cairo College of Fine Arts professor, had invited such participants and that people had come to hear them. That such a public link between business and art was even imaginable in 1999 indicates a change in the expectations and hopes that artists had regarding the reception of art and the development of their careers.

Similarly, throughout the press on the obelisk affair, there were calls for businessmen to continue financing public art projects. But such calls were usually paired with the stipulation that businessmen consent to be guided in this by artist-specialists. In the artists' view, businesspeople should defer to them when it came to aesthetics, and they ought to pay artists well for such work. As the dean of the Cairo's College of Fine Arts said, "We are happy to have the cooperation of businessmen, but we must ensure that this cooperation follows certain principles so that it does not result in a visual mess."[33]

I suggest that these maneuverings were, above all, attempts by artists to make sense of the changes going on around them and to have some control over the aesthetic parts of the process. They were attempts to establish cultural authority over the process of doing art in the realm of urban planning and beautification, not complete autonomy from the economic and political fields of power. Autonomy was expressed mainly in the desire to keep the middlebrow tastes of businessmen (especially the nouveaux riches) at bay. This desire of artists—from all generations—to be recognized and treated as specialists with expert knowledge of visual culture and taste was a major theme that emerged again when artists talked about business. Artists claimed that they had special abilities, and if private sector businessmen would only recognize their expertise, artists might be able to improve the appearance, and ultimately the experience, of the urban environment. They also wanted contracts with the private sector in order to make more money and enhance their economic prestige more generally.

Their efforts paid off to some extent. In 1999, the Syndicate of Plastic Artists worked hard to gain legal recognition for the category of "artist-consultant." The People's Council then passed Law 154 of that year, which provided for the creation of an official registry of specialists to be used by the government and private businessmen undertaking public art and art-related projects.[34] It was assumed that if the 2 percent law could be enforced, specialists would be drawn from this registry to fulfill the requirement. It remains to be seen whether the law or the registry will actually help artists establish some legal,

institutional footing on which to stand in their claims for legitimacy—either with state actors or with private businessmen.

CONCLUSIONS

The obelisk affair came at a time when the economic bubble was bursting. Artists' envy of the project became more palpable as increasing numbers of them were being left in a lurch: contractors broke their agreements, work went uncompensated for, and artists could not keep up their payments on newly purchased apartments, cars, computers, and the like. What had seemed to be a bright yet uncertain future was looking increasingly grim. Artists' calls for business patronage diminished a bit, because it seemed that the private sector was less dependable than the public sector. But calls to improve public taste did not diminish, I think in part because the negative effects of freewheeling economic "reform" were becoming more visible in the city streets in the form of half-finished or poorly regulated projects, and, of course, poverty. The questions were: who to blame, and from whom to expect a solution?

In Chapter 3, I discussed how the state cultural apparatus was usually able to win artists' consent to an ideal of a caretaker state. Here, I have tried to show the cracks that I saw emerging in this hegemonic project—both within the field of cultural production and in relations between that field and others (political and economic) in Egyptian society. These fissures emerged when artists imagined and dealt with their various publics. Containing them, I have argued, involved several strategies. First, artists of middling backgrounds created a hierarchy of taste in which they tried to contain (or deny) the influence of their middlebrow origins and claim a superiority in cultural or artistic knowledge that differed in intensity by generation. Second, in defining this hierarchy of taste, they simultaneously sought to distance themselves and their artistic production from the contaminating effects of nonartist political and economic elite taste, and the taste of the general population. Creating a separate sphere of specialization and highbrow taste was one way (among others analyzed in previous chapters) to counter the marginality and irrelevance they felt as artists in Egyptian society. They hoped to gain legitimacy for their careers, to gain more control in matters of art and culture, and, ultimately, to make art more central to the modern nation's progress in a period of uncertain change.

The similarities between the two generations involved in this project were in part the effect of their shared petit bourgeois backgrounds—backgrounds that threatened the very bases of legitimacy and status that they were trying

to claim in the realm of highbrow taste. The differences between them appeared to arise from their contrasting experiences of coming of age under either Nasser or Sadat. Ahmad Mahmud eloquently explained how these different experiences influenced artists' outlooks on politics and the general population:

> Generation is not merely a period of time. It's the circumstances in which a group emerged. The emergence itself is what's important, not the division between the groups.
>
> We in the younger generation are totally different from past generations. All the past generations had a political upbringing, an upbringing of conferences and lectures [*tarbiya siyasiyya, tarbiyat nadawat*]. We were brought up on the streets [*tarbiyat al-shari'*]. The culture of the streets. Our basic relationship to the world is through the streets.

I asked, "Isn't the street political, also?" He clarified:

> The street is a more realistic politics. A politics of a way of living, not a politics of principles [*siyasat ma'isha, mish mabadi'*]. Any artist [of our generation] can have in his compositions a piece of communism that he needs, a piece of socialism, imperialism, capitalism. There is no specific form of politics. Quite the opposite, it is a flexible politics.[35]

Mahmud's words, along with evidence presented in this chapter, suggest that programmatic state ideologies were starting to have less relevance or utility for younger members of the cultural elite as they engaged with their imagined internal "publics." This translated into less blaming of the people for bad taste and more blaming of the entire "system" of which they were a part. One also has to entertain the possibility that this "flexibility" and lack of specific politics that Mahmud captured were themselves effects of the apolitical language of neoliberal capitalist globalization that emphasized flexible capital and subjectivities.

When young artists engaged with external publics such as the curators and art buyers increasingly coming to Egypt from the United States and western Europe, certain key aspects of the "old" ideologies were reinvigorated, slightly reformulated, and certainly reproduced. Pairing the example of the obelisk controversy with a discussion of foreign-run galleries, festivals, and curatorial seminars will show that there was a central link between attempts to contain bad taste within the social body and struggles to keep external threats at

bay (cf. Ross 1989:46; Verdery 1991:59). This link was especially strong because both bad taste and external threats were seen to result from the unbridled spread of capitalism. Artists—both young and old—were still trying to figure out whether the benefits of economic change would outweigh the potential costs to both their artistic production and their control over art's value.

GAZIBIYYA SIRRI
The Search: Personal Papers

GAZIBIYYA. The name means "magnetism" or "attraction." It is a most appropriate name for one of the most famous Egyptian artists of all time. Gazibiyya (as she is known and as she signs her paintings) has won the coveted State Merit Prize, her works have been exhibited all over the world, and she has had books written about her. But more than these surface accolades that fill up the many pages of her resume, Gazibiyya is known and respected for a prolific lifetime of quality art-making. One can really call it a journey. Critics have divided her work into different periods (academic classicism, socialist realism, expressionism, abstraction) and different themes (portraits, socialist realism, houses, humans, deserts, seas, flowers), but such divisions do not capture the sense of over sixty years of continuous, committed boundary pushing that one gets by looking at her oeuvre, or indeed by talking to her.

Gazibiyya Sirri (b. 1925) is a short, sprightly, fiery, and intense woman. I was completely intimidated by her the first time we met some ten years ago. She speaks her mind most bluntly and refuses to answer or cuts off questions that she finds stupid, irrelevant, or too personal. She's been known to have tantrums. She's also incredibly funny and friendly and smiles a lot. And she works constantly. But to say these things is to fall in step with so many other art writers (most of them men, many of them Western) who harp on her personality, gender, and size as if these were the main keys to her art. And as if her personality were unusual for a woman. Some commentators have even said as much, forgetting about all the Egyptian women one can see on the streets and on television joining their male counterparts in dramatic fits over

various injustices. But I would not be surprised if Gazibiyya's intensity and nonstop passion for art were not in some basic way motivated by the incessant comments about being an "intense *petite femme*" (Amal Gayed as quoted in Sirri 1998:47). There is a way in which she refuses these characterizations: she emphasized to me that she resents gender-based interpretations of her work, because they imply an inequality between male and female artists, or at the very least a ghettoization of her art based on the fact that she's a woman.[1] But there is also a way in which Gazibiyya cultivates such characterizations.

Most artists in Egypt have well-developed narratives about themselves and their art. Gazibiyya's is overwhelmingly practiced and tight. She talks about being the "wild" sister in her family, about hitting a boy who stole her yellow crayon in primary school, of wanting to eat paints, she loves them so much. There's a good chance that she is consciously and mischievously performing this image of the wild artist, in part because so many artists in Egypt don't really value rebellion, and because the few who claim to be rebellious really aren't.

She captivated me with the narrative she usually tells: She was born in the cosmopolitan 1920s into a multi-ethnic elite family that included Turks and Greeks. She grew up in an old Mamluk-style house in Hilmiyya, an old urban district, where she says "all the important intellectuals lived." She was brought up in an artistic atmosphere, and was especially influenced by two uncles who took her to Groppi, a famous European-style coffee shop, where she heard classical music. (Every time I walk by Groppi today, I remember her story.) The uncles also painted; one of them shared a studio with the famous pioneer painter Ahmad Sabri, and it was there that she pored over the drawings in her uncle's copy of the *Description of Egypt* from Napoleon's exhibition. She received her college degree in 1948 from the High Institute of Fine Arts for Girls, before independence and before co-ed education. She drew nude studies and painted portraits. She joined the Group of Modern Art, which aimed to delve into Egyptian popular and traditional imagery and present it in a modernist way. She followed her predecessors among Egyptian artists in studying in Europe. In the 1950s, she went to France and studied with Marcel Gromaire, then to Rome, then to the Slade School in London. The renowned French critic and painter André Lhote predicted she would be the source of a "contemporary Egyptian style." Gazibiyya even won a prize at the Venice Biennale in 1956, but the British-French-Israeli attack on Egypt after Nasser nationalized the Suez Canal overshadowed the news of that victory in the press. She paints nearly

every day and has what she calls a "sensual love" for color. She says she gets "obsessed" with a certain subject for years. She also laments that Cairo is not what it once was, with all the dirt, noise, pollution, and people who probably don't "appreciate beauty," as she told me.

Gazibiyya's narrative taught me the importance of narrative among artists, of performing stories about the artistic self. But I think that this narrative has tended to dominate critical frames of interpretation that focus on her early biography, international accolades, energy, "lust for color," and the stylistic features of her constant experimentation. But her way of telling it and the art criticism division of her work into periods, themes, or styles really do not capture what I see as Gazibiyya's intense self-reflection about her process: how she lives with the work, how she progresses from one work to another, how she relates to her materials. For that you have to go straight to the art work. If you analyze the details of themes, styles, and techniques in her work, you see that she has really stuck to it. I would say that she is notable among Egyptian artists for constantly pushing the formal dimensions of her work. She is also one of the few whose every step of artistic development is documented in the work (not just in her thought). By looking at her oeuvre, you can also see the different ways she has *actively engaged* with art forms and styles from around the world, thereby debunking the idea that Egyptian modernists just imitated the Europeans. To me, her paintings also reveal—to an unusual degree—the tide of change in modern Egypt and the ambivalent feelings that it can produce in an artist. Looking at her work as it moves from literal representations of the new nation's mothers to fragmented representations of the tragic and comical circumstances of Nasser's Egypt, to abstracted houses falling apart and on fire, to idyllic paintings of the desert or rural Egypt is like looking at a visual record of the various reckonings with different ideas, styles, and themes of the modern that have interested Egyptian artists for the better part of a century. One also gets the sense of Gazibiyya's interweaving of the personal and the political, and her commitment to always pushing the boundaries of each. Her body of work is thus a visual companion to that of her peer Latifa Zayyat, who lived through the same heady moments and upheavals of the transformation from colonialism and recorded the experience in her autobiography *The Search: Personal Papers* (1996).

Gazibiyya's visual autobiography begins in the 1950s. She is well known and loved for her figurative work from this period, which some viewers describe as "socialist realism." Indeed, at first glance, much of the work seems to show the artist's support of revolutionary ideals. There are paintings of peasants, in-

cluding one called *Rebellious Peasants.* There are paintings of women—women playing the revolution song, women teaching (some are self-portraits), and a lot of mothers (including mothers of martyrs) holding children and/or nursing babies. Gazibiyya seems to have provided a visual counterpart to the emphasis that Nasser and feminists of the time were placing on the productive role of women in the new nation—as workers and "makers" of Egypt's new citizens (see Bier 2006). These paintings are not just socialist realism, however. They are done in a style and composition that unmistakably borrow from Pharaonic compositional techniques and representation of facial features. Some of them may also be read as reclamations of what Matisse took from Islamic and North African designs and compositional techniques (see fig. E.1).

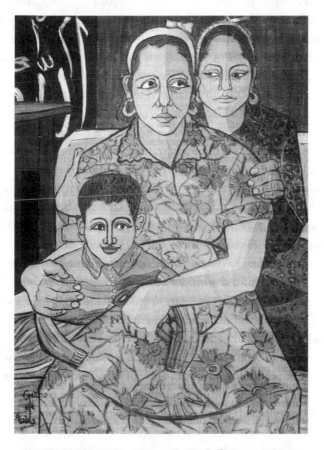

Figure E.1 Gazibiyya Sirri, *Umm 'Antar,* oil on canvas, 1953. Courtesy of the artist.

As the 1950s wore on, the anti-revolutionary aspects of Nasser's rule became all too apparent to leftist intellectuals. But, judging from their art work, it seems that many artists retained hope that the Nasser regime would live up to its initial promise of social equality and justice. Not Gazibiyya. Although most critics see her work as an exceptional example of the socialist realism being done in the Nasser era, I think that her ambivalence about what was going on can be very clearly read in the paintings. For in the mid 1950s, she started to do a series of works on games, the most famous of which shows children swinging (*Swinging*, 1956). When discussing this painting, Gazibiyya has been known to say cunningly, "Nasser . . . Did he not lean sometimes to the right and sometimes to the left?" (Carmine Siniscalco as quoted in Sirri 1998:16). Other paintings are of a marionette show, a girl walking on a tightrope with a red balloon, a girl jumping rope on top of a group of Egyptian houses, and children playing hopscotch. Some of these paintings make use of Pharaonic-era perspective. At first glance they seem playful, perhaps interpretable under the framework of art naïf as authentic Egyptian art. But Gazibiyya's comment about *Swinging*, and analysis of the paintings themselves, reveals a deeper ambivalence that interests me. Take as an example *Hide and Seek* from 1958 (fig. E.2).

The painting shows people (children? and the figure on the left is dressed somewhat like a peasant) running in fear—and their expressions suggest that it is not only the fear of being chased in the game, but of something else. The tree on the left appears to be dead, or dying, and the colors are drab. By the time Gazibiyya did this work, Nasser was well into his confrontation with the Left, and his imprisonment of intellectuals (and Islamists) had begun. I think that Gazibiyya's paintings of this period reflect a sense both that life might be made better by the post-independence reforms and also that the whole thing might just be a game, a charade. In 1959, she did a painting of a prison and signed her name under a prison number. Then in 1960 came a painting of a girl swinging through the air but "holding onto nothing" (the title of the painting). In the 1960s, Gazibiyya started to break up the forms in her compositions. Other paintings from that decade include *A Lost Family* (1960), *Intellectuals' Dilemma* (1962; a cubistic rendering of some men looking hopefully up and others looking despairingly downwards), and *Racial Discrimination* (1963; a cubistic painting depicting people of different races). She says that she wanted to find a solution to her feeling of being stuck within the lines of figures. I also see this change as an allegory of the times. The subjects of the

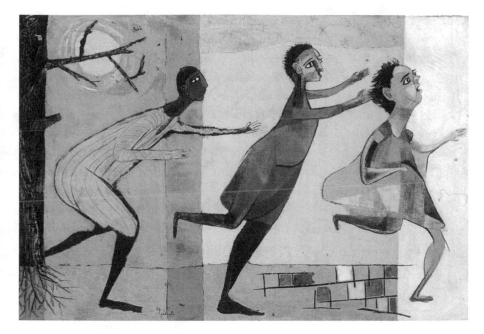

Figure E.2 Gazibiyya Sirri, *Hide and Seek*, oil on canvas, 1958.
Courtesy of the artist.

work get increasingly dark, with figures looking downtrodden or angry, cut through by lines or color fields. The critic Ahmad Fu'ad Salim has written that Gazibiyya at this time "became part of a texture worn out from drinking in vain from the nectar of a national dream" (Sirri 1998:43).

Then comes a famous painting from 1967—the year the dream of Arab nationalism was broken in a devastating defeat by Israel. Egypt lost the Sinai. Titled *Grief* (plate 10) this painting shows the artist standing corpselike, rendered in gray and black, looking out at nothingness (not even at the viewer). There is the pyramid icon of Egypt placed in front of a drab cement and brick building, the setting sun behind them. This is one of the most poignant artistic reactions to 1967, of which there are few, probably because it was so devastating. But I think the painting is really interesting because it marks a divide in Gazibiyya's work. After this point, she would never again go back to the kinds of themes or styles she was concerned with in the 1950s and early 1960s. The devastation of *Grief*, and the sharp break (never looking back) that came after it, communicate to me—as nothing else has—the fundamental significance of that moment for Egyptian intellectuals and indeed for all Arabs.

Almost immediately afterwards, there appear paintings of "disintegrated houses"; she called one of her paintings from that period *Houses with Their Heads on Fire* (fig. E.3). While an unknowing Western critic might regard these as an imitation of some American abstractionism, they are actually a progression of the artist's personal search to move beyond block forms, which coincides with the breaking apart of block ideologies such as Arab nationalism and socialism, and with the breaking apart of traditional social bonds by the processes of industrialization and urbanization. In many of these paintings, people and houses mesh through lines; they disintegrate together.

When Sadat launched the October 1973 War to win back the Sinai, Gazibiyya's work changed again. All the tight lines and confusion disappear. The canvases open up to broad washes of color, and simple shapes like pyramids and squares appeared. Again, American critics might see her as overly influenced by color field painting, but there is more to it than that. She started to paint the desert, perhaps because there was promise of the Sinai desert being

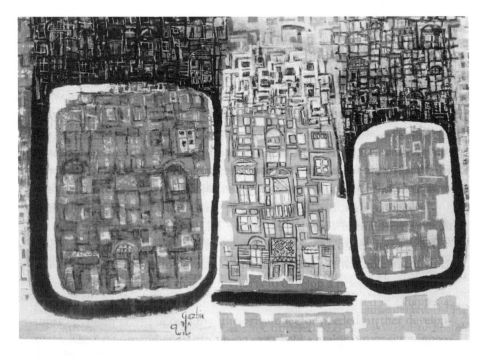

Figure E.3 Gazibiyya Sirri, *Houses with Their Heads on Fire*, oil on canvas, 1968. Courtesy of the artist.

recovered. Amidst the craziness that many intellectuals describe as life in the 1970s, when Sadat turned the world topsy-turvy, she painted simplicity. I read this partly as an escape from the confusion. Then she returns briefly to the same tight and chaotic representation of people and houses and titles using the word "grief." Perhaps the peaceful paintings of the desert could no longer keep the rest of the world out, perhaps she felt that the canvas had become too opened up to allow for further possibilities. The unpopular (to many Egyptians) Camp David accords were signed, Sadat's economic policies really started to show their downside, and the president was assassinated.

In the 1980s and on into the 1990s, Gazibiyya moved very deeply into abstracted expressionist paintings of houses, the sea, flowers, and especially people. The paint became much thicker. The colors became riotous. She used a knife. Sometimes there were fields of color reminiscent of her 1970s work, with the people expressively painted inside of them, or the color fields appeared on top of the busy and chaotically rendered people. Sometimes everything disappeared in an explosion of color. Sometimes just a few bright lines on a color field indicated the artist's intention. She was moving back and forth between busyness and simplification, between figuration and abstraction. The works often have the feel of her trying to grasp the changes in urban culture around her, but in a different way than Muhammad 'Abla and al-Ginubi.[2]

It is these works especially that collectors cannot appreciate, or refuse to, perhaps because they prefer figuration or are nostalgic for older themes. Collectors would often say to me, "I like Gazibiyya, but the early stuff." Nonetheless, it has been in later years that Gazibiyya has become one of the best-selling and most lauded contemporary Egyptian painters. She's had blockbuster retrospectives and has taken a prominent place in the "Egyptian canon."

It is extremely curious to me, given Gazibiyya's artistic trajectory, that she should have started painting Orientalist-like watercolors alongside her other work. Starting in the late 1990s, Gazibiyya began to exhibit watercolor paintings depicting villagers in Luxor and Aswan. These are based on yearly visits she makes to the south. There is very little that is ambivalent about these paintings. No clear signs of struggle, grief, poverty, or modernity. They are stellar versions of the kinds of paintings Westerners have been doing in Egypt for years. But perhaps it is not so surprising that, in her later years, Gazibiyya should have turned to such anaesthetized representations of Egypt's villagers. She has worked hard, she has lived and painted struggle and ambivalence and beauty and grief. She has seen Egypt change dramatically, and like most people

her age, particularly elites, she is not happy with what her country has become. After visiting an exhibition of these watercolors at a gallery frequented by diplomats, the famous Armenian Egyptian artist Anna Boghiguian wrote:

> When I gaze at Gazibiyya's work now, I remember Egypt as it was thirty years ago. The role of the artist has changed, but artists are still struggling to create and to give an identity to an unstructured art world. . . . But then, those who gave form are gone, and they have left closed doors behind them. And the spectators are always changing, they move and fade away, leaving the artist with her work to reflect on what has happened in those years. ("Devouring Abundance," *al-Ahram Weekly*, February 18, 1999)

Is Gazibiyya retreating into nostalgia, exhausted? Does she know her collectors all too well and wish to live an even more comfortable life? Is she discovering potential in other subjects and the medium of watercolor? What is the unfolding relationship between these new works and her continued exploration, in oil, of abstracted figuration and bright colors?

I think that these questions can be asked of many Egyptian artists, but for Gazibiyya, along with a few others, they are especially open-ended. This is why spending time with her works is so productive—for no answers are produced, particularly to the question of Egypt. Only more questions, more searching.

5 COLLECTING A NATION, DISPLAYING (A) CULTURE

PRELUDE:
CONNECTING PRODUCTION AND CONSUMPTION

"There are no collectors in Egypt." This was the answer I received countless times to my queries about who bought art there. Artists and gallery owners compared the supposed "lack" of collectors in Egypt to what many presumed to be a plethora of enlightened Westerners who had enough appreciation of art to collect it. In fact, many Egyptian artists envied their counterparts in Europe and the United States, whom they assumed to be well supported by collectors. The supposed dearth of collecting was taken as yet more evidence of how artists in "the West" (*al-gharb*) had it made, while Egyptian artists suffered from an artistically illiterate public.[1]

Initially, I took these claims that there were no collectors at their face value. In the early years of my research, during the mid 1990s, it was clear that galleries were either not selling much work or were being secretive and selling a lot from the back room. One prominent gallery owner sat me down and said, "Look, there is no art market in Egypt." Red dots on exhibited artworks were just not that frequent. My attempts to reach collectors were thwarted by gallery owners, who either claimed that they did not really know any or that they could not give me any names—collectors being their currency and something that they kept private. Attempts to reach collectors through artists likewise failed because many of them did not know any personally, or because the galleries had protected their middleman relationships and did not introduce artists to their buyers for fear that they would be left out of future purchases.

(Buyers and artists often tried to avoid the 30 percent commission usually charged by galleries.) In my dissertation, I therefore concentrated on what was at the time the largest collector of Egyptian art: the state.

Many artists, critics, government officials, and even private sector gallery owners maintained that there really was no community of collectors in Egypt for several reasons, one of which involved the state itself. At the time of my main research (1996–2001), the Ministry of Culture bought more art from a greater variety of artists than any private gallery did. The ministry had political reasons for collecting such a wide array of Egyptian art, and furthermore it had no need to control supply to increase demand. The influential history of the Ministry of Culture in producing the current dynamics of art production and consumption in Egypt, along with its continued pertinence for the vast majority of Egyptian artists, has made it important to focus attention on it in some of the other chapters. These have included discussions of state collecting and display. For example, in Chapters 3 and 4, I discuss how the state encouraged certain kinds of art (connected to national ideology) through its acquisitions and public art displays and how artists vied for such acquisitions and public art commissions. In this chapter, I focus on the equally (and perhaps someday more) important contexts of private collecting and display, thus expanding my analysis of the connection between production and consumption.

Another important reason why many artists kept telling me (even as late as the summer of 2004) that there were no art collectors in Egypt is that most artists were still not fortunate enough to sell their work in the private sector. Most considered themselves lucky even to get a government acquisition. Their only connection to the private sector was through gifts that they gave to friends. The very big names in the older generation were more successful on the private market, in part because they had, over the course of many years, built connections to people who had the means to buy. Artists who held high-level government positions were also in a position to offer quid pro quos for purchases of their work. But for the most part, artists in Egypt, like artists in the United States, had to rely on spouses or other employment to get by (see Plattner 1996). Those who did sell enough on the private market to support themselves were not about to reveal their sources.

Raymond Moulin (1987) discusses secrecy as a primary feature of art markets, particularly among dealers and collectors. Egypt was no exception. Sometimes, art collectors did not like to discuss their activities outside of their social circle. Many collectors were nervous that their collections were not up

to snuff. Some artists suggested that collectors were reticent about showing their collections to me because they presumed that as a Westerner or specialist in art, I was more expert than they were and feared that I might potentially pronounce a negative judgment on their taste and acquisitions. This might very well have been the case in some situations, particularly those where I did not reach the collector through mutual friends and acquaintances. Artists and some collectors also suggested that the secrecy was related to fear of the evil eye (*hasad*); if someone envied a collection, the collector might be harmed.

Gallery owners, more than anyone else, contributed to this secrecy surrounding the art market. They often did not tell artists who bought their work, in part because there was considerable leeway in such a market for artists to sell directly to buyers and little recourse for gallery owners who lost sales in this way. In fact, there was no such thing as gallery representation of a particular artist until just after 2000, and then only in the increasingly competitive world of downtown galleries and foreign curators, which I document in Chapter 6. Gallery owners were also reluctant to give me the names of their customers, and one expressed total shock that I had asked him. They carefully guarded collectors' names, because the market was so tight and sources of capital hard to come by. They were also secretive about the extent of their sales. It is quite likely that some gallery owners were nervous that I was mining them for this information with a view to starting my own gallery.

These experiences led me to believe, along with the artists, that there was no real art market in Egypt. Although I sensed that the private sector art market was growing in an unprecedented fashion beginning in about 1998, it took me nearly three years to realize that a significant group of collectors did exist, but that access to them was not to be gained through artists or the gallery channels. I started calling all the rich people I knew in Egypt and asking them if any of their friends or family members had bought art. Within a few days, I had a list longer than I could have hoped for.

COLLECTING AND DISPLAY IN EGYPT

This chapter examines the growth, beginning in the 1990s, of art collecting and display among Egyptians. This was the time of intensified economic "reform" under the rubrics of open markets and privatization. Westerners (many of them newcomers to Egypt) mistakenly thought that the burgeoning of cultural activities in the private sector was largely due to the progress of freedom and capital. However, the surge in private collections discussed here, and in

the private sector art market discussed in Chapter 6, also resulted from public sector programs, including intensified government support of and attention to the fine arts; government encouragement of private collecting; and government economic reform programs that assisted the growth of expendable and investment capital. Government support of the fine arts produced a category of "young Egyptian artists," which was then taken up by the private sector and turned into a market. In the 1990s, state actors also began to encourage private collecting by publishing articles in the state newspapers calling on the public (especially the new neoliberal elites) to invest in art, and by opening a museum dedicated to Egypt's "first" collector—Muhammad Mahmud Khalil—and publishing books on his collection (al-Jabakhanji 1995; Salmawy 1995). The private sector market grew exponentially in the form of tens of new galleries. It was motivated and energized by the capital created by the market liberalization and development programs, which concentrated wealth in the hands of few Egyptians, and by all of the foreign diplomats and Western contractors who came along with these programs. The interest in art collecting and display also reflected changes in the composition, aspirations, resources, and expressions of many elites.

To better understand these political aspects of art collection, and their connection to the poetics of collection and display among particular collectors, it is necessary to push much of the existing scholarship. Most of the work on private collectors has been done on Western contexts.[2] Moreover, it is limited in its applicability, because it tends to focus on "motives," "impulses," and the "obsession" to collect.[3] One could argue that such a theoretical emphasis on motive makes sense, because it is (perhaps) the dominant feature of Western collecting practices. However, it is worth thinking about what aspects of collecting we may perhaps miss or misunderstand in this analytic focus on motive, impulse, and drive. One of the things we might lose is an appreciation of the possibilities contained in different genealogies of the modern, and how collectors in different locations might reckon with those. Oscar Vázquez has argued that studies of the motives for collecting "presuppose an imaginary essential collector, much as the motivations of artistic intention presuppose an imaginary, essential artist" (2001:3). Both presuppositions end up "fixing" artists and collectors into certain social categories, which often have more to do with our own desires than with what artists and collectors are actually doing—especially those in Egypt. In Chapter 1, I showed how Enlightenment theories of the artist impede our understanding of Egyptian

artists. We also need to "provincialize" European-derived theories of art col-
lecting (cf. Chakrabarty 2000).

It is problematic at best to attribute a subconscious obsession with collection
to Egyptian collectors, or to assume that they have some unitary motive that
drives them to collect. Furthermore, collecting cannot be reduced to a function-
alist story of calculated class distinction and identity, a reduction that Bourdieu
is often thought to make.[4] Art collecting and display in Egypt were not simply
an "expression" or "reflection" of identities (class, national, gender, etc.). Such
a formulation often assumes a one-to-one correlation between aspects of the
artwork and its display and aspects of identity, and assumes that artworks and
people's identities have unitary meanings. Additionally, the mechanics of the
art market cannot by themselves explain the dynamics of collecting and display
in Egypt (cf. Moulin 1987; Plattner 1996). It is not that motive, art collecting
as calculated class distinction or expression of identity, or art markets are not
important. To some extent, the scholarship on these things informs my analysis
here. However, I see the practices of art collecting and display in Egypt as more
multifaceted and complicated than any of the oft-used theoretical frameworks
and topical foci allow for, partly because these practices were reckonings with
different constellations of the modern from those available to Western collec-
tors. They simultaneously included postcolonial, nation-oriented ideas of au-
thenticity, progress, and decline; the legacy of socialism; growing public piety;
Orientalism; classicism; and avant-gardism, among other things.

In this chapter, I aim to illuminate the multiple, sometimes contradic-
tory, poetics and politics of collecting and display—the connection between
meaning and power, between signification and processes of social change and
domination. Inspired by Arjun Appadurai's seminal query into the social life
of things (1986), I examine the many ways in which objects communicate,
create, and or were used to organize meaning and value, and the connec-
tion between this process and the (re)production or challenges to elite power
throughout the major economic, political, and social transformations that
have taken place in Egyptian society since colonialism. My field research on
this topic focused on the objects that people collected (kind, style, price, age,
etc.), how people displayed objects as part of a larger system of décor, and
the value and meaning they gave to objects and patterns of display.[5] I was
also interested both in the ways people narrated their collections and in the
relationship between their presentation and the aesthetics of the way they re-
ceived me in their homes. These field inquiries form the basis of the following

analysis of how Egyptian collectors created social connections and distances through the social life of objects, how these practices were related to their social backgrounds and political outlooks, and how collecting as a practice was connected to, even constitutive of, the larger political and economic processes in modern Egypt—primarily Nasserism, class transformation under market liberalization, changes in the urban landscape and its visual culture, the development of state cultural policy, and nationalism.

To get at these connections between poetics and politics, it is useful to look carefully at four cases of collectors who had different backgrounds, worldviews, and interests in art.[6] Two were from the old landowning aristocracy, but one had become a capitalist entrepreneur. Two were intellectuals, but one was from the older generation and the other was a returnee who had spent many years in Europe and the United States. To a large extent, these individuals shared with their social circles particular tastes, meanings, and values ascribed to art, and their connection to larger political outlook. Rather than insisting on a one-to-one correlation between their social status and their art collecting, however, I try to use the complexity of each case to discuss the role of collecting and display in specific elite Egyptians' reckonings with genealogies of the modern, and their relationship to elite domination. The evidence suggests that the role of art was quite significant to the reproduction of nationalism and elite power, and indeed was becoming more so as the Egyptian economy was further opened to global capital.

Art collections in Egypt were ways of organizing the meanings of social change, of making sense of the processes of decolonization and capitalism in Egypt, and of creating modern national identity. They acted as metaphors for an ideal world in which collectors had control over these processes and the social relations they engendered, in ways that have been described by Susan Stewart ([1984] 1993). Collectors were able to create this ideal by creating strict boundaries (through objects and décor) between the chaotic exterior and the safe, ordered, and "civilized" interior of the home. Collections were thus strategies of "containing" low- and middlebrow taste (see Ross 1989). They also created set relations between things that stood in for shifting social relations between collectors and other Egyptians. And they "fashioned" themselves as art producers who had "captured," arranged, and manipulated the unique collection (S. Stewart [1984] 1993:157–64). It was in this self-fashioning, this working out through objects of the social "problems" brought forth by decolonization and capitalism, that collectors formulated their subject positions.

Through art, elites could emphasize "good" family and friend connections, and therefore high taste and discernment. They could also claim that Egypt now had a high culture of its own, as evidenced in its art. Collecting Egyptian art was also a way for elites to claim Egyptianness against populist charges that they were too Westernized. Also through art, elites could reference an era in which they imagined that such social and taste hierarchies were stable, an era in which the "negative" effects of their own capitalist activities were not seeping into their public and private spaces. This was akin to "imperialist nostalgia," or "mourning what one has destroyed" (Rosaldo 1989). Elites could look at paintings and objects that, on the surface, denied the poverty, pollution, population growth, public religiosity, and other important aspects of contemporary life in post-*infitah* Egypt.[7] Similarly, techniques of display and décor that emphasized interiority and a radical distinction from the outside created the illusion of a protected space in which elite power was not challenged, and in which disturbing relations of production were nearly erased. Their understanding of beauty in the home operated in a way like the aesthetic described by Terry Eagleton for Europe. It was "conveniently sequestered from all other social practices, to become an isolated enclave within which the dominant social order can find an idealized refuge from its own actual values of competitiveness, exploitation and material possessiveness" (Eagleton 1990:9). Also through art, elites could emphasize their own "liberal" outlook, and/or their view that art (and their appreciation of it) represented civilization or progress. They then constructed as their burden the "mission . . . to uplift" the rest of Egyptians who, in their view, did not appreciate art (Rosaldo 1989:108). Non-nostalgic art collecting among young (often returnee) collectors also created social difference even as it celebrated it, and the elitist nature of liberalism as it played out in Egypt became immediately apparent.

Art collecting and display in Egypt was thus not necessarily about the obsessive desire to own things; nor was it merely a calculated practice of class distinction or assertion of status. Art collecting and display was a mode by which different elites came to terms with the specific and quite dramatic social, political, and economic changes that characterized post-independence Egypt. As we shall see from the four case studies, they did so in individual ways that also connected with larger projects, most notable among them the quest to attain or maintain control over social change and also paradoxically find refuge from it. However, they were not always successful. Although serious social hierarchies persist in Egypt, partly due to the practices of art collecting and display

that I analyze here, these practices could not completely keep at bay the challenges to elite tastes, power, and worldviews. As I shall show, some of these challenges even "infiltrated" the deepest interior of the home.

NEW THINGS ARE TASTELESS

My visits to collectors' homes always involved a major shift in my material comfort, as well as awkward attempts to play the part of a wealthy foreigner living an effortless life in Cairo. Even though I am much better off than most Egyptians, I still felt the radical disparity between my Cairo lifestyle and that of the collectors—with their many servants, private cars, and luxurious apartments. I often carried a comb and wet-wipes in my purse and surreptitiously tried to erase the wind-blown and grimy effects of my dusty, hot taxicab rides to their residences. At the end of an interview, if someone asked if I had "my driver" or "the car" with me, I was embarrassed to admit that I had come by cab—even though most Egyptians cannot even afford to ride in one.

But one evening in the taxi, I did not have this feeling. This was simply because the address was downtown—in a crowded, commercial area of Cairo abandoned long ago by Egyptian elites for fancier, quieter, greener neighborhoods like Zamalek, Maadi, Muhandiseen, and Heliopolis. It was surely an unusual address for an Egyptian collector, because most of the apartments in the area had either been turned into legitimate office space or illegitimate one-hour-to-one-day "rentals." However, as I climbed the wide marble staircase of the European neoclassical-style building and noted the fancy ironwork handrail, I realized that the tenant I was going to visit must be one of the only ones left from the earlier days—back when the old aristocracy had occupied these apartments, when the staircase was well-lit, without piles of trash, and the place did not have an abandoned feel to it.[8]

As I neared Nabil Gabriel's floor, I saw that the sole light in the whole building was coming from the glass-paned door of his apartment, which had highly polished wood and clean, frosted glass. The entrance was distinctively marked by an engraved brass plaque bearing the family name, vibrant plants next to the door, and a welcome mat. I rang the doorbell, once again nervous about the effects of the taxi ride on my hair and makeup. A butler answered. I was escorted into a salon that was like stepping back in time, save for the television set placed awkwardly amongst the antique "Louis" furniture set reproductions.[9] It was a meticulously maintained apartment that had many of the original features that one would have found in an elite home on the

eve of the 1952 revolution: crystal chandeliers and wall sconces; gilded chairs with floral embroidered seat cushions; oriental rugs; ornately carved oak hutches; glass vitrines displaying objets d'art; and paintings and etchings in gold frames. Everything was polished to the hilt (fig. 5.1).

I sat awkwardly on one of the chairs and awaited the entrance of my interviewee, a friend of a friend. He came and introduced himself in English, wearing a pressed shirt and slacks with fancy leather slippers. Suddenly, a maid arrived and he asked what I would like to drink, listing as the options cappuccino, espresso, and whiskey. Not the simple pot of tea that an artist would automatically put on the stove at my arrival. He mentioned that the coffee came from Europe and seemed to take pleasure in showing me he was liberal enough to have whiskey in the house. I soon met his wife and children, who all spoke impeccable English with me and French with one another (the use of French among Egyptians of this social background being quite common). Indeed, very little Arabic was spoken throughout the night, although it was clear that Gabriel himself (at least) was fluent in it. Throughout the evening, I was offered special drinks several times, as well as chocolates wrapped in fancy foil out of a crystal bowl.[10] Over the course of my research with collectors, it

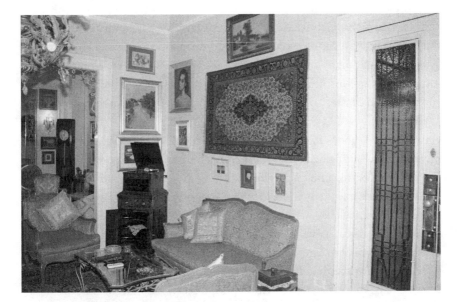

Figure 5.1 Nabil Gabriel's entrée.
Photograph by Muhammad 'Abd al-Ghani.

became apparent that the aesthetic of reception in these homes mirrored the philosophy of collection, the choice and presentation of artworks, and the aesthetic of reception in the galleries they frequented. People of Gabriel's social background often visited galleries in the upscale neighborhoods, where visitors were often offered chocolates and, if they stopped to buy, drinks like juice or cappuccino. The artwork at these galleries was usually of the *asala* variety (see Chapter 2): paintings of landscapes, peasants, flower and fruit still lifes, some Pharaonic imagery, and some portraits of society figures. These paintings were either by living or deceased artists; the latter generally sold for a higher price.

Gabriel told me that he did not really visit art galleries because he "did not have the time." He was more interested in collecting antique objects, in line ideologically with his careful maintenance of his inherited art collection. His father had been a well-known art critic and had been close to many of the "pioneers" (*ruwad*) of the first and second generations of Egyptian artists. These artists had often given gifts of paintings and sculptures to critics like Gabriel's father (a practice well known in the United States too). Thus, Gabriel had inherited an impressive collection of what is now blue-chip Egyptian art. Like many other collections, this one had been built in part through friendships and connections with artists.

The values that Gabriel attributed to his family's collection were the same as those that drove his collection of antiques, and were part of a larger worldview shared by many old-money elites in neoliberal Egypt. Collecting was a major part of this group's social practice of distinguishing themselves as those who have taste, in contrast to other Egyptians (usually the lower classes, the middle class, and the nouveaux riches), who they thought lacked what Gabriel called "the trained eye." But the classification of the vast majority of Egyptians as lacking taste was not merely about upper-class, old-money distinction. Collecting and displaying art (and antiques) were also a major way of organizing meaning in a world where the upper class had less control over public life, even if they maintained many of the privileges that they had enjoyed for decades. It was also a way of coming to terms with the fact that capitalist development in Egypt—which they promoted and took advantage of—produced unexpected and uncontrollable results in public spaces. The most important of these included a rise in public piety, most noticed in dress and the blaring loudspeakers of thousands of new mosques; population growth and migration to the cities (tied to increasing lack of economic security); the

spread of cheap consumer goods (many imported from Asia); television soap operas and pulp print literature; pollution; and "haphazard" urban development. Just as these post-*infitah* aspects of Egyptian life troubled artists' senses of taste, as discussed in Chapter 4, they also posed a serious challenge not only to collectors' taste but also to their preferred modes of behavior and comportment and to their worldviews in general. Through art collecting and display, ideal models of the world were erected in elite homes—models in which the place of nonelite Egyptians was clear and controlled, and in which the objects they produced were sifted through in a process that focused attention on the collector as the "real" selector, the "real" producer. But collecting was not just about the creation of the individual collector (see S. Stewart [1984] 1993); it was also about the assertion of distinctive families (cf. Marcus 1992).

Almost all research on art collecting and display shows that they are key distinction-making activities. One of the main ways in which this distinction was marked in Egypt was by reference to a long family interest in art that went back decades. I usually began discussions with collectors by asking them how they got interested in art in the first place. Most collectors immediately talked about how art had always been important in their family. They often mentioned the broader social circles of which their families were a part as evidence of the art-friendly milieu in which they had grown up. Gabriel said that his mother had "initiated" him when he was a young boy, and that his father was an art critic who was friends with some of the most important artists of his time. Gabriel also spoke proudly of his family's relationship with the famous Egyptian feminist and society woman Huda Sha'rawi, and he later showed me a photograph of her with his father, which she had dedicated to him in French as her "chargé d'affaires." I suggest that collectors' constant reference to their families was a combination of the kind of elite emphasis on lineage that one finds in New York high society (e.g., the Astors and the Rockefellers), along with what might be called an Arab emphasis on purity of descent and nobility of lineage (see Abu-Lughod 1986). The immediate and primary focus on family as pivotal in aristocratic Egyptians' understanding of their art collecting and display was a culturally specific mode of distinction in other ways as well.

While Gabriel was talking about listening to his father explain paintings to their guests as a boy, I asked if formal education had also helped him appreciate art. He said no. By emphasizing their families rather than school, collectors could show that their taste was inherited, not learned or acquired. Bourdieu argues that only the highest French elites can claim inherited or

innate taste, and it is the social incontestability of innate taste that enables the reproduction of their power (1984). Similarly, though not in the same way, the old-money Egyptian elite viewed learned or acquired taste in art as second-rate. (Notable exceptions to this valuation were artists and art professors, whose acquired cultural capital was accepted and respected by old elites, as evidenced by the fact that many of them spoke very highly of their taste and collected their art.) They had an extremely negative view of the quality of the public education system instituted after colonialism, which has been a major factor in the presence and proliferation of lower- and middle-class tastes in public spaces. Indeed, elites' denial of formal education's influence on their taste can also be interpreted as their negative judgment of the project of Nasserist socialist public education to inculcate true taste among the masses, despite their acceptance of artists' educationally acquired taste.[11]

Indeed, when collectors talked about their parents' and grandparents' jobs and friends, they were also referencing a connection to prerevolutionary high society—a connection that carried with it a certain kind of prestige, nostalgia, and judgment about revolutionary ideology and what came after. "Things were different then," they often said nostalgically, sometimes using as an example their view that the arts were more appreciated in wider society. Many of these collectors thought that the revolution had politicized art and taken away its beauty, and that later developments (e.g., the open-door economic policy) had exacerbated what they called a "decline" in public taste. When I asked Gabriel his opinion of aesthetic appreciation in Egypt, and whether or not it had changed over the years, he said, "You want to know the truth? The truth is sad. It's very sad. The Egyptian eye over the years has lost its training. . . . it doesn't pay attention to details anymore, to perfection anymore, to beauty anymore."[12] It is not only through reference to their families that old-money elites created distinction and commented on postcolonial Egypt. It was also through what they collected, how they displayed their collections, and how they talked about the objects themselves.

Gabriel showed me each antique piece in his house by touching it or picking it up with his hands. Similarly, nearly all collectors I met touched the surfaces of paintings and sculptures as they showed them to me. This may be related to the fact, discussed in Chapter 1, that artists believed in touching artworks to understand and appreciate them. It also challenges Bourdieuian claims that elites engage with art through the mechanism of a "pure gaze" (1983, 1993). In this case at the very least, I think that this touching was also

related to the ideological valorization of manual craft and a desire to have a social connection with "distinctive" craftspeople. The effect was to replace these craftspeople with the collector as the "real" producer. It was important, however, that these craftsmen were viewed as having some genius or talent. They were not the (potentially uncouth) laborers who made floors, appliances, and so on. Gabriel explained why he loved his objets d'art and why he continued to display his father's collection of classic Egyptian paintings and sculptures (he had not sold any of them):

> [An old thing] reflect[s] the personality, the time, the effort, and the genius of the person who made it. Because it was done at the time with some sort of a conscience, or some sort of a print . . . the person puts his fingerprints on it, in a manner that's exclusive and not reproducible. . . . And every time I see a piece of work that's old I feel I'm connecting with the person who made it. . . . I don't know who this person is. I'll probably never meet that person, but it's a nice feeling.

And later that evening, he said: "New things are tasteless."

In these statements, Gabriel was not offering a Marxist critique of capitalist alienation, but rather fetishizing the collection. Susan Stewart writes that the "further the object [in the collection] is removed from use value, the more abstract it becomes. . . . The dialectic between hand and eye, possession and transcendence, which motivates the fetish, is dependent upon this abstraction" ([1984] 1993:164). Gabriel's interaction with his objets d'art clearly shows this dialectic at work. Collections like these, through the fetishization as objects, often serve as "metaphor[s] for the social relations of an exchange economy" (S. Stewart [1984] 1993:164), and in the process, as ways of controlling and taking advantage of those relations. Gabriel's description of how his desire to connect with the makers of objets d'art related to his larger worldview illustrates the ambivalence felt by such elite art collectors about the social effects of capitalism: "I believe that lately the world is going towards an eradication of personality. People . . . just follow the trend. So where is your personality? Where is my personality? Where am I in this? Where is my choice? . . . That is the unfortunate current business reality today that says we need to do things faster, better, and with less and more. It's a very sad business reality."

For some art collectors, then, collecting was a means to reclaim the distinction, and perhaps the master-servant relations, of a different era. But this reclamation was asserted in the language of capitalism itself, in terms of possessive

individualism and choice. "I think the whole experience of art . . . is the pride of ownership," Gabriel told me.

Through art objects, many collectors claimed connections with ordinary people, even as they simultaneously isolated themselves more and more from the rest of Egypt in gated communities, elite resorts, and luxury apartments.[13] In preference to actual connections with lower- or middle-class people, collectors claimed to discover "exceptional" ordinary Egyptians who were personally unknown to them by acquiring objects the latter had created. This kind of connection to an unknown person through an object was also preferable than an actual relationship with a lower- or middle-class Egyptian. As Susan Pearce says of collections, "detached from any context, they are removed from the sphere of actual social relationships with all the tensions, efforts of understanding and acts of persuasion these imply. This detachment is, indeed, a very substantial part of the attraction for their collectors who use them to create a private universe" (1994:200). Detachment was important for attachment to be made, and particularly attachment to an imagined national community.

Indeed, an important way in which many of these collectors were different from their counterparts discussed in the literature on Western collecting and distinction was that they constituted national identity through collection of objects.[14] It was important to nearly all the collectors I met to think of themselves as simultaneously part of Egypt and better than their compatriots. They felt themselves superior to other Egyptians in part because, in their view, they were innately able to discern the beautiful. Here again we see that the critique of capitalism was more often than not simply nostalgia for precapitalist power relations and systems of prestige. In post-*infitah* Egypt, Gabriel competed with collectors (perhaps originally from lower classes) who could *buy* bigger and better collections without having a real appreciation of them. Thus it was necessary to emphasize the supposedly innate ability of discovery. Discussing his "finds" in out-of-the-way places, Gabriel said, "It's the gratification of finding something rare, and having the ability of bringing it up from the middle of nowhere into an exhibition place where hundreds can admire the object."

By displaying their unique objects to friends and acquaintances, Gabriel and others like him not only established themselves as part of an exclusive community within the general population. Through discussing these objects, they participated in that community, and reproduced ties within it. Gabriel told me that he always gave visitors a tour of his collection, adding, "I have people who come on a regular basis, and they say, 'Since the last tour, what's

new?'" A community of art lovers and people of distinction was thereby created through repeated social visits and discussion about art. Even children became socialized into the community in this manner. Gabriel and his wife spoke proudly of a time when he had been away on business and his young children had given "the tour" to some guests.

An important part of "the tour" that his children heard taught them to think of Nasser differently than most Egyptian youth, who revered him for what they saw as his valiant fight against prerevolutionary class oppression and Western domination. With his son trailing right behind us, Gabriel pointed out several paintings by the famous artist George Sabagh (1897–1951). Before commenting on the pastoral subject of the work, he told the story of how "[the work of] Sabagh was nationalized by Nasser." He asked me if I knew what "nationalized" meant but didn't wait for an answer: "Nationalized means that the government will step into your home at 3 o'clock in the morning, take away everything and throw you out of the country, if you're a foreigner. If you're an Egyptian, they will take everything and keep you in the country, with a ten-pound-a-month salary."

Like many families of the old moneyed classes, Gabriel resented the Nasser government's sequestration of their private wealth and what he saw as low government salaries that did not do much for the population. Gabriel said that Sabagh, since he also had French citizenship, had thought that a newly independent government would take his works, so he had hidden them with Gabriel's father. And this is how, Gabriel said, "he grew up with Sabaghs all over the place."[15] Here we see that the movement of art objects, their collecting, and their display were part of political and social memory passed down to future generations, and therefore part of the reproduction of a group's identity as distinct and superior. Artworks were also a key part of the formation of political ideology and worldview. They continued to shape the way in which social change was understood and also provided models for social interaction.

Gabriel contended that the Egyptian eye had lost its ability to discern good taste in part because of popular culture like television—a medium that became widespread after *infitah*. At the beginning of our interview, he said that television was largely responsible for the downfall of the country. He told me that he knew this because every week he went to the family's estate (*'izba*) in the Delta,[16] where there were at least 150 peasants working his land—"peasants like the woman who brought you coffee"—and he could see that they had been ruined by television. Not only was he drawing a distinction between the art on

his walls and the television sets in peasant homes (conveniently ignoring the large television set within our reach), but through reference to the woman who had brought me coffee, he was also using distinctions between material objects as a blueprint (or justification) for hierarchical social interaction. The woman, it need not be said, did not speak the entire time I was in the house. Another nameless peasant woman was represented in a sculpture in the dining room.

In Gabriel's narrative, villagers like this one no longer possessed the ability to discern beauty (if they ever had).[17] When art was being used to draw a contrast between elites and peasants, it was also being used to draw a contrast between the present and the past—a past when (elites imagined) the countryside was idyllic. In the present, they saw peasants infiltrating the city, and consumer goods polluting the "purity" of the countryside. During the tour, Gabriel asked if I had ever heard of a place called Shubra. Shubra is nationally famous for being the most densely populated area of Cairo, and for being a *sha'bi* (popular, of the masses) neighborhood. It used to be a country playground for Egypt's royal family. Gabriel then pointed to a large gravure, hung above several others with similar scenes, and said that this was Shubra "back in 1923." It had been done by one of the first European professors at the Cairo College of Fine Arts, and Gabriel called my attention to the fact that it had a signed dedication to Prince Yusuf Kamal. I remarked that the prince had funded the college for the first twenty years. He seemed less interested in my retelling of this history than in getting me to recognize the difference between the Shubra of the past and that of the present. "It's amazing what Shubra looks like now," he said. The difference between the Shubra of today and the Shubra of colonial times is indeed extraordinary. But his choosing to call attention to an engraving of the old Shubra and discuss it in this way had more meaning than just the pointing out of a visual contrast. In the context of his tour, the visual change was used to call forth a whole set of other contrasts between people, places, and time periods that then signaled an entire regime of taste and hierarchy of values. It was important for Gabriel that I, the receiver of this narrative, understand its significations. Here, as is often the case, the collection did not "displace attention to the past"; rather, the past was "at the service of the collection," as Susan Stewart puts it ([1984] 1993:151).

The next two collectors that I discuss also communicated nostalgia as they spoke of their collections of old paintings, antiques, or new paintings that they thought had an "older spirit." Drawing on Susan Stewart's 1984 book *On Longing*, Kathleen Stewart (1988) argues that "positing a 'once was' in relation

to a 'now' . . . creates a frame for meaning, a means of dramatizing aspects of an increasingly fluid and unnamed social life. . . . To narrate [nostalgia] is to make an interpretive space that is relational and in which meanings have direct social referents" (227). For many Egyptian elites, narrating nostalgia through art was a way of linking oneself to families and social circles whose value (they imagined) had once been stable and not subject to populist critique. It was also a time when power and prestige were more a matter of inheritance than in the era of neoliberal reform, when they could be acquired by self-made millionaires.

The purchase and display of older (often pastoral) works, and the nostalgic narratives attached to them, enabled elites both to criticize the uncomfortable effects of the capitalist economy that they dominated and also to keep alive a vision of Egypt that was devoid of those negative effects (cf. Rosaldo 1989). I would even suggest that visions of a bucolic countryside in particular (rather than one suffering from tremendous poverty) were needed in order to excuse or justify their actions and position as elites morally. As we shall see more with the next collector, such visions could also serve to affirm collectors' Egyptianness in the face of populist charges that they did not have Egypt's best interests at heart or had become too Westernized.

When I left Gabriel's apartment, and descended the dark, dirty staircase, it occurred to me that much of what the family had said was related to this stark division between outside and inside in the building. Through Gabriel's collecting and display, they were not simply creating their identities as a distinctive social class. They were also trying to create a distinction between the inside of their home—a space over which they had almost complete control—and the outside city streets where they had much less control. In the streets and alleys around this apartment building were beggars, illegal peddlers, men and women in Islamic dress, prostitutes and their clients—people whose way of dealing with the economic stress caused in large part by elites was found extremely distasteful by them. Thus, art collecting, display, and décor in general were strategies by which many elites created a space of distinction that was intended to be impervious to outside forces that they not only despised but feared would spin out of control. Susan Stewart ([1984] 1993) has discussed how collections emphasize a kind of interiority and sanctity, but they also threaten to imprison. That seemed to be happening here.

After I left the apartment, I noticed that Gabriel had not turned on the outside hallway lights for me. Neither had another francophone collector,

who lived in a similar kind of building, when I visited her earlier in the week. I wondered whether this was an accident. It certainly was uncommon among Egyptians. It seems to me that, accident or not, such an oversight reveals the way in which for these collectors, the apartment door was the boundary of taste and consideration, by which there was an attempt to mark a distinction with an outside world that had increasingly become a polluted (and polluting) space for these people.[18] But that world was creeping in. In both of these visits, the collectors said that they did not like to open their windows because of the noise and pollution outside. Gabriel's apartment had heavy drapes over all of his closed windows to prevent the dust from coming in—dust from the desert that is turned black by industrial and car pollution. He was annoyed that these drapes still did not keep the insidious dust away and explained that he kept some of his collection in glass cases to "try to keep the dust away." This inherited apartment in a part of Cairo long ago abandoned by the aristocracy was maintained by a steady flow of the owner's new money, acquired through international development and business work. But even that money could not keep the outside from filtering in.

ONE GETS TIRED OF THE PASTORAL

I took a cab to Zamalek to meet Muna al-Sawi, the middle-aged aunt of an Egyptian friend of mine who lives in the United States. Al-Sawi had recently started building a reputable and expensive collection of modern Egyptian art. Zamalek, where she lived, is a leafy island in the middle of the Nile, where many people from the old aristocracy or landed gentry inhabit spacious apartments in neoclassical buildings on quiet streets. Sons and daughters or grandchildren of the prerevolutionary aristocracy still lived in many of these apartments, or they rented them out to foreign residents in Cairo such as diplomats, journalists, and academic researchers. Al-Sawi's family's flat was premium property, because it overlooked the Nile, was in a well-kept building, and was quite large. The family was able to maintain the luxury of the space through their successful agrobusiness ventures. Many prerevolutionary large landowners had also been able to evade Nasser's land redistribution measures and make it through to the Sadat and Mubarak years, when their wealth and connections enabled them to secure the best business contracts newly available (see Hussein 1973; Mitchell 2002). Al-Sawi's family became a major importer of farm machinery and still had an estate in the Delta, on which they grew exotic fruits and flowers for export to Europe. Like

many well-off Cairenes, her family also owned homes in seaside resorts on the Mediterranean and at al-Guna, on the Red Sea coast. Al-Sawi's art collection was distributed throughout her four homes and her office.

Al-Sawi answered the door dressed impeccably in a blouse, skirt, and low heels, and she clearly frequently visited a coiffeur who straightened and cut her hair into a stylish bob. She greeted me graciously and escorted me into one of a few seating areas in that part of the flat. These were little groupings of faux eighteenth-century "Louis" chairs and small tables that dated from at least the 1950s, if not before—similar to those at Gabriel's house and very different from the garish imitations made in workshops in Damietta bought by middle-class families. Each salon area in al-Sawi's house seemed ready for tea served on china at any moment. Instead of the fluorescent lights found in most homes in Egypt (from those of the rural poor to those of the urban middle class), al-Sawi had crystal chandeliers. There was no television set in sight that I remember. Many paintings had individual lights placed over them. Drapes framed the view out over the Nile.

Al-Sawi immediately started talking gregariously, in fluent English, about the art on her walls. There were a number of European paintings done in the classical style, such as still lifes. She told me that these were part of her mother's collection and that such paintings used to be all the rage. But then, she said, European works became "unavailable," and people like herself started to "discover" Egyptian art. This vaguely referred to time of "unavailability" coincided with the worldwide explosion in prices for European art in the 1940s and 1950s and the Nasser government's sequestration of European artworks owned by the aristocratic elite. It also coincided with the Nasserist shunning of what were conceived to be Westernized lifestyles and the state's encouragement and veneration of modern Egyptian art. Thus, al-Sawi's subsequent interest in Egyptian art likely stemmed from the way the Nasserist revolution had affected her family, its lifestyle, and its wealth.

Her interest was also cultivated by several owners of high-class galleries that had a similar aesthetic to her apartment. Al-Sawi was especially influenced by the opinions of one gallery owner in Zamalek who had cornered the market in blue-chip works by the "pioneers" (ruwad) of Egyptian modern art. The gallery owner gave al-Sawi books on the pioneers and advice about her collection. Al-Sawi referred to her frequently throughout my subsequent tour of the house, and it was clear that the gallery owner had a large influence on her choices and interest in building a "good" collection of Egyptian art.

Once when I was visiting with this gallery owner, an art critic came in to shoot her weekly television show in the gallery. After exchanging pleasantries, the critic said that she was concerned that the gallery owner was selling Egyptian art to foreigners who took it out of the country. In the critic's view, such art was part of the national patrimony, which should remain in Egypt. Like many other Egyptian artists and curators, she also thought that such works should not be in private collections, because then "regular" Egyptians would not have access to them. In contrast, private collectors thought that they could better protect the works than the bureaucrats at the underfunded state offices.[19]

The art critic was particularly concerned over a rumor that the painting *al-Dalala* had left the country. The gallery owner assured her that that particular painting had been sold to a good "Egyptian girl" who lives "right here" on the Nile (the Nile being a metaphor for Egypt). You can imagine, then, my excitement at the coincidence when al-Sawi started her tour by showing me this very painting, hung prominently in the entrance hall to her apartment. So this was the good collector who had purchased one of these famous pieces that the art critic thought should be kept by the state so that the public could view it! *Al-Dalala* is a very famous and much sought-after painting done by al-Husayn Fawzi in 1940,[20] and it was al-Sawi's first purchase of such magnitude. The painting is of a *dalala*—the name for a tradeswoman or dealer—showing her wares to the lady of the house (fig. 5.2).

I asked al-Sawi what she liked about the painting. She immediately replied, "It's a very Egyptian scene." As evidence, she pointed out the incense burner and prayer beads on the chest, and the *dalala*'s handmade basket. Here we see a collector recounting her interest in something as stemming from its Egyptianness, which could (perhaps rightly) be understood as reflective of her pride in her culture and heritage, and in Egyptian artists who express them. After all, she did not spend such a vast sum of money on a European scene. Nonetheless, the painting depicts, and al-Sawi presents, a very particular imagined version of Egypt. It is a scene from colonial Egypt—probably from the 1910s or 1920s. This was a time when it was improper for elite women to appear outside their homes, and in which lower-class *dalalas* peddled their wares to women who had the "luxury" of living in seclusion. The woman purchasing cloth is most likely part of the new bourgeoisie that emerged in the first part of the twentieth century, and that is depicted by Naguib Mahfouz in his novels as embodying the transformation from Ottoman decadence to nationalist dedication. The *dalala* is portrayed as darker-skinned—a marker of lower status

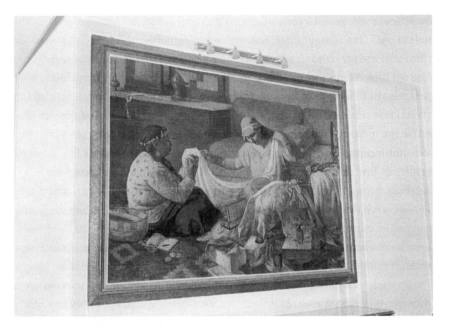

Figure 5.2 Al-Husayn Fawzi, *Al-Dalala*, oil on board, 1940.
Photograph by Muhammad 'Abd al-Ghani. Courtesy of Nadia Mostafa.

then and now—while the elite woman has lighter skin (and the light falls on her in the painting). In style and subject matter (an intimate portrayal of the harem life), this painting is a local version of European Orientalism. What to make of al-Sawi's categorization as "very Egyptian" of a painting that has the capacity to reference a complicated history of class and racial hierarchies, and that recalls European paintings that produced a whole repertoire of visual stereotypes of the Orient? How do we understand her willingness to purchase such a work for more than 100,000 Egyptian pounds?[21]

In the past two decades, there has been a massive growth in Arab elite interest in the work of European Orientalists (both originals and copies). Christa Salamandra (2004b) argues that Arab consumption of such art should not be read as evidence of culturally "naïve" elites being "duped" by gallery owners into buying stereotypes of themselves, but rather as a "paradoxical" search for a premarket authenticity articulated through market flows themselves. Collectors often locate this authenticity in the "realistic" details of the paintings (see also Scheid 2005). We could read al-Sawi's insistence on the typicality of the scene in *al-Dalala*, as evidenced for her by the details of the incense burner,

basket, and so on, as a yearning for a kind of authenticity that precedes the market her family had been intimately involved in building, and that enabled her to buy such an expensive painting in the first place. Calling something "typical" is also to construct a stereotype, which is less distinguished by its falseness than by its attempt to "fix" inherently ambivalent social relations (cf. Bhabha 1994; Scheid 2005). An idealized interpretation of a *dalala* and her elite customer elides the ambivalence of inequality—not only between these two subjects but also between the collector and those who work for her (and, by extension, between rich and poor in Egypt). When al-Sawi collected the work, it temporarily exited the market. This further enabled an interpretation that emphasized "fixity" through the eliding of market relations both in the painting and around the piece itself in the space of the home. Al-Sawi was quite keen to further "fix" the work. She worried that the panels of the painting were coming apart and was looking for a top-quality restorer to repair it.

It is very important that al-Sawi also definitively stated that this painting was typically *Egyptian* and by an *Egyptian*. This emphasis is thus a bit different from the cases of Arab consumption of European Orientalism studied by Christa Salamandra (2004b) and Kirsten Scheid (2005), through which there is often a creation of a generalized Orient, or an imagination that "perhaps" the scenes represent a particular period of Islamic empire. Here, however, the language of Orientalism communicated to the collector a specific place that she called her home, and she was proud to own a painting by an artist from that place. Just as the Orientalist style can be interpreted in a way that elides uncomfortable hierarchies and ambivalences, it also acts as a specific cultural locator for a viewer who would be accused by many Egyptians of not being really "Egyptian" at all. Orientalism, in the painting and in al-Sawi's appreciation of it, thus carried another set of meanings than it did in the context of European art (cf. Beaulieu and Roberts 2002).

In her discussion of Lebanese collectors of Orientalist art, Scheid (2005) shows that artworks become "an index of allegedly pre-extant social classifications, but also a site for enacting these divisions" (451); and that to "engage [stereotypes] in daily living *while* passing judgment on them, is to participate in what they make possible" (460). She is talking more about East/West and transethnic relations, but her argument can be extended here to understand the consumption of Egyptian-made Orientalist art among the "renewly"[22] wealthy. There may be no way completely to access what al-Sawi's love of *al-Dalala* and other Orientalist paintings in her collection says about her own

perception of market relations and social hierarchies. However we can say that the desire to purchase this painting, and its display and the talk about it, all worked to enact divisions and to enable viewers to participate in what stereotypes (e.g., of Egypt, of history, of lower-class women) make possible.

A visit to al-Sawi's home also revealed how the transition from old wealth to renewed wealth was often created, and managed, through the collection and display of artworks as part of a whole schema of décor. Al-Sawi's décor choices and art collecting reflected her mother's penchant for European classicism, which was the most accepted high culture among Egyptian elites prior to the revolution. But they also showed the production of a new kind of *Egyptian* high culture among elites. This new high culture, which was common among the renewly wealthy, drew on some of the same features of the old high culture that we saw in Gabriel's apartment (e.g., classicist art in gilded gold frames, antique gold furniture in the French eighteenth-century style, formal and expensive aesthetics of reception). But it emphasized Egyptianness rather than Europeanness; in fact, it asserted the existence of a modern Egyptian high culture. At the time when al-Sawi's mother and Gabriel's father were building their collections, some members of the aristocracy and the new bourgeoisie purchased modern Egyptian art of the time as a way to encourage the development of a homegrown art movement, believing that any civilized modern nation needed to have an art movement. By the 1990s, the artists of that era had gone from having their work "supported" to having it become a legitimate and highly sought after part of Egyptian high culture. Egyptian "pioneers" of modern art were those who had died and who were fortunate enough to be featured in local art criticism and art history—both death and being written about increased the value of their work. The value was also increased by the development of a significant private sector art market in the 1990s. The high prices for this work conferred artistic value and worked to create an Egyptian high canon.

Al-Sawi said that she wanted to start collecting what she called "the early Egyptian classicists." Like Gabriel's references to his family, her continuous references to classicism recalled an era that was often remembered as a time in which their class status was not as challenged by the tenets of Nasserism and the rise of a military class, and in which social boundaries between themselves and the rest of the population had been easier to maintain.

But they were also, it is important to note, references to *Egyptian* classicism. Al-Sawi spoke of her desire to take down all of her mother's European works and replace them with Egyptian ones. She also showed pride and

excitement in the discovery of modern Egyptian art. Part of this interest in Egyptian art among collectors like al-Sawi was a function of the market. Gallery owners have created a market for Egyptian "classicists," and certainly even many members of the elite could no longer afford the top European classicists, as Egypt's most famous collector, Muhammad Khalil, had once been able to do in the early twentieth century. But they could have concentrated mainly on the cheaper work in European eighteenth- and nineteenth-century styles that was sold in the furniture shops they patronized, and that they sometimes bought as accents for the rest of their collections or for décor. Or they could have ignored such paintings entirely and instead decorated their walls only with expensive tapestries, antique calligraphic works, or other old pieces from around the world. The relatively recent interest in Egyptian modern art among this group, I suggest, was related to a newfound sense of being Egyptian, an articulation of Egyptianness that was neither old wealth (which the spread of Nasserist ideology made incredibly unpopular) nor a second-rate imitation of Europe. Through the creation of a category of "Egyptian classicists" and collection of their work, renewly wealthy Egyptian elites evaded charges, or perhaps their own sense, that they were not "really" Egyptian (according to other Egyptians) or that they were not "really" elite (according to Western elites). I also think that the new interest in Egyptian art stemmed from their desire to reconnect with what they imagined to be their heritage, because many of them had spent significant time in the West, building businesses there, until Sadat and Mubarak reversed Nasser's restrictions. Al-Sawi had also studied anthropology abroad, and it seems quite likely that it was through that discipline that she gained an extra appreciation for local Egyptian culture.

The kind of art by living artists that al-Sawi purchased fit with her taste in earlier Egyptian art and, in at least one case, with the phenomenon of collectors being friends with artists. For example, she collected art by Farid Fadil (see Chapter 2), whose paintings of pastoral scenes are a contemporary version of Egyptian Orientalism. Fadil was a friend of al-Sawi's and many other collectors' families, and, like Ahmed Sabri and other pioneers of the 1920s and 1930s, he frequently did portraits for them and other society people. He did several of al-Sawi's daughter. Social relations among a certain group were thus reproduced through the production and consumption of paintings of one of its members.

Al-Sawi said she loved Fadil's use of light, so she also purchased his pastoral

work. She also displayed village-themed work by artists like Hasan Sulayman (she liked the poses of the village women washing clothes in an irrigation ditch) and Gazibiyya Sirri (see the interlude on Sirri). Not all of these artists created work in a style that could be called classicist (some were more in the realm of expressionism or art naïf), but their idyllic treatment of village life and people was indeed a version of native Orientalism. I have argued that such works were a key way in which elites (especially those with rural estates) could imagine an Egypt in which their activities had no negative effect. Collections of such art might also have been a means by which these people were socialized into the national citizenry. They became more securely "Egyptian" when they appreciated (through art) the people and places that have been considered the "real" Egypt in intellectual discourse for a century. Other collectors I met were more exuberant than al-Sawi in discussing such pastoral works as "real" Egypt and often would look at such paintings and remember visits to the family estate as children. Some would say that Egypt had "really used to look like that" before it had been "ruined," and others would even tell me that if I went to a village today (they assumed I had never been to one), I would see life "exactly this way." This insistence on either decline or the continuing idyllic, as expressed through viewing artworks, were both part of the same logic that enabled elites to build distinction from peasants while connecting with "authentic Egypt." They could be thus part of and above the nation at the same time.

A comment al-Sawi made towards the end of our tour shows that she recognized this problematic positioning. After I asked what she liked about each painting (many of them pastoral), she mentioned that she was looking for other kinds of Egyptian art to collect, because "one gets tired of pastoral paintings." No doubt she found the repetition of the pastoral in her collection dull in part because the pastoral was only represented in limited ways (mostly idealist). Perhaps her training in anthropology also did not sit well with such portrayals of the peasantry. Her comment, placed alongside similar ones made by other collectors, could also have been a contemporary version of the century-old elite discourse about peasant life being simultaneously beautiful and boring (C. Smith 1983). Paintings of things seen to be dull eventually make one weary. The comment also shows the structural limitations that elites inevitably faced in really "connecting with" such Egyptian people and places. As we were discussing the pastoral scenes further, al-Sawi said that artists could not paint in rural areas the way they had used to, because they "get henpecked." As in Gabriel's case, we see that art collecting and display (and

talk about it) was an important way in which elites expressed their irritation about the ways in which Egyptian society has changed, or was perceived to have changed, since colonialism. The imagined docile peasant of the past now "henpecks," watches "bad" television, and migrates to Cairo. Paintings that refuse to portray peasant modernity (either in a negative or positive light) were bound eventually to seem dull. Both of these things—the dullness of idyllic imaginations of village life, along with the "invasion" of the lower classes and their taste into social spaces that they did not previously occupy—created weariness and frustration among many elites. Collection and display of art was an attempt to cure this, but it could never quite succeed.

BEAUTY DEEPENS ONE'S SENSE OF BELONGING

I met the famous Islamic intellectual 'Abd al-Wahhab al-Misiri, a professor of English and Comparative Literature at 'Ayn Shams University, who is known throughout the Arab world for his encyclopedia on Jews and Judaism, through a mutual friend. (The latter, a young Egyptian political scientist, set up the interview and accompanied me to it.) Al-Misiri presented himself as an Islamic modernizer who would assist in helping Egyptian society resist Western decadence, consumerism, and alienation. He owned a small apartment building in Heliopolis, a Cairo neighborhood built in the early twentieth century for the up-and-coming bourgeoisie, now home to many upper- and upper-middle-class Cairenes, foreigners, and the country's president. Heliopolis has some of the only arcade architecture in Egypt, and the arcades provide shoppers with shade as they visit boutiques, and five-star hotels nearby are prime locations for the weddings of the city's elite.

As we approached al-Misiri's building on a quiet and tree-lined residential street, I immediately noticed the *dikkat al-nawraj* outside near the vestibule (fig. 5.3). *Dikka*s are carved wooden benches that were part of a mechanical wheat threshing apparatus used by farmers before people like Muna al-Sawi's family began importing gasoline-powered farm machinery. One of the first gallery owners in downtown Cairo started buying these benches from villagers in the late 1980s and selling them to elites as décor for their homes. Indeed, they became very popular among a certain class of Egyptian intellectuals and returnees.

As we shall see, these benches and the conglomeration of art and crafts objects of which they were a part in al-Misiri's home did not simply reflect nostalgia for pre-capitalist Egypt. They were also a medium through which

owners sought to connect with or remember ordinary Egyptians of the past (the grand- or great-grandparents of many them had been rural people). Through these objects, left-of-center collectors like al-Misiri could also show their empathy for or appreciation of the craftsmanship of rural Egyptians. As in the case of Nabil Gabriel, their collection of old things can be read as a critique of (or guilt over?) the effects of capitalism. The collection thus becomes a fetish, a metaphor for social relations. Al-Misiri's home not only contained several of these *dikka*s, but also old clay water vessels, carved calligraphic marble plaques, Bedouin jewelry, tapestries, pieces of iron gates, painted tiles, hanging brass lamps with hand-blown glass globes, menorahs and other antique Jewish ritual objects, and *mashrabiya* windows (plate 11).[23]

Al-Misiri's penchant for old things was similar to that of Nabil Gabriel, though not completely the same. For one, he told me that his attraction to many of these antique objects stemmed from the point when he had become interested in Islam and had started to collect Islamic antiquities. Through his discussion of old objects in an autobiography he is writing, al-Misiri also

Figure 5.3 Entrance to 'Abd al-Wahhab al-Misiri's home.
Photograph by Muhammad 'Abd al-Ghani.

articulates his critique of capitalism, and more particularly of Sadat's open-door policy, in even more direct terms than Gabriel:

> My interest in plastic arts is connected with my passion for old things. When I came back from the USA to Cairo and the open-door policy in 1979 I got a real cultural shock. My response (or reaction) was to become acutely interested in old things and I developed an obsessive desire to possess them. . . . Old things, unlike goods, cannot be repeated or mass produced. They affirm private space and uniqueness.[24]

Al-Misiri's love of what he would call the humanism of Islam was wrapped up in this critique of capitalism and expressed through collection and display of objects. Islam, in this view, emphasizes a moral community that is the antithesis of capitalist society. Al-Misiri recognized and appreciated this aspect of Islam in his collection of handmade objects and fine art made by Muslims, in particular his selection of *mashrabiya* (carved wooden screens) as a decorative element on walls, windows, and furniture. The contemporary art he collected was often inspired by Islamic art as well—such as the many works he had by Mustafa al-Razzaz (see the interlude that follows Chapter 3). Through his collecting, al-Misiri articulated Islam as a source of beauty and belonging. This was a bit unusual among collectors, who generally deemphasized Islam in their collecting, and most of whom would be unlikely to leave their guests to perform prayers (as al-Misiri did when I was there). Al-Misiri's explicit mention of Islam, however, was akin to the often spiritual language used by Egyptian collectors to describe their love of art. In this, they resembled Victorian collectors who, confronted with the social crises brought on by the Industrial Revolution, turned to art, and to pastoral art in particular, "as a substitute for dislocated spiritual values" (Macleod 1996:10, 336).[25]

Al-Misiri's collection also differed from those of Gabriel and al-Sawi, because he was not solely interested in objects that were in good shape and of recognized "antique" quality that would fetch high prices. Rather, as we can see from the *dikka*, al-Misiri was interested in a wide variety of old things, many of them rough, broken, and dirty. In this acceptance of and interest in "unrefined" old objects, he was like many artists and intellectuals. Likewise, al-Misiri's collection was not primarily made up of blue-chip, top-notch paintings by deceased Egyptian pioneers, though he did have some of these. Furthermore, he did not emphasize these works as "masterpieces," as did the other collectors. Rather, the highlights of al-Misiri's art collection were pieces

by people of his generation—artists in their fifties and sixties, whose work sold for middle-range prices.[26]

Again, we see the creation, through art, of social connections and group identity. Most of the artists whose work he collected were his friends, and he liked to talk at length about these friendships and the discussions about art that they produced. These friends were all part of the larger intellectual circles that included writers, filmmakers, and scholars such as al-Misiri himself—all of the same generation who came of age in the Nasser era and were greatly affected by it (both negatively and positively). Thus, al-Misiri's art collecting, like his writing and speaking engagements, and narrative to me, was part of his construction of himself as an intellectual who has dealt with the legacy of post-independence political and economic change. And through his art collecting and friendships with artists, al-Misiri participated in a larger intellectual community.

For economic elites like Gabriel and al-Sawi, reference to family was key in discussing art collecting. It was less so for intellectual elites like al-Misiri, because many of them did not come from families interested in intellectual matters and their formative intellectual experiences and interest in art occurred through education and friendships with one another. Many collectors spoke of how they had come to appreciate art through parents or other relatives, and in doing this, they were not only citing their pedigrees but also recalling a time when, they imagined, the arts had been more appreciated in Egyptian society in general. But reference to family was strikingly absent from al-Misiri's narrative. He made no attempt to let the (presumably ignorant) anthropologist know that he had a good pedigree, or to use kin references to tell stories about the "good old days," perhaps because he could not. It is probable that al-Misiri was more like many of the artists discussed in this book, who came from the provinces (and/or more modest families) and therefore "learned" their art appreciation through state and other institutions. In his autobiography, al-Misiri writes: "I really cannot tell the source of my interest in the visual arts. In Damanhour [a town in the Nile Delta], there were no exhibitions or museums, and we did not have any antiques or paintings (like those conventional paintings that we find in the houses of middle-class people . . .)." He then goes on to thank his secondary school art teacher for his influence and spends several pages discussing all that he learned from and saw in art museums in Europe and the United States. It was not just that many intellectuals became interested in art, and in collecting it, from teachers, museums, and (in many

cases) government-sponsored travels to the West. Talking about these experiences and the art one had seen could be important aspects of participating in intellectual circles, in which acquired cultural capital was the norm. For al-Misiri, it was also a way to distinguish himself from other intellectuals, whom he said stuck to their own specialties (like writing) and never learned anything about the visual arts.

One of al-Misiri's favorite artists was Rabab Nimr, also a good friend. What al-Misiri saw in her work was directly related to what he liked about old objects, and was thus also part of a general philosophy about capitalism and modernity that many secular intellectual elites of his generation possessed, though al-Misiri presented this philosophy as being specific to his Islamic outlook. As soon as we started talking about his interest in art, al-Misiri announced his position, saying right away: "I do not like any Western art after World War I." He said that he was opposed to what he called the "completely deconstructive aspects of postmodernity, the separation of art from life that modernity brings with it, repetition, consumerism, lack of sanctity, utilitarianism, lack of humanism and humanity, and anonymity." He elaborated that he looked for the same thing in art that he saw in his old objects: a humanity and sanctity unique to a specific time and place. Rabab Nimr's work embodied this for him.

He showed me a group of drawings she had done for an upcoming book on Coleridge that he was editing, and he spoke at length about her paintings as we toured the collection. For him, the main evidence that her art was not alienated was the rich imagination that he said went into her work, and the fanciful and "humanistic" way she rendered the human and animal figures and the relationship between them (fig. 5.4). In his autobiography, he compliments the "childish/childlike, complex, mythical world" and the "relations between man and the world of birds and animals" in Nimr's work. In these drawings, al-Misiri saw human uniqueness and sensitivity (not cogs in a machine), and he saw humans as relating to the world around them (not alienated from it). However, this critique of capitalism was still launched through a fetishization of objects (art and antiques) that stood in for social relations of production.

Many of the pieces in al-Misiri's collection, including some by Nimr, had been gifts. Through gifts of art and discussions about it, al-Misiri and other "intellectual collectors" created communities of shared interest and distinction. Discussing the circulation of drawings among collectors in early modern Europe, Genevieve Warwick argues that gifts of art between friends are a way

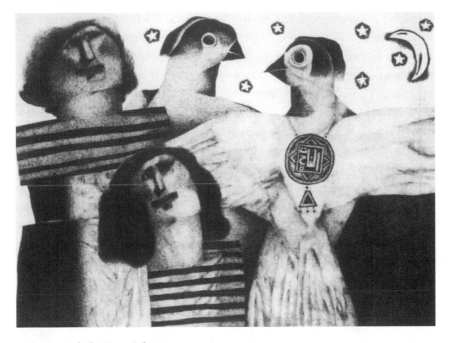

Figure 5.4 Rabab Nimr, ink on paper, 2000.
Courtesy of the artist.

of "resist[ing] the social implications of capitalist trade . . . all the while work-ing within its economic system of exchange values" (Warwick 2000:63). I think this is exactly what was going on in the prevalence of art gift giving between artists, collectors, and their family members that we have seen in all the cases thus far. It is well known that collectors often tend to downplay the financial dimensions of their collections (see Moulin 1987) so as not to appear vulgarly interested in profit. This was indeed one case in which the values associated with art were the reverse of those of the economic world (Bourdieu 1993). With Egyptian collectors like al-Misiri, there was the added explanation that gift giving was an important way to create and maintain meaningful social rela-tionships at a time when the pursuit of profit threatened the stability of such friendships. Gifts of art (which denied the economic) signified displeasure with the negative effects of capitalist expansion and an attempt to contain them.

This displeasure is also related to why al-Misiri collected many paintings and clay sculptures that depict peasants or *sha'bi* (urban folklore) themes, such as work by the Egyptian "pioneer" Raghib 'Ayad (see the interlude following Chapter 6). Although he did not discuss these very much during our tour, I

sensed that the choice of this work also fulfilled his desire for "the human" as opposed to the "anti-human." Our mutual artist friend had told me that al-Misiri had once described an abstract collage of his as "anti-human." Al-Misiri told me that he opposes almost all abstract art of the modern variety on that basis. He writes that modern artists "have become experimentalists who do not carry human or moral burdens." For him, not carrying such burdens goes against his values as a Muslim and as an Egyptian. Work that has figuration, then, is more human, more beautiful, and more Islamic. This belief challenges many non-Muslim understandings of how Muslims view figuration, and it evidences an active engagement with Islamic tradition.[27]

Al-Misiri also liked figurative contemporary Egyptian art because it related to a specific time and place. It was not alienated, generalized, or reproducible. Al-Misiri did not favor Egyptian paintings and sculptures for patriotic purposes. Rather, he collected them because in his view these works were connected to, and therefore connected him to, the specific place where he lived. As he writes in his autobiography: "Beauty . . . deepens one's sense of belonging."

Through collecting and display of these works, there was also an attempt to "fix" the specific place of Egypt, to make it less susceptible to the undesirable effects of time. In the quotation from his autobiography cited earlier, al-Misiri speaks of returning from the United States and feeling "shock" at the way Egypt had changed as a result of market liberalization. This discourse of shock was another register of the kind of unsettled feeling among elites that I have discussed as connected to the post-Nasser changes in public culture. I have been arguing that this feeling of loss of control, of Egypt becoming "unrecognizable," as some people put it, was managed through collection of antiques and art objects. Al-Misiri's art collecting began in earnest upon his return to an Egypt he felt he did not recognize. For an intellectual who (like many) had been committed to some of the revolutionary ideals, this experience could cause great personal angst. Through the display of these objects in a personal space (the home), elites were able to deal with these feelings of loss, and concentrate their energies on a space over which they had fuller dominion. They were able to distinguish this space from the "chaos," the loss of socialist, nationalist, or religious values, that they saw growing on the outside.

This collector's description of the troubles he had in designing his house after his return documents this process quite clearly and points to how intellectuals regularly acted out their anxieties for one another through certain

kinds of discourses. Al-Misiri writes that he returned to find that those work-
ing on his building had made it "unbelievably ugly." He continued:

> I used to tremble in fury whenever I entered the building; the architect had
> used a glittering material called granulite, the walls black, the ceiling orange
> and the façade disgustingly modern. I used to say to myself that this was a
> building fit for a big, or small, tradesman but so unfit for a professor of poetry
> like myself. . . . It was impossible to accept the building or the flat in their ugly
> utilitarian condition. I am no different from many Egyptians who are getting
> so repelled by the growing ferocity of their cities (especially Cairo), and are
> remodeling their homes because they spend longer times in them they used to.
> However, I can claim that my motives were different in some aspects.

The "difference" from others was the appreciation of Islamic styles and other
design elements from two designer friends of his, one of whom he described as
having worked to "remove [Cairo] from the pit of architectural unsightliness
that it had fallen into." Al-Misiri was not alone in retreating into the home
because of distress about the visual culture changes in post-*infitah* Egypt,
though for him these changes were perhaps even more disturbing because the
"masses" were not doing what those who had once supported socialism hoped
they would.

Through friendships with artists and designers, collectors produced dis-
courses and spaces of distinction through art. The home became a private
space in which they attempted to develop and maintain a certain taste and
style that they believed was lacking in public Egypt. However, just as the dust
and pollution seeped into Gabriel's apartment, contractors with "tradesman's"
taste could bring al-Misiri to fury.

ART IS ONE OF THE BEST TOOLS TO LIBERALIZE A POPULATION

As an anthropologist from the United States, I always have to wonder what is
going on when I enter a fieldwork situation and suddenly become very com-
fortable. Cultural differences seem to fall by the wayside, and you feel as if
you are just hanging out with "one of your own." This happened to me one
morning in mid July 2004, the apex of Cairo's hot summer. I thought I was go-
ing to meet a collector like many of the other collectors I had been visiting. He
lived in the fancy Cairo neighborhood of Zamalek, and I fully expected to see
a collection of "safe" artwork by the old masters or prominent contemporary
middle-aged artists. I assumed that he was a son of the old aristocracy who,

like al-Sawi's family, still keep their apartments in the Italianate buildings of the area. But from the minute I entered his apartment, I felt as though I were in the apartment of any one of my friends in New York—young, intellectual Arab expatriates or Americans who do research in the Middle East. There were all the telltale signs, which were not actually that different from the signs in al-Misiri's house: old brass lamps hanging from the ceiling; embroidered Middle Eastern throw pillows; Bedouin rugs and table runners; an engraved copper tray on a carved wooden stand used as a coffee table; *mashrabiya* accents; Aswan shawls used as curtains; carved wood and iron ornaments from old rural houses integrated into the decor; pottery; other local (but not "Louis"-style) antique furniture, such as chests; and contemporary drawings, paintings, collages, and photographs on the walls (fig. 5.5). There was an easy messiness about the place, with the newspapers and magazines scattered around, a few empty glasses on the tables, and a bit of dust.

I was at home not just this with this type of décor but with this kind of collector: Khalid Wagdi dispensed with all the usual preliminary formalities I had

Figure 5.5 Interior of Khalid Wagdi's home.
Photograph by Jessica Winegar.

come to know so well in visiting collectors. Evidently, he felt no need to "prove" his distinction in this encounter with me. He was dressed casually in a wrinkled white T-shirt and baggy shorts (the wearing of which in front of guests—especially unrelated women—can convey a certain immorality in Egypt). He spoke fluent American-style English, which he had learned while doing a Ph.D. in the United States, where he had also worked for twenty years. He used the same vocabulary that I and other stateside cultural elites would use to describe the world, employing the same *ya'ani*s and *khalas*es that pepper the English of the international Arab elite and of Americans who study the Middle East—filler words meaning "you know" and "enough!" Almost all of my questions made immediate sense to him, and I had to do none of the tortured, yet revealing, reframing of questions necessary with other collectors in order to make my queries comprehensible within their worldviews. Nonetheless, there were a few things that did not quite fit in this image of comfortable similarity. Wagdi pronounced "avant-garde" the French way and "can't" the British way. And his colloquial Egyptian when we were saying goodbye was fluent, needless to say.

Wagdi was one of many Egyptians who had recently started buying contemporary, nontraditional art by primarily middle and younger generation artists. Many of these collectors, like Wagdi, had returned to live in Egypt after an absence of anywhere from ten to forty years for education or on business. Some of these returnees (or their parents) had originally left because the nationalization of private industries begun in the 1950s had denuded them of their inherited wealth or capitalist aspirations; they returned because of the more favorable conditions created by Sadat's and then Mubarak's push for increased privatization and liberalization of the economy. Some returnees still maintained homes and business interests abroad and divided their time between Egypt and the United States or Europe. Other collectors had not yet returned to live part- or full-time in Egypt, but had started coming back for longer and more frequent vacations, during which they consumed art.

This group of art buyers frequented the downtown galleries that I discuss more fully in Chapter 6, and Wagdi's reception of me was akin to what one encountered at these galleries. At such venues, one was not immediately greeted with chocolates and soft drinks as at some of the other tony galleries in the wealthy neighborhoods. There was no "Louis" furniture for gallery guests to sit on, nor were there big flower arrangements to navigate past. The downtown galleries favored by returnees like Wagdi generally had a more modernist aesthetic—white walls, bright track lighting, spaces empty of everything but

art and, perhaps, simple wooden seats and a desk. One gallery had *mashrabiya* tables and fired clay ashtrays set about—a kind of shabby *sha'bi* chic. Two of the galleries had adjoining gift shops, which sold, among other things, handmade silver jewelry, coffee-tablebooks, postcards depicting Cairo from the 1920s to the 1950s, Arabic novels and poetry translated into English, and expensive English-language fashion and style magazines. Wagdi's apartment was a domestic version of these galleries. Its mixture of old and new and its "down-to-earth intellectual" style were combined with signs of real wealth, but these were muted, unlike those in the homes of families with old money. Wagdi, like other returnees in their thirties and forties, was opposed to ostentatious displays of wealth, such as gold furniture, for reasons of both politics and taste.[28] Instead of soda, cappuccino, or whiskey, Wagdi offered bottled (notably not tap) water. He did not have a servant to bring such drinks. Instead of sitting in the living room, we sat at his desk, which was strewn with papers and held a computer. Throughout this first meeting, he let us be interrupted by his cell phone several times. He turned on the air-conditioning for my comfort, but it caused a rattle in the window. He tried to jerry-rig a solution for the benefit of the tape recorder, but I sensed that when he was by himself, the noise did not bother him. Everything seemed very casual, very much the way things are in my home.

Wagdi was unusual among these new Egyptian collectors of young artists' work in that his interest stemmed from parents who were art professors at the Cairo College of Fine Arts, and, like Nabil Gabriel, he had grown up surrounded by famous artists of the 1950s and 1960s. He had also attended the College of Fine Arts himself and was a practicing architect. Thus his interest in art was broader, deeper, and comparatively more personal than that of other returnee collectors who had less of a family connection to the arts, and whose interest stemmed mostly from participation in cultural elite communities abroad. Wagdi was also different from collectors like Gabriel and al-Misiri because he was interested in contemporary art done by young Egyptian artists—what he called the "avant-garde."

When I asked him how he had become interested in this kind of art upon his return to Egypt in 2001, he said:

> I wanted to start seeing *contemporary* because all I knew were the oldies. So I wanted to know what's going on. . . . I believe in what Voltaire says: "People that always talk and think about the past, they don't really like the present and look forward for the future." So I'm a modernist. I'm always for the avant-garde,

because that leads us to someplace. I wouldn't say that I was very impressed by the artistic scene in Egypt. But nevertheless there is some effort, and one should encourage the effort, even if it's not very genuine from my point of view. There's a lot of mimicking. And that's fine, because there's no art that doesn't do cut and paste in the world with a twist, and the twist is the idea.[29]

Here we see a more empathetic version of the discourse of imitation and sub-standardness that often obtained among Egyptian artists and among foreign curators who circulated through the galleries that Wagdi visited. As an artist himself, Wagdi understood how imitation could often be part of the artistic process. But he also saw it as a *stage* in the process and believed that true artistic expression comes later.

Wagdi thus saw that his role as a returnee collector was to help encourage art to develop beyond imitation. This view was part of his larger philosophy about Egyptian culture and society, and what he thought it needed. He said that Egyptians were suffering from an "identity crisis" because "they don't understand fusion, even though their history is full of fusion." He continued, "the culture . . . is one-sided and whenever you have a political situation where you have no middle, it will always go to one of the extremes. . . . In most democratic countries, people are in the middle." As an example of work that expresses the fusion he celebrates, Wagdi pointed out the work of Anna Boghiguian, an Egyptian-Armenian artist. "I like her work because it is a bit cartoonish . . . you can see the decay of the city. The city . . . is our shithole in the world and people are expressing that."[30]

Later in the conversation, he gave an example that expresses his view of Egyptians' lack of understanding fusion and difference (though the story was meant to show that he was more comfortable being himself in Egypt than in the United States). He said that a "Ninja girl" had come up to him on the street (I had to ask what he meant: a woman in a full black Islamic dress with a *niqab* face veil) and told him that his thick black glasses made him look "so Jewish." He had yelled at her, saying, "Look what you're wearing—a tent—you look like shit, and you [have the gall to] stereotype [me]. Fuck you and your religion." It was not just the anti-Semitism that made him so mad; it was also her religiosity as expressed in her dress—a religiosity that most returnees and intellectuals found abhorrent. (Many, though not all, found anti-Jewish statements abhorrent too.)

This episode, and no doubt many others in which Wagdi saw Egyptians

as closed-minded, further motivated his art collecting. Speaking of the collectors' role in encouraging the art scene in Egypt, he said, "Me, as a liberal, I take the point of view of liberals, and art in general is one of the best tools to liberalize a population and [get them to] see the different and accept the other." I have no doubt that all art collectors in Egypt thought that women in *niqab*s were a sign of regression, too, and saw their own art collecting as a sign of progress. But Wagdi was one of the few who described art collecting in such functional, political terms that evinced a clear secular, liberal outlook. But this outlook was also elitist.

The ideological project of supporting art to liberalize society immediately struck me as very similar to the patronizing patronage of the socialist state, and so I asked Wagdi what he thought of the state's support of art. He paused a bit and then said that he did not know that much about the state's activities (cf. Westerners' ignorance of state activities discussed in Chapter 6). But then, he went on to praise the private sector galleries from which he often bought art: "For me, the independent [galleries] are much more vital and they have much more *flexibility*. So the art relates more to the people than these guys that are sitting behind desks [producing for government shows or academia]" (emphasis added). I pushed Wagdi and asked how he came to have a different view than his parents, who were government arts professors. He replied immediately with a robust laugh, "Money, darling! Money!" Wagdi was an entrepreneur who had businesses in Los Angeles, Saudi Arabia, and France. He was clearly a proponent of the free market. This extended to his view of the role of art in society ("to liberalize" it) and why he collected art ("to encourage" experimentation). Neoliberal economic philosophy depends on what I would call "neoliberal cultural philosophy" and vice versa. In both, "freedom," "autonomy," and "flexibility" are key values.

In Wagdi's mocking ("Ninja girl") of the woman's veil, we see the limits of his liberalism (cf. Mahmood 2005), which were also visible in our discussion of his favorite artist's works. He liked to collect the work of the Egyptian-Lebanese artist Lara Baladi, whose work has gotten international attention in part through the efforts of one of the new downtown galleries that Wagdi liked. He and the artist had become good friends, in part because, he said, they shared an outlook on life in Egypt. Hanging in his bedroom were two large Baladi photographs of the midriffs of lower-class Egyptian women (distinguished as such by their floral robes and the kind of gold jewelry they are wearing), with their hands on their skewed hips. They appear to be belly

dancing. He showed them to me, saying:

> This is Lara. This is her hysterical work. . . . Look at this Egyptian kitsch. I love
> it. I encourage her because I can see her fusion and looking forward. And she's
> making fun of everything. I like that.
>
> JW: You like how she makes fun of kitsch?
>
> KW: Yeah. Yeah. I like that.

Baladi was somewhat unusual among artists in Egypt in that she was willing
to deal overtly and playfully with social class in her work. Many artists who
did so, like Baladi, usually came from international elite backgrounds that
gave them some analytic distance. Often, this art took the form of sarcasm,
which has traditionally not been a mode that interests Egyptian artists.[31] Al-
though Baladi's work has many rich valences, Wagdi read sarcasm as the main
one. He liked this "making fun" of the "kitsch" of what he called the "middle
class." Where other collectors tried to keep the kitsch effects of capitalism out
of their homes, Wagdi welcomed it, but in a particular form that he described
as "cartoonish" or "sarcastic." For Wagdi, this work both created and was the
result of a distance from other Egyptians. Indeed, it was Wagdi's particular re-
lationship to international capital flows (as their beneficiary) that enabled this
distance from the tastes and styles of people who had a less positive relation-
ship to these flows. For some collectors, this distance was expressed through
refusal to engage kitsch in art collecting and in a distinction between inside
and outside. For Wagdi and others, the distance was articulated by calling
these tastes and styles "kitsch" and "fusion." Furthermore, it is very likely that
this taste in art among collectors like Wagdi was formulated through years of
living in the United States and European countries, where this kind of art is
(not uncoincidentally) popular.[32]

But Wagdi's collection of this art was also his way of crossing that distance
and connecting with other Egyptians. This connecting and creating social
distance through objects was akin to that of the other collectors discussed,
although quite different in its form. Unlike Gabriel and al-Misiri, Wagdi did
not offer any (even unwitting) critique of capitalist alienation. His comments
on the changes in taste and visual culture produced by capitalism took the
form of a discourse of kitsch that blurred critique and celebration. And un-
like al-Sawi, Wagdi did not see his inherited pastoral paintings as evidence of
an ideal Egypt. His display of them was more like a testament to the history
of Egyptian modern art that his parents had been involved in and showed a

respect for that genealogy. (He said, "These people were academicians, they were great craftsmen.") Wagdi collected the kind of contemporary art that he did because it reconnected him to his culture after a long absence. He returned in 2001 in part because he did not want his whole family (many of whom now live in the West) to become completely disconnected from their roots. Many returnees also came because business opportunities seemed better and there were exciting new spaces to socialize in (galleries, upscale coffee shops, bars, restaurants, and resorts). Wagdi said that after his return, he started collecting because he "wanted to know what's going on" and that "through these [artists] I read my people." In this sense, Wagdi was like al-Misiri, who tried to reconnect with Egypt through art after his absence in the 1970s. At first, Wagdi took the same path as al-Misiri and tried to reconnect through the old (he said he was into "the ethnic thing"). In his home, he had many objects similar to those in al-Misiri's collection (e.g., an old marble sink, carved wooden screens from the countryside, fruit sellers' lamps). But whereas al-Misiri liked contemporary art that he thought perpetuated the values inherent in the old things, Wagdi moved towards art that in his opinion took an amusing look at the contemporary version of the culture that once produced those old things.

It was very telling that Wagdi's interest in connecting with, or "reading," Egypt through art had a much more prominent nationalist bent than that of most other collectors I knew. When I asked him about this, he said: "I don't know. Nationalism implies a little bit of a fascist ideology. I don't think I'm a fascist. But I like to encourage my people. I don't think there is anything wrong with that." Wagdi's emphasis on encouraging and reading Egypt, and the prominent role that art collecting played for him in that process, may not have been overtly patriotic but it was certainly more explicitly nation-oriented than the philosophies of the other collectors, except to some extent Muna al-Sawi.

Wagdi's comments on his collection exemplify how neoliberal capitalist globalization has actually enhanced the national attachments of some of its biggest Egyptian beneficiaries—especially in the realm of their collection and display of culture.[33] Perhaps the same is true of other Arab expatriates and American scholars of the Middle East who have the means to live international lives but whose taste and modes of art collecting are often very much focused on Egyptian culture. This in part explains my continued comfort with Khalid Wagdi and my appreciation of his love of old things, as well as art that highlights the fusion, cartoonishness, and kitsch that I also see in Cairo. But it is

perhaps even more imperative that we ratchet up our critical stances when we consider styles and tastes similar to our own. After all, what is funny kitsch to some is actually beautiful and tasteful to others.

CONCLUSIONS

This chapter has outlined the multifaceted poetics and politics of art collecting and display among different kinds of collectors, who have reckoned with social change in postcolonial Egypt in different ways. By focusing on four differently situated collectors, I have tried to give an in-depth sense of the varied ways in which the post-independence changes in Egyptian social relations and visual culture were given meaning, managed, instantiated, and taken advantage of through collecting practices. Art collection and display were key ways in which elites came to think of and represent themselves as a distinct group in relationship to other social classes and to the general shift from socialism to neoliberalism in Egypt. Art gave many the concept of an Egyptian high or liberal culture that was national and elitist at the same time. Art collection was also important for elites trying to orient themselves to the larger collective of the nation and evaluate social changes within it since independence, and in some cases, it played a key role in the formation of neoliberal elite subjectivity. Ultimately, this chapter has suggested that practices of art collecting and display were key to both the enactment and production of social hierarchies and divisions in Egyptian society. Indeed, art, and décor more generally, became important means by which elites justified their positions in society. Through collecting and display, elites could imagine that their social power had come about harmlessly and continued to have no ill effects. The implication was that their activities were unequivocally beneficial for Egypt. However, the transgressions of their taste that elites tried unsuccessfully to contain tell another story.

CODA:
THE EFFECT OF THE NEW PRIVATE COLLECTING ON ARTISTS

Artists who belonged to collectors' social circles were much more likely to have their works collected than artists who did not. Because most collectors were economic elites, it was likely that the artists whom they would come to know the best were those who had the money to participate in their social activities. These artists were usually those who were able to pass socially as well by virtue of their wealth or their successful reading of the upper class.

Most artists in Egypt were from a much lower economic background than and did not behave or speak like the higher classes, whether the latter were francophone or anglophone elites, old-money aristocrats, the renewly wealthy, or returnees.[34] This fact greatly decreased their chances of meeting private collectors and moving successfully enough in their worlds to cultivate the long-standing connections required to have their art collected regularly. Not surprisingly, many of these artists also produced work that did not translate well to upper-class contexts and so was devalued in them.

In partial accordance with its claimed socialist mission, the state had leveled the playing field somewhat, but it had also produced other inequalities. The Ministry of Culture spent significant sums collecting the work of artists whose lack of social connections and status limited their market access. Without the state, these artists would never have earned anything from their art. In the early to mid 1990s, this was especially true of artists who worked in the abstract or in unusual media—art that gained popularity in the private sector only later. At the same time, some artists (particularly of the older generation) were also able to use state connections to make money in both the public and private sector art markets. Like some of the collector businesspeople with contacts in the government, they blurred the distinction between the public and the private to their advantage.

State support was both necessary and problematic for artists, but private sector support, in the form of collecting, was also not free of problems. Support from the private market that dealt mainly in figurative, folk, and pastoral themes was fine for those artists who did that kind of art. Others who started out doing that kind of work gradually came to feel that they had to keep doing it just to support their families, even if they wanted to move on to other styles, themes, and media. Finally, there were those who took time away from producing the art they believed in, in order to do paintings that would sell. The other private sector market that developed in the late 1990s, in art by younger artists who did not do folk and pastoral paintings, also had advantages and disadvantages from the perspective of artists. Some artists who sold their works in this market made more than they would have in sales to the state and also felt liberated from some of the social obligations that were required to do well in state spaces (e.g., obedience to the older generation). For the first time, they did not have to do paintings of peasants in order to sell to the private market. However, the purchase and funding of art with international capital also presented certain limitations. Just as the older private market preferred

certain styles, themes, and media, so did the new market. New social obligations presented themselves—most notably learning how to speak English and to market work across cultures and classes in a meaningful way. International capital was brought in by people who had interests that did not always align either with those of the artists they worked with or with those of the artists who were shut out. In the next chapter, I turn to that story.

'ABD AL-HADI AL-GAZZAR
I Say to You

TODAY IN EGYPT he is known simply as "Gazzar." His name evokes images of paintings that are now famous among artists, critics, and collectors, and his work has been deemed a central part of the Egyptian modern canon. But unlike many artists who have a similar canonical status, Gazzar and his work have been subject to multiple and conflicting interpretations.

'Abd al-Hadi al-Gazzar's life and politics are not easy to encapsulate in the categories of his day. He cannot necessarily be called a patriotic nationalist, a communist, a Nasserist, or a royalist. Likewise, his paintings carry ambiguous and often contradictory messages and signs. Some invoke "Gazzar" as one of the first, and few, artists who could capture the "essential spirit" of Egypt—by painting the magical ceremonies, folk dress, and symbols of Sayyida Zaynab, the old Cairo neighborhood where he grew up, in art naïf style. Others laud him as a truly patriotic painter of the Nasser era, who captured the technological spirit of the new modernizing nation. I tend to agree with the few who think that there is a sad and foreboding quality to many of his works, which we variously read as Gazzar's comment on the negative effects of colonialism and the dark side of nationalism.

Gazzar was born in 1925 and died in 1966. His lifetime spanned the key years of the transition from colonialism to the postcolonial state. Through his work and life, I've gained a sense of one intellectual's coming to terms with the ambiguities of this process, through creative engagements with both the genealogies of the modern that were available at the time and those that were just becoming visible. I see a critic of Western colonialism who also has

a fondness for Western art styles, theories, and training. I see an advocate of independence who both celebrates and takes a cynical view of modernization and a supporter of social equality who obliquely criticizes Nasser's social programs yet also cements a visual tradition of objectifying the poor. And I see the son of a shaykh move out of the old religious elite and become part of a new secular-oriented intellectual environment, while still dealing artistically with religious themes.

Gazzar spent the first fifteen years of his life in prewar cosmopolitan Alexandria. Then his family moved to one of the oldest popular neighborhoods in Cairo (Sayyida Zaynab), which would become an inspiration for much of his early work. Gazzar left medical college and entered art school to pursue his true love. It was 1944, the year before World War II ended. At this time, artists and other intellectuals began to articulate explicit ideologies for artistic production related to the new political horizons. Manifestos were announced, and official groups were formed. Gazzar joined the Contemporary Art Group, founded by his mentor Husayn Amin in 1946, whose aim was to reach "universal values" through deep artistic exploration of the specificities of place and culture. As 'Izz al-Din Nagib (2000) points out, the members shared with the earlier Art and Freedom Group (a Trotsky-inspired collective formed in 1939) a disdain for the academicism of the pioneering generation and a propensity to surrealism. But in contrast to the French-speaking cosmopolitan elitism and surrealist alienation of Art and Freedom, Gazzar's collective used surrealist-inspired styles and thought (which were a bit different from those in Europe) to bring out the spiritual and magical aspects of social life in old urban neighborhoods. Gazzar's works in particular escape the charge that he merely did folkloric motifs, because they suggest a darker vision, an ambivalent social commentary.

The Story of Zulaykha (1948) is such a work (plate 12). We see the recognizable folk symbols that appear in much Egyptian *asala* art (a cat, a woman in traditional dress, a vase, etc.), but they are not rendered as an idyllic expression of an unnamed "authentic Egyptian woman." This is Zulaykha, presumably from the story of Joseph and Zulaykha found in the Talmud, Bible, and Qur'an. In Egyptian folklore, Zulaykha represents betrayal, lust, and immorality (for attempting to seduce Joseph while married to Pharaoh). Is the painter using Zulaykha, the woman, as an allegory for Egypt selling its soul and betraying itself in its desire to become Western? In this vein, does the

ship represent travel away from the home country, and the electricity tower Western modernization? Perhaps, on the other hand, this painting presents a sympathetic view of Zulaykha, such as that found in Sufi poetry. Is this the Zulaykha who represents astonishing beauty, and the despair of unrequited love? Does the flower symbolize the "forsaken dream" of marrying Joseph, as 'Ismat Dawistashi suggests (see Roussillon 1990:127)? Is the young girl her daughter, perhaps from a previous unlucky marriage? Are her hand gesture and her facial expression, then, like those of the Egyptian women I've seen when they wail in despair? Perhaps, if the ship refers to the Suez Canal, Zulaykha represents Egypt as frustrated with colonialism. This painting is neither a clear representation of ideal Egyptianness or womanhood nor an obvious political message. It raises more questions than it answers.

The same year that Gazzar finished this painting, he was arrested for exhibiting another one that had a much more direct political element. *The Popular Chorus, or The Theater of Life* depicts a row of barefoot Egyptians standing in front of empty bowls. The authorities were clearly displeased with the notion that people were going hungry under colonialism and royal rule. The two wealthiest members of Egypt's pioneer generation of artists, Muhammad Nagi and Mahmud Sa'id, worked their social connections to get Gazzar out of jail.

Once the revolution occurred and Nasser came to power, Gazzar began to tackle the themes of nationalism and modernization directly. Many artists did this, because the government encouraged artistic representation of its projects through competitions and grants. Gazzar is perhaps best known at home and abroad for his painting *The Charter*, done in 1962 (fig. F.1).

This painting has become something of an icon for Nasserists and for the 1952 "revolution" more generally, especially because it bears the name of the text in which Nasser outlined his ideology. It is often understood as an unabashed celebration of Nasser. That's what I first saw in the painting. The figure in the center holds Nasser's charter and wears a crown bearing the new nation's logo, there are the requisite peasant and the laborer, and the newly nationalized Suez Canal is portrayed in the background. But on closer examination, and now that I've spent years in close friendship and collaboration with Egyptian artists, I think that the artist was trying to reveal the costs of the new kind of nationalism. Are the figures being called on to worship the new nation unthinkingly? Is technology, including a gun and tank, wiping out what came before, creating a militarized society? The peasant looks forlornly at the remainder of his crops; the nation's headdress is a dead tree. Alain Roussillon describes this painting

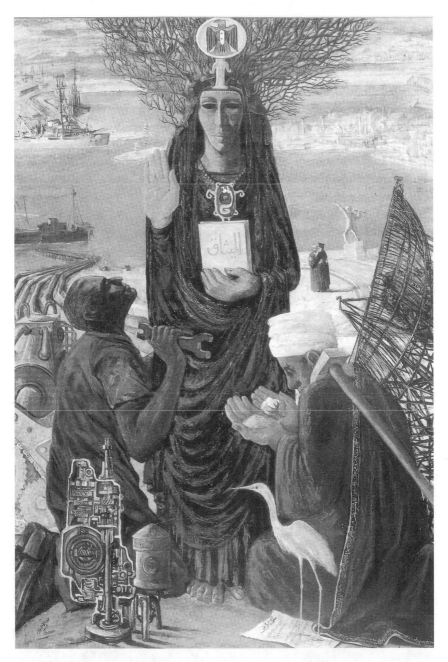

Figure F.1 ʿAbd al-Hadi al-Gazzar, *The Charter*, oil on wood, 1962.
Courtesy of Laila Effat.

as representing both "the coming to a head and the petering out of the period of popular mythologies" (1990:79).

In 1964, the ambivalent view of technology and modernization becomes more apparent. In *The High Dam* (1964), submitted for a government contest on the subject, we see man imprisoned in technology, and the remnants of Gazzar's earlier subjects reduced to a small hole on the lower right (fig. F.2).

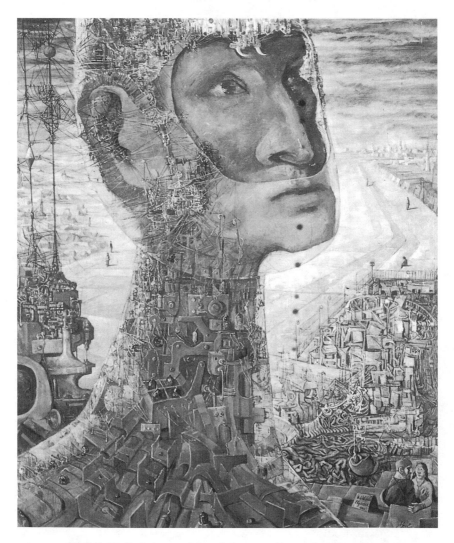

Figure F.2 'Abd al-Hadi al-Gazzar, *The High Dam*, oil on celotex, 1964.
Courtesy of Laila Effat.

The same year, Gazzar did a truly apocalyptic scene entitled *Body Descending from the Sky* (fig. F.3). This work, unlike so much of the art celebrating the "new society," foreshadows the negative effects that would become much talked about later on—when people began to acknowledge the repression, corruption, and militarization of the Nasser era, and its disastrous fall in the war against Israel in 1967.

I think Gazzar's works are often misunderstood as nationalist romanticism, when they actually reveal a prescient ambivalence about the nationalist project. In this sense, I would say that Gazzar was similar to his peer the poet Salah 'Abd al-Sabur, whose sets of poems *People of My Country* (1962) and *I Say to You* (1981) are also seen as irrelevantly romantic today but document the hopes of

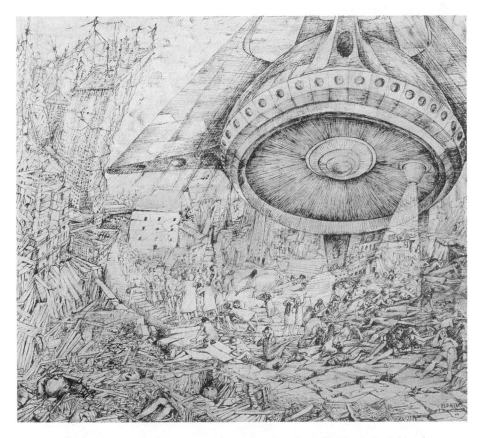

Figure F.3 'Abd al-Hadi al-Gazzar, *Body Descending from the Sky,* India ink and watercolor on paper, 1964. Courtesy of Laila Effat.

Arab nationalism and its fall. *I Say to You* is written in a consciously prophetic manner. Perhaps, like 'Abd al-Sabur, Gazzar was also trying to tell his fellow Egyptians that true liberation would not come from an empty revolution.

Gazzar did not live to see the absolute demise of independence's promises. He is among the few Egyptian artists to achieve almost mythical status because of their untimely deaths at early ages. Inasmuch as he died suddenly from a heart attack in 1966 at the age of forty, his reputation was not spoiled by the charges of government corruption, nationalist pandering, and artistic mediocrity that were to plague some of his colleagues later on. His early death also released the interpretation of his works, perhaps beyond the boundaries of his own intention. They have enabled me, some fifty years later, to sense what it really means to be an Egyptian artist reconciling political and social ideals with their stark reality.

6 ART AND CULTURE BETWEEN EMPIRE AND SOVEREIGNTY

PRELUDE

I ended the preceding chapter by arguing that we should subject our own tastes and preferences in art to the same critical scrutiny that we bring to others', if not more. It is very easy to criticize the vast majority of contemporary Egyptian art—especially the work that seems more overtly nationalist or provincial in its emphasis on pastoral, folk, Pharaonic, or still life themes. It is also deceptively easy to praise as avant-garde the new art that does not conform to these trends, and especially that which casts an ironic eye on aspects of contemporary Egyptian life. When I returned from fieldwork, I gained the distance to wonder why it was that I eventually chose to move closer to a new art space in Cairo that was exhibiting this kind of art, and attracting foreigners and Egyptians with taste similar to my own. Why did I prefer this social space? Why did I exuberantly tell everyone that the Egyptian art scene is becoming more exciting and vibrant thanks in large part to the efforts of this new space? Why do I still do that sometimes, even though just yesterday my best friend in Egypt said that she had stopped going to these galleries, because she just "couldn't bear it" anymore?

These questions form the background of this chapter, in which I turn my critical lens on the spaces in which I was most comfortable: new galleries that featured young Egyptian and foreign artists, installation and video artists, photographers, and mixed media painters and sculptors—most of whom rejected the Pharaonic and the pastoral. Thinking critically about the art and spaces I like has been a difficult process, not only because I have been forced to

challenge my own sense of what is "good" and "interesting" art, formulated by my own reckoning with the modern.[1] It has also been difficult because those whose worldviews and projects I discuss have responded to earlier drafts of this text with some of the most defensive postures I have encountered. I was accused of being a nationalist and an apologist for the state, among other things. Part of their shock undoubtedly stems from their sense that I was "on their side." But it also arises from the fact that their dominant positions (in addition to linguistic and cultural distance from the rest of the art world) usually protected them from such criticism.

In this book, I could also have completely dismissed the nation-oriented dimensions of contemporary art production, as most art critics who were in these circles did. But that would have been to ignore something that was very important to most Egyptian artists. Furthermore, I could have dismissed the new developments in the art scene, as many patriotic art critics did. But then I would be ignoring new spaces, artists, and international connections that have become an important part of the art scene in Egypt as well. In what follows, I analyze this new private sector with the same critical tools that I have applied to other features of the art world in earlier chapters. If it appears more critical, that may be because it is harder for us to have the deeply modernist, teleological bases of our artistic preferences revealed. Or, it may be because these preferences are part of a whole system of domination that needs to be confronted more assertively.

· · ·

On a January evening in 2000, the streets of downtown Cairo were flooded with people attending the opening night of an arts festival arranged by the city's newest gallery owners, who had recently come to Egypt from abroad. Egyptians and Westerners, many of whom had not previously socialized together, mixed at the various exhibitions, concerts, plays, and films over the next week. There was a palpable excitement in the air. The galleries were packed (a rare occurrence), and large audiences were entertained by theater, music, and dance well into the night. The Nitaq Festival was unlike anything seen previously in the Egyptian art world. On the surface, the event seemed to be such a massive success that it was repeated the following year. But that was it. Problems inherent in this mixed nationality festival became especially insurmountable after the U.S. invasions of Afghanistan and Iraq and the escalation of the Israeli-Palestinian conflict.

On that same January night, members of the Fine Arts Committee of the Egyptian Supreme Council of Culture were spending their monthly meeting debating the negative effect that a mostly foreign-run festival might have on Egyptian art and audiences. Artists whose work had not been selected were not short of complaints about the caprice of the market and foreign gallery owners' taste. The Egyptian director of the festival's theater component refused any American funding. Meanwhile, Western audience members lauded the festival organization as being better than anything the state had ever done but continued their usual disparagement of the "quality" and "level" of the art made by Egyptians.

The Nitaq Festival brought to the fore many of the tensions that had been building in the Egyptian art world since the mid 1990s, when a foreign-dominated private sector art market emerged for the first time since colonialism. These significant shifts were partly the result of attempts by the Mubarak government to attract foreign investment. Market liberalization pressures from the International Monetary Fund and the United States, combined with the growth and availability of global communications technologies, enabled an unprecedented expansion of private sector art institutions, markets, and audiences. Curators new to the Egyptian art scene brought and developed significant ties to nongovernmental Western art institutions. They also cultivated a lucrative market among foreign and Egyptian young professionals who worked in the new finance, technology, and real estate companies. The reactions to the Nitaq Festival, and to the new market it spurred, suggest how artists living and working in the postcolony perceived the breakdown of the socialist state and the influx of foreign capital as both liberating and predatory—particularly in the Middle East, where memory of past imperialisms loomed large over current events. They also suggest how Western curatorial attitudes towards postcolonial artists in the metropole, despite having been critiqued thoughtfully and effectively, were being rearticulated in the ex-colonies with arguably even greater hubris.[2]

This chapter is concerned with what happened in Egypt's state-centric, nation-oriented field of artistic production when the intensified global circulation of art and money pushed for the privatization of the culture industries and the disaggregation of the nation. This process is occurring in countries all over the world that are exiting socialism; but, as I have suggested in this book, it has been especially fraught in places where socialism arose out of the struggle for national liberation, and where ideologies of culture were cast

in anti-colonial nationalist terms and instrumentalized in state institutions.[3] The subsequent decline in socialism's popularity, the bloating of state bureaucracies, and the international pressures to liberalize markets, raised a series of questions for arts interlocutors in Egypt (and beyond): Is neoliberalism the new imperialism? If so, with what ideology can it be resisted, now that state socialism has proven itself woefully inadequate? What is the role of the state in fields of artistic production that are no longer bound by the socialist project and the territorial nation-state? And how does one take advantage of new international opportunities without ceding cultural integrity? What will good art look like? Who will determine its value, and according to what criteria? With the war in Iraq and the second Palestinian Intifada, such questions were particularly charged for Egyptian artists and intellectuals, who regularly positioned themselves as spokespeople of the Arab world.[4] The formulation of these questions and answers to them was an important part of the process of reckoning that I have discussed in this book, for the inadequacy and indispensability (Chakrabarty 2000) of European-derived genealogies of the modern made themselves exceptionally apparent at this intercultural juncture.

In what follows, I want to call analytic attention to the particular tenacity of colonial logics and cultural national attachments as art from Egypt increasingly circulated internationally.[5] Such logics and attachments persisted despite the best intentions of both Western curators (who were critical of U.S. and Israeli policies in the region) and Egyptian art arts interlocutors (the majority of whom were uncomfortable with patriotic nationalism). They persisted in part because international political discourse treated the Middle East as an especially problematic premodern, violent, undemocratic space in need of Western salvation, and because Egyptians resented that categorization. Also, there are some things specific to Euro-American genealogies of the modern that reactivated such colonial logics and national attachments in the transformation to neoliberalism. First, modern art has an ambivalent relationship to commoditization, because it is often positioned as a field of refuge from market values, a positioning I have shown in earlier chapters to exist in some (though not all) aspects of Egyptian artistic production. Second, modern art evaluation is still dominated by ideologies of development and progress, which map easily onto West/non-West hierarchies in formerly colonized societies, and such teleological art evaluation produces a narrative of former glory and current decline for societies that also possess famous ancient art, Egypt being prominent among them. And, third, modern art in Egypt (as

I have argued throughout this book) is made by a field that emerged through colonialism and anti-colonial nationalism; it therefore becomes the locus of historically constituted East/West cultural politics, as well as North/South political struggles.

These tensions and contradictions between the elitist, colonial, socialist, nationalist, and internationalist cosmopolitan histories of modern art hung like specters over the Egyptian art world. In the context of ongoing occupations in the Middle East, and the spread of radical Islam they helped provoke, these histories shaped ambivalent interpretations of events like the Nitaq Festival, which signified the struggles documented by many scholars over how "culture" is to be represented, consumed, circulated, governed, and owned in the era of neoliberal capitalist globalization (Brown 2003; Coombe 2005; Ginsburg et al. 2002; Marcus and Myers 1995; Myers 2002; cf. Mazzarella 2004; Urban 2001; Yúdice 2003). The international expansion of a capitalist art market *in particular* triggered reckonings with the modern that emphasized colonial cultural logics and national cultural attachments, but these took forms different from their earlier enunciations.

The second related set of arguments put forward here concern the ways in which the increased circulation and commodification of cultural goods like art reshaped power relations between and among Westerners and Egyptians. I focus on the contests among different kinds of culture brokers: art critics and curators whose apparatus of judgment and market ideology was formulated primarily in Western arts and educational institutions; and those whose outlook was primarily shaped through experience in Egyptian institutions. While Western curators presented their hierarchy of cultural, artistic, and generational value as universal,[6] Egyptians were struggling to relativize it. They articulated a different kind of cosmopolitanism that made room for (at different times) artistic variety, respect for elders, and, most important, national/cultural integrity. Four main areas of contest emerged between and among these groups as they tried to navigate the global circulation of Egyptian art objects: the category of young artists; claims of expertise and knowledge; rights to represent Egypt abroad; and the ethics of capitalism. The battle over whose terms would dominate in each of these areas provoked unexpected critiques, realignments, and consolidations of power that complicate the simplistic story of the free market forcing a seamless and triumphant "transition" out of socialism.[7]

As I began to show in Chapter 3, post-1989 Egyptian cultural policy was actually largely responsible for initiating the privatization of the art market

and for promoting a neoliberal artistic subjectivity and cultural component to neoliberalism more generally. Here, I suggest that the new development in Egypt's cultural policy was not simply a reaction to international donors' imperatives and the changing nature of state sovereignty; it was also partly the result of Egyptian arts interlocutors no longer accepting the idea that the state could satisfy all artists' desires or by itself produce a dynamic art scene. At the same time, artists continued to feel that ideally the state should prevent the complete takeover of market values and logics in the art world. Most artists and state curators thus did not always and completely abandon socialist-oriented and/or nationalist cultural ideology. Neoliberalism in the art world both weakened and strengthened certain aspects of older nationalist/socialist attachments, depending on context. The nation was reconceptualized as a cosmopolitan, internationally oriented entity, but state surveillance simultaneously took on new forms.

Just as the new cultural policy opened up some avenues of artistic activity while trying to close others, so the new foreign curators offered artists new channels of exposure, but at a price. Despite (or perhaps because of) their best intentions, these newcomers could not escape art's Euro-American modernist legacy that emphasized the break between "old" and "new" and only valued the latter. And they could not escape the way that this legacy grafted onto the logic of colonialism (e.g., European and American culture represented the pinnacle of what was really innovative and most highly valued) and onto the logic of neoliberalism (e.g., the free market will defeat "backward" socialism). These people were engaged in laudable attempts to break the Western canon's exclusion of contemporary Middle Eastern art and to provide artists with an alternative to state institutions. But, as I shall show, their position as brokers of Egyptian art, who came from artistic and institutional traditions different from and more highly valued internationally than those in Egypt, made it very easy for them to slip into colonial logics to accomplish the ostensibly good work that they were doing. As Fred Myers has shown in another context, curators engage with art forms that are foreign to them "from the historically established problems and discourses of their fields" (2002:258). Furthermore, while offering alternatives to the state, these curators also enhanced their own power by using tried and true Ministry of Culture techniques. It is here that we can see the ways in which the two major regimes of power in the culture industries—one state-based and one consolidated through international nongovernmental circuits—actually colluded with each other.

In Egypt, and perhaps in other similarly situated art worlds, the combination of expanded markets and new, though historically constituted, national attachments produced a range of subjectivities that emphasized not only flexibility and mobility (Ong 1999) but also cultural allegiance, broadly defined. At the time of the Nitaq Festival, there was an emerging sense of "cultural sovereignty" among artists, critics, and curators that was nonjuridical, relational, strategic, context-specific, and in part produced by the state's new articulations of "graduated sovereignty" (Ong 1999). Thinking about the various disagreements that Egyptians had with foreign curators as articulations of cultural sovereignty is useful for several reasons. First, it highlights the link to and transformation of earlier ideas of national sovereignty developed in the colonial period. As we shall see, these Egyptian articulations of cultural sovereignty contained elements of modern definitions of sovereignty in that, at a basic level, they were expressions of self-determination that drew their power from earlier notions of "national culture" formulated in a similar time of intensified foreign "interest." Furthermore, there was the specific element of older domestic sovereignty, in that Egyptians wanted to exclude external systems of art authority from their own art world. However, Egyptian articulations were different from earlier exercises of sovereignty in that they were primarily nonjuridical, relational, and could be disaggregated from territorial nationalism and the nation-state.[8] As Stephen Krasner (1999) and Aihwa Ong (1999) have variously suggested, different kinds of sovereignty can overlap or become disconnected, and aspects of them can change while others remain the same. As I shall show, most Egyptian artists, critics, and curators attempted to exercise a kind of sovereignty over the ways in which their art circulated in the global cultural marketplace, but they did not erect barriers to this circulation. In fact, they welcomed the opening of cultural channels and believed that the future of Egyptian art depended on its engagement with the rest of the world. Meanwhile, sovereignty claims were noticeably absent in other areas of the Egyptian art world. For example, there were no cultural patrimony laws governing modern art objects, and there were no policies that controlled the flows of non-Egyptian art images or styles into the country or tried to curb their influence on Egyptian art. The evidence presented here, then, shows that graduated sovereignty was also at work in the field of artistic production, not just in the sectors of technology and finance so favored by globalization scholars.

Some social theorists might see this as the last gasp of nationalist sentiment among artists in Egypt, an attempt to hold onto something whose demise is sure.

In this opinion they would be (perhaps unwitting) bedfellows of the Western art critics who came to Egypt and promoted the idea that nation-based art and nationalist sentiment are inherently retrograde, and who declared the inevitability of nationalism's decline. Instead of seeing Egyptians as having reactionary reactions to neoliberalism, I suggest that we instead read their responses as critical and active reckonings with the global cultural economy, and as engagements that also shaped that economy's particular manifestations at specific moments. State curators' actions, then, did not reflect a nation-state's loss of control, but rather evidenced the emergence of a new kind of governance, in which the state released sovereignty over the mobility of its internationally oriented subjects and the media they used in their work, but reminded them that they remained under surveillance to ensure that they did not sell out their culture and its art. And Egyptian artists' articulations of cultural sovereignty were not assertions of identity locked in the past, but rather a historically and socially constituted, and ongoing, reckoning with new market forces in the cultural realm. They shared a commitment to art serving a broader social purpose than a foreign or elite-oriented market would allow. Egyptian critics of Western-driven art market privatization were thus not using worn-out versions of nationalism. Rather, they were articulating, through a complicated framework of cultural sovereignty that drew on various genealogies of the modern, a desire to make the global circulation of Egyptian art and the privatization of the art market happen on their own terms, for the benefit of the artists' community and for society as a whole. I submit that these newly articulated postcolonial national attachments and ideologies of culture have become especially pronounced in arenas of cultural production like art, which have been historically linked for over one hundred years to notions of national authenticity and its representation.

THE REBIRTH OF THE PRIVATE SECTOR

In the colonial period, there emerged a private sector market in modern Egyptian art made by the first graduates of the European-staffed College of Fine Arts in Cairo. This art market was comprised of European residents in Egypt and the aristocracy left over from the Ottoman era. With independence in 1952, many private collections were sequestered and nationalized by the state. Art sales outside state channels drastically decreased.[9] In the 1990s, however, a large number of private art galleries opened. This significant development was due to a number of factors, including the massive post-1989 increase in state encouragement of the visual arts. It was also due to the government's

new economic policy, which produced greater numbers of Egyptian nouveaux riches and brought in foreign executives, diplomats, and NGO workers eager to buy art. New laws also allowed foreigners to open businesses such as art galleries. These developments coincided with the burgeoning Western interest in finding new frontiers in contemporary art. Curators had already mined the art scenes in Latin America, South Asia, and East Asia. Middle Eastern art became the next hot commodity, and remained so, especially after 9/11. For the most part, the tremendous growth in foreign presence was North American and western European. Not only did artists from abroad set up residence in Egypt, but foreigners began opening galleries in downtown Cairo and bringing in foreign critics, buyers, and curators.

These galleries were part of a more general growth in private art enterprise in the 1990s. At least four Egyptian-owned galleries opened in Zamalek. Other elite Egyptians opened spaces in similarly upscale areas of Cairo. Indeed, Egyptians ran the majority of private galleries in Egypt. For the most part, they tended to exhibit classics of modern Egyptian art or *asala* work. The exhibition aesthetics of these galleries was markedly different from those in the downtown galleries, with their generally minimalist, white-cube aesthetic. In contrast, these Egyptian-owned galleries often sold objets d'art, such as vases, alongside artwork. Paintings were often placed in gilded frames. And some of the exhibition spaces resembled aristocratic apartments that had been turned into galleries, complete with fancy chairs for guests to sit on (see fig. 6.1; cf. the collectors' aesthetics discussed in Chapter 5).

At the time of my fieldwork, the majority of the sales at these galleries were to Egyptians, primarily those of the old moneyed classes. However, these galleries did have a foreign clientele consisting largely of embassy personnel and traveling businesspeople, such as those who worked for the Middle Eastern divisions of global companies. Many of these buyers were American and British, with a smaller group of French, Italians, and Gulf Arabs. Many of the sales data for these galleries were not documented or were kept private. However, based on the data I was able to acquire, as well as those of Khalid Hafiz,[10] I estimate the average total sales for this group of galleries around 1999 to be in the range of 300,000–500,000 Egyptian pounds annually (approximately U.S. $88,000–147,000 at the time). It should be noted that sales varied substantially from one gallery to another. They could also rise or fall dramatically from one month to another, because they were heavily linked to the unstable, fluctuating economy.

Figure 6.1 Interior of an *asala*-oriented gallery.
Photograph by Jessica Winegar.

The new downtown galleries, the focus of this chapter, catered to a different clientele. The majority of foreigners who bought art at these galleries tended to be western European rather than American. They may have worked at local cultural centers, but on the whole they were less connected with the diplomatic community than those who bought at the Egyptian-owned galleries. However, the greatest difference between these two sets of galleries seemed to be the Egyptian buyers. Egyptians buying from the downtown galleries tended to be much younger than those who bought elsewhere. They were employed in the then-booming private technology and real estate industries and were not necessarily from the old aristocracy. Many gallery owners observed that they were newly wealthy, or were the sons and daughters of the first nouveaux riches who had acquired their wealth with the 1970s capitalist reforms. Although sales were rising rapidly, at the time of my fieldwork, these galleries did not sell nearly as much as the others specializing in more realist work. Again, access to accurate sales data was an issue,[11] but I can estimate that in 1999 this group of downtown galleries sold in the range of 100,000 to 300,000 Egyptian pounds (approximately U.S.$30,000–88,000) in total.

I should note that by far the biggest buyer of art in Egypt at the time was the government. The annual acquisitions budget in 1999, for example, was a hefty

650,000–1,000,000 Egyptian pounds (approximately U.S.$190,000–340,000),[12] but this figure did not include government commissions of work, such as the obelisk discussed in Chapter 4. Nor did it account for other sales made by public galleries to private buyers. The cumulative figure for art sales to and through the government was therefore quite substantial.

Many of the government exhibition halls also subscribed to the minimalist, white-box aesthetic, though some spaces revealed signs of their previous aristocratic use as palaces and villas (see fig. 6.2). While the major public spaces tended to exhibit the kind of abstract or experimental work shown at the private downtown galleries, in group exhibitions, they showed the full range of contemporary artistic production. The dominance of state support of the arts, and the aesthetic similarities between public and certain private exhibition spaces,

Figure 6.2 Interior of Cairo's Centre for the Arts.
Photograph by Jessica Winegar.

will be important to keep in mind as I discuss the contests and occasional alliances that occurred between all the players in the changing Egyptian art scene, and that were especially palpable during the arts festival and events produced by the new Quartz Gallery.

The Quartz Gallery was the most prominent foreign-owned gallery to open in Egypt in the 1990s. The circumstances of its opening, and its architectural features, clearly embodied the dramatic shifts in economy, politics, and international relations in post-independence Egypt. In 1998, a Canadian resident of Egypt opened the space in the heart of downtown Cairo. He rented and renovated the first floor of a three-story building whose grand, high-ceilinged apartments had become seriously dilapidated. The original owners of the apartments, well-heeled professionals and affluent families, had let them fall into disrepair after Nasser's rent control laws limited the amount they could take from their renters. In the 1990s, many Nasser-era laws regarding national protection and income redistribution (that Sadat had not already reversed) were being overturned. It was now legal for a non-Egyptian to open and run a gallery in Cairo, just as the People's Assembly was discussing ways to revamp the rent control law.

For many foreigners and upper-class Egyptians, the building that housed the Quartz Gallery, with its French doors, marble-tiled floors, floor-to-ceiling windows, and ornate iron balconies, was a nostalgic reminder of grander times before the onset of state socialism.[13] After the renovations, the space not only still bore the traces of pre-Nasser wealth. It also reflected a kind of reversal, over a period of twenty-five years, of the economic, political, and cultural direction of the country. The owner, who had already spent several years in Egypt as a business entrepreneur in other areas, opened a space whose aesthetic was a mixture of the colonial elite past and contemporary Soho chic, thereby embodying a certain history of Egypt's engagement with foreign elites.[14]

The Quartz owner drew on his own experience in working in the arts in England when he told me that the key to building a stronger, more progressive art movement was to develop the private sector. He was able to convince other new gallery owners that their efforts to develop a new market would be strengthened if they ignored the state altogether. As discussed in Chapter 4, most Egyptian artists agreed that the private sector needed further development. The 5,000-member artists' union even held a major symposium in 1999 that strategized ways to get Egyptian businessmen involved in support of the arts. Thus, artists did not oppose the idea of a new art market per se.

The problem was that the new market did not represent the kind of equitable multicultural globalizing private sector that Egyptian artists desired, and as a result there were serious concerns that market values would negate their existing apparatus of evaluation. The majority of artists argued that while the new private sector had the potential to counteract the stagnancy of the government, it was anything but benign. Indeed, the growth of this new private sector both produced and reproduced certain hierarchical relations in the art world, even as it challenged others. Westerners contested the existing local hierarchy of value, which generally privileged the public sector over the private, and which gave older artists more respect and prestige than younger ones. In the meantime, however, even as the new private sector players celebrated the younger generation, they used familiar ageist techniques (among others) to place these artists in a lower position in a neocolonial hierarchy that valued the West above the rest. There was a telling contradiction in the ways that the new brokers described the contemporary art scene in Egypt. On the one hand, they talked about being impressed by the art and the volume and vitality of art activities. At the same time, they described the work as "undeveloped," the art world as stagnant because of the bureaucratic state, and artists as overly self-righteous and competitive. The next section suggests that this contradiction explains many of their activities.

THE BATTLE OVER "YOUNG ARTISTS"

Jean and John Comaroff have called attention to the ways in which youth have come "to occupy the innovative, uncharted borderlands along which the global meets the local," and how anxieties around neoliberalism are often located in the category of "the youth" (2000). It is no accident, then, that young artists became the focus of such intense battles between the established Egyptian curators and the newcomers. The fall of the Berlin Wall in 1989 signified the end of the Cold War and the emergence of a new world order. The Young British Artists (YBAs) became all the rage. That same year, the visual art scene in Egypt was put on a new course by the creation of the Salon al-Shabab, the major state art exhibition discussed in Chapter 3, in which young artists were encouraged to be "flexible" and to mix what were thought to be "local" and "international" media, styles, or concepts. As the Egyptian government was enacting neoliberal reforms in the economic sector (or giving lip service to them), in the cultural sector, it was contributing to the production of a new kind of national subject among young artists—one

that was secular, "progressive," and amenable to the new direction in which Egypt was heading.

When foreign curators arrived on the scene, they brought their own kind of interest in "young Egyptian artists" and worked to create such a category. The ways in which they did so denied the state's early role in creating this same "young generation," particularly when they selected artists who had first shown with the government. And instead of interpreting the works themselves as having to do with *Egypt* as a national entity (as Egyptian interlocutors might), foreign curators and audiences viewed these works within the frame of personal expression, as being about personal lives and histories within a particular cultural context. "Everything now is about 'al-personal,'" one Egyptian artist kept saying to his friends, speaking Arabic, but using the English "personal"—a word used by many Westerners when describing which Egyptian art they liked best. The emphasis on the personal in this case tended to displace the political, and in that sense fit the alienating logics of neoliberal capitalism.

While asserting new hierarchies of artistic value, Westerners were also overturning the local gerontocratic system through discourses that pulled cultural and generational differences into an integrated West/rest, young/old hierarchy. The growth of a younger generation was originally enabled and constrained by a kind of paternalist gerontocracy, coupled by cultural respect for elders. Younger artists criticized the domination of the older generation, but they also emphasized their indebtedness to and respect for them. The newly arrived foreign curators, however, regularly categorized locally esteemed older generation artists as outdated, and the large public arts sector directed by older artists and curators as indicative of a lagging art movement. They thus mounted several challenges to most Egyptians' understanding of the ministry's role in the Egyptian art world, and a battle began in which older generation state curators and private sector curators fought over who could lay claim to the young artists.

The downtown galleries initiated the Nitaq Festival to "invigorate" the art movement in Egypt. They thus employed the same language that had first been used by the Ministry of Culture in its projects—a language that suggests a prior dormancy. But the Nitaq Festival organizers and their supporters argued that their event, and the private sector more generally, gave these artists exhibition opportunities that they would not otherwise have had. They also said that the private sector encouraged young artists to work in genres

that the older generation did not accept. For example, one gallery owner explained that "the majority of artists that the downtown galleries deal with are young. Because the older artists, the established artists, they've *got* exhibition spaces." When I countered that for the past ten years, young artists had actually been getting a lot of exhibition opportunities from the government, the gallery owner paused, then agreed. But he went on to recuperate the private sector narrative, saying that he wanted to "give some credence" to installation work, "because it's so accepted everywhere else. Video work, it's accepted everywhere else. And you don't get older people doing it, at all." Older Egyptian artists, he explained, "Are so into these grooves that their work doesn't really interest any of us. The majority of work done by older artists is just . . . so regional, so parochial, so Middle Eastern . . . that it really is of no use to me."

Other downtown gallery owners, as well as curators and critics visiting Egypt, also frequently characterized the work of older artists as parochial, often calling it "too folkloric," which implied that it was too reliant on local folklore to have international significance. On the other hand, some critics argued that older generation artists were not sufficiently culturally specific in their work. For example, an independent curator from London wrote that the work of Gazibiyya Sirri (see the interlude following Chapter 4) and 'Abd al-Rahman al-Nashar, two extremely respected older artists, was "generic abstract expressionism" with no "cultural specificity" or "relevance."[15] Artists were thus trapped in the no-win situation of the "culture game" (Oguibe 2004), being asked to represent their culture but then being judged as provincial for doing so.[16] These were clear examples of how the Western modernist emphasis on the new colluded with colonialist language of native backwardness and generational hierarchy.

The general prejudice against artists over the age of forty-five was based largely on the assumption that age automatically denied one inclusion in the category of "innovative." The idea that artwork must be innovative was paired with the idea that it must also be "contemporary." Thus "innovative" was considered to be "contemporary," whereas not innovative was "backward." For example, I asked one of the American curators coming through Cairo how she evaluated and chose art. She said that it had to be "contemporary," which she described as "having something to say about what is going on in the world today." She devalued older artists' work as "not contemporary." It could be argued, according to her definition, that all work being produced in Egypt was "contemporary," even work that did not fit the dictionary definition of

"innovative." Floral still lifes were contemporary because they spoke to the long-standing taste of many middle- and upper-class Egyptians. Paintings of peasants or pyramids were contemporary because they represented very popular elite images of what it meant to be Egyptian. But what this curator implied by "contemporary" was work that fit easily into the general aesthetic of the international avant-garde. Even though this aesthetic is ill-defined and too broad really to use here, it can be understood as the kind of aesthetic that dominates Chelsea galleries in New York, blockbuster shows like the Whitney Biennial, and international exhibitions such as Documenta in Germany.

It seems to me that the problem for older Egyptian artists whose work was read by outsiders as "traditional," either in terms of materials or subjects, was that it evidenced a preoccupation with expressions of national identity, rather than ironic uses of traditional themes and styles that would make variations on such work acceptable in the hip art venues of the West (e.g., the new realism exhibited in New York galleries in the 1990s). It was thus read as retrograde, not "contemporary." To further accomplish this framing of older artists' work as retrograde and culturally backward, foreign curators ignored the vast numbers of younger artists who did *asala*-oriented work, as well as the older artists who did *muʿasira*-oriented work. Additionally, the frequent use of the word "still" in Western discourse about older generation Egyptian art was indicative of the vast generalizations, and lacunae, that went into this framing of art preoccupied with things other than irony. Discussing an exhibition of older generation artists, the London curator Lucy Till wrote that they exemplified the problems of an environment where "art education and patronage *still suffer* from Nasserite centralization and hierarchical structures, and *still adhere* to Arabist, nationalist, and increasingly Islamist, doctrines. Artists continue to . . . utilize *old-fashioned* motifs and traditions" (emphases added).[17]

Westerners thus positioned themselves as the possessors of progressive time and the ultimate arbiters of avant-garde art vis-à-vis manipulation of generational differences. Western art develops and has contemporaneity, whereas art from elsewhere is not guaranteed currency. In this sense, many Western audiences treated contemporary modern art from Egypt the way they have often treated "primitive" art (cf. Clifford 1988; Fabian 1983; Price 1989). Underlying the activities of the downtown gallery owners and their Western associates, then, was the idea that contemporaneity must emerge from the sluggish backwaters of the Egyptian art movement, but with their assistance. Just as Westerners have collected non-Western objects to fashion their own self-image in

opposition to "primitives," Westerners in Egypt positioned contemporary Egyptian art as backward, thereby affirming themselves as avant-garde.

I suggest that curators also persisted in this narrative, despite their lack of evidence to support it, because they needed to create a private sector market and legitimize themselves as that market's developers and/or representatives. The colonial framing, and silencing, of Egyptian art as a backward space dominated by out-of-touch elders was a particularly effective method for "developing" a new market, judging by the art's increasing sales, popularity among foreign audiences, and mention in famous magazines like *Art in America*. The Euro-American modernist emphasis on the "new," in collusion with market forces, drove this continuous search for young artists in Egypt, as it did around the world. The discourse of "emergence" was an important element of this process. Western writers, including myself, rhapsodized that a new generation of artists was emerging.[18] Yet I now see this discursive emphasis on "emergence" as key to the reproduction of modernist teleological thinking, which, as James Ferguson (1999) has shown, often produces tremendous anxiety among those burdened with the task of emerging.

The theme of emergence carried with it the implication that young artists were not yet free from the shackles of their cultural background. In a manner familiar to scholars of colonialism, Westerners positioned young artists as lower in a cultural hierarchy by questioning their mental capabilities. Some artists, even those in their late twenties and thirties, were said to have ideas and to be doing work that were stuck in "high school." Many Westerners complained to me (assuming I agreed) that the young artists did not have the skills, knowledge, or intellectual savvy to articulate their artistic vision. At times, I also used this explanation when trying to understand the disconnects between some Egyptian artists and these non-Egyptian curators. But I realized that the assumption that it is the artists (not the Westerners) who were incapable of articulating across cultural (and indeed linguistic) boundaries reflected the extent to which artists from around the world are expected to conform to a Eurocentric lexicon. It is also striking that much of this discourse about young artists was already operative in the universities and at the Ministry of Culture to justify the local age hierarchy. For example, one of the main criticisms of young artists' work among the elders was that it is not "mature" (*nadig*) or "ripe" (*mistiwi*).

This neocolonial curatorial attitude was painfully experienced by young artists. For example, one curator told a friend of mine to make the journey

from Alexandria to Cairo to show her his slides. When he arrived to meet her at an opening, she kept putting him off, until finally she breezed through his images and declared that she was not interested in figurative art. He persisted and asked what she thought of his work. He recounted to me that she had scolded him for asking an "art student question" that was not one "an artist" should ask. He spoke about how angry he was at being strung along only to be put down. Similarly, another artist was insulted within earshot for doing work that was "immature."[19] When three young artists were selected by Europe-based curators for an important show at the Venice Biennale, a critic opined that there was "still" the idea in Egypt that big works were better, when the rest of the world was working in a more quotidian style, and that perhaps the experience would allow the artists to "develop and explore new modes of expression."[20] The implication, of course, was that these artists needed to change, not that they were doing work that needed to be understood on its own terms. Young artists were thus essentially at the mercy of North Americans and western Europeans who positioned themselves as the ultimate arbiters of what, and who, was "developed."

Indeed, time and again, Western participants or visitors to the art scene in Egypt insinuated that Egypt was behind the times, and that much of the art produced rehashed older styles long abandoned in the West, or was just folkloric. The fact that they had this opinion, and even recognized that there was a local version of it, was evidenced by a U.S. review of the Cairo Biennial by an American artist and professor resident in Cairo. After criticizing the exhibition's organization and the Egyptian art scene for lagging behind, he further supported his argument thus: "Even the Biennale organizers speak of Arab art in terms of catching up with and absorbing ideas from the West."[21] But as I shall soon show, Egyptians felt that it was one thing for them to reckon with this modernist teleology among themselves and quite another to have it thrust on them by Westerners.

Younger artists were aware that most Western curators were critical of older generation artists because many of them were part of the state apparatus.[22] So when interacting with them, they emphasized their own criticisms of the state and elders and downplayed their ongoing connections to them. It is significant to note that the highly contextual circumstances of young artists' opposition to the state often went unrecognized by Westerners. They were unaware that most young artists also actively sought to maintain their ties to the state, especially for employment, exhibitions, commissions, and acquisi-

tions. This is partly because the foreigners were culturally and linguistically hampered in their communication with these artists. Their best communication was actually with a very small, elite group of young artists whose English was impeccable, who had extensive overseas experience, and who had been educated abroad or at the elite private American University in Cairo. Their structural position enabled a less tempered critique of the state. The availability of this small group, combined with many foreign curators' view that the state was inherently bad for art, resulted in the misrecognition that all young artists were engaged in a valiant struggle against state control.

Meanwhile, older generation artists who were most connected to the Ministry of Culture resisted any challenge to the state's own narrative of its accomplishments regarding young artists and newer media. It did not escape notice that the young artists who participated in the Nitaq Festival, and who were selected by Western curators for shows abroad, were in large measure those whose careers had been launched through the ministry's annual competitions. Now, it seemed to many older artists, the private sector was not only capitalizing on the accomplishments of the state, but the ministry was being denied credit for those achievements. One older artist criticized a local English-language magazine for claiming that Nitaq was an opportunity for young artists to exhibit, because they were shut out by the state. Indeed, one would be hard pressed to find Egyptians (of any age or aesthetic persuasion) who thought that the state ignored younger artists or new media, given the preponderance of discursive and material support for them.

Even though the private sector narrative regarding generation and progress lacked substantial evidence, it did reveal the tension within the ministry's policy of promoting young artists, while insisting on an age hierarchy. This tension was made clear in the minister's reaction to the exodus of young artists to one of the new galleries: "This gallery owner can take whomever he wants from the young artists. It doesn't concern me that he takes the sons of the Youth Salon. First of all, you cannot refuse any artist his freedom. . . . They [the young artists] can make mistakes, they are not children. But there is no doubt that we are aware of [them] and know where they are in the end."[23]

Here the language of artistic freedom is paired with a patronizing reminder of the state's panoptic authority over young artists. In another poignant reminder of surveillance, a state curator called artists to tell them that it was inappropriate for them to exhibit in a new gallery at the American University while the Israelis were killing Palestinians with U.S.-supplied ammunition.

Thus, in this post-1989 system of cultural governance, artists were encouraged to move freely, to draw on a variety of international trends in their work, and even to exhibit it outside of the country, but they were admonished to do so in a way that maintained their cultural integrity as first nurtured by the state.

Young artists thus became the subjects of two operations of power—one emanating from the Egyptian state apparatus and one from Western curators. Just as state officials "created" young artists to prove Egypt's cultural progress, Western curators "created" young artists to prove theirs. While the state gave prizes to certain kinds of art and emphasized surveillance, Western curators chose the same kinds of art and used a combination of neoliberal and neocolonial discourses to justify those choices.

Although young artists were pulled betwixt and between these two regimes of power, most did not fully submit to either but rather made their way through the minefield by combining teleological, national, and cosmopolitan aspects of the modern. They sought to take advantage of the (often unexpected) opportunities offered by both the public and private sectors, formulating artistic stances that melded the least offensive aspects of free-market ideology with the least restrictive aspects of state socialism and nationalism. Although some ended up choosing sides, most tried to navigate the situation by adopting a new kind of flexibility rooted in freshly articulated notions of cultural sovereignty and artistic integrity. They found ways to discursively frame the art they were already producing in ways that fit with the cultural policy initiatives and/or international marketing strategies. And some capitalized on or created new social connections, or learned foreign languages, in order to move more easily within and between these different worlds. Others were inspired by the artistic possibilities offered by new media, and by the new dialogues experienced within Egypt and through emerging international channels.[24] For example, artists were particularly impressed, in the early days, by the owner of the Quartz Gallery, who had an infectious excitement for younger artists' work, and who—unlike the government curators—set aside hours every week for viewing portfolios and gave personal attention to the work of anyone who made an appointment.

It is of interest that Western curators were uncomfortable with the "free-market" competition that their work engendered. Some attempts by young artists to adopt the subjectivities necessary for competing in the international art market were disparaged, and they were criticized for being overly competitive with one another. Gallery owners and critics complained to me that

artists were unduly envious when a colleague got an exhibition and they did not, or when the gallery secured private funding for one artist's exhibition and not another's. One gallery owner told me that curators, critics, and buyers who came to Egypt said that there was more in-fighting and backbiting than in any other art scene that they had seen. He agreed with their assessment that Egypt was "not ready" to go international, because Egyptian artists were "unable to work together." The gallery owner further argued that artists were losing opportunities abroad because of their "inability . . . to acknowledge every person's right to create something." He partially blamed himself, while using paternalistic language that justified his position as a cultural gatekeeper: "I feel like I made a mistake in assuming that Egyptian artists are ready for an international audience. They were given a lot of criticism that perhaps I shouldn't have exposed them to." Gallery owners also told me that they thought that young artists had undeserved expectations. For example, when a variety of artists said that the catalogues for one show were of poor quality—either because of content or the printing itself—the gallery owner was incensed. The gallery had paid for the catalogues, and some of the artists had refused to use them. Although I was not able to interview the artists involved, I did speak with others who felt that they received the short end of the stick in dealings with private gallery owners. Their primary complaints were about catalogue quality, the limited efforts of gallery owners to market their work, faulty or late advertising of exhibitions, and unfair changes in commission rates. One could see acts such as ripping up catalogues that the gallery owners had printed (which happened) as forms of resistance. Certainly, for an Egyptian artist to "expect" certain standards from a Western gallery owner or curator was an unexpected challenge to their power. It is also likely that they felt some freedom to resist the strictures of gallery owners in the private sector, whereas such acts in a government space would surely have cast them out of favor for a good many years.

Such disagreements between young artists and foreign curators were rooted in several understandings, held by the majority of Egyptian artists, of how galleries should operate. First, I would argue, young artists were operating with the model of the ideal state discussed in Chapter 3, which included the idea that resources should be fairly and evenly distributed. Thus, they perceived private gallery owners' behavior towards certain artists as unfair favoritism. Also, they presumed that certain things—such as rates and timings—should be set. This understanding stemmed from their experience with the state art

bureaucracy that produced exhibitions, advertising about them, and prize scales according to a schedule set far in advance. Of course, snafus happened, but overall the bureaucracy ensured a remarkable level of predictability. Artists not only expected the private sector to be as predictable in such things, but also to be better at them. While poor-quality exhibition catalogues were tolerated in the public sector because of the faults in the system, they were not excused in the private sector. Furthermore, artists believed that art in the private sector should sell, prices should be higher, and commissions should be clear.[25] And artists generally believed that Western gallery owners were better trained and therefore should not make the same mistakes an Egyptian would. The actions of young artists also suggest that they thought that the private sector should afford them more control over the marketing and documentation of their work than was traditionally allowed in the state galleries. Many of these expectations came across as too demanding and arrogant to foreign observers who felt that Egyptians should appreciate their benevolence rather than complain. Gallery owners' views were also shaped by a different system of selection and evaluation, in which concepts of "distribution of resources" had no place.

The solution to all these problems, or so it seemed to these foreigners (including, I admit, myself at times), was a healthy injection of contemporary art and business sensibilities from western Europe or North America. The development of a private sector with international connections was hailed as the answer.[26] Ironically, the evolutionary perspective towards Egyptian art, and the modernization development rhetoric that went with it, often ran counter to the postmodernist deconstruction of art canon hierarchies that had brought these people to Egypt in the first place, and on which they wrote articles. While many curators attempted to understand the elements in Egyptian society that shaped artists' work, and wanted to valorize young artists as at the forefront of artistic change in a "static" Third World art scene, they could not quite break free from their dual conceptualizations of the West as superior and as a savior.

Consider an article by Marilu Knode, then curator at the Milwaukee Institute for Visual Arts.[27] Writing in *Art in America*, she compared the 2001 Cairo Biennial with the Nitaq Festival. In the article, the young Egyptian artists in the biennial (as well as sub-Saharan African artists) are each criticized for doing work that "[needs] refinement" and that is "flat," "amateur" or "undistinguished." Middle Eastern art is characterized as "a combination of older styles of modernism." Meanwhile, in a separate section entitled "And from the

West," Western artists' work is not subject to the same scrutiny or developmental language. The author suggests merely that the work varied in quality.

Juxtaposed to this negative review of the biennial is a glowing accolade of the Quartz Gallery and the Nitaq Festival. Of the festival, Knode writes, "one got a glimmer of how the younger generation is starting to break free from the confines of outmoded styles of artistic production." The new gallery is characterized as "exceptional." Here, a nonstate, Western institution is seen as the catalyst for much positive change in the art world. In her article, Knode continued this metaphor of the West as catalyst, particularly by reference to another period of Western influence in Egypt: the young artists exhibiting at the new gallery are seen as part of the "post–Camp David generation" of young artists. She writes that because they came of age when Egypt had a "more open policy toward the rest of the world," they "evidence a basic understanding of the artistic movements of the past two decades in the West" (note that the necessity of such an understanding is not even questioned).[28] But, Knode cautions, "there is still great variation in the quality of works produced, [depending on] whether the artist studied in Egypt or abroad." Notice that the writer does not recognize or acknowledge that other standards of quality might exist in the world.

Indeed, most foreign curators evidenced a preference for Egyptian artists who had experience abroad. For example, once when a curator recommended two artists for a show in Paris, I commented that they were among the wealthiest young artists, spoke fluent English, and had studied at the American University. The curator responded that their work was probably more interesting because of this background. But she also decided to change one of her choices to a less privileged artist. At the time of this writing, Western curators largely prefer artists who already have significant international experience, if not those who had opportunities early in life to live and travel overseas.

Clearly, these curators were struggling to manage their own postmodern art sensibilities and left-of-center politics (cultivated at home) with the easy neocolonial frameworks they found themselves adopting when faced with art from elsewhere. Knode herself expressed this struggle eloquently in another article, writing: "As the Western art world slowly begins to grapple with artistic production in the Middle East, we are confronted with many loaded political and social differences that need to be understood. After the contextualizing push of the 1980s it is impossible to bring artists from 'outside' into a Western context that often judges them unfairly against different cultural traditions, or aestheticizes them in ways inappropriate to the works."[29]

These examples show that it was much easier for Western curators to say that young Egyptian artists were doing work that was "powerfully local" yet "open to the increasingly global cultural discourse" than to dismiss them outright. To dismiss such artists would have negated the curators' reasons for being there, which included passionate commitment to art, as well as career advancement. In their view, young artists just needed to develop their work and get more skills and experience in what was imagined to be an "international" art language. In this way, the older generation served as the foil against which a progressive art movement could be built with Western assistance.

Thus, it seems that many Western critics and curators were aware of the potential problems of judging Egyptian work according to alien standards. Yet at the same time, they could not escape their teleological "West above the rest" way of categorizing the art and artists. Curators persistently constructed cultural difference in such a way that they staged themselves as avant-gardes. As the analysis of primitivism (Clifford 1988; Miller 1991; Price 1989; Torgovnick 1990) and theories of modernity remind us, "staging the modern has always required the non-modern, the space of colonial difference" (Mitchell 2000:xxvi). Curators constructed this difference because of their need to lay claim to a new art-producing region—a need shaped by their own personal and institutional priorities and trajectories.

CLAIMS AND ASSUMPTIONS OF AUTHORITY

Like the category of young artists, knowledge and expertise became another flashpoint in the struggle over whose terms would dominate in the new global circulations of contemporary Egyptian art. Conflicts over the circulation of cultural knowledge and objects have been going on all around the world, and appear to have become particularly prominent after the end of the Cold War (see, e.g., Brown 2003). Egypt is no exception, as the government's recent attempts to reclaim Pharaonic objects held by European museums indicate. A Nitaq-period curatorial seminar held by Americans at the American University in Cairo provoked not claims on objects, but rather claims on expertise in and knowledge about cultural objects. On the surface, state curators appeared to articulate a fairly traditional notion of domestic sovereignty over who had legitimate authority over Egyptian art and artists. At the same time, however, their assertions of cultural sovereignty were not limited to the national polity but were meant to apply to certain circulations of art beyond the boundaries of the nation-state. Objects, and even artists, were encouraged to move inter-

nationally, but Egyptians wanted to determine the terms according to which these circulations took place.

In the spring of 1999, I was told of a screaming match that occurred between the Egyptian director of a major public art gallery and an American art professor at the American University in Cairo. The art professor told me that he had come to invite the director to a two-week seminar he had arranged with a colleague from a visual arts institute in the United States. The two had titled the seminar "Contemporary International Curatorial Practice: Integrating East and West." They had devised a program of readings and several speakers, including themselves, two of the new downtown gallery owners, a Turkish curator, and a young Egyptian artist/art critic. The objective, listed on the syllabus, was "*To bring curatorial expertise* to Egyptian art students, *to provide them* with the tools to contribute to the complex commentary of contemporary artistic practice and presentation, *to prepare students* to think critically about the historical, social and cultural differences between *east and west* when dealing with contemporary culture, and to open a dialogue between the next generation of critics and artists so that they can have a positive affect [*sic*] on contemporary cultural dialogue" (emphases added).

The professor told me that he had wanted to invite one of the prominent government curators personally, because he was sure that she would be interested in such an event. He was wrong. The government curator was livid that she had not been consulted prior to the planning of the event, and that these outsiders were coming to, in her words, "tell us what to do" and to "Americanize" Egyptian art. The battle that ensued was the direct result of conflicting expert claims in the contemporary Egyptian art scene that reveal both the interplay and clashes between two regimes of power, as well as different reckonings with genealogies of the modern. While many European and American curators claimed to know what was best for Egyptian art based on "international expertise," Egyptian curators asserted sovereignty through and over their knowledge of and expertise in Egyptian art.

Western seminar organizers, critics, and gallery owners claimed to have more expertise than Egyptian arts administrators who worked for the Ministry of Culture. This expertise, as they constructed it, was based on two distinct sets of knowledge. First, they presented themselves as having technical expertise in curating and in running a gallery—often merely by virtue of the fact that they were not Egyptian. Despite the fact that some of these people had never been solely responsible for running a gallery abroad, they did not

perceive this as a lack of experience in Egypt. They indicated that they knew more about how to run a gallery "properly" than did administrators at the Ministry of Culture, whom they criticized as being too "traditional," or not knowledgeable about the basics of running arts spaces.

Their critiques of the government were articulated through a stance of superiority that presumed that most Egyptians were unaware of their problems or were incapable of solving them. This stance very quickly reminded many Egyptians (not just the state officials) of the posturing of colonial administrators. It also triggered long-standing anxieties about backwardness. For example, the participants told me that one of the most dramatic and embarrassing episodes in the whole seminar was when the American curator led them to the state-run museum of modern art. She asked the manager questions about the philosophy of the museum and its system for changing exhibits. The manager had no answers, in part because in Egypt (as elsewhere) such matters are the responsibility of the museum director, not the manager (who oversees the staff, facilities, etc.) The seminar leader then led the participants through the museum and criticized the layout and lighting. Similarly, in her *Art in America* article, the U.S. curator Knode criticized the Cairo Biennial organizers for having an "opaque curatorial process," which resulted in "too much substandard, hackneyed work," without recognizing that the administrators themselves had discussed these problems ever since the biennial began, and that they knew that their attempted solutions had failed. She also took the Ministry of Culture to task for poor installation of the biennial and the catalogue: "Many of the labels were not translated into English. The lack of attention to detail was particularly noticeable in the poorly edited bilingual catalogue."[30] Here it is clear that it is the Egyptians, not Euro-Americans, who were expected to bear the onus of communicating across linguistic and cultural boundaries.

The second kind of knowledge that the new critics and curators used to claim expertise was knowledge about "global" or "Western" art. As one curator told me, "Many of these people [the government arts administrators] don't know anything about art." An American artist resident in Cairo wrote in the *New Art Examiner* that Ministry of Culture officials, "as political appointees," are "generally unaware of the global art world." [31] The referent for these kinds of statements, it should be clear by now, was "contemporary Western art." However ill-defined, Western art was the presumed standard. Even if a number of foreigners acknowledged that some state curators were aware of art trends outside of Egypt, most argued that they did not really under-

stand them, or else they would have encouraged their local development in what they called less "superficial" or "imitative" ways (cf. similar discourse among artists discussed in Chapter 2). For example, the director of one downtown gallery complained that in the annual young artists' competition, state judges encourage installation or large paintings just to follow a trend, and that the work indicated that the young artists did not "really know what they are doing." Thus, foreign curators in Egypt, along with foreign visitors to art exhibitions, tended to claim authority based on a privileged knowledge of contemporary art outside of Egypt.

Although Egyptian artists and administrators often recognized these claims to expertise that were based on knowledge procured overseas (whether by a European or an Egyptian), they asserted another kind of knowledge as equally important—that of Egyptian art and its history. In fact, artists often used the term *khabir* ("expert") to describe those who knew intimate details about the major trends in the history of Egyptian art, from Pharaonic times through the modern period. During their heated argument, the Egyptian government curator had rhetorically asked the American seminar organizer, "What do *you* know about Egyptian art?" For some people who had spent their whole careers studying Egyptian art, the sight of newcomers quickly asserting their expertise in Egyptian art was too much to bear. In their view, they should be the recognized experts in "their" modernism. Even though many of the newcomers were interested in learning more about Egyptian art history and knew they should, their inherent position of dominance nonetheless lent an air of hubris to their claims. For example, one of the seminar speakers had decided to show the participants slides of the work of Inji Aflatun, a painter jailed for her communist activities in the 1960s. She explained to me that her aim was to encourage students to do political art by "showing them that they have political artists in their own art history." The assumption that Egyptians did not know about Aflatun was grossly inaccurate, however, as the painter is one of the most famous names in the contemporary Egyptian art world (see fig. 3.1). Although this curator could be quite sensitive to the importance of local modernisms and was likely to admit that some Egyptian curators had more knowledge of Egyptian art than she did, her actions reveal the ways in which many foreigners underestimated the extent to which this knowledge was a crucial part of the local construction of expertise.[32]

Khibra is the Arabic word for expertise and, like the English, conveys notions of "knowledge" and "experience." Egyptian experts drew their power

from both. There were many knowledges one could have to be an expert, such as knowledge of art techniques, knowledge of Western art (historical or contemporary), or knowledge of Egyptian art. The latter, however, was key. One could not be an expert without it. "Experience" was also crucial to the construction of *khibra* in the Egyptian art world. Like knowledge, there were many kinds of experience that one could claim to be considered an expert. Experience outside of Egypt, primarily in the United States or Europe, was certainly one of them. But it was not the most important. The primary experiences necessary for expertise in the Egyptian art world were based on age and institutional location.

State curatorial reaction to the seminar clarifies this point. When the public sector gallery owner was shown the program of speakers for the seminar, she latched onto the name of Khalil Amin, a younger generation artist turned art critic. He was to give a lecture on the history of modern Egyptian art. She said in disgust, "Khalil Amin? I *made* Khalil Amin!" It is likely that she was angry that a young artist whom she had first introduced to the public had been invited before her, and also that she wanted to assert her own status and expert knowledge in the Egyptian art world to someone she considered to be an ignorant outsider. This statement clearly shows the point raised earlier that the state concentrated its subject-making efforts on younger artists. It also shows some Egyptians' indignation when foreigners did not recognize (intentionally or not) the local structures of authority that were bolstered by gerontocracy and the socialist state bureaucracy. Directors of public galleries in Egypt were supposed to be granted expert status. Other older generation arts administrators at the National Center of Fine Arts were readily asked to serve on panels of experts to give lectures about Egyptian art, to curate shows, or to judge art competitions. Thus, both age *and* institutional location were necessary to the construction of, and strategic claims to, expert authority.

In sum, we see some overlaps and some crucial differences between these various claims to expertise. Knowledge of Western art and curatorial practice, and experience in the West, although more than sufficient for the newcomers, was only one part of the local construction of expertise. For most artists in Egypt, knowledge of Egyptian art, age, and institutional location were more important. Yet the claims made by the organizers of the seminar *assumed that there was no locally constituted expertise*. In a seminar purporting to "[integrate] East and West," none of the major Egyptian curators were invited to speak. The organizers introduced the seminar by saying that their goal was to

"improve" curatorship in Egypt, to "bring their expertise," and to "provide the tools" to discuss contemporary artistic practice. This framing made them the sole agents, and the proceedings of the entire seminar indicated that "Western" curatorial practice, in their sense, was to be the "international standard." One younger generation attendee was disappointed by this positioning. She told me, "It took the form of teacher-student really fast. They just came here to teach us." She had been eager to participate in the seminar because she had recently fallen out of favor with a state curator after a fight about him meddling in her work. But not long after being irritated by this seminar, she left the art scene.[33] Western curators' neocolonial, pedagogical display of expertise that denied any local knowledge or authority disgusted this artist and was surely what had infuriated the government curator as well—that, and the challenge to the cultural sovereignty that undergirded local authority.

It is significant here that the state curator framed her response to this challenge in more resolutely nationalist terms than she normally would have in other circumstances, for example when facing her local critics who advocated pastoral or folkloric nation-based works and in other interactions with foreigners overseas. She said, "What do *you* know about Egyptian art?" She did not claim to know more about, or even an equal amount, about British art or American curating, for example. If we want to see her refusal to participate as an act of resistance, the form of this resistance reveals not only the emergent power in the art world, but also what it was up against. Using Lila Abu-Lughod's concept of resistance as a diagnostic of power (1990), we can see here that her response shows both the confidence and usefulness of nationalist claims *and* the exclusionary power of foreigners who claim "knowledge" about the "international" art scene. She reiterated her expertise in Egyptian art, but maintained a significant silence regarding art from elsewhere, despite the fact that she had been instrumental in increasing Egypt's connections to Europe and the United States, particularly through her founding of the Egyptian section of the International Art Critics Association. Thus, her expert claims and assertions of cultural sovereignty were both *strategic* and *context-specific*.

When she and other state curators continued their attempts to make Egypt "international," they increasingly locked horns with others trying to do the same thing. As examples like that of the seminar show, local actors and newcomers competed over who would control the value of Egyptian art and artists as they went global, and ultimately who would benefit from that process.

Most Egyptians wanted to decide what constituted the nation and its art without it being decided by market forces. Thus, they claimed sovereignty over the processes of knowledge and expertise making around cultural goods. At the same time, they redefined the nation as an international, cosmopolitan entity, expanding beyond the territorial boundaries of the nation-state. The nation was *the* primary frame that "organiz[ed] discourse and political action" in these contexts (Brubaker 1996:7), and the internationalization of Egyptian art therefore reproduced the nation as a category of practice. While assertions of national sovereignty were especially vociferous when Westerners laid claim to Egyptian cultural production within the national space, they were also poignantly articulated when cultural goods traveled outside that space.

WHO HAS THE "RIGHT" TO REPRESENT EGYPTIAN ART ABROAD?

Many scholars have noted the ascendancy of rights discourse in the post-1989 world, and in particular the application of this discourse to the global circulation of cultural knowledge and objects (see Brown 2003; Coombe 2005). In the Egyptian art world, the issue was not one of "copyright," but rather of rights to cultural representation outside the boundaries of the nation-state. As I have argued, Egyptian cultural policymakers had, since the early 1990s, been intensively trying to build bridges between the Egyptian art scene and the rest of the world. But most of their attempts were through official channels, such as cultural centers, consulates, and state-run international biennials. People in the new private sector, on the other hand, were rapidly building connections abroad through nonstate channels in a pattern well known to scholars of globalization. The Nitaq festivals were major social events where such connections were procured. These connections also produced challenges to the state's authority and legitimated the new authority being claimed in the private sector.

This process was both enabled and fortified by the long-standing Euro-American dominance of the international art market and its structures of judgment. Such dominance still relies on neocolonial framings of non-Western art, despite the attempts made by some Westerners to challenge these (see Oguibe and Enwezor 1999). Indeed, Western interest in Egyptian art was not primarily motivated by a desire to exploit and control; many curators and viewers were genuinely excited by the work. Some even tried to get to know artists and learn more about Egyptian cultural life, especially those who lived in Cairo (as opposed to curators who flew through over a weekend). But the overwhelming framework for Western engagement with Egyptian art was one

of modernist teleological progress, with Western art figured as more avant-garde than Egyptian. In response, many Egyptians (both those embedded in and outside of state institutions) tried to assert their sovereignty over exactly how this art—what they perceived to be the cultural production of their nation—would circulate internationally. These assertions did not imply that they were inherently against Western curatorship. Rather, they (young artists especially) wanted to take advantage of the new opportunities on equal terms, and to be respected as people with their own culture and artistic traditions. But just as Western curatorial projects were bolstered by an apparatus of power rooted in the colonial era, Egyptians' claims to cultural sovereignty tapped into the reservoir of anti-colonial national ideology. These historical connections did not completely determine people's engagement with the new global cultural economy, but they certainly shaped how claims were staked and how the participants perceived one another.

In listing the goals of the Quartz Gallery, the owner stated that he wanted to "have contemporary Egyptian art acknowledged internationally and ensure that the Quartz Gallery is recognized as a major part of that process." It became clear to many Egyptian artists that he was actively seeking contacts to promote their art abroad. He traveled frequently. He invited foreign curators and critics to Egypt. Like the owners of the other private galleries downtown, he also networked extensively among foreign elites in Cairo, such as directors of foreign cultural centers and businesspeople in private companies. In just a short time, he had built a reputation for his gallery such that many people interested in art who came through Cairo found their way there. Furthermore, people overseas who were interested in art from the Middle East were directed to the Quartz via correspondence.

Many young artists who were anxious to advance their careers abroad excitedly took note of these activities. Working solely within the government channels, one certainly had opportunities to exhibit abroad, especially through cultural centers or biennials (whose nationality-based structure led to invitations going through the state in most countries). Artists welcomed these state-sponsored chances to exhibit overseas. However, many saw the private sector as offering them additional opportunities to get into foreign galleries, to get residencies abroad, to sell work for higher prices than those set by the state acquisition structure, and to get funding for large projects. In a sense they became bricoleurs of the neoliberal era, flexible in their picking and choosing from public and private sectors, local and international sources.

In the opinion of the private sector gallery owners, increasing the international visibility of the artists they represented was one way to expand the art market beyond the state and create a new profile for Egypt as having a vibrant private sector art scene and interesting young artists. If artists became known abroad, not only would art sales increase, but artists' and curators' reputations among foreign and Egyptian buyers at home would also be enhanced. In addition to the marketing of individual artists, some gallery owners explicitly aimed to advance the image of the Egyptian art scene abroad, to promote the idea that "things were happening" there. The Quartz Gallery's early efforts in this regard culminated in an exhibition titled "Cairo Modern Art in Holland." It was very successful in Europe, but caused a fair amount of controversy at home.

Young artists, state curators, and Egyptian art critics all emphasized that the new gallery owners' goal of increasing the exposure of Egyptian art abroad was not as novel as they claimed it to be: "putting Egypt on the international art map" had been a government goal for over a decade. Furthermore, older generation artists believed that the state should be primarily responsible for representing Egyptian art abroad. This perspective had a long legacy dating back to nationalist socialism; it was legitimated by the continued international practice of national representation at biennials and triennials. Thus, when the Quartz Gallery staged exhibitions with titles like "Made in Egypt," these older artists felt that it was wrongly usurping the state's prerogative to represent Egyptian art abroad. There thus emerged a struggle for sovereignty over the representation of Egypt in the West through its cultural goods.

Articles in the Ministry of Culture's newspaper were representative of various attempts to reconcile the government's goal of increasing the international visibility of Egyptian art with the sense that the private galleries were pulling the rug out from under it. One arts page editor repeatedly drew her readers' attention to this, asserting that only the state should represent the nation's artists in another country, and that to have an individual, and a foreigner no less, claim to represent Egyptian art abroad did not conform to "the protocols of cultural and artistic exchange."[34] Clearly, the protocols to which she was referring were those dating from at least the 1950s, which are built on the model of biennials or exchanges between government-run cultural centers. According to this logic, if an exhibition is marketed as "Egyptian art," then it is the state, as a representative of the nation, that should organize it. The owner of the Quartz Gallery had a right to do exhibitions abroad of indi-

vidual artists, the arts editor declared, so long as he did not "use the famous name of Egypt to market the gallery's works." In an interview that appeared in the same paper, the minister of culture likewise paired the language of artistic freedom with a reminder of state prerogative, saying, "They are welcome to exhibit in Amsterdam or Beirut, but not in Cairo's name. This is completely unacceptable."[35]

This case highlights the central issue at stake in many of these battles: who has the "right" to represent a nation? When state officials discovered that private sector curators were engaged in similar activities (e.g., arranging seminars, holding group exhibitions abroad, or exhibiting young artists), their reaction was to challenge them on nationalist grounds, using a language of rights that was but one of the new strategies of governance that were emerging. Instead of creating new cultural patrimony laws to manage the global flow of modern Egyptian art (as is done with antiquities), state officials emphasized the moral unacceptability of letting a foreigner represent Egypt abroad without any consideration of the desires of Egyptians themselves.

This kind of argument made sense to most older (and some younger) artists for three main reasons, each related to genealogies of the modern in the Egyptian context. First, Nasserist ideology was being revitalized among Egyptians who were from class backgrounds that suffered under colonialism and who were not easily able to navigate the neoliberal economy (see Gordon 2000). Egyptians' assertion of their ability to manage their international affairs without foreign intervention or representation harked back to Nasser's leadership of the Non-Aligned Movement. Second, the moral nature of the rights language made sense to a generation of young Egyptians who had been brought up during the first phase of market liberalization in the 1970 and 1980s, in which foreign intervention was increasingly deemed immoral, and often counter to Islamic religious ethics. The third reason that this argument made sense was because of the larger context of American and Israeli aggression in the Middle East, which, in many Egyptians' view, threatened the very moral core of their culture (and the morality of the world, for that matter). To many Egyptian intellectuals, the spread of capitalism in the cultural realm had potential to do as much violence as the bombs over Gaza and Baghdad. Finally, I should mention that this nationalist assertion of rights to represent Egypt abroad was laughed at by many of the young artists who were getting international attention through the new galleries. International success enabled their critique of the state's claims in this regard.

CULTURE AND CAPITAL

> *They take our art and sell it abroad. We get nothing from it. They*
> *do nothing for Egyptian art here. What's the difference between that*
> *and what the British did with our cotton?*
>
> **Younger generation Egyptian art critic, 2003**

Egyptian artists did not share the more extreme European modernist views that economic interest always pollutes artistic production, but the history of colonialism and post-independence socialism meant that the relationship between culture and capital was especially fraught in other ways. The concerns that the unchecked spread of free-market values might compromise the integrity of Egyptian art reflected a wider concern in Egyptian society: if U.S.-driven neoliberalism opened up the Egyptian *economy* to Western products, it would also make Egyptian *culture* susceptible to unwanted Western control. This fear that the commoditization of art would take away their power to assign it cultural value made it that much more crucial for many artists and curators to continually reassert expertise rooted in knowledge of Egyptian art.

It is no surprise that certain non-Egyptians involved in the art scene in Egypt saw this state support of the arts as inherently limiting or controlling of artistic production. The capitalist model of artistic production and consumption is pervasive in the United States. One could argue that it is becoming increasingly prevalent in western Europe and parts of East Asia as well, despite the fact that many European governments have ministries and/or strong socialist-inspired programs that support the arts. The owner of the Quartz Gallery echoed the perspective of many foreigners when he implied that the public sector controls artistic production more than the private, and that the development of a private sector, through activities like the festival, is the sure future:

> Whenever you have state control of the arts, that has to loosen its grip. And it only loosens its grip if the private sector makes a strong showing and then people leave the public sector. Support the private sector, invest in the private sector, and then it breaks down the public sector and loosens its control. The public sector has to recognize what's happening, and [then] it allows more freedom in the various areas. But in such a conservative country like Egypt it will take more time. But it happened in Eastern Europe, it happened in South America.[36]

This gallery owner's juxtaposition of the private and public sector reveals two assumptions shared by other Western curators of Egyptian art. One is that there exists a state/society divide and a state-inspired conservatism that must be broken up (see Chapter 3 for a critique of such assumptions).[37] And the second is that the private sector will *inevitably* take over the public. I suggest that their assumption that the free market would eventually triumph was largely shaped by their own experiences as a generation who had come of age when Reagan and Thatcher radically privatized arts funding, and corporations became the main supporters of art in the United States, Britain, and elsewhere (see Wu 2002). They then exported this model to a different context, Egypt, where the public sector had *increased* its arts funding while encouraging the growth of the private sector. I also suggest that this assumption of market triumphalism was part of the seductive teleological thinking underlying neoliberal projects. Indeed, curators' postmodern art sensibilities did not transfer into rejection of modernist teleologies when they encountered Egyptian art.

In addition to promulgating these ideological reasons for developing a private sector, gallery owners certainly had a financial interest. The primary goals for a private gallery owner in Egypt were to cover costs and to make a profit from selling art. These goals influenced decisions regarding whose art to exhibit, when, and for how much. Even though young Egyptians sought private sector clients as a way to make a living, many were not convinced that a complete private sector takeover of the art market was desirable. The economic disparities wrought by Sadat's program of market liberalization (*infitah*), and the leftist socialist intellectual tradition, produced deep suspicions of wholesale privatization, particularly in the cultural industries. In their view, one could not ensure artistic quality, let alone cultural integrity, in a completely money-driven environment. One Egyptian artist articulated this perspective in no uncertain terms, saying: "Private galleries are, by necessity, commercial galleries. And the nature of government galleries is not commercial. In one of the stages of societal change, we will still need more guaranteed protection from the predatory [nature] of the private gallery that will always strive to establish the style of the artist depending on the art market in general. And unfortunately the tastes of the buyers that are in Egypt are mostly superficial."

This sense that one could not risk letting the audience dictate the production of art was pervasive. For example, many young artists I knew faulted foreign diplomats and Egyptian aristocrats alike for only wanting to buy paintings with pastoral or folkloric themes that superficially represented

"Egypt" to them. In their view, if the market were given free rein, then artists doing experimental work, abstraction, installations, and the like might be ostracized. Similarly, artists who were against new media argued that many Westerners (and the Ministry of Culture) preferred experimental work; therefore there was a danger that authentic (i.e., pastoral/folkloric) Egyptian work would disappear for lack of support. In short, Egyptian artists of both major aesthetic perspectives were concerned that the open market would unfairly encourage certain kinds of art at the expense of others. The challenge was often an ethical one: how to take advantage of the new channels of art exposure, inspiration, and clientele without compromising one's artistic vision and cultural integrity. For some artists, the solution was to keep the socialist ideal of a caretaker state intact and help develop cultural policy that was updated and productive, not ossified.

Thus, as the private sector sought to overturn state dominance in the consumption of art, using the language of freedom of expression, many Egyptians responded with the argument that while a healthy private sector was necessary to encourage international connections and more creativity, the state could and should protect artists from the vicissitudes of the global art market because of its stable salaries, its offers of acquisition and prize money, and its less opaque system of assigning artistic value.[38] Intellectual support for the ideal of a caretaker state also stemmed from the sense that it was important to have strong government programs for the arts to stem Islamism, the most extreme strands of which were born in Egypt, and which (artists thought) posed a particular threat to image makers.

This is not to say that Egyptians did not recognize the ways in which the government steered artistic production; they certainly did not see the government as wholly impartial, and neither did they always support the state uncritically. But for many artists, the government's problems (gerontocracy, corruption, bureaucracy) were well known and therefore easy to face, whereas the problems of the new private sector were still unclear, and therefore much more threatening. While the American curator had described the ministry as making "opaque" decisions, many Egyptians felt that the newcomers' decisions were actually more opaque. This sense resulted in the spread of rumors among many local artists. These appeared ridiculous to those of us who had some cultural or linguistic access to the new gallery circuits, but are understandable when one considers how little access others had and the logics they brought to the situation from other backgrounds.

The rapid physical expansion of these galleries' spaces, the noticeable increase in high-quality catalogues and opening receptions, and the massive production of the Nitaq Festival led many in the art world to wonder where exactly all the money was coming from. Add to that the rather sudden appearance of several unknown foreign critics and curators. One critic raised his suspicions of Quartz's activities in front of a packed audience at an artists' union conference, saying that he was not exactly sure what the gallery's intentions were. Furthermore, Egyptian artists and audience members sometimes discussed the festival or private galleries using words such as "dubious," or "suspicious,"[39] and gossiped endlessly about the possible ulterior motives of the new Western interest in Egyptian art. The minister of culture registered his doubt in a statement that served both as a reassurance and an assertion of government surveillance, saying: "if there is anything around these galleries that is being hidden behind a curtain, then there are authorities that are taking care of it."[40] This idea that a Western-owned private gallery could be involved in questionable activities or have dubious intentions stemmed not only from an ideological issue with capitalism but also from a more general suspicion of foreign conspiracies. The issue of U.S. support for Israel, and famous instances of Israeli espionage in Egypt, were evidence for many artists that the presence of foreigners should not be trusted blindly.

One volatile reaction to a private gallery show reveals the extent to which these concerns pervaded intellectual thought, and the ways in which they were linked to arguments about capitalist globalization and national sovereignty. A writer for the main Egyptian literary weekly wrote an angry criticism of an installation work by a Lebanese artist, which contained songs of the Christian Lebanese Phalangists who, armed and guarded by the Israeli army, massacred thousands of Palestinians in the Sabra and Shatila refugee camps in 1982. He begins the article with a critique of Egyptian intellectuals who had recently begun to support normalization with Israel and links his concerns in this regard to those over "globalization" ('awlama). He then goes on to argue that globalization rhetoric serves as a mask that hides oppression and inequality, and questions what he calls "the uncomfortable [uncertain] role that [the gallery] plays in the heart of Cairo." Although many Egyptian viewers did not agree that this installation was outrageous anti-Muslim, anti-Palestinian propaganda, the writer's doubts about foreigners' intentions in general were shared by a large number of art world people.

I do not want to give the impression that artists sat around worrying about

the CIA and Israeli spies. My point is that the concern that foreigners were pursuing their own interests while promoting and buying Egyptian art was frequently cast in the idiom of conspiracy and espionage. Jon Anderson (1996) has suggested that conspiracy theories are actually "premature" attempts to "entextualize" incomplete information in an abstract or otherwise performative language that moves from specific events to "more general, less particular categories." Certainly, most artists were not privy to a depth of information regarding the activities of foreigners in Cairo, partly because they usually moved in different social circles, but also because of linguistic and cultural differences. Anderson argues that these theories appear in circumstances where people are "excluded from the political decisions" and "from knowledge that is taken into account in political decisions." He further suggests that "conspiracy theories flourish in hierarchical systems" (1996:97–98). In the Egyptian art world, decisions were made in private, secrecy was premium, and hierarchy paramount. This was not only true in the areas where foreigners operated, but also in the authoritarian state, whose new articulations of surveillance led to even more suspicions and fears.

CONCLUDING REMARKS

The intensity of the excitement and criticism that occurred over the Nitaq Festival and the other activities discussed here indicates that the transformation out of socialism, and the privatization of markets, produces tremendous ambivalence and anxiety in national culture industries. For people working within these industries, the stakes were just as high, if not higher, than for those working in the economic sector. In this chapter, I have asked why many Egyptians found it important to rearticulate their authority over Egyptian art as it increasingly entered the international art market. I do not think that it was simply a matter of envy, personal affronts, or knee-jerk nationalism. While it is important to recognize that state actors, whose authority was rooted in national institutions, had the most to lose if Egyptian art were completely privatized, it is also important to understand that artists and critics of varying relations to the state were concerned that the globalization of Egyptian art solely through the private sector might disrupt local hierarchies of value that had been constituted through anti-colonial nationalism and enshrined in the policy and institutions of state socialism. Older tensions inherent in the production of modern art were thus reinvigorated; just as previous imperialisms were viscerally remembered, particularly after the invasion of Iraq.

In the struggle over whose terms would dominate as Egyptian art and artists traveled in new international circuits, two regimes of power, comprised of Egyptian public sector curators and Western private sector elite, worked in tandem and against each other in new strategies of governance and control, vying for the rights to represent and market Egypt. Both laid claim to art knowledge and expertise, and both had young artists as their subjects. The Western elites drew their power from the inequalities and evolutionary ideology that have persisted since the colonial era, even if they did not recognize it as such.[41] The modernist legacy of artistic judgment based on progress and newness helped reproduce West/non-West evolutionary hierarchies through art. The state elites drew their power from national institutions and from widely shared, socialist-inspired nationalist ideologies. Furthermore, their articulations of sovereignty were wrapped up in new kinds of Egyptian state surveillance. And while Western-oriented activities of the private sector interrupted the status quo, they also contributed to a renewed consolidation of Western power and elitism in the international art scene (see Oguibe 2004).

The assertions of cultural sovereignty among state actors and other Egyptians were much more relational than autonomous: Egyptian sovereignty was to be realized through its integration (on an equal footing) into the international art scene. Furthermore, the exercise of cultural sovereignty was not all-encompassing, but rather graduated. It was meant to protect or control certain aspects of cultural production but not others. It was context-specific and strategic.

Arjun Appadurai has indicated that "there may be some embarrassing new possibilities for equity hidden in [the] workings" of capital (2000:1). Indeed, the evidence from Egypt suggests that global art world flows have caused cracks in the state's hegemonic project and have compromised long-standing claims to authority, especially those based on generation and institutional location.[42] It would be a mistake to insist that artists working in formerly colonized countries, or those exiting socialism, must choose between state cultural policy and a capitalist art market. Both options have their costs. That is why many young artists living in Egypt are now trying to come up with another way that blends some of the positive aspects of both the private sector and the public sector, and that recognizes both the problems and the potential of nation-oriented art in the current global order. As one young artist who regularly exhibits at the Quartz Gallery told me, "A group of friends and I are trying to create something different. A different space and set of

connections that are not the Quartz and not the state." Stephen Turner argues that sovereignty projects can be "the ground rather than the antithesis of a truly 'critical' internationalism" (2002:99–100). Perhaps these new articulations of sovereignty, less connected to the state apparatus as they are, will allow artists to live with neoliberalism but not be imprisoned by it.

RAGHIB 'AYAD
Return of the Spirit

IN LOCAL ART HISTORIES, 1908 is the year that marks the "beginning" of Egyptian modern art. The Cairo College of Fine Arts admitted its first class of students that year. Some of these, like Raghib 'Ayad (b. 1892), would become known as the "pioneers" (*ruwad*) of modern art in Egypt. Ninety years later, in 1998, 'Ayad's contributions were honored by Egyptian artists when they named a new gallery space after him (the Raghib 'Ayad Gallery, Gezira Arts Center). Over the course of nearly a century, 'Ayad and his cohort came to be venerated in a significant volume of art writing. It was through the creation of an art critical press (in newspapers, magazines, and books) that they were, in fact, created as a "generation," worthy of honor and respect for their accomplishments in laying the aesthetic and institutional groundwork for what was to become the largest art scene in the Arab Middle East.

But in the writing on 'Ayad, one also gets a sense of the work that has gone into creating this idealistic image of the honorable forefathers. The image of the pioneers as good nationalists creating a pure Egyptian art begins to break down the harder you look, especially at artists like Raghib 'Ayad. He is remembered for having struggled against the Western academicism that he believed plagued Egyptian graduates of the European-style art schools. He is also well known for paying attention to ignored Coptic subjects and Coptic art traditions, and for being instrumental in gaining Christian art entry into what became the accepted tripartite history of Egyptian art: Pharaonic, Coptic, Islamic. And writers have focused on how he invented his own system of studying abroad, because he did not have some of the connections and resources that others

in his cohort did. ('Ayad and his friend Yusif Kamil took turns working each other's jobs while the other one went to Europe; see Abu Ghazi 1984.) In the art histories, then, one gets glimpses of the complicated social scene and artistic projects of 'Ayad and his cohort—but they are often brushed over in the interest of creating a seamless national narrative. 'Ayad's paintings and sketches of rural and urban folk life are iconicized as an expression of "authentic" Egypt. I think that's the reason I initially did not give them the close attention they deserved. It was only when I asked an artist friend who stood out among the pioneers, and he replied without hesitation, "Raghib 'Ayad," that I tried to see what it was that made him outstanding. Spending some time with his works reveals a much more complicated and interesting story than one gets from the art histories. It reveals an artist trying to create an Egyptian modernism different from European modernisms but that bore some relationship to them. To accomplish this, he looked back to the Pharaonic era for inspiration and explored the theme of the Egyptian peasant as a kind of icon for distinctive cultural identity. 'Ayad's project is thus akin to that of the novelist and playwright Tawfiq al-Hakim, whose famous novel *Return of the Spirit* (1933) used both peasant and Pharaonic themes to call forth and define the spirit of the new nation.[1]

There is an early study of a female nude from 1914, done on one of the artist's trips to Rome just after graduating from the Cairo arts college. The painting is classical European academicism in both style and subject, something 'Ayad would have been taught by his French and Italian professors in Egypt. There is also a story circulating in oral and written histories that 'Ayad was a bad student (Abu Ghazi 1984:6–7; Nagib 2000:61). He didn't like anything he was taught, and found the lessons restrictive. In Europe, he likely became interested in other kinds of European art, such as that of Toulouse-Lautrec. For in the early 1920s, after his first trips to Europe, he abandoned nudes and started to paint Egyptian cafés and night club scenes.

By the 1930s, 'Ayad was no longer doing nudes and other classical subjects at all, and he had shed the European academic style. He had become even more interested in nonelite Egyptians, particularly the peasantry, and appears to have spent significant time studying the prominent place of line marking out the color fields (or taking their place altogether) in Egyptian folk paintings. A painting from 1930 shows this transition away from classical academicism quite well (fig. G.1).

In this work, we see 'Ayad's developing interest in peasants and their lives, which would later come to dominate his work. We also see gestural brush-

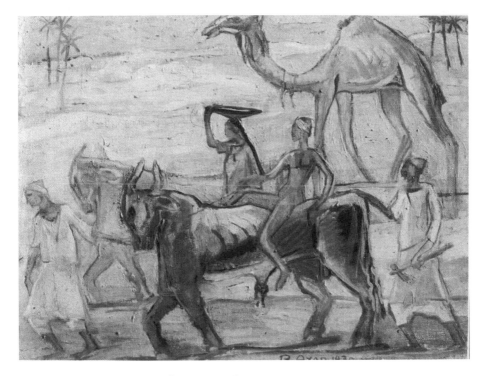

Figure G.1 Raghib 'Ayad, *Village Scene*, oil on canvas, 1930.
Courtesy of the Museum of Modern Egyptian Art.

strokes emerging from the fields of oil color and highlighting the figures with outlines. While one could see this technique as evidence of European expressionism's influence on the artist, I think it might be a sign that the artist was looking at the art made by some of the peasant subjects he was portraying, in which line plays a prominent role. Some critics have seen his move away from figurative realism as a response to the concern with representations of the figure in Islam, even though he was Christian (see al-'Attar 1996). Perhaps. But 'Ayad was also moving away from oils and towards watercolor and marker—a media switch that I think also contributed to the emergence of quick line drawing. The change in style could be media, topic, or theory driven. It was probably all three. A work from 1957 shows a fuller realization of these new elements, and how far 'Ayad had veered from the academicism taught by his European professors (fig. G.2).

In this ink painting, called *Horse Dance* (*raqsat al-khayl*), 'Ayad has taken on the subject of rural weddings, where horse dances were often part of the

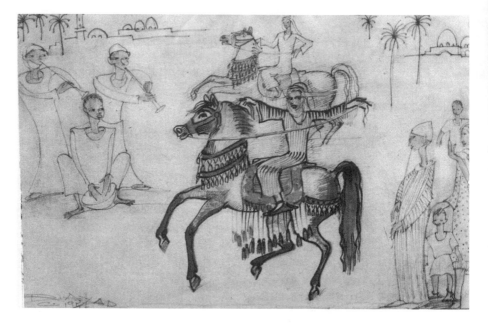

Figure G.2 Raghib 'Ayad, *Horse Dance*, ink on paper, 1957.
Courtesy of the Museum of Modern Egyptian Art.

festivities. They were also portrayed in folk art. In making lines dominant, 'Ayad has added motion to these kinds of subjects, which were usually presented statically in European Orientalist paintings. Indeed, I would say that 'Ayad's move from academic realism towards dynamic, gestural lines was a critique not only of the styles he had been trained in but also of the whole image of the "East" that these styles helped create. Similarly, 'Ayad's engagement with ancient Egyptian art was a significant departure from the work of Europeans like David Roberts, whose hyperrealist pictures of Pharaonic temples and sculptures became part of a long Orientalist tradition of representing the East. Today, we might recognize paintings such as 'Ayad's to be stereotypical. But it is very likely that, at the time, they were akin to Manet's *Olympia* in their radical refusal of established European Orientalist styles and themes.

Unlike some of his Egyptian contemporaries, 'Ayad did not just nod towards ancient Egypt and insert Pharaonic motifs here and there. He actually studied the compositional and perspectival strategies of ancient Egyptian artists and reinvigorated them in his own practice. In Pharaonic paintings and reliefs, different scenes unfold in layers atop of one another to tell a story.

And figures are presented in two dimensions, with each part of the figure represented in its "ideal" perspective. In Pharaonic art, this was done in order to perpetuate the universe, not to represent the world (as in Orientalism). Events and people could thus be apprehended from multiple perspectives and points in the story. By engaging with the mechanics of Pharaonic art, 'Ayad was able to break out of certain European modernist conventions he had been taught and reinvigorate an art that he likely considered to be closer to his own historical traditions. We can see the beginnings of this Pharaonic influence in the 1930 *Village Scene* (see fig. G.1). But it is in a painting from 1958 called *Agriculture* (al-Zira'a) that we see a more sustained engagement (see plate 13).

The different stages in the Egyptian agricultural process are depicted in layers from the bottom to the top: water buffalo drawing water from the ground; men scooping water from the irrigation ditch; the tilling of the land and then the threshing of the wheat with water buffalo; pack animals transporting the wheat from the fields; and then, at the very top, women using the wheat to bake bread and serve it at a wedding (signified by the dancing horse). What is really interesting about this painting is that the Pharaonic compositional techniques, perspectives, and subjects (ancient Egyptians painted harvests too) also give us connotations of socialist realism. This painting was done at the height of the Nasser period, and Nasserist discourse—like 'Ayad's painting—depicted the peasant as a heroic laborer for the nation. Although socialist realism never really took root in Egypt the way it did in the USSR and Eastern Bloc countries, there were certainly Egyptian artists who were inspired (or encouraged by government grants) to do socialist themes in realist or semi-realist formats.

From relatively early in his career, 'Ayad also worked on Coptic subjects. His favorite subjects were spiritual ones: monasteries, churches, and monks. These works are unique, not only in that they deal with Coptic life (something that rarely interests artists even today), but also in that they engage with religious practice in Egypt more generally. In an entire century of modern art production in Egypt, there have been very few artists who have dealt with religious themes in their work, in part because most artists have been concerned to distinguish themselves from public religiosity and the religious elite. 'Ayad did not shy away from artistic explorations of religious life, nor from giving Coptic art a higher profile, especially through his work establishing the Coptic Museum. One could perhaps see this body of 'Ayad's art and his institutional work as attempts to reinsert religious spirituality into Egyptian modernism,

which had shared with its European counterpart a general tendency towards the separation of religion and art. He was most definitely attempting to get modern Copts, and Coptic art traditions, recognized alongside Muslims and Islamic art as part of the nation and its patrimony.

Still, the way 'Ayad has been incorporated into nationalist art histories flattens out what I see as his contributions to Egyptian art. He did more than just paint "authentic" peasant life. He revolutionized the practice of art-making and played a key role in creating Egyptian modernism. More often than not, 'Ayad remains at the margins of these nationalist art histories, which tend to focus on artists like the sculptor Mahmud Mukhtar or the famous Alexandrian painter (and relative of the royal family) Mahmud Sa'id. 'Ayad may have a gallery in his name now, but he does not have museums dedicated to his works like these other two artists. Perhaps his location at the margins of local art history is related to the extent to which his works always threaten to exceed the interpretive frameworks they have been forced to inhabit.

FINAL INTERLOCUTIONS

CRITICISM AFTER POSTMODERNISM

"But, really, is there any good art being made in Egypt?" I had just finished my dissertation on Egyptian art, and I found myself incapable of answering this question posed to me by a U.S.-based Arab intellectual, except to secretly berate what I considered to be his exilic elitism towards his peers "back home." I had spent the greater part of my research and writing trying to "provincialize" the entire apparatus that allowed for such questions to be phrased in this way, from these locations (Chakrabarty 2000). But the question sticks with me, particularly because I know that people in Egypt will also read this book with it in mind.

To answer the question about whether or not there is good art in Egypt does not just require us to lay bare the "inadequacy" (Chakrabarty 2000) of the assumptions underlying the question and critically reflect on the locations from which it is articulated. It also requires acknowledging the "indispensability" of this question for Egyptian artists themselves, particularly for their project of "refashioning futures" (Scott 1999). Extreme relativism not only reproduces universalism's constitutive outside other (see Mitchell 2000:xiii; Scott 1999:127), which artists' complex genealogies of the modern deny, but it also leaves them in an artistic and political lurch. Their demand for interlocution from anyone who engages with Egyptian art has a purpose: to stake out the future through the past and present.

Resisting the neocolonial posturing of much critical discourse about art from Egypt, while not falling into a paralytic relativism that would frustrate

(if not infuriate) my informants, is indeed a challenge. To steer the beginnings of a course through this minefield, I am inspired by David Scott's ruminations on "criticism after postcoloniality" (1999) and by Talal Asad's important essay on "discursive tradition" and the anthropology of Islam (1986), both of which draw on the work of Alisdair MacIntyre (1981). Asad conceives of discursive tradition as fundamentally dynamic, as not solely located in the past or in constructions or imitations of it. His concept pivots around the idea that arguments are a necessary part of the constitution and reproduction of a discursive tradition and how it imagines futures. Egyptian artists made that clear. Their debates were reckonings within a discursive tradition that made coherence out of various genealogies of the modern.

So how to meet their demands of interlocution, to give one possible response to the question that has been bothering me, not to mention many Egyptians, for some years? The answer, I think, lies in first recognizing, and respecting, that there is a discursive tradition here and that the most effective criticism (for its practitioners) will bear a significant relationship to it. More precisely, as Scott writes, "criticism that explicitly locates itself within the terrain and thus the vocabulary of a tradition is criticism that enters the moral space of such an argument simultaneously to contest/confirm it and reshape/retain it" (1999:10). Criticism must be "self-consciously strategic . . . cognizant not only of its partialness but of itself as a practice of entering an always-already constituted field of argument . . . a 'zone of engagement'" (Scott 1999:156). Asad further reminds us that any writing we do on this discursive tradition will "be in a certain narrative relation to it," and that it will therefore be "contestable," like all arguments relating to the tradition (1986:17; cf. Marcus and Myers 1995). The following paragraphs are an all too brief foray into this kind of strategic criticism, but I hope they will inspire others (both Egyptians and Westerners) to engage critically with modern Egyptian art in a more productive way than they have in the past. Like the interludes earlier in this book, they form another possible model for engaging with this art, but in the end, of course, they are also open to criticism.

THE CONSEQUENCES OF THE NATION

My interlocutors were generally concerned that I convey to different audiences a sense of their worldviews, their interests, and their art—a task that I set out to do in writing this book. They also asked me, "So what do you think about the work?"—a question I have only partially answered in the previous

chapters, and that I would like to address more directly now. But I would like to do so not from the superior posture of assessment, which presumes the universality of my hierarchy of values, but rather from partially within their discursive tradition, with some added insights of my own.

Several major lacunae are revealed when we take the Egyptian art that has been produced and hold it up against a tradition that insists that art make some connection with the past and with the public, that emphasizes the virtues of family and nation in relationship to artistic careers, and that assumes that art should serve the greater good. First, the secular-national resistance to developing notions of modern Islamic or Coptic art utilizing principles within those traditions, and the refusal to deal visually or textually with the forms of piety (especially public) that have grown exponentially in Egypt in the past three decades, puts arts interlocutors at a greater distance from important parts of the very past of which they claim to be a part, and from the very people whom their art is supposed to benefit (i.e., nonelite Egyptians and their own family members). An additional distance is produced by the relative absence of artistic reflection on their own circumstances of urban middle-classness. Thus, Islamic scholars, ordinary pious people, and other middle-class family and peers are regularly excluded from the very discursive debates valued within the tradition of making art. I submit that the absence of art in this vein and the exclusion of other interlocutors are major factors in the reproduction of versions of the nation that do not do what they are supposed to from artists' perspectives. Even the most elitist and secularist arts people sense that these versions are exclusionary in nature and limited in vision, and perhaps my interlocution here will help them figure out why.

In the place of this absence of religion and urban middle-classness, we have the presence of art that deals with rural or urban "folk" themes or materials. These also create divides and reproduce exclusionary, limited versions of the nation that do not accomplish many things that artists want them to. The lifeways of the urban and rural poor are imagined and idealized, just as they are disparaged, traditions are invented for and attributed to them, and their material culture is appropriated and used in artworks—all to create an anaesthetized, romantic vision of the nation, which does not speak to the "masses" artists purportedly seek to benefit but rather serves elite and state interests. Paintings of idyllic village scenes or installations using mud brick or amulets to ward off the evil eye may seem relatively benign compared to the radical economic disparity and political oppression that the poor suffer

in Egypt. But I suggest that these erasures of poverty through the overdetermined presence of idealized subalterns provide a more comfortable image of the nation's "progress" to the very people who consider themselves to be in charge of it, and who claim to be more "enlightened." This self-ascribed role is furthered by inclusion in art (figurative or abstract, *asala* or *mu'asira*) of elements that consistently position nonelites as magical or suspicious, quaint, without agency, and ultimately premodern. It is also furthered by the absolute exclusion of subaltern interlocutions. In these ways, the power of those allowed in the discussion (and especially collectors, whose activities are even more complicit in the reproduction of poverty), is conveniently masked, while at the same time the premodern, against which they distinguish themselves, is highlighted. This kind of presence of poor people's images, material culture, and so on, inherently forecloses any hope that art will be able to cross social divides.

I hope that this modest attempt to engage artists and their art on their own terms, with added critical lenses from my own genealogies, reveals spaces for the production of art that are not marred by paternalistic pedagogy and prejudice. Perhaps it will also reveal spaces for the consumption of art other than those dominated by anxious politics, elitism, and neocolonial attitudes.

FUTURES OF NATIONAL RECKONING

I am thus led back to the space where I began this book, Liberation Square in the heart of Cairo, the nation's capital. The buildings surrounding Liberation Square—the Egyptian Museum of Pharaonic art, the Nile Hilton, the Islamic bank and former headquarters of the Arab Socialist Union, the main citizens' administration building, the U.S. Embassy, and McDonald's—embody the constellation of forces that shape cultural production and consumption in Egypt. Imagined histories and national patrimony have played a significant role, as have private sector investment, the state, religion, and foreign political and economic interests. While these buildings overlook the square, the center has seen many a facelift over the years. It has been a bus station, a park, and a gated security zone. There have been fountains, small sculptures, urns, and billboards urging Mubarak's reelection. Sellers of lighters, combs, and snacks have congregated there. It has witnessed the construction of public toilets and of a subway station that bears the official name of the square since the 1970s—Sadat Square (Midan al-Sadat). But Egyptians insist on using the name "Liberation" instead of "Sadat" for the square, which says something

about their views of that president and also about the legacy of colonialism and Nasserist state socialism.

Artists told me that there was often talk among government officials of putting a large work of public art in the center of the square. Should it be an original Pharaonic statue, like the one of Ramses that graced the area in front of the main train station? An obelisk? A piece of contemporary art? These different kinds of art have been erected and taken down at various times. This point about Liberation Square is most telling. Art is seen by some as an appropriate focal point for this and other squares in Egypt, but people cannot agree on which art is right or who should do it.

On the one hand, this situation signifies what I see as the central place of art in constructions of the Egyptian nation—central because it is so disputed. On the other hand, the fact that the middle of this central square in Egypt's capital city is always changing signifies how the struggle to define the nation, and to articulate liberatory positions from its bases, is far from over. Such political and artistic projects may be defined or carried out in different ways, depending on how the ideologies and experiences of arts interlocutors shift with local and global political and economic change. Just as Liberation Square is always under construction, but people agree on this name rather than on the official one, arts interlocutors always work to construct the nation in different ways, but in reference to an agreed-upon value of cultural sovereignty. By making art and culture, they continue to reckon with the historical and contemporary forces that have shaped their lives and artistic imaginations.

REFERENCE MATTER

NOTES

Introduction: Cultural Politics and Genealogies of the Modern in the Postcolony

1. The Middle East has been largely absent from the wide-ranging academic discussions about post-socialism, despite the existence throughout the region of governments that claim(ed) to be socialist, or at least had/have command economies (e.g., Algeria, Egypt, Iraq, Libya, Syria, Sudan, Yemen). Certainly, socialism in Egypt, even in the Nasser period, was not of the same breadth or depth as in the Eastern Bloc countries, and it was often more of a means to an end (decolonization) than an end in itself. Therefore, socialism did not come to be the defining category in most Egyptians' understanding of culture and politics, and few Egyptians today actually think of their society as "socialist" or "post-socialist" even if they often embrace elements of socialist ideology. As I shall show throughout this book, the decades-long presence of central planning (in art and in the economy) and the discursive reiteration of socialist ideology (especially in state bodies and intellectual circles) has produced a situation that, with the spread of neoliberal capitalist globalization, could be called a transformation from socialism. I follow Katherine Verdery (1996) in calling this a transformation rather than a "transition," because, as she points out, the latter implies that the changes will result in Egyptian society becoming completely like Western capitalist societies, which is not the case. What Verdery calls the language of "transitology" (1996:16) is disturbingly akin to the language of modernization, a teleological language that I try to analyze rather than adopt. I thank Laura Bier for her help in conceptualizing socialism in Egypt, and I hope that Middle East scholars will start contributing to the wider academic discussions on the transformations from socialism around the world.

2. As Ferguson 1999 suggests, this "decrying" has not led anthropology to fully divest itself of teleological developmentalist thinking in other areas as well.

3. For an entire oeuvre of possible answers, see the pathbreaking journal *Third Text*,

330 NOTES TO PAGES 4–9

which was founded in 1987 to examine Western exclusions and their legitimating bases (even though some essays perhaps unwittingly reproduce them).

4. In anthropology texts, too.

5. For an anthropological view on redemptive value associated with art, see Myers et al. 2001.

6. Cf. Abu-Lughod's explication of assumptions associated with Muslim women (2002) and Mahmood's critique of the liberalism underlying them (2005). For an abbreviated discussion of how such assumptions about gender have worked in the art world, see Winegar 2002. The idea that Islam is inherently iconoclastic, and that therefore Muslims always have an anxious relationship to image-making, denies the dynamic relationship that many of them have with their religion and its tradition of interpretation. Flood 2002 gives examples of Islamic art containing images, and documents the complexities of the issue among Muslims throughout history and its rise as a contested issue only at particular historical/political junctures. Western naïveté about Islam and iconoclasm can also have political ramifications. For example, Elliott Colla discusses how it provided justification for European removal of Pharaonic objects from Egypt (forthcoming).

7. There have been very few forays into the visual arts specifically from this perspective, despite the fact that art is arguably the penultimate field for the working out of "the modern." See Guha-Thakurta 1992, 1995, 2004; Harney 2004; and Kapur 1993, 2000.

8. Elliott Colla's suggestions helped me think through this aspect of the concept.

9. Such formulations of agency plague anthropological theory, particularly in its consistent use of the category "local," as Asad saw over a decade ago (1993).

10. This book is focused on the contemporary period, and therefore the discussion of the historical constitution of the visual art field is abbreviated in most of the chapters. A fuller historical study is in the works (Winegar n.d.).

11. In my discussions of neoliberalism, I am guided by Mitchell 2002's analysis of it in the Egyptian context, and by theoretical renderings of its workings in the realm of culture in Comaroff and Comaroff 2000, Ong 1999, Stanziola 2002, Stevenson 1999, and Yúdice 2003.

12. The most famous of these is Arjun Appadurai, particularly his earlier writings on globalization (1996). For especially evocative anthropological assessments of the endurance of the nation in this global juncture, see Abu-Lughod 2005 (also on culture producers in Egypt), Bernal 2004, Ong 1999, and Thomas 2004.

13. I am referring here to Frederic Jameson's infamous claim that all Third World literature is national allegory (1986), and to Aijaz Ahmad's critique of the teleological, Orientalist nature of this claim (1987).

14. In this book, I use both real names and pseudonyms. Artists, critics, and curators were all to some extent public figures, but they often said and did things that, if relayed in a book, could cause them undue harm or anxiety. Therefore I have decided to create pseudonyms or hide the identities of people whose statements and actions occurred in private or semi-public contexts, unless they were referring directly to artworks and personal pro-

cesses of creating artworks. I have also created pseudonyms or otherwise hid the names of places that are being analyzed through a critical lens. However, I have kept the real names of critics when discussing their work in the public sphere (published writings or lectures), and the real names of artists when I feature their work in the interludes or chapters.

15. I thank Fred Myers for this turn of phrase.

16. Gell's theory of agency denies any value to semiotic approaches or emphases on meaning. I hope this study shows that there is room for both considerations.

17. For more on the debates over contextual versus formal analysis/presentation of objects, see Jones 1993; Karp and Lavine 1991, esp. pts. 3 and 5; Mullin 1995; and Myers 2002, esp. chaps. 8–10. Familiarity with Clifford's art-culture system (1988) and Oguibe's concept of the culture game (2004) is also important for understanding how objects are made "ethnography" instead of "art," and the potential problems that arise from that move.

18. In any case, these schemata are much less static than they are assumed to be. Fred Myers writes that the category of the aesthetic "represent[s] a discursive tradition of contest and negotiation . . . in Western art history" itself (1994a:13). This is not to say that studies of cultural styles or aesthetics are not valuable, particularly if they are self-reflective about the notions of style or aesthetics employed.

19. In Egypt and other Arab countries, there is a field called "aesthetics" ('ilm al-ja-mal), but the artists and critics I knew seemed generally uninterested in it. People rarely mentioned it, although a couple of arts professors included some references to it on their syllabi. This field would resist attempts to bound it as "Egyptian" anyway, because it consciously dialogued with both European and Islamic theories of aesthetics (for a good recent example that contains helpful Arabic references, see 'Atiyya 2000).

20. This book is not a study of genealogies of the modern per se, or as Asad won-derfully puts it, "a way of working back from our present to the contingencies that have come together to give us our certainties" (2003:16; cf. Asad 1993). It is rather an analysis of how these genealogies, as related to modern art, were reckoned with by arts inter-locutors in Egypt after 1989. I hope that readers can recognize, with my pointers, the general contours of these genealogies and will forgive the fact that I have left their fuller excavation to a future project. For an exemplary model of the kind of excavation I have in mind, see Scheid's dissertation on modern art in Lebanon (2005).

21. Bhabha's theories of hybridity and Appadurai's related theories of global flows, when applied in full to artists living and working in Egypt, reveal their metropolitan speci-ficity quite clearly. As Bhabha admits, he is writing primarily of minorities and exiles in the metropole (1994); and Appadurai indicates that the inspiration for his theorizing comes from his own biography as a scholar from India living and working in the West (1996).

22. The evidence in this book raises questions as to whether dominant trends in translation theory, which have influenced much avant-garde art writing, have in fact fully shed their modernist baggage when it comes to the visual arts. In other words, can these trends account for the shifting complexities of art made by nondiasporic art-ists living and working in the postcolony—many of whom try to resolve, rather than

celebrate, experiences of "in-betweenness," and whose practices of translation usually emphasize "rooted" entities or "invented" traditions? Can it deal with this art without adopting the posture of modernist criticism and condemn it as unenlightened, or even too modernist, in comparison to work by artists in diaspora or exile?

23. The "flows" concept has been rightly criticized for adopting the terms of neo-liberal capitalist globalization (see Graeber 2002). I intend to invoke those terms by my use of it here.

24. My argument complements that of Abu-Lughod, whose work on Egyptian television shows that "the national is still a potent frame of reference, especially in the many countries where the state has been the prime actor in the creation and regulation of media" (2005:27). I suggest that the nation is even more potent in Egypt, for a variety of reasons ranging from the fame of Egypt's ancient civilization, to its position as the leader of the Arab countries, to the success of state institutions in inculcating national ideology.

25. Howard Morphy also found the concept of "frame" useful in understanding art. Drawing on Erving Goffman, he uses frame "to refer to the encompassing set of cultural practices and understandings that defines the meaning of an object in a particular context" (Morphy 1991:21). Although like Morphy I am interested in both "native" and "Western" meanings defined through frames, I use the concept more broadly to account for action, experience, and politics.

26. To do so might very well be a worthless endeavor anyway. As Rogers Brubaker writes, "precisely because nationalism is so protean and so polymorphous, it makes little sense to ask how strong nationalism is, or whether it is receding or advancing" (1996:10).

27. In a sense, I am writing against the ethnographic present as well, because the problems associated with it become immediately evident when writing about the art world. Interlocutors' insistence on the contemporary, global, and political nature of their enterprise, as well as my involvement in that, made me particularly cognizant of how the ethnographic present would cement teleologies, deny our coevalness, elide my own presence in the process of making culture, and ignore the ongoing politics of art and knowledge making (see Fabian 1983).

28. Mannheim recognized these differentiations as well. See Pilcher 1994.

29. See, e.g., Clifford 1988; Errington 1998; Jones 1993; Miller 1991; Price 1989; Stocking et al. 1985; Torgovnick 1990.

30. For extra sensitive and insightful exceptions, see Verdery 1991; Boyer 2001a, 2001b; Lomnitz 1992. Boyer and Lomnitz 2005 provides a useful analysis of the history of anthropological engagement with native intellectuals since the early years of the discipline.

31. Excellent examples include Coombe 1998; Fabian and Matulu 1996; George 1997, 1998, 1999; Karp and Lavine et al. 1991; Karp et al. 1992; MacClancy et al., 1997; Marcus and Myers et al. 1995; Mullin 2001; Myers 2002; Myers et al. 2001; Phillips and Steiner 1999; Scheid 2005; Steiner 1994; Thomas 1999.

32. Mine is the first attempt to understand the production and consumption of vi-

sual arts in Egypt with Bourdieu's concept of the field. Previous scholars have done very interesting work showing the concept's utility for understanding the production and consumption of literature in Egypt (Jacquemond 2003; Mehrez 1994).

33. The major exhibition had been the traveling *Forces of Change: Artists of the Arab World*. See Nader et al. 1994.

34. *Al-Ahram*, September 26, 1999.

35. I should note that not all the curators were white Euro-Americans, but nearly all of them worked primarily from or in relationship to institutions located in Europe and the United States.

Amina Mansur: The Map of Love

1. It is perhaps apt that this factory once produced envelopes—a medium of business and communication across boundaries, and a medium that encloses and is opened.

Chapter 1. Becoming an Egyptian Artist: "Freethinking" in the Mainstream

1. In his essay on the historical genesis of the artistic field, Bourdieu positions himself in opposition to Becker, whom he accuses of looking for the development of art from within the field of art itself, rather than examining the development of the field that made the existence of art and artists possible. This criticism goes a bit too far. The categories of modern art and artists, even though they emerged at the historical juncture Bourdieu discusses, continue to be produced and reproduced (even on a practical level) by art worlds—and especially by the institutions within them.

2. This is not a study of Euro-American art worlds so I cannot fully explore these questions, although I hope that this material will encourage others to do so. Peter Bürger (1984), for one, has provided some useful commentary on the assumptions and failures of the autonomy concept in the West.

3. As a kind of intellectual intervention into Latin American debates on art and modernity, it makes sense that Néstor Canclini takes these formulations for granted at times in order to argue a particular vision and agenda for art (1995). It also likely that Latin American formulations are quite different from the ones I present here.

4. There were certainly other sources of learning beyond the boundaries of the art school, and it is not my intention to give the impression that students were fully inculcated with the "messages" of any source. However, my focus here is on art schools, because they were the first, and often the most important, sources of models for how to live an artistic life.

5. There were artists who took private lessons or were self-taught. Also, some of the private colleges that were built in the 1990s had art departments. But the fees at these colleges were quite high, and even higher for the older American University in Cairo, which was attended only by the very rich and those on special scholarships. This chapter is concerned with the majority of artists, who were trained in public colleges.

6. But these were stereotyped portrayals: artists were usually male and generally unkempt, often in outlandish clothing, drinking excessively, and womanizing. Less common was the image of the male artist as an esthete, or the female artist as a tasteful, learned rich woman. Although these stereotypes of artists are similar to those in the United States, they were not nearly as widespread, because of the lesser awareness of the visual arts as a distinct field or career among the general Egyptian population. I thank Walter Armbrust for directing me to some useful film references.

7. All quotations of Manal Amin are from an interview on September 16, 1999.

8. Ahmad Mahmud, interview, January 8, 2001.

9. Political science and economics are the most highly ranked schools for humanities students.

10. See table, Reid 1991: 182.

11. Ibid.:174. Reid notes that Egypt was ahead of the times. Open admissions to higher education were not instituted in Italy or the United States until several years later.

12. Iskandar et al. 1991. Iskandar also argues that elites upset with the high prices of art charged by European artists sought to create a cheaper pool of artists among Egyptians.

13. Hanan 'Atiyya, interview, May 13, 2000.

14. A few who did not score high enough waited and took the test again the following year, hoping to place in the art college ranks.

15. Nadia Gamal, interview, May 15, 2000. Gamal is unusual in that she chose to attend art school even though she had placed in a higher rank. Students who scored higher on the exam could choose to go down a notch and enter an art college, but this was very unusual and sometimes socially unacceptable. This explains why there were several artists who obtained their degrees in medicine and then became artists after a short period of working as doctors.

16. I should note that the once nominal fees have been creeping upwards in recent years and do pose some difficulty to poor families.

17. College of Art Education, Helwan University, *Dalil al-Talib: Activities and Student Services*, 1999–2000.

18. The Indian modern art movement is similarly rooted in this colonial history, during which artistic value and beauty were "fully determined by European academic methods and classical canons" (Guha-Thakurta 1995:75). In the Egyptian case, European methods and canons shaped ideas of value and beauty, but did not "fully determine" them.

19. It should be noted that Pharaonic art had been taught alongside Western art for years at the College of Art Education, which also had art history requirements in Coptic and Islamic art. Perhaps art education students were more exposed than others to local artistic traditions because they were expected to teach them in grade school, where students have lessons on their "Pharaonic grandfathers," the "opening" of Egypt to Islam, and the "brotherhood" of Muslims and Christians in Egypt.

20. It was in art class that students learned that one easy way (though not the only

way) to create "authentically Egyptian" art was to paint, draw, or sculpt peasant women. As discussed in the next chapter, cultural authenticity in art has, since the early twentieth century, been created and judged through representations of such women, presumed to be the least affected by Westernization. Students readily learned this icon of the nation in their classes. See Baron 1997 for another discussion of this iconography.

21. Additionally, the main word for "sculptor" (*nahhat*) was used for stonemasons and for other laborers on construction sites.

22. 'Ali Yasin, interview, March 1, 2000.

23. Hisham Ahmad, interview, February 29, 2000.

24. 'Ali Yasin, interview, March 1, 2000.

25. E.g., Hisham Ahmad, interview, February 21, 2000, and discussion with Sa'id al-Salam, May 3, 2000.

26. The middle generation (*al-gil al-wasat*) was composed of those artists born roughly between 1950 and 1960 who began their careers in the 1970s. Numerically, they were by far the smallest generation, and they were often considered to be part of the younger generation by the *kubar*. The decline in state support for the arts under Sadat, discussed in Chapter 3, was one of the major reasons why most people who graduated art school during the 1970s did not go on to become artists.

27. An exception would be the Islamic university of al-Azhar, where people wore easily recognizable "Islamic" dress. It is interesting to note that there were several women who wore the full black face veil and gloves at the College of Fine Arts in Cairo. I once asked a student if she knew any of these women. She shook her head and said in disbelief, "I don't know what they're doing here. It should be forbidden [for them]. Doing pictures of things, I mean." This kind of covering was distinguished from the colorful headscarf, which this student started to wear after she later got married and had children.

28. Artists in many countries with Muslim majorities have produced figurative art since the beginning of the modern art movements in those places, and indeed figurative art has dominated artistic production throughout the Middle East. Indonesia, the Gulf States, and to some extent Jordan are the exceptions. The heavy influence of Islamic calligraphy and abstract designs on contemporary art in those places is discussed at length by Wijdan Ali (1997).

29. Aestheticians and psychologists, especially Freudians, often endorse this image of the artist, which is found throughout Western literature and theorizing about the visual arts, as well as in contemporary films such as Ed Harris's *Pollock* (2000) and Julie Taymor's *Frida* (2002). For more explication of this image, see also Williams 1958; Wolff 1981; Zolberg 1990.

30. This urge to retain the idea of artists as unique individualists is related to the persistence of the European-derived modernist ideology of the aesthetic. As I argue in the Introduction, it is also related to a desire to maintain utopian visions of liberatory political agency.

31. Rana 'Amir, interview, November 23, 1996.

32. Muhammad al-Laythi, interview, March 13, 1997.

33. Discussion, August 19, 2002.

34. Interview, October 25, 1999.

35. A 1972 survey of 34,000 upper-level bureaucrats revealed that they considered university professor to be the most important profession in Egyptian society (see Reid 1990:186). This assessment may have declined since then, especially if the value of professors is reflected in salaries and money spent on education more generally.

36. Interview, February 29, 2000.

37. Common jobs secured at the Ministry of Culture included those of museum docents and public gallery assistants; personal assistants to department directors; compilers of visual and written materials that documented the ministry's activities; restorers of art and material culture in the ministry's holdings; and organizers of youth programs.

38. Membership required an established record of exhibitions if one did not possess an art degree.

39. Even within this formality, though, some men (especially higher-ups in the Ministry of Culture) wore unusually bright colors or patterned jackets and shirts.

40. Many found studio spaces for cheap in poor neighborhoods well before they found potential spouses and apartments. But artists always aspired to more spacious and better lit studios.

41. This idea of religious practice connoting strength rather than weakness is a major theme in Elizabeth Fernea's film *A Veiled Revolution* (1981), in which non-veiled Egyptian women express admiration for the strength of those who had put on the veil, and veiled women talk about the strength needed to make the choice to wear it and to keep it on. However, women artists who did wear a headscarf, particularly of the younger generation, were teased, criticized, and discriminated against by older men and women in the art world. For many artists, the veil was not seen as the sign of strength of character, but rather as a sign of blind adherence to social mores, and as a misunderstanding of the requirements of Islam. For artists of the older generation, men and women both, the veil carried associations that went against their worldview as artists. It was associated with the rise of Islamism, which was criticized for being extreme and rigid. As indicated in this chapter, extremeness and rigidity were anathema to artists. I think that for artists the visuality of the veil also mattered. Artists against the veil spoke of it as confining to the head and hair, and limiting to clothing style choices because it must always be worn and matched with the rest of an outfit.

42. I do want to clarify that there was a concept of illegitimate economic capital, which was capital acquired by artists through extreme corruption. For more clarification, see Chapter 4.

Muhammad Mukhtar, Al-Ginubi: Season of Migration to the North

1. For more on the ambivalence towards the south, see Abu-Lughod 2005 and Colla 2000.

Chapter 2. Cultural Authenticity, Artistic Personhood, and Frames of Evaluation

1. The interview took place on February 16, 1999.

2. Indeed, these kinds of authenticity dynamics are found in most art worlds peripheral to western Europe and the United States, including those in Australia, eastern Europe, and East Asia.

3. I thank Susan Carol Rogers and Kirsten Scheid for helping me consider this point.

4. Events in the 1970s, such as the Camp David accords and Sadat's trade reforms (*infitah*), produced a similar kind of public discourse on Egypt's relationship to the West in the postcolonial period.

5. Several scholars have written about the affinity between anthropology and nationalism, both of which emerged in the same historic period of late nineteenth-century capitalist expansion. They have also analyzed how anthropology and nationalism both tend to objectify culture and bind it to particular people and places (see Gupta and Ferguson 1997; Handler 1988; Kapferer 1988; Malkki 1995; Spencer 1990; Verdery 1991). Richard Handler in particular argues that anthropologists must be careful to disentangle their own discourse from nationalist discourse. This problem is compounded by the fact that the word for "culture" in Arabic (*thaqafa*), and especially its usage in Egypt, carries connotations of refinement and civilization (cf. Elias 1994). Also, it will probably become apparent to the reader that Egyptian artists seem quite anthropological in their self-conscious descriptions of themselves and their Egyptianness. To remedy this sticky situation, I want to make clear that when I use the word "cultural," I mean the common (though not agreed upon) American anthropological usage of that word; and when I use "culture," I am referring to a local concept of Egyptianness (*masriyya*).

6. Also, as Scott argues convincingly, anti-essentialist constructivist positions are inherently essentialist (2004, esp. p. 3).

7. The sheer volume of media coverage and academic studies of globalization during my fieldwork was astounding. President Mubarak frequently lauded Egypt's entry into "the age of globalization," conferences were held on the subject, and both popular and academic articles about it appeared (e.g., Muhammad Sayyid Ahmad, "Globalization and the Specificity of the Middle East," *al-Ahram*, March 9, 1999, 31; Haydar Ibrahim, "Globalization and the Dilemma of Cultural Identity," *'Alam al-Fikr*, December 1999, 95–135).

8. There is a complicated history here that cannot be sufficiently explored in this chapter. For a more in-depth examination of the subtle shifts in intellectual nationalist thought prior to independence, see Gershoni and Jankowski 1986, 1995.

9. This romanticization of the peasantry is combined with a disdain for their perceived backwardness and ignorance, which is evident in the literature of the early twentieth century and was also present among the artists with whom I worked. For other discussions of this intellectual ambivalence towards peasants, see Abu-Lughod 2005 (esp. chaps. 3, 6–7) and Colla 2000.

10. Authenticity is a notoriously difficult concept to define, in part because it is related to the sensual, emotional, and expressive domains. Its varying definitions are

reflected in the multiple debates about how one acquires it (see Golomb 1995). What is shared between all of these formulations of authenticity, however, is their historical emergence in modernity. Authenticity is a dilemma of modern selfhood. In the Arab world, *asala* was not recognized in the dictionaries as "authenticity" until the late 1800s (see Shannon 2001:86, see also Salamandra 2004a:15–19).

While a comparative perspective is necessary for understanding this relationship between authenticity and modernity in various locations, it is also necessary to analyze what is meant by authenticity among specific people at particular places in time. Writing about the importance of authenticity among musicians in Bolivia, Michelle Bigenho (2002) distinguishes between "experiential," "cultural," and "unique" authenticity. Egyptian artists share the idea that authentic art and artists should be both unique and culturally sincere. But perhaps because they work in a visual medium, the experiential aspect of authenticity is deemphasized. Certainly experiential forms of authenticity are important in other Arab artistic forms. For example, Shannon's study of musicians in Syria (2006) discusses the importance of the sensory aspects of authenticity, as musicians and music-listeners experience a kind of emotional ecstasy (*tarab*) that indexes the authenticity of the musician (cf. Zuhur 1998). *Tarab* is not generally used by Egyptian artists or audiences to describe their engagement with visual arts. For an interesting discussion of how authenticity becomes commodified among Syrian and Gulf elites, see Salamandra 2004a and b.

11. Intellectuals often cite Jamal Hamdan's geo-sociological approach (1970), which argues that the geography and environment of Egypt greatly affected political and social formations in the country. Psychological and anthropological studies focus more on the various components of the Egyptian personality (see the studies quoted in Khalifa and Radwan 1998, also Raf' 1996). They do so in a way that is sometimes similar to the culture and personality studies in American anthropology.

12. Abu-Lughod also discusses the "nostalgic register" in Egyptian television serials (2005). Although *asala* is not a defined aesthetic stance among television intellectuals, similar notions of authenticity are operative in that context.

13. Sometimes artists invoked their regional backgrounds when they discussed their cultural constitution (particularly artists from the Alexandria area or from the rural south). Other possible bases for identity, such as being Arabs, Muslims, or of a certain class or family history, were used much less frequently. Egyptian Christians were a notable exception, because they often discussed a specific religious identity, which sometimes drew on a form of nationalist ideology that claimed Copts as the original Egyptians.

14. Authenticity, like culture, is one of the most complicated words in the English language, and it has a complex history in Western philosophy, which I must necessarily abbreviate here. Helpful analyses of this complexity include Golomb 1995 and Trilling 1971.

15. In Chapter 4, I discuss how artists use these concepts in other contexts to distinguish themselves from nonartists.

16. As discussed in Chapter 3, artists devalued political art that was blatantly critical of the state not so much out of fear of punishment or censorship as out of an under-

standing that such work would not be accepted—an understanding that several artists referred to as "self censorship." In addition to the very real institutional constraints on the possibility for critical political art, there was also an aesthetic aversion to it. For example, when discussing American or European artists whose work had clearly critical political content, several artists expressed disgust and said that it "hit the viewer over the head," was "too direct," or "too superficial." Indeed, much Western political art seems to go against their notions of sincerity and honesty. Many Egyptian artists' dislike of political art was probably also related to their experiences of state socialist artistic programs, which dominated the Egyptian art scene in the late 1950s and early 1960s.

17. As discussed in Chapter 1, at times, it was acceptable for a young artist to be influenced by her or his professor or deceased Egyptian artists. The locally valued importance of building a tradition of Egyptian art, in addition to the cultural value of respect for older generations, ensured that a moderate amount of influence was welcome. But even young artists were criticized when this influence was seen to approach imitation, defined as the direct transfer of a style or certain material elements. In these cases, critics would say that the young artist needed to "find his own way" or "develop himself" as an individual artist.

18. Egyptian artists were not the only ones concerned about imitation and artistic copyright. A few years prior, a German artist had taken Wahba to court, accusing him of copying his own work in this piece. Wahba won the case against him.

19. This position is very similar to that of Syrian musicians and visual artists, who valorize the Old City, the countryside, and the desert (Shannon 2005, 2006).

20. Shannon notes a similar emphasis on "Eastern spirit" (*ruh sharqiyya*) in Syrian evaluations of musicians and visual artists (2005, 2006).

21. Wisa Wasif was a famous intellectual who founded the Haraniyya School of craft production in a village near the Pyramids in 1952. The school is based on the idea that village youths have an innate creativity that should be developed outside the realm of formal education. The village is best known for its weavings, which are usually purchased by local and foreign elites, who hang them on the walls in their homes.

22. Lam'i 1984, 1999.

23. Gamal Lam'i, interview, October 25, 1999.

24. This move was part of a larger trend. Several artists had also acquired homes (or studios) just outside of Cairo in Giza near the Pyramids, usually to escape the pollution, and to live closer to the monuments and the peasants.

25. 'Izz al-Din Nagib, interview, April 21, 1999.

26. 'Ismat Dawistashi, another member of the Asala Collective, told me that the crafts had become "museumified" or commercialized for the tourist trade and that they had effectively "stopped and haven't developed anymore."

27. As with many paternalist attempts to support craftspeople, the result was that the crafts were further museumified and sold mostly to elite Egyptians and foreigners eager for a "piece of authentic Egypt" on their mantles. In comparison, collectors of African

art from the Côte d'Ivoire were also in search of an authenticity embodied in the object (Steiner 1994). Clifford 1988 discusses how such objects come to "stand for" entire groups of people, and Price 1989 illuminates the social class bases necessary for the consumption of these objects as museumified objets d'art. For more on this issue, see Chapter 5.

28. 'Ismat Dawistashi, interview, March 6, 2000.

29. Ibid.

30. 'Ismat Dawistashi, exhibition catalogue, February 2000.

31. This theme of historical loss also predominated among the Indian artists that Guha-Thakurta has studied (1995:72).

32. Nearly every day, one can find an Egyptian television program on Pharaonic sites. These programs often refer to the ancient Egyptians as Egyptians' grandfathers.

33. E.g., Youssef Chahine's famous film al-'Ard (The Earth), based on the story by 'Abd al-Rahman al-Sharqawi.

34. For example, Nagib Mahfouz's literature is filled with noble ibn al-balad characters. See also Messiri 1978.

35. At the same time, peasants were the objects of considerable derision in the media, and the term baladi could be used in a derogatory way to describe the lower taste of those who live in such urban districts (see Abu-Lughod 2005).

36. Farid Fadil, interview, September 20, 1999. Like the paintings and sculptures of other asala-identified artists, Fadil's work was very popular among the American Embassy community and some of Egypt's richest businesspeople (see Chapter 5). At the same time, he was unknown to most artists in the mainstream art world, because he did not participate in their social circles.

37. If that were indeed true, then the asala artists would have achieved their goal of connecting to society. This elitist statement by Salim reflects that of many mu'asira artists, who claimed that attempts to bring art to the people were futile, because the people were too ignorant. Of course, the asala position was equally elitist in its paternalism: the artist would educate and uplift the masses.

38. Interview, October 25, 1999.

39. Diya' Dawud, discussion, June 4, 2000.

40. Note that 'Atiyya uses the same word—infitah—that is used to characterize Sadat's economic "opening" to global capital.

41. Abu-Lughod (2005:153–54) found this theory of the Egyptian character among elite television producers in Cairo. It is also similar to the "Anthropophagist Manifesto" developed by Oswaldo de Andrade in 1920s Brazil for dealing with European cultural influences.

42. Sabah Na'im, interview, September 16, 1999.

43. Ibid.

44. The most famous example is Laroui 1976. Through ethnographic examination of Syrian musicians' and artists' actual engagements with ideas of heritage and tradition, Jonathan Shannon counters these Arab intellectual arguments by showing that

these engagements constitute neither backwardness nor "escapism" but rather "promote cultural imaginaries that challenge both the banalities and violences of everyday life in modern Syria . . . and the dominant paradigms of modernity in European thought" (Shannon 2005:362).

45. Fears of backwardness emerge whenever culture producers feel that they are being marginalized, and as such they are not specific to the formerly colonized world. See, e.g., the discussion of them in Greece in Jusdanis 1991, and in Australia in Burn et al. 1988.

46. Remarks made at the annual conference at the Cairo College of Applied Arts, March 1999.

47. Discussion, June 4, 2000.

48. Remarks made at the Artists' Syndicate Conference, April 1999. It was clear that many foreign art buyers in Cairo preferred paintings of Egyptian scenes or paintings that included conventional symbols. Abusabib 2004 discusses a comparative case of how the idea of "identity" is suspected to be a colonial imposition in the Sudanese art world.

49. Ionna Laliotou, personal communication, February 2001; cf. Herzfeld 1986.

50. In a similar vein, Nak-chung 1998 argues that nationalist literature in Korea emerged in response to Japanese imperialism, and Trumpener 1995 shows the same for the nationalist literatures of Czechoslovakia, Austria, and Hungary (the empire being the Austro-Hungarian).

Chapter 3. Freedom of Talk: Cultural Policy and the Transforming State

Epigraph: Alaa Al-Aswany, interview with NPR's Robert Siegel, www.npr.org/templates/story/story.php?storyId=4508427 (accessed May 24, 2006). Aswany is the author of the best-selling novel *The Yacoubian Building,* recently made into a film.

1. Stevenson 1999 has a very intriguing argument that post-unification German cultural policy creates neoliberal subjects through techniques of governmentality, but there has been almost no other scholarly work in this vein.

2. Neoliberalism usually needs states for its reinforcement. The clashes that occur at every meeting of international trade and lending organizations remind activists that state security apparatuses play a large role in guaranteeing neoliberal economic planning.

3. It is important to clarify that the field of cultural production was not synonymous with the state. State institutions were part of the field of cultural production, and were at some level produced by it.

4. My discussion of the hegemonic draws on Gramsci 1971's argument about the central role of consent in hegemony.

5. For a good example of one of the few scholarly explorations of non-Western cultural policy (in Latin America), see Stanziola 2002.

6. Scheid 2005's discussion of how art becomes an index of civilization and modernity in Lebanon makes an interesting comparative case to the issues I discuss here and in the remaining chapters of the book.

7. At the time of this writing, it is one of very few permanent pavilions owned and

operated by a non-Western country at the Venice Biennale.

8. Husni ran a cultural center in the city of Alexandria, whereas Nagib ran one in the Delta. These different experiences—one urban, one rural—may have influenced their diverging aesthetic perspectives.

9. The propagandistic nature of these trends eventually led to their falling out of favor among artists, and later led to an aversion to politically motivated art trends in Europe and the United States.

10. I am not aware of whether the practice of restricting or taking away resources, followed by conceding them, was part of official policy during Nasser and Sadat; and I do not want to imply a vulgar instrumentalism to state actors. Rather, I am interested in the possible *effects* of these contradictory actions.

11. Artists often discuss the Akhneton era as one of the most creative in all Pharaonic art history.

12. The sculptor 'Ali Yasin remembers hearing about the scandal several times on the radio in his Upper Egyptian village. He said that the villagers talked about the amazing fact that a painting could cost millions of dollars and chalked its loss up to the ridiculously wasteful and inefficient Sadat government.

13. The painting now hangs in its own room at the new Mahmud Khalil museum in Cairo, but several artists told me they think that it is a forgery and that the real Van Gogh was never returned.

14. Ahmad Mahmud, interview, September 7, 1999.

15. Official statistics obtained in 2000 from Dr. Ahmad Nawwar, director of the National Center of Fine Arts, Egyptian Ministry of Culture. The statistics are for the years 1998–99.

16. Here I use the older name to retain a sense of the fact that it is an actual center that is national in orientation.

17. A popular television program at the time called *Huwwar ma'a al-kubar* (Discussion with the Elders) covered the issue of cultural threats to the youth in nearly every episode I watched. There was also a Ministry of Youth, and some of its programs also indicated concern with "outside" cultural threats.

18. In addition, the minister may have been influenced by the boom in the international art market in the 1980s, which was propelled by the emergence and marketing of young artists. It is also possible that the growing Western valorization of youth culture had some effect on the minister's planning. However, if the minister had simply been trying to mimic the West, he probably would not have chosen to call the event a "salon." In the western European context, an art "salon" recalls the staid, classical exhibitions of the nineteenth century against which modernists like Manet rebelled. However, in the Egyptian context, the word "salon" did not carry this same connotation. Rather, it evoked the image of the literary salons of the early twentieth century in which Egyptian intellectuals debated artistic and political matters, including nationalism and imperialism. At the time of my fieldwork, I heard about several attempts to revive the literary salon in Egypt.

19. In 1999, for example, more than 1,200 works were submitted (Salon al-Shabab catalogue).

20. In 1999, this equaled approximately $147 to $1,470. The prizes (first through third) were distributed in the categories of painting, sculpture, graphic design, drawing, installation, ceramics, and computer graphics. The grand prize could be from any of these categories. Other prizes, called encouragement prizes and salon prizes, were also distributed.

21. 'Izz al-Din Nagib, interview, October 11, 1999.

22. Interview, June 3, 2000.

23. Interview, October 25, 1999.

24. Hussein Bikar was a renowned artist and critic who was in his eighties at this time.

25. Interview, March 2, 1999.

26. *Ibda'*, October 1999.

27. *al-Shumu'*, March 1999, p. 36. The story of the *Shumu'* gallery and magazine shows clearly that even though artists divided themselves into opposing aesthetic camps, the spaces of the art world were often quite mixed. Nagib wrote regularly in the magazine and was its editor in 1991. The gallery often exhibited the work of *asala*-oriented artists and hosted roundtables to discuss Egyptian identity in art. One of these was headed by Usama al-Baz, consultant to the president on political affairs and fan of *asala* art. Yet *Shumu'* also exhibited the Minister of Culture's art, and he, a political colleague of al-Baz, was featured in several issues of the magazine. The son of the magazine and gallery owner was also married to the minister's niece.

28. Interview, May 30, 2000.

29. Interview, October 25, 1999.

30. Interview, October 25, 1999.

31. I was once an uncomfortable witness to an argument between an artist and another member of the Supreme Council for Culture, in which the former was complaining that the council had not recommended him for exhibitions outside the country. Later, this member told me that the council sometimes gave out "little things" to these complainers—little things like a nomination to represent Egypt at the Sharqa Biennial in the United Arab Emirates, which at the time was small and relatively inconsequential.

32. *Ibda'*, October 1999.

33. The government had recently allowed the destruction of some historic buildings in the Khan al-Khalili bazaar across the street to make room for a small shopping mall, so Nagib's fear was palpable and well-founded. It is interesting that when I asked shopkeepers who maintained their small stores opposite the new mall what they thought about it, they said it ruined the neighborhood, and that foreign tourists liked the old buildings better anyway. Artist informants said that the new building, like so many other new projects being built in Cairo and Alexandria, was done in flashy "Gulf taste" (*zu' khaligi*)—a reference to the styles many Egyptians encountered on their travels to work

in the oil-rich nations of the Gulf.

Mustafa al-Razzaz: Book of Revelations

1. For more on Egyptians' idealization of folkloric images of Nubia and Nubians, see E. Smith 2006.

2. Ethical issues regarding the idealization of other groups' heritages were still ignored, as they were in the rest of the Egyptian art world. Chapter 4 and my remarks concluding this book deal with this problem.

3. For more on the *Mihwar* works, see Karnouk 1995.

Chapter 4. Cultivating Civilized Publics

1. Depictions of technology during the period were not all celebratory, as I suggest in the interlude on 'Abd al-Hadi al-Gazzar.

2. Approximately $14,660 to $146,600.

3. Canclini 1994 (esp. chap. 3) provides a rich discussion of similar concerns about the public among Latin American artists, and how these are refracted through modernist traditions and modernization projects.

4. My theoretical positioning in this chapter owes much to Swartz 1997's contextualization of Bourdieu 1993's theory of the field of cultural production within the rest of his oeuvre.

5. E. Smith 2006 also discusses how Nubian intellectual *tathqif* projects are taken up by all different kinds of Nubians (including nonintellectuals) as conferring status and prestige.

6. They mentioned groups like the Friends of Art and Life, for example, which were interested in creating art based on local folklore (see Said 1986).

7. Although most artists venerated the Nasser period, they also criticized certain elements or results of Nasser's policies. Younger artists in particular criticized the growth of the state bureaucracy, and older artists remembered the imprisonment of intellectuals. Nonetheless, these negative aspects of the Nasser period were often explained away (see Gordon 1992). For more on the place of the Nasser period in the construction of historical memory, see Podeh and Winckler 2004.

8. There was also the idea in some revolutionary discourse of raising the "awareness" or "consciousness" of the masses (*taw'iya*). Although there were limits to how "conscious" the government wanted its public, this idea continued to shape artistic production in the 1990s.

9. 'Izz al-Din Nagib, leader of the Asala Collective mentioned in earlier chapters, wrote a book about his experience called *Al-samitun: tajarib fi al-thaqafa wa al-dimuqratiyya bil-rif al-misri* (The Silent Ones: Experiments in Culture and Democracy in the Egyptian Countryside) (1985), in which he blames local officials, rather than leftist intellectuals such as himself associated with the regime, for "silencing" the peasants.

10. Very little work has been done that analyzes contemporary Egyptians' constructions of the Sadat period, but for basic overviews see Baker 1990 and Hinnebusch 1988. Mitchell 2002 and Sonbol 2000 also provide interesting perspectives.

11. Mitchell 2002 discusses this massive real estate boom and bust and its relationship to neoliberal reforms. He also discusses how people from the old moneyed classes took advantage of these reforms, in part through social connections. I use the term "renewly" wealthy here and in Chapter 5 to describe this group.

12. Anonymous article under the editorship of Makram Hinayn, *al-Ahram*, October 19, 1999.

13. Anonymous article under the editorship of Muhammad Salima, *al-Ahram*, October 31, 1999. These arguments indicated that the obelisk, like many other kinds of Pharaonic art, was lent a certain sanctity. The idea of copying it (*istinsakh*) automatically implied devaluation. This issue was discussed in *Akhbar al-Yaum*, October 30, 1999. Additionally, many older generation artists and critics objected to the fact that the obelisk was constructed of polyester resin. While young artists have enjoyed working with resin since the mid 1980s and have experimented extensively with the use of new materials to make traditional forms, the practice still met with much resistance in the late 1990s. For example, during the annual international granite symposium in Aswan, there was much talk about the "nobility" and "Egyptianness" of granite and criticism of the use of synthetic materials in sculpture. To create a Pharaonic form out of resin, and to cover it with symbols and slogans, was considered by many the equivalent of artistic treason.

14. These comments exemplify how the spread of urban practices and forms to the "idyllic," "authentic" countryside was seen as particularly threatening by many older generation artists.

15. Anonymous article under the editorship of Muhammad Salima, *al-Ahram*, October 31, 1999.

16. Muhammad Salima, *al-Ahram*, April 2, 2000.

17. Anonymous article under the editorship of Makram Hinayn, *al-Ahram*, June 6, 1999.

18. Muhammad Salima, *al-Ahram*, March 5, 2000.

19. 'Ali, 'Arafa 'Abduh, "Jara'im al-Qubh," *Akhbar al-Adab*, January 2, 2000.

20. Guwayda, Faruq, "Qadaya Jamaliyya," *al-Ahram*, March 14, 1999.

21. I use the word "awareness" instead of "consciousness" because the latter has Marxist connotations that were not necessarily implied in the usage of the term *wa'i* among artists.

22. "Man al-mas'ul 'an tajmil wajh al-Qahira," *Akhbar al-Yaum*, October 30, 1999.

23. The other work criticized was a sculpture of Muhammad 'Abd al-Wahhab in Midan Bab al-Sha'riyya.

24. *Al-Ahram*, October 31, 1999.

25. Anonymous article under the editorship of Makram Hinayn, *al-Ahram*, October 24, 1999.

346 NOTES TO PAGES 202–225

26. Here I do not wish to imply that older artists resisted experimentation. Many of them did use Pharaonic forms or symbols in their work. It is quite likely that they would have supported a more senior artist if he or she had chosen to use the obelisk form. However, no one in the younger generation commented that a real Pharaonic obelisk was inherently better than a contemporary version.

27. Undoubtedly on occasion my presence as an American prompted these seemingly self-deprecating comments. However, they were made in a variety of other contexts between artists as well.

28. Tariq al-Kumi, interview, May 4, 2000. All his quoted remarks are from this date.

29. Given his public stature, his good relations with the Ministry of Culture, and the fact that our interview was taped, it is not surprising that Tariq al-Kumi did not include government *arts* officials in his critique of the state.

30. This distinction between the "understanding" of artists and the "feeling" of the people was repeated many times and could be indicative of a Cartesian-based social hierarchy, yet young artists would also often say that the people understood more than artists, or that a good artist is one who knows how to feel.

31. Three months later in fact, in April 2000, Tariq al-Kumi opened a one-man show at a major exhibition hall in Cairo. And, as mentioned earlier, he received another lucrative contract for a project in Alexandria.

32. Although sales of individual artworks were increasing at the time of my fieldwork, very few artists supported themselves solely through their work. Those who taught at the universities were not paid very well. Many young artists made small statuary and other knickknacks for the tourist industry but then suffered greatly when the industry declined after the Luxor massacre in 1997. Plus the industry was seasonal. Many artists I knew relied on family members for additional support during rough times or just made do with less. Thus, any opportunity for contract work was greatly sought after.

33. Hazim Fathallah, quoted in *Akhbar al-Yaum*, October 30, 1999.

34. The law favored older generation artists, as an artist had to have over fifteen years of experience to be included in the directory.

35. Ahmad Mahmud, interview, April 26, 2000.

Gazibiyya Sirri—The Search: Personal Papers

1. For more on this perspective and the related disavowal of feminist evaluations of art among Egyptian women artists, see Winegar 1999, 2002.

2. For images of these works, see Sirri 1998.

Chapter 5. Collecting a Nation, Displaying (a) Culture

1. Plattner 1996 shows, however, that the art market in the United States supports a miniscule percentage of artists, and Halle 1993 indicates that many American art collectors do not really know very much about the art they collect.

2. Alsop 1982 is a well-known exception.

3. The literature generally follows two broad trends: the psychoanalytic and the Marxist-inspired. In both of these trends, writers generally focus their analytic attention on *why* people collect, and often search for subconscious or utilitarian "motives," "impulses," and "drive." Sometimes, the collector is even diagnosed as having obsessive and often compulsive tendencies, or as someone who collects to reduce anxiety or trauma (e.g., Muensterberger, 1993). More anthropologically oriented authors have taken this approach in an interesting direction to argue that collecting is part of a particularly Western subjectivity where possessive individualism and the desire to create disciplinary systems of classification are paramount (see Breckenridge 1989; Clifford 1988). Sociologically inspired authors, like Bourdieu (1984), have tended to focus on elites as motivated to collect art in order to express and consolidate their class domination. There is an interesting parallel between what these theorists argue about collecting and their approach to collecting. In other words, there is a theoretical obsession with obsession. Understanding motive from psychological, sociological, or anthropological points of view no doubt has its uses. But it seems to me that we need to question the scholarly weight given to motive itself.

4. The debates over rigidity and flexibility in Bourdieu's theories are ongoing (see Calhoun et al. 1993). Halle 1996 argues that Bourdieu's concept of cultural capital is "fatalistic," and that there are not especially significant cultural barriers between social classes. Halle's critique is not very well developed, and in any case it seems to stem from his emphasis on causality and his view of Bourdieu's theory from American shores. In my view, Bourdieu's theory of art and taste is not inherently rigid, but rather when applied to France, it reveals the rigidities of that system.

5. Contexts of home display are incredibly important to our understanding of collecting activity, yet despite David Halle's (1996) call to follow his lead in this regard, few have done so.

6. I focus exclusively on Egyptian collectors of modern Egyptian art, most of whom I met in 2003 and 2004. Very few Egyptians were interested in collecting modern art from other Arab countries or from elsewhere in the developing world. Still fewer Egyptians had the means to collect Western art, though many desired to do so. In some cases, this absence of interest in other non-Western art stemmed from many collectors' lack of knowledge of art outside of Egypt and the West. But more often, the absence of other non-Western art in Egyptian collections resulted from the fact that such art was usually devalued in comparison to modern Egyptian art. In typical Egyptian elite fashion, these collectors saw Egypt as the cultural center and pinnacle of the Arab world (thereby rendering all other modern Arab art of lesser value); and they saw Egypt (and by extension Egyptian art) as more developed and civilized than other places whose art might otherwise be geographically accessible (e.g., sub-Saharan Africa and most of Asia). I should note, however, that many Egyptian elites had knickknacks and tourist art from their worldly travels in their collections, and some had Oriental rugs and tapestries from

Central and East Asia—objects that have worldwide recognition and antique value despite the contemporary "less civilized" nature of their provenance (in many Egyptians' eyes). However, I concentrate here on the collection of the kinds of art discussed in this book, and on its historical precedents.

The gender imbalance of my selection (three men and one woman) should *not* be taken as representative of art collectors in Egypt. Although I do not have exact numbers, I would estimate that at least half of the people who bought art at the time of my fieldwork were women. Many, though not all, did so as the family member responsible for decoration of the home. The unfortunate imbalance in my selection here is merely the result of the accidents of fieldwork, during which I was able to obtain more substantial contacts with male collectors. In part, this was because I did my fieldwork with collectors during summers, when wealthy women were often summering outside of Cairo while their husbands remained to take care of official business. It should be noted that although many of these women did not have formal employment, they did important work for the family businesses by making connections and participating in social circles in the summer resorts. This could involve discussion and purchase of art for the summer villas, and planning for charity art exhibitions, among other things.

Although non-Egyptian (primarily Western) purchases of contemporary Egyptian art were important, I do not have space to attend to them here. The opening of Egypt's economy to the West in the 1970s, combined with a second restructuring of the economy in the 1990s to encourage foreign investment and market liberalization, brought European and American businessmen and diplomats to Egypt who subsequently became interested in collecting Egyptian art. Many of them were attracted to work that "looked Egyptian" to them (e.g., paintings of country landscapes and peasants). There were also foreigners who purchased more abstract or conceptual work; they tended to be either of a younger generation (i.e., under forty-five) or were involved in the intellectual and creative industries (e.g., writers, artists, academics).

7. *Infitah*, literally "opening up," is the word used to describe the market liberalization begun in the Sadat era.

8. For a fascinating, if nostalgic, description of the social and aesthetic changes in these European-style buildings downtown, see Aswany's novel *The Yacoubian Building* (2005).

9. This ubiquitous elite furniture style was a reproduction of eighteenth-century French furniture. It was an amalgam of Louis XIV and Louis XV styles, and it was sometimes derisively referred to by its critics as "Louis Faruq" furniture—Faruq being the name of Egypt's last king before independence.

10. Such chocolates could cost as much as 25 Egyptian pounds per kilo, more than many Egyptians made in a week.

11. Gabriel's children attended a private French school. I do not know of one collector whose children attended public schools, though I am certainly not implying that collectors did not support public education in principle.

12. Nabil Gabriel, interview, August 3, 2004. All his quoted remarks are from this interview.

13. This simultaneous connection with and distinction from cultural others that is enacted through art collecting practices is similar to that found by Margaret Dubin (2001) in her analysis of white collectors of Native American art.

14. No doubt some of the French people analyzed by Bourdieu constituted Frenchness through art collecting, but one would have to read between the lines of his 1984 opus on distinction to access this possibility.

15. In 1974, just after Sadat reversed many of Nasser's policies, one of Sabagh's cousins came to take the collection back. Gabriel's family did keep a couple of the paintings.

16. See Mitchell 2002 for a very useful discussion of the oppressive history of the ʿizba system.

17. This was a common view among Cairene elites. See Abu-Lughod 2005.

18. Once I heard the story of one elite man who used to put a tissue between his shirt collar and neck (to catch the sweat and dirt) before rushing from the door of his house to his air-conditioned car. Petra Kuppinger's research on the rise of gated communities (2004) and Soraya Altorki and Donald Cole's study of gated coastal villages (1998) highlight similar attempts by elites to create spaces of protection and distinction.

19. Such debates were similar to those elsewhere, and they are often classist, racist, ethnocentric, or all three—e.g., ancient Egyptian art (the British Museum or the Egyptian Museum), Iraqi Sumerian art (private collectors or the Iraqi government), and Native American art (U.S. museums or Native American tribes).

20. Al-Husayn Fawzi (1905–99) was one of the first generation of modern Egyptian artists. In the 1930s, he went on a study trip to Paris, where he undoubtedly saw Orientalist art in museums. Upon his return, he founded the first printmaking department in the Arab world, at Cairo's College of Fine Arts, where he taught for many years.

21. At that time, this was roughly the equivalent of $30,000.

22. I use this word to connote the fact that many of the prevolutionary elite families have had most of the Nasserist restrictions on their wealth and income generation removed and therefore have become "renewly" wealthy in the eras of Sadat and Mubarak.

23. A mashrabiya is a kind of screen made out of carved, interlocking pieces of wood. It is a hallmark of Islamic architecture.

24. Al-Misiri was one of the few collectors I met who truly seemed "obsessed." This and all the quotations here from al-Misiri's autobiography are from a draft written in English.

25. See also Mona Abaza's brief but insightful analysis of the contradictions inherent in al-Misiri's views on décor and his "Islamic philosophy," and the class inflections of his nostalgia for old things and village life (Abaza 2002:149–53).

26. From 3,000 to 25,000 Egyptian pounds, or approximately U.S.$900–$7,500 in 1999.

27. For more on this issue, see Introduction, note 6.

28. Like many American academics, and anthropologists especially, many of these collectors were also aware of the fact that their wealth put a distance between them and ordinary people. Décor and dress (among other things) sometimes worked to diminish that gap.

29. This and all subsequent quotations of Khalid Wagdi are from an interview conducted on July 15, 2004.

30. For more on this artist and images of her work, see Boghiguian 2003.

31. For most Egyptian artists, artistic treatments of class would probably be too overt a reflection of their own personal struggles. Some might very well have not-so-distant relatives who dress(ed) like the women in Baladi's photographs, and so they would be much less apt to publicly "poke fun" of their style in artwork. Until the arrival of the Quartz Gallery, discussed in Chapter 6, there was no real local equivalent for the term "kitsch," and sarcasm and irony were hardly ever elements in artwork. As I write this text, I am receiving emails from a good friend asking me what the heck all this sudden talk about "kitsch" is among foreigners and the artists they like. This is partly because the English-language literature on kitsch has not been translated in Egypt, but I think it is also because artists were trying to get away from the kitsch of their own backgrounds, not make fun of or celebrate it. Sarcasm and irony require a certain distance, which visual artists (unlike writers) did not possess (or were not granted) because of their liminal class and intellectual status.

32. Sarcasm and irony in Western art developed with the expansion of industrialization and capitalism.

33. For other excellent examples of how globalization has often enhanced national attachments, see Bernal 2004, Ong 1999, and Wang 2002. As Vitalis 1995 has shown for colonial Egypt, capitalist entrepreneurs at that time (the "comprador" class) also articulated a "business nationalism" that actually garnered them a competitive advantage in an economic environment of shifting local/international relations. The same may have been true of Wagdi (I do not know enough about his business activities to say), but certainly his nationalism, like that of the early Egyptian capitalists, "proved flexible enough to accommodate shifting and pragmatic assessments of interest" (Vitalis 1995:45).

34. Likewise, many artists were excluded from the realm of foreign collectors. Although these art buyers were less concerned to know artists personally (yet often delighted in "discovering" unknown artists from the lower classes), there was still significant inequality in how these artists were chosen—particularly by foreigners who frequented the avant-garde spaces detailed in Chapter 6, where experience abroad and knowledge of English were important determinants of whether or not an artist would be desired.

Chapter 6. Art and Culture Between Empire and Sovereignty

1. The prevalence of these two evaluative adjectives "good" and "interesting" in U.S. academic and art circles is likely due to their vagueness. They can be used to signify that one is "in the know" without having to articulate exactly what the standards of

evaluation are. Furthermore, as Mieke Bal suggests, "interesting" can be a "catch-phrase destined to obscure more specific *interests* (in the stronger sense of German critical philosophy)" (1994:105; parentheses added for clarification).

2. See Oguibe and Enwezor et al. 1999; Oguibe 2004; and everything in the journal *Third Text*, especially the incisive writings of Rasheed Araeen.

3. This chapter discusses a situation that is similar in some ways to the transformations occurring in the former Eastern Bloc. Here, as in previous chapters, we see similarities in the versatility of functions fulfilled by cultural nationalism; the reinvigoration of East/West hierarchies and competitions; the combination of a desire to engage the West while defending oneself from outsiders' demonization of life under socialism; the important role of morality and memory in understandings of the nation; and the general experience of dislocation (see esp. Berdahl et al. 2000; Boyer 2001b; Verdery 1996). However, as will become clear, there are two crucial differences that distinguish the Egyptian case. The first is that Egyptian socialism was the outcome of the experience of colonialism, and so in Egypt, recent transformations carry a particular postcolonial cast. The second is that Egypt, as part of the Middle East, plays a central role in what many have called the new American empire. This fact makes the transformations particularly suspect to Egyptians.

4. Egyptian intellectuals have long considered Cairo to be the intellectual and cultural center of the Arab world, a view shared, sometimes begrudgingly, by many Arab intellectuals today.

5. To get a sense of the roots of these logics and attachments in the realm of material culture, see Colla (forthcoming) on the conflicts between different groups of Westerners and Egyptians surrounding Egyptian antiquities. Colla's book makes for an excellent historical comparison to the case I discuss here.

The transformations in the contemporary Egyptian art world occurred at the same time as similar changes in the Senegalese art scene, as analyzed by Harney 2004, in which artists became increasingly beholden to Western patrons in a way that "mirror[ed]" the earlier "overlordship" of the state, with an additional "insidious neocolonial dimension" (230).

6. I am using the concept "hierarchy of value" as explicated by Myers 2001.

7. As noted in the Introduction, I follow Verdery 1996 in calling this a transformation rather than a "transition," because the latter assumes that the changes will result in Egyptian society becoming completely like Western capitalist societies. This assumption, and the teleological thinking underlying it, was held by many of the Western curators discussed herein. Therefore, I analyze the language of transition rather than uncritically adopt it.

8. The most useful comparisons to the Egyptian case that I have found are in Native American sovereignty struggles. See in particular Coffey and Tsosie's development of a concept of cultural sovereignty that harnesses long-standing values to assert autonomy from external control, and from definitions of political sovereignty that negate or as-

similate cultural difference (2001). See also Cattelino 2004's exploration of tribal sovereignty as interdependence, as in relationship to nonindigenous economies, systems, and regimes of sovereignty.

9. For more detailed information on the art market in prevolutionary Egypt, see Iskandar et al. 1991.

10. Hafiz's figures are in an unpublished report produced for the 1999 curatorial practice seminar at the American University in Cairo.

11. Most gallery owners said that the sales were so miniscule that they had not really kept track of them until recently, when sales began to rise. There seemed to be less confidentiality regarding sales figures from these galleries than from the others, though that might be due to my closer relationship with these gallerists.

12. Information obtained from Tharwat al-Bahr, director of the Museum of Modern Egyptian Art.

13. Cf. Bissell 2005.

14. This may be an unintended effect. The gallery owner stated that he had chosen the gallery based on its high ceilings, best for displaying art, not out of nostalgia for the colonial period. Still, it is interesting that no Egyptian-owned private galleries have high ceilings, a fact which makes one entertain the thought that there is an important similarity between the aesthetics of the colonial period and those of the new elites benefiting from neoliberalism.

15. Lucy Till, *Cairo Times*, July 10–16, 2003.

16. Over the course of the next few years, it turned out that what many of these curators wanted was what I would call a "new Orientalist" representation of Egypt. It consisted mainly of photographic explorations of urban life with distinctive features that were culturally locatable (people in local dress, Arabic billboards, etc.). For more on this kind of work, and contrasts to it, see the interlude on Muhammad 'Abla.

17. Lucy Till, "Cultural Identity Crisis," *Cairo Times*, July 10–16, 2003. I have no idea what the Islamist trends are to which she refers. As I have discussed throughout the book, artists strayed very far from Islamist themes and ideology for a number of reasons.

18. See, e.g., David 2004; Winegar 2002; Zurbrigg 2001.

19. In fairness, the artist may not have understood the comment because it was made in English.

20. Lucy Till, "Art and Politics in Venice," *Cairo Times*, June 26–July 2, 2003. The author also conveniently ignores the tremendous number of artists in the West working in large scales.

21. *New Art Examiner*, November 1999.

22. Westerners' characterizations of older generation artists certainly stemmed in part from the fact that many of them worked for the government—either as administrators or committee members at the Ministry of Culture, as curators, or as university professors. Indeed, the term "older artists" was often used interchangeably with "official artists," with the assumption that these artists did work that was in line with state

ideology or, more generally, that the state controlled their artistic production. In these judgments, Western curators and audiences often lumped together *asala* and anti-*asala* artists. Furthermore, the term "official artists" masked the reality that the state's control over artistic production varied according to context, and even then was not completely dominating, as Chapter 3 has shown. These framings sometimes suggested that such artists were state propagandists along the lines of Nazi or Soviet artists, which was certainly not the case. Finally, the term set up too neat of a distinction between artists who were supposed spokesmen for the state, and those who were not. The fact that many younger generation artists were also connected to the state (e.g., as employees, recipients of state arts money, as panelists and committee members at state arts events, or even as generally in favor of state support for the arts) was either unknown or strategically ignored. For many of the Western curators and critics, the (perceived) presence of the state in an artist's life automatically poisoned the work and rendered it "backward." Therefore, to recognize the young artists' connections to the state would immediately devalue their work to such a degree that the foreigners would have little justification for their preference towards them.

23. *Al-Qahira*, August 28, 2001.

24. Artists whose articulations of cultural sovereignty were mainly expressed through iterations of pastoral and folkloric motifs remained marginalized by both the public and private sector curators. These artists were the hidden majority who found no place either in the battles between state and foreign curators or the struggles of young artists to resist the limitations of either side.

25. Gallery owners told me that they took fixed commissions (usually about 30%), and it did appear that most transactions conformed to this rule. However, artists complained that if there were any inconsistencies, such as those that might arise if certain discounts are given, or incidental expenses incurred, the onus fell on them. I was not able to corroborate their claims.

26. Note the similarity to international development discourse here, especially in its Egyptian manifestation as analyzed by Mitchell 2002.

27. "Report from Egypt: Local Conditions, Western Forms," *Art in America*, January 2002.

28. Nor is there a recognition that the majority of Egyptians opposed the Camp David Accords with Israel, or that prior to the Sadat years Egypt had been "open" toward exchanges with the Eastern Bloc and with formerly colonized countries of Africa and Asia.

29. "Curating in the Middle East: Inova interviews Rosa Martínez," *New Art Examiner*, November 1999.

30. *Art in America*, January 2002.

31. *New Art Examiner*, November 1999.

32. In my discussions with these foreign curators, I often asserted my own expert status as someone who "knew" Egyptian art better than they (the temptation was too great).

33. She found another way in the neoliberal economy: she started an NGO that got

corporate and foundation funding for arts programs in a poor Alexandria neighborhood.

34. "Is It the Right of Quartz to Do an Exhibition Abroad in Egypt's Name?" *Al-Qahira*, December 11, 2001.

35. *Al-Qahira*, August 28, 2001.

36. This ideology was also contextual in the sense that many Americans and Europeans thought that, in their home societies, government support for the arts was important. There seemed to be a general assumption that state funding for the arts in the Middle East meant more direct control over artists than state funding in the West, despite the infamous NEA scandals in the United States.

37. Many Westerners also believed that Egyptian artistic production was controlled or limited by social conservatism more than artistic production in the West. Religion and gender were seen to be the main areas where this conservatism took root.

38. This perspective on the state exists in French art circles as well, and given that the Egyptian Ministry of Culture was inspired by the French version, it is likely that this ideology of a caretaker state came partially from the French. It mapped onto people's views of the ideal state socialist project, wherein the state protects citizens from capitalist exploitation.

39. This language was frequently found in the Egyptian press and used especially to discuss imperialist, Zionist, or Jewish threats to Egyptian culture more generally—not just in the sphere of the arts.

40. *Al-Qahira*, August 28, 2001.

41. It should be noted that, as this market grew, the staff of these new galleries gradually came to have some of the critiques that I had, particularly of Western critics and other curators who came through Cairo on quick jaunts. The Quartz Gallery staff in particular also changed some aspects of the gallery's operation. For example, they included Egyptians on the Board of Directors and tried to make sure that wall text and gallery literature were also printed in Arabic.

42. Thomas 2004's analysis of cultural politics and globalization in Jamaica offers an interesting comparison. While the cases are similar, in that globalization has produced new forms of subjectivity and reoriented citizens away from the nation-state in some regards, in some areas of Egyptian cultural politics, orientation towards the nation-state did not disappear (though it did change in form). Furthermore, citizenship did not appear to be experienced as transnationally as in Jamaica. And while threats to the nation and the nation-state produced moral debates over values in both cases, in Egypt these were articulated through discourses of sovereignty and, to some extent, liberation as much as crisis. Perhaps the greatest similarity between cultural politics in Jamaica and Egypt is that globalization has significantly challenged gerontocracies of rule.

Raghib 'Ayad: Return of the Spirit

1. Colla 2001–2 provides a rich analysis of how Pharaonic themes and objects become co-opted for the nation in this novel as well as al-Hakim's memoir.

REFERENCES

Abaza, Mona. 2002. *Debates on Islam and Knowledge in Malaysia and Egypt: Shifting Worlds*. London: RoutledgeCurzon.

'Abd al-Sabur, Salah. 1962. *Al-nas fi biladi* (People of My Country). Cairo: Dar al-ma'rifa.

———. 1981. *Aqulu lakum* (I Say to You). Cairo: Dar al-shuruq.

Abdel-Malek, Anouar. 1968. *Egypt: Military Society*. New York: Random House.

Abrams, Philip. 1988. Notes on the Difficulty of Studying the State. *Journal of Historical Sociology* 1 (1): 58–89.

Abu-Ghazi, Badr al-Din. 1984. *Raghib 'Ayad*. Cairo: Al-hay'a al-'amma lil-ist'alamat.

Abu-Lughod, Lila. 1986. *Veiled Sentiments: Honor and Poetry in a Bedouin Society*. Berkeley: University of California Press.

———. 1990. The Romance of Resistance: Tracing Transformations of Power through Bedouin Women. *American Ethnologist* 17 (1): 41–55.

———. 1993. *Writing Women's Worlds: Bedouin Stories*. Berkeley: University of California Press.

———. 1998. The Marriage of Feminism and Islamism in Egypt: Selective Repudiation as a Dynamic of Postcolonial Cultural Politics. In *Remaking Women: Feminism and Modernity in the Middle East*, ed. Lila Abu-Lughod, 243–69. Princeton: Princeton University Press.

———. 2002. Do Muslim Women Really Need Saving? Anthropological Reflections on Cultural Relativism and Its Others. *American Anthropologist* 104 (3): 783–90.

———. 2005. *Dramas of Nationhood: The Politics of Television in Egypt*. Chicago: University of Chicago Press.

Abusabib, Mohamed. 2004. *Art, Politics, and Cultural Identification in Sudan*. Uppsala, Sweden: University of Uppsala Press.

Adler, Judith E. 1979. *Artists in Offices: An Ethnography of an Academic Art Scene.* New Brunswick, N.J.: Transaction Books.

Afifi, Fatma Ismail. 1997. The Kom Ghorab Project in Cairo. In *Art Criticism and Africa,* ed. Katy Deepwell. London: Saffron Books.

Ahmad, Aijaz. 1987. Jameson's Rhetoric of Otherness and the "National Allegory." *Social Text* 17:3–25.

Ali, Wijdan. 1997. *Modern Islamic Art: Development and Continuity.* Gainesville: University Press of Florida.

Alsop, Joseph. 1982. *The Rare Art Traditions: The History of Art Collecting and Its Linked Phenomena Wherever These Have Appeared.* Princeton: Princeton University Press.

Altorki, Soraya, and Donald Cole. 1998. *Bedouin, Settlers, and Holiday-makers: Egypt's Changing Northwest Coast.* Cairo: American University in Cairo Press.

Anderson, Benedict. [1983] 1991. *Imagined Communities: Reflections on the Origin and Spread of Nationalism.* London: Verso.

Anderson, Jon W. 1996. Conspiracy Theories, Premature Entextualization, and Popular Political Analysis. *Arab Studies Journal* 4 (1): 96–102.

Appadurai, Arjun. 1986. *The Social Life of Things: Commodities in Cultural Perspective.* Cambridge: Cambridge University Press.

———. 1996. *Modernity at Large: Cultural Dimensions of Globalization.* Minneapolis: University of Minnesota Press.

———. 2000. Grassroots Globalization and the Research Imagination. *Public Culture* 12 (1): 1–21.

Armbrust, Walter. 1996. *Mass Culture and Modernism in Egypt.* Cambridge: Cambridge University Press.

Asad, Talal. 1986. *The Idea of an Anthropology of Islam.* Occasional Papers Series. Washington, D.C.: Center for Contemporary Arab Studies, Georgetown University.

———. 1993. *Genealogies of Religion: Discipline and Reasons of Power in Christianity and Islam.* Baltimore: Johns Hopkins University Press.

Aslan, Ibrahim. 2004. *Nile Sparrows.* Translated by Mona El-Ghobashy. Cairo: American University in Cairo Press.

Aswany, Alaa al-. 2005. *The Yacoubian Building.* Translated by Humphrey Davies. Cairo: American University in Cairo Press.

'Atiyya, Muhsin. 1998. Al-thaqafa wa al-fann: al-qabiliya lil tahawwul al-shakli ka khassiyya fi al-takwin al-thaqafi lil fannan al-misri 'abr al-tarikh (Culture and Art: The Capacity for the Transformation of Form as a Particularity of the Cultural Composition of the Egyptian Artist Throughout History). Unpublished paper from the Third National Meeting of Plastic Arts, Supreme Council of Culture, Egypt.

———. 2000. *Al-qiyam al-jamaliyya fi al-funun al-tashkiliyya* (Aesthetic Values in the Fine Arts). Cairo: Dar al-fikr al-'arabi.

'Attar, Mukhtar al-. 1996. *Ruwad al-fann wa tal'iyat al-tanwir fi misr* (The Pioneers of

Art and the Emergence of Enlightenment in Egypt). Cairo: Al-hay'a al-misriyya al-'amma lil-kitab.

Bahnasi, 'Afif al-. 1997. *Al-fann al-'arabi al-hadith: bayna al-hawiyya wa al-taba'iya* (Modern Arab Art: Between Identity and Dependency). Cairo: Dar al-kitab al-'arabi.

Baker, Raymond. 1990. *Sadat and After: Struggles for Egypt's Political Soul.* Cambridge, Mass.: Harvard University Press.

Bakewell, Liza. 1995. Bellas Artes and Artes Populares: The Implications of Difference in the Mexico City Art World. In *Looking High and Low: Art and Cultural Identity*, ed. Liza Bakewell and Brenda Jo Bright, 19–54. Tucson: University of Arizona Press.

Bal, Mieke. 1994. Telling Objects: A Narrative Perspective on Collecting. In *The Cultures of Collecting*, ed. John Elsner and Roger Cardinal, 97–115. Cambridge, Mass.: Harvard University Press.

Baron, Beth. 1997. Nationalist Iconography: Egypt as a Woman. In *Rethinking Nationalism in the Arab Middle East*, ed. James Jankowski and Israel Gershoni, 105–24. New York: Columbia University Press.

Barthes, Roland. 1977. *Image-Music-Text.* Translated by Stephen Heath. New York: Hill & Wang.

Beaulieu, Jill, and Mary Roberts, eds. 2002. *Orientalism's Interlocutors: Painting, Architecture, Photography.* Durham, N.C.: Duke University Press.

Becker, Howard. 1982. *Art Worlds.* Berkeley: University of California Press.

Bennett, Tony. 1992. Putting Policy into Cultural Studies. In *Cultural Studies*, ed. Lawrence Grossberg, Cary Nelson, and Paula A. Treichler, 23–37. New York: Routledge.

Berdahl, Daphne, Matti Bunzl, and Martha Lampland, eds. 2000. *Altering States: Ethnographies of Transition in Eastern Europe and the Former Soviet Union.* Ann Arbor: University of Michigan Press.

Bernal, Victoria. 2004. Eritrea Goes Global: Reflections on Nationalism in a Transnational Era. *Cultural Anthropology* 19 (1): 3–25.

Bhabha, Homi. 1990. The Third Space. In *Identity: Community, Culture, Difference*, ed. Jonathan Rutherford, 207–21. London: Lawrence & Wishart.

———. 1994. *The Location of Culture.* London: Routledge.

Bigenho, Michelle. 2002. *Sounding Indigenous: Authenticity in Bolivian Music Performance.* New York: Palgrave.

Bier, Laura. 2006. From Mothers of the Nation to Daughters of the State: Egyptian Women and Nasserism, 1952–1967. Ph.D. diss., New York University.

Bissell, William Cunningham. 2005. Engaging Colonial Nostalgia. *Cultural Anthropology* 20 (2): 215–48.

Boghiguian, Anna. 2003. *Anna's Egypt: An Artist's Journey.* Cairo: American University in Cairo Press.

Bourdieu, Pierre. 1984. *Distinction: A Social Critique of the Judgment of Taste.* Translated by Richard Nice. Cambridge, Mass.: Harvard University Press.

———. 1993. *The Field of Cultural Production: Essays on Art and Literature*. New York: Columbia University Press.

Boyer, Dominic. 2001a. Foucault in the Bush: The Social Life of Post-Structuralist Theory in East Berlin's Prenzlauer Berg. *Ethnos* 66 (2): 207–36.

———. 2001b. Yellow Sand of Berlin. *Ethnography* 2 (3): 421–39.

Boyer, Dominic, and Claudio Lomnitz. 2005. Intellectuals and Nationalism: Anthropological Engagements. *Annual Review of Anthropology* 34:105–20.

Breckenridge, Carol. 1989. The Aesthetics and Politics of Colonial Collecting: India at World Fairs. *Comparative Studies in Society and History* 31:195–216.

Brown, Michael F. 2003. *Who Owns Native Culture?* Cambridge, Mass.: Harvard University Press.

Brubaker, Rogers. 1996. *Nationalism Reframed: Nationhood and the National Question in the New Europe*. Cambridge: Cambridge University Press.

Bürger, Peter. 1984. *Theory of the Avant-Garde*. Minneapolis: University of Minnesota Press.

Burn, Ian, Nigel Lendon, Charles Merewether, and Ann Stephen. 1988. *The Necessity of Australian Art: An Essay About Interpretation*. Sydney: Power Publications.

Calhoun, Craig, Edward LiPuma, and Moishe Postone, eds. 1993. *Bourdieu: Critical Perspectives*. Chicago: University of Chicago Press.

Canclini, Néstor García. 1995. *Hybrid Cultures: Strategies for Entering and Leaving Modernity*. Minneapolis: University of Minnesota Press.

Carpenter, Edmund. 1971. The Eskimo Artist. In *Anthropology and Art: Readings in Cross-Cultural Aesthetics*, ed. Charlotte Otten, 163–71. Garden City, N.Y.: Natural History Press.

Cattelino, Jessica R. 2004. High Stakes: Seminole Sovereignty in the Casino Era. Ph.D. diss., New York University.

Chakrabarty, Dipesh. 2000. *Provincializing Europe: Postcolonial Thought and Historical Difference*. Princeton: Princeton University Press.

Chatterjee, Partha. 1986. *Nationalist Thought and the Colonial World: A Derivative Discourse*. Minneapolis: University of Minnesota Press.

———. 1993. *The Nation and Its Fragments: Colonial and Postcolonial Histories*. Princeton: Princeton University Press.

———. 1995. The Disciplines in Colonial Bengal. In *Texts of Power: Emerging Disciplines in Colonial Bengal*, ed. Partha Chatterjee, 1–29. Minneapolis: University of Minnesota Press.

Clark, T. J. 1984. *The Painting of Modern Life: Paris in the Art of Manet and His Followers*. New York: Knopf.

Clifford, James. 1988. *The Predicament of Culture: Twentieth-Century Ethnography, Literature, and Art*. Cambridge, Mass.: Harvard University Press.

Coffey, Wallace, and Rebecca Tsosie. 2001. Rethinking the Tribal Sovereignty Doctrine:

Cultural Sovereignty and the Collective Future of Indian Nations. *Stanford Law and Policy Review* 12 (2): 191–221.

Colla, Elliott. 2000. Shadi Abd al-Salam's *al-Mumiya*: Ambivalence and the Egyptian Nation-State. In *Beyond Colonialism and Nationalism in the Maghrib: History, Culture, Politics*, ed. Ali Abdellatif Ahmida, 109–43. New York: Palgrave.

———. 2001–2. The Stuff of Egypt: The Nation, The State, and Their Proper Objects. *New Formations* 45 (Winter): 72–90.

———. Forthcoming. *Conflicted Antiquities: Egyptology, Egyptomania, Egyptian Modernity*. Durham, N.C.: Duke University Press.

Comaroff, Jean, and John Comaroff. 1991. *Of Revelation and Revolution: Christianity, Colonialism, and Consciousness in South Africa*. Chicago: University of Chicago Press.

———. 2000. Millenial Capitalism: First Thoughts on a Second Coming. *Public Culture* 12 (2): 291–343.

Coombe, Rosemary J. 1998. *The Cultural Life of Intellectual Properties: Authorship, Appropriation, and the Law*. Durham, N.C.: Duke University Press.

———. 2005. Legal Claims to Culture in and Against the Market: Neoliberalism and the Global Proliferation of Meaningful Difference. *Law, Culture and Humanities* 1 (1): 32–55.

d'Acevedo, Warren. 1973. *The Traditional Artist in African Societies*. Bloomington: University of Indiana Press.

Danto, Arthur. 1964. The Artworld. *Journal of Philosophy* 61:571–84.

David, Catherine, ed. 2004. *Tamass 2: Cairo*. Rotterdam: Witte de With.

Disuqi, 'Asim al-. 1995. *Jam'at hilwan: al-tarikh wa afaq al-mustaqbal* (Helwan University: History and Future Horizons). Cairo: Helwan University.

Douglas, Mary. 1966. *Purity and Danger: An Analysis of the Concepts of Pollution and Taboo*. London: Routledge & Kegan Paul.

Dubin, Margaret. 2001. *Native America Collected: The Culture of an Art World*. Albuquerque: University of New Mexico Press.

Eagleton, Terry. 1990. *The Ideology of the Aesthetic*. Oxford: Blackwell.

Elias, Norbert. 1994. *The Civilizing Process: Sociogenetic and Psychogenetic Investigations*. Translated by Edmund Jephcott. Malden, Mass.: Blackwell.

Errington, Shelly. 1998. *The Death of Authentic Primitive Art and Other Tales of Progress*. Berkeley: University of California Press.

Fabian, Johannes. 1983. *Time and the Other: How Anthropology Makes Its Object*. New York: Columbia University Press.

Fabian, Johannes, and Tshibumba Kanda Matulu. 1996. *Remembering the Present: Painting and Popular History in Zaire*. Berkeley: University of California Press.

Ferguson, James. 1999. *Expectations of Modernity: Myths and Meanings of Urban Life on the Zambian Copperbelt*. Berkeley: University of California Press.

Fernandez, James. 1971. Principles of Opposition in Fang Aesthetics. In *Art and Aesthetics in Primitive Societies*, ed. Carol Jopling, 356–73. New York: Dutton.

Firth, Raymond. 1951. The Social Framework of Primitive Art. In *Elements of Social Organization*, ed. id., 155–82. London: Watts.

Flood, Barry. 2002. Between Cult and Culture: Bamiyan, Islamic Iconoclasm, and the Museum. *Art Bulletin* 84 (4): 641–59.

Forge, Anthony. 1967. The Abelam Artist. In *Social Organization: Essays Presented to Raymond Firth*, ed. M. Freedman, 65–84. London: Cass.

Foucault, Michel. 1984. Nietzsche, Genealogy, History. In *The Foucault Reader*, ed. Paul Rabinow, 76–100. New York: Pantheon Books.

Gell, Alfred. 1998. *Art and Agency: An Anthropological Theory*. Oxford: Oxford University Press.

George, Kenneth M. 1997. Some Things That Have Happened to "The Sun After September 1965": Politics and the Interpretation of an Indonesian Painting. *Comparative Studies in Society and History* 39 (4): 603–34.

———. 1998. Designs on Indonesia's Muslim Communities. *Journal of Asian Studies* 57 (3): 693–713.

———. 1999. Signature Work: Bandung, 1994. *Ethnos* 64 (2): 212–31.

Gershoni, Israel, and James Jankowski. 1986. *Egypt, Islam, and the Arabs: The Search for Egyptian Nationhood, 1900–1930*. Oxford: Oxford University Press.

———. 1995. *Redefining the Egyptian Nation, 1930–1945*. Cambridge: Cambridge University Press.

Gharieb, Samir. 1986. *Surrealism in Egypt and Plastic Arts*. Cairo: Foreign Cultural Information Department.

Ghitani, Gamal al-. 1990. *Kitab al-tajaliyyat* (Book of Revelations). Cairo: Dar al-shuruq.

Ginat, Rami. 1997. *Egypt's Incomplete Revolution: Lutfi al-Khuli and Nasser's Socialism in the 1960s*. London: Frank Cass.

Ginsburg, Faye, Lila Abu-Lughod, and Brian Larkin, eds. 2002. *Media Worlds: Anthropology on New Terrain*. Berkeley: University of California Press.

Goffman, Erving. 1974. *Frame Analysis*. New York: Harper.

Golan, Romy. 1995. *Modernity and Nostalgia: Art and Politics in France Between the Wars*. New Haven: Yale University Press.

Golomb, Jacob. 1995. *In Search of Authenticity: From Kierkegaard to Camus*. London: Routledge.

Gordon, Joel. 1992. *Nasser's Blessed Movement: Egypt's Free Officers and the July Revolution*. New York: Oxford University Press.

———. 2000. *Nasser 56*/Cairo 96: Reimagining Egypt's Lost Community. In *Mass Mediations: New Approaches to Popular Culture in the Middle East and Beyond*, ed. Walter Armbrust, 161–81. Berkeley: University of California Press.

Graeber, David. 2002. The Anthropology of Globalization (With Notes on Neomedi-

evalism, and the End of the Chinese Model of the Nation-State). *American Anthropologist* 104 (4): 1222–27.

Gramsci, Antonio. 1971. *Selections from the Prison Notebooks.* New York: International Publishers.

Guha-Thakurta, Tapati. 1992. *The Making of a New "Indian" Art: Artists, Aesthetics, and Nationalism in Bengal, 1850–1920.* Cambridge: Cambridge University Press.

———. 1995. Recovering the Nation's Art. In *Texts of Power: Emerging Disciplines in Colonial Bengal,* ed. Partha Chatterjee, 63–92. Minneapolis: University of Minnesota Press.

———. 2004. *Monuments, Objects, Histories: Institutions of Art in Colonial and Postcolonial India.* New York: Columbia University Press.

Guilbault, Serge. 1983. *How New York Stole the Idea of Modern Art: Abstract Expressionism, Freedom and the Cold War.* Chicago: University of Chicago Press.

Gupta, Akhil, and James Ferguson. 1997. Beyond "Culture": Space, Identity, and the Politics of Difference. In *Culture, Power, Place: Explorations in Critical Anthropology,* ed. id., 33–51. Durham, N.C.: Duke University Press.

Hakim, Tawfiq al-. 1933. *'Awdat al-ruh* (Return of the Spirit). Cairo: Maktabat misr.

Halle, David. 1993. *Inside Culture: Art and Class in the American Home.* Chicago: University of Chicago Press.

Hamdan, Jamal. 1970. *Shakhsiyyat misr: dirasa fi 'abqariyyat al-mikan* (The Character of Egypt: A Study in the Uniqueness of Place). Cairo: Maktabat al-nahda al-misriyya.

Hanafi, Hasan. 1980. *Al-turath wa al-tajdid: mawqifna min al-turath al-qadim* (Heritage and Renewal: Our Relation to Ancient Heritage). Cairo: Al-markaz al-'arabi lilbahth wa al-nashr.

Handler, Richard. 1988. *Nationalism and the Politics of Culture in Quebec.* Madison: University of Wisconsin Press.

Harney, Elizabeth. 2004. *In Senghor's Shadow: Art, Politics, and the Avant-Garde in Senegal, 1960–1995.* Durham: Duke University Press.

Herzfeld, Michael. 1986. *Ours Once More: Folklore, Ideology, and the Making of Modern Greece.* New York: Pella.

Heyworth-Dunne, James. 1938. *An Introduction to the History of Education in Modern Egypt.* London: Luzac.

Hinnebusch, Raymond A. 1998. *Egyptian Politics Under Sadat: The Post-Populist Development of an Authoritarian-Modernizing State.* Boulder, Colo.: Lynne Rienner.

Hobsbawm, Eric, and Terence Ranger, eds. 1983. *The Invention of Tradition.* Cambridge: Cambridge University Press.

Home, Stewart. 1996. The Art of Chauvinism. Available at: http://bak.spc.org/everything/e/hard/text/shome.html (accessed May 24, 2006).

Hourani, Albert. 1983. *Arabic Thought in the Liberal Age: 1798–1939.* Cambridge: Cambridge University Press.

Hughes, Robert. 1991. *The Shock of the New*. New York: Knopf.

Hussein, Mahmoud. 1973. *Class Conflict in Egypt, 1945–1970*. New York: Monthly Review Press.

Ibrahim, Sonallah. 2001. *Zaat* (Self). Translated by Anthony Calderbank. Cairo: American University in Cairo Press.

Ingold, Tim, ed. 1996. Aesthetics as a Cross-Cultural Category. In *Key Debates in Anthropology*, ed. id., 249–93. London: Routledge.

Iskandar, Rushdi, Kamal al-Malakh, and Subhi al-Sharuni. 1991. *Thamanun sana min al-fann* (Eighty Years of Art). Cairo: Al-hay'a al-misriyya al-'amma lil-kitab.

Jabakhanji, Muhammad Sidqi. 1995. *Muqtanayat Muhammad Khalil al-fanniyya* (Muhammad Khalil's Art Collection). Cairo: Ministry of Culture.

Jacquemond, Richard. 2003. *Entre scribes et écrivains: Le champ littéraire dans l'Égypte contemporain*. Paris: Actes sud.

Jameson, Frederic. 1986. Third World Literature in the Era of Multinational Capitalism. *Social Text* 15:65–88.

Jones, Anna Laura. 1993. Exploding Canons: The Anthropology of Museums. *Annual Review of Anthropology* 22:201–20.

Jusdanis, Gregory. 1991. *Belated Modernity and Aesthetic Culture: Inventing National Literature*. Minneapolis: University of Minnesota Press.

Kapferer, Bruce. 1988. *Legends of People, Myths of State: Violence, Intolerance, and Political Culture in Sri Lanka and Australia*. Washington, D.C.: Smithsonian Institution Press.

Kapur, Geeta. 1993. When Was Modernism in Indian / Third World Art? *South Atlantic Quarterly* 92 (3): 473–514.

———. 1998. Globalization and Culture: Navigating the Void. In *The Cultures of Globalization*, ed. Fredric Jameson and Masao Miyoshi, 191–217. Durham, N.C.: Duke University Press.

———. 2000. *When Was Modernism? Essays on Contemporary Cultural Practice in India*. New Delhi: Tulika.

Karnouk, Liliane. 1988. *Modern Egyptian Art: The Emergence of a National Style*. Cairo: American University in Cairo Press.

———. 1995. *Contemporary Egyptian Art*. Cairo: American University in Cairo Press.

Karp, Ivan, and Steven Lavine, eds. 1991. *Exhibiting Cultures: The Poetics and Politics of Museum Display*. Washington, D.C.: Smithsonian Institution Press.

Karp, Ivan, Christine Kreamer, and Steven Lavine, eds. 1992. *Museums and Communities: The Politics of Public Culture*. Washington, D.C.: Smithsonian Institution Press.

Khalifa, 'Abd al-Latif Muhammad and Sh'aban Jaballah Radwan. 1998. *Al-shakhsiyya al-misriyya: al-malamih wa al-ab'ad* (The Egyptian Personality: The Features and Dimensions). Cairo: Dar gharib.

Koptiuch, Kristin. 1999. *A Poetics of Political Economy in Egypt*. Minneapolis: University of Minnesota Press.

Krasner, Stephen. 1999. *Sovereignty: Organized Hypocrisy.* Princeton: Princeton University Press.

Kuppinger, Petra. 2004. Exclusive Greenery: New Gated Communities in Cairo. *City & Society* 16 (2): 35–61.

Lam'i, Gamal. 1984. "Modernization Theory in Art as an Introduction to the Contemporary Egyptian School." *Helwan University Research Studies* 7 (2): 59–78.

———. 1999. "Turath and Multiculturalism in Postmodern Art: Future Plan for Art and Art Education Colleges in the Arab World." Paper presented at the Seventh Scientific Conference at the Cairo College of Art Education.

Laroui, Abdallah. 1976. *The Crisis of the Arab Intellectual: Traditionalism or Historicism?* Berkeley: University of California Press.

Lewis, Justin, and Toby Miller, eds. 2003. *Critical Cultural Policy Studies: A Reader.* Oxford: Blackwell.

Linnekin, Jocelyn. 1991. Cultural Invention and the Dilemma of Authenticity. *American Anthropologist* 93:446–49.

Liu, Lydia, ed. 1999. *Tokens of Exchange: The Problem of Translation in Global Circulations.* Durham, N.C.: Duke University Press.

Lomnitz, Claudio. 1992. *Exits from the Labyrinth: Culture and Ideology in the Mexican National Space.* Berkeley: University of California Press.

MacClancy, Jeremy, ed. 1997. *Contesting Art: Art, Politics and Identity in the Modern World.* Oxford: Berg.

MacIntyre, Alisdair. 1981. *After Virtue.* London: Duckworth.

Macleod, Dianne Sachko. 1996. *Art and the Victorian Middle Class: Money and the Making of Cultural Identity.* Cambridge: Cambridge University Press.

Mahmood, Saba. 2005. *Politics of Piety: The Islamic Revival and the Feminist Subject.* Princeton: Princeton University Press.

Mahmud, Mustafa Mutada 'Ali. 1998. *Al-Muthaqqaf wa al-sulta: dirasa tahliliyya li-wad'a al-muthaqqaf al-misri fi al-fatra min 1970–1995* (The Intellectual and Authority: An Analytic Study of the Situation of the Egyptian Intellectual in the Period 1970–1995). Cairo: Dar qiba'.

Mahon, Maureen. 2000. The Visible Evidence of Culture Producers. *Annual Review of Anthropology* 29:467–92.

Malkki, Liisa. 1995. *Purity and Exile: Violence, Memory, and National Cosmology Among Hutu Refugees in Tanzania.* Chicago: University of Chicago Press.

Mannheim, Karl. 1952. *Essays on the Sociology of Knowledge.* London: RKP.

Marcus, George. 1992. *Lives in Trust: The Fortunes of Dynastic Families in Late Twentieth-Century America.* Boulder, Colo.: Westview Press.

———. 1995. Middlebrow into Highbrow at the J. Paul Getty Trust, Los Angeles. In *Looking High and Low: Art and Cultural Identity,* ed. Brenda Jo Bright and Liza Bakewell, 173–98. Tucson: University of Arizona Press.

———. 1998. *Ethnography Through Thick and Thin*. Princeton: Princeton University Press.

Marcus, George, ed. 1983. *Elites: Ethnographic Issues*. Albuquerque: University of New Mexico Press.

Marcus, George, and Fred Myers, eds. 1995. *The Traffic in Culture: Refiguring Art and Anthropology*. Berkeley: University of California Press.

Mazzarella, William. 2004. Culture, Globalization, Mediation. *Annual Review of Anthropology* 33:345–67.

Mehrez, Samia. 1994. *Egyptian Writers Between History and Fiction*. Cairo: American University in Cairo Press.

Mehrez, Samia, and James Stone. 1999. Women, History, Memory: Huda Lutfi. *Alif* 19:223–44.

Messiri, Sawsan el-. 1978. *Ibn Al-Balad: A Concept of Egyptian Identity*. Leiden: E. J. Brill.

Miller, Daniel. 1991. Primitive Art and the Necessity of Primitivism to Art. In *The Myth of Primitivism: Perspectives on Art*, ed. S. Hiller, 50–71. London: Routledge.

Miller, Toby, and George Yúdice. 2002. *Cultural Policy*. London: Sage Publications.

Mitchell, Timothy. 1991. The Limits of the State: Beyond Statist Approaches and Their Critics. *American Political Science Review* 85 (1): 77–96.

———. 2000. The Stage of Modernity. In *Questions of Modernity*, ed. id., 1–34. Minneapolis: University of Minnesota Press.

———. 2002. *Rule of Experts: Egypt, Techno-Politics, Modernity*. Berkeley: University of California Press.

Morphy, Howard. 1991. *Ancestral Connections: Art and an Aboriginal System of Knowledge*. Chicago: University of Chicago Press.

Moulin, Raymond. 1987. *The French Art Market: A Sociological Review*. New Brunswick, N.J.: Rutgers University Press.

Mullin, Molly. 1995. The Patronage of Difference: Making Indian Art "Art, Not Ethnology." In *The Traffic in Culture: Refiguring Art and Anthropology*, ed. George Marcus and Fred Myers, 166–98. Berkeley: University of California Press.

———. 2001. *Culture in the Marketplace: Gender, Art, and Value in the American Southwest*. Durham, N.C.: Duke University Press.

Muensterberger, Werner. 1993. *Collecting: An Unruly Passion—Psychological Perspectives*. Princeton: Princeton University Press.

Munir, Walid. 1998. *Thaqafat al-fannan al-'arabi bayna al-sira' wa al-tafa'ul* (The Culture of the Contemporary Arab Artist Between Struggle and Interaction). Unpublished paper from the Third National Meeting of Plastic Arts, Supreme Council of Culture, Egypt.

Myers, Fred. 1991. Representing Culture: The Production of Discourse(s) for Aboriginal Acrylic Paintings. *Cultural Anthropology* 6 (1): 26–62.

————. 1994a. Beyond the Intentional Fallacy: Art Criticism and the Ethnography of Aboriginal Acrylic Painting. *Visual Anthropology Review* 10 (1): 10–42.

————. 1994b. Culture-making: Performing Aboriginality at the Asia Society Gallery. *American Ethnologist* 21:679–99.

————. 2001. Introduction: The Empire of Things. In *The Empire of Things: Regimes of Value and Material Culture*, ed. id., 3–61. Santa Fe, N.M.: School of American Research Press.

————, ed. 2001. *The Empire of Things: Regimes of Value and Material Culture*. Santa Fe: N.M. School of American Research Press.

————. 2002. *Painting Culture: The Making of an Aboriginal Fine Art*. Durham, N.C.: Duke University Press.

Nader, Laura. 1974. Up the Anthropologist—Perspectives Gained from Studying Up. In *Reinventing Anthropology*, ed. Dell Hymes, 284–311. New York: Random House.

Nader, Laura, Salwa Nashashibi, and Etel Adnan. 1994. *Forces of Change: Artists of the Arab World*. Washington, D.C.: National Museum of Women in the Arts.

Naef, Silvia. 1996. *À la recherche d'une modernité Arabe: L'évolution des arts plastiques en Égypte, au Liban, et en Irak*. Geneva: Slatkine.

Nagib, 'Izz al-Din. 1985. *Al-samitun: tajarib fi al-thaqafa wa al-dimuqratiyya bil-rif al-misri* (The Silent Ones: Experiments in Culture and Democracy in the Egyptian Countryside). Cairo: Printed privately by the author.

————. 1997. *Al-tawwajuh al-ijtima'i lil-fannan al-masri al-mu'asir* (The Social Direction of the Contemporary Egyptian Artist). Cairo: Al-majlis al-'ala lil-thaqafa.

————. 2000. *Fajr al-taswir al-misri al-hadith* (The Dawn of Modern Egyptian Painting). Cairo: Al-hay'a al-misriyya al-'amma lil-kitab.

Nak-chung, Paik. 1998. Nations and Literatures in the Age of Globalization. In *The Cultures of Globalization*, ed. Fredric Jameson and Masao Miyoshi, 218–29. Durham, N.C.: Duke University Press.

Niranjana, Tejaswini. 1992. *Siting Translation: History, Post-structuralism, and the Colonial Context*. Berkeley: University of California Press.

Oguibe, Olu. 2004. *The Culture Game*. Minneapolis: University of Minnesota Press.

Oguibe, Olu, and Okwui Enwezor, eds. 1999. *Reading the Contemporary: African Art from Theory to the Marketplace*. Cambridge, Mass.: MIT Press.

Ong, Aihwa. 1999. *Flexible Citizenship: The Cultural Logics of Transnationality*. Durham, N.C.: Duke University Press.

Pearce, Susan M. 1994. Collecting Reconsidered. In *Interpreting Objects and Collections*, ed. id., 193–204. London: Routledge.

Perry, Richard Warren, and Bill Maurer, eds. 2003. *Globalization Under Construction: Governmentality, Law, Identity*. Minneapolis: University of Minnesota Press.

Phillips, Ruth, and Christopher Steiner, eds. 1999. *Unpacking Culture: Art and Commodity in Colonial and Postcolonial Worlds*. Berkeley: University of California Press.

Pilcher, Jane. 1994. Mannheim's Sociology of Generations: An Undervalued Legacy. *British Journal of Sociology* 45 (3): 484–89.

Plattner, Stuart. 1996. *High Art Down Home: An Economic Ethnography of a Local Art Market.* Chicago: University of Chicago Press.

Podeh, Elie, and Onn Winckler, eds. 2004. *Rethinking Nasserism: Revolution and Historical Memory in Modern Egypt.* Gainesville: University Press of Florida.

Price, Sally. 1989. *Primitive Art in Civilized Places.* Chicago: University of Chicago Press.

Raf', 'Aliya'. 1996. *Al-shakhsiyya al-misriyya: dirasa anthrubulujiyya lil-madrasa al-misriyya lil-fann wa al-hayaa* (The Egyptian Personality: An Anthropological Study of the Egyptian School of Art and Life). Alexandria: Dar sadiq.

Reid, Donald Malcolm. 1991. *Cairo University and the Making of Modern Egypt.* Cairo: American University in Cairo Press.

Rofel, Lisa. 1999. *Other Modernities: Gendered Yearnings in China After Socialism.* Berkeley: University of California Press.

Rosaldo, Renato. 1989. Imperialist Nostalgia. *Representations* 26:107–22.

Ross, Andrew. 1989. *No Respect: Intellectuals and Popular Culture.* New York: Routledge.

Roussillon, Alain, and Christine Roussillon. 1990. *Abdel Hadi Al-Gazzar: An Egyptian Painter.* Cairo: Dar al-mustaqbal al-'arabi.

Said, Hamed. 1986. *The Friends of Art and Life.* Cairo: Ministry of Culture.

Salamandra, Christa. 2004a. *A New Old Damascus: Authenticity and Distinction in Urban Syria.* Bloomington: Indiana University Press.

———. 2004b. Authenticity Commodified: Transnational Markets and Arab Locals. Paper presented at the Fifth Mediterranean Social and Political Research Meeting, Florence and Montecatini Terme, March 24-28, 2004, organised by the Mediterranean Programme of the Robert Schuman Centre for Advanced Studies at the European University Institute.

Salih, Tayeb. 1970. *Season of Migration to the North.* Translated by Denys Johnson-Davies. Portsmouth, N.H.: Heinemann Press.

Salim, Ahmed Fu'ad. 1998. *I'adat qira'a harakat al-fann al-misriyya fi itar naqd al-'aql al-tashkili* (A Rereading of the Egyptian Art Movement Through Criticism of the Artistic Mindset). Unpublished paper from the Third National Meeting of Plastic Arts, Supreme Council of Culture, Egypt.

———. 1999. *Sab' maqalat fi al-fann* (Seven Articles on Art). Cairo: Al-hay'a al-'amma lil qusur al-thaqafa.

Salmawy, Mohamed. 1995. *Mohamed Mahmoud Khalil: L'homme et le musée.* Cairo: Ministry of Culture.

Sassen, Saskia. 1996. *Losing Control? Sovereignty in an Age of Globalization.* New York: Columbia University Press.

Scheid, Kirsten. 2005. Painters, Picture-Makers, and Lebanon: Ambiguous Identities in an Unsettled State. Ph.D. diss., Princeton University.

Schein, Louisa. 2000. *Minority Rules: The Miao and the Feminine in China's Cultural Politics.* Durham, N.C.: Duke University Press.

Scott, David. 2004. *Conscripts of Modernity: The Tragedy of Colonial Enlightenment.* Durham, N.C.: Duke University Press.

———. 1999. *Refashioning Futures: Criticism After Postcoloniality.* Princeton: Princeton University Press.

Shannon, Jonathan Holt. 2005. Metonyms of Modernity in Contemporary Syrian Music and Painting. *Ethnos* 70 (3): 361–86.

———. 2006. *Among the Jasmine Trees: Music and Modernity in Contemporary Syria.* Middletown, CT: Wesleyan University Press.

Shukri, Ghali. 1990. *Al-muthaqqafun wa al-sulta fi misr* (Intellectuals and Authority in Egypt). Cairo: Dar akhbar al-yawm.

Sirri, Gazibiyya. 1998. *Gazbia Sirry: Lust for Color.* Edited by Morsi Saad El-Din. Cairo: American University in Cairo Press.

Smith, Charles D. 1983. *Islam and the Search for Social Order in Modern Egypt: A Biography of Muhammad Husayn Haykal.* Albany: State University of New York Press.

Smith, Elizabeth. 2006. Tributaries in the Stream of Civilization: Race, Ethnicity, and National Belonging Among Nubians in Egypt. Ph.D. diss., New York University.

Soueif, Ahdaf. 1999. *The Map of Love.* New York: Anchor Books.

Sonbol, Amira El-Azhary. 2000. *The New Mamluks: Egyptian Society and Modern Feudalism.* Syracuse, N.Y.: Syracuse University Press.

Spencer, Jonathan. 1990. Writing Within: Anthropology, Nationalism, and Culture in Sri Lanka. *Current Anthropology* 31 (3): 283–300.

Stanziola, Javier. 2002. Neoliberalism and Cultural Policy in Latin America. *International Journal of Cultural Policy* 8 (1): 21–35.

Starrett, Gregory. 1998. *Putting Islam to Work: Education, Politics, and Religious Transformation in Egypt.* Berkeley: University of California Press.

Steiner, Christopher. 1994. *African Art in Transit.* Cambridge: Cambridge University Press.

———. 2001. Rights of Passage: On the Liminal Identity of Art in the Border Zone. In *The Empire of Things: Regimes of Value and Material Culture,* ed. Fred Myers, 207–31. Santa Fe, N.M.: School of American Research Press.

Stevenson, Mark A. 1999. German Cultural Policy and Neo-Liberal Zeitgeist. *PoLAR* 22 (2): 64–78.

Stewart, Kathleen. 1988. Nostalgia—A Polemic. *Cultural Anthropology* 3 (3): 227–41.

Stewart, Susan. [1984] 1993. *On Longing: Narratives of the Miniature, the Gigantic, the Souvenir, the Collection.* Durham, N.C.: Duke University Press.

Stocking, George W., ed. 1985. *Objects and Others: Essays on Museums and Material Culture.* Madison: University of Wisconsin Press.

Stoler, Ann Laura. 1997. Sexual Affronts and Racial Frontiers: European Identities and

the Cultural Politics of Exclusion in Colonial Southeast Asia. In *Tensions of Empire: Colonial Cultures in a Bourgeois World*, ed. Frederick Cooper and Ann Laura Stoler, 198–237. Berkeley: University of California Press.

Suny, Ronald Grigor, and Michael D. Kennedy, eds. 1999. *Intellectuals and the Articulation of the Nation*. Ann Arbor: University of Michigan Press.

Svašek, Maruška. 1997. Identity and Style in Ghanaian Artistic Discourse. In *Contesting Art: Art, Politics and Identity in the Modern World*, ed. Jeremy MacClancy, 27–62. Oxford: Berg.

Swartz, David. 1997. *Culture & Power: The Sociology of Pierre Bourdieu*. Chicago: University of Chicago Press.

Thomas, Deborah A. 2004. *Modern Blackness: Nationalism, Globalization, and the Politics of Culture in Jamaica*. Durham, N.C.: Duke University Press.

Thomas, Nicholas. 1999. *Possessions: Indigenous Art/Colonial Culture*. London: Thames & Hudson.

Torgovnick, Marianna. 1990. *Gone Primitive: Savage Intellects, Modern Lives*. Chicago: University of Chicago Press.

Trilling, Lionel. 1971. *Sincerity and Authenticity*. Cambridge, Mass.: Harvard University Press.

Trumpener, Katie. 1996. Imperial Marches and Mouse Singers: Nationalist Mythology in Central European Modernity. In *Text and Nation: Cross-Disciplinary Essays on Cultural and National Identities*, ed. Laura Garcia-Moreno and Peter C. Pfeiffer, 67–90. New York: Camden House.

Turner, Stephen. 2002. Sovereignty, or the Art of Being Native. *Cultural Critique* 51:74–100.

Urban, Greg. 2001. *Metaculture: How Culture Moves Through the World*. Minneapolis: University of Minnesota Press.

Van Nieuwkerk, Karin. 1995. *"A Trade Like Any Other": Female Singers and Dancers in Egypt*. Austin: University of Texas Press.

Vázquez, Oscar E. 2001. *Inventing the Art Collection: Patrons, Markets, and the State in Nineteenth-century Spain*. University Park: Pennsylvania State University Press.

Verdery, Katherine. 1991. *National Ideology Under Socialism: Identity and Cultural Politics in Ceauşescu's Romania*. Berkeley: University of California Press.

———. 1996. *What Was Socialism, and What Comes Next?* Princeton: Princeton University Press.

Vitalis, Robert. 1995. *When Capitalists Collide: Business Conflict and the End of Empire in Egypt*. Berkeley: University of California Press.

Von Eschen, Penny M. 2004. *Satchmo Blows Up the World: Jazz Ambassadors Play the Cold War*. Cambridge, Mass.: Harvard University Press.

Wang, Horng-luen. 2000. Rethinking the Global and the National: Reflections on National Imaginations in Taiwan. *Theory, Culture & Society* 17 (4): 93–117.

Warwick, Genevieve. 2000. *The Arts of Collecting: Padre Sebastiano Resta and the Market for Drawings in Early Modern Europe*. Cambridge: Cambridge University Press.

Williams, Raymond. 1958. *Culture and Society, 1780–1850*. New York: Columbia University Press.

———. 1977. *Marxism and Literature*. Oxford: Oxford University Press.

Winegar, Jessica. 1999. Representing Women, Women Representing: Reflections on Art in Egypt. *Civil Society* 8 (95): 6–11.

———. 2002. In Many Worlds: A Discussion with Egyptian Artist Sabah Naeem. *Meridians: A Journal of Feminism, Race, Transnationalism* 2 (2): 146–62.

———. n.d. The Making of Modern Egyptian Art. Unpublished manuscript.

Wolff, Janet. 1981. *The Social Production of Art*. London: Macmillan.

Wu, Chin-tao. 2002. *Privatising Culture: Corporate Art Intervention since the 1980s*. London: Verso.

Yúdice, George. 2003. *The Expediency of Culture: Uses of Culture in the Global Era*. Durham, N.C.: Duke University Press.

Zayyat, Latifa. 1996. *The Search: Personal Papers*. Translated by Sophie Bennett. London: Quartet Books.

Zolberg, Vera. 1990. *Constructing a Sociology of the Arts*. Cambridge: Cambridge University Press.

Zuhur, Sherifa, ed. 1998. *Images of Enchantment: Visual and Performing Arts of the Middle East*. Cairo: American University in Cairo Press.

Zurbrigg, Kerstin. 2001. Cultivating History. *Nka: Journal of Contemporary African Art*, 14 / 15 (Spring–Summer): 62–65.

INDEX

Abaza, Mona, 349n25

'Abd al-Sabur, Salah, 273–74

'Abduh, Muhammad, 68, 99

Abnudi, 'Abd al-Rahman al-, 81

Abu-Lughod, Lila, 7, 189, 303, 330n6, 332n24, 338n12, 340n41

Abusabib, Mohamed, 341n48

Aesthetic / aesthetics, 4, 12–13, 22, 47, 59–60, 231, 331n18, 331n19, 335n30; Islamic, 99, 105, 123, 331n19

Ahmad, Aijaz, 333n13

Alexandria, 27, 37, 81, 88, 98, 184, 192, 269

Ali, Muhammad, 52

Ali, Wijdan, 335n28

Altorki, Soraya, 349n18

Ancient Egypt, *see* Pharaonic art / Pharaonicism

Anderson, Jon, 312

Andrade Oswaldo de, 340n41

Anthropology, 12–18 *passim*, 22–25, 31, 94ff, 129, 248f, 276, 332n30, 337f

Appadurai, Arjun, 20, 229, 313, 331n21

Armbrust, Walter, 7, 33, 334n6

Art: and anthropology, 11–12, 14f, 18, 22–24, 331n17; and issue of imitation, 6, 18, 26, 60–64 *passim*, 95, 102–6 *passim*, 110, 112, 119, 140, 164–65, 170, 177, 218, 222, 261, 292, 301, 339n17, 339n18; and money, 1, 3, 33, 73, 76, 80, 165–66, 187–88, 211–12, 254–55, 277f, 308–12; and primitivism, 22– 24, 290–91, 298; and rights discourse, 304–7, 313; and teleologies / notions of progress, 1–9 *passim*, 15–18, 26, 32, 38, 57, 93, 95–96, 104, 112, 126, 140, 142, 159, 168ff, 183, 188, 213,

231, 261, 278, 287–91 *passim*, 308, 313; and value, 4, 12, 14, 18, 24f, 46, 62, 138, 161–62, 165–66, 209, 215, 278, 280, 286, 303, 308, 310, 338–39n16; evaluation of, 1–6 *passim*, 11f, 16–20 *passim*, 26, 30–36 *passim*, 86, 91–96 *passim*, 102f, 105, 129, 140, 169–70, 277, 279, 288, 289–90, 291–92, 296–97, 298, 354n37

Art collectives, 98–99, 113, 177f, 217, 269, 344n6

Art criticism, 162, 170, 185, 194–97 *passim*, 244; Euro-American, 3–4, 11, 18, 26, 92–94 *passim*

Art education, 32, 44–80, 83; and colleges of art, 51–61 *passim*, 68, 72, 83, 88, 109, 175, 240, 260, 315, 334n19; and colonialism, 52–55 *passim*, 63, 97, 334n18; and pedagogy, 50, 57–61, 65, 66, 129, 334n19; and state socialism, 52, 55, 63, 83, 190, 195; as path to career, 49, 50, 54, 190

Art history, 11f, 23, 58–61, 82, 97ff, 123

Artists: and family relations, 45, 54ff, 62, 70–71, 74ff, 80, 161, 323; as artisans of nation, 21; as state employees, 44, 69, 144, 159–60, 163, 166, 175, 181, 190f, 292, 336n37; ideologies of, 3, 31–36 *passim*, 46ff, 53–56, 64–65, 69–70, 74, 79, 91, 101, 103f, 129, 217, 335n29, 335n30; religious practices of, 67, 76–78, 336n41. *See also* Generations, Intellectuals

Art markets, 26, 34, 225–29, 266–67, 277–82 *passim*, 291, 303, 308–12. *See also* Galleries

Asad, Talal, 7, 322, 330n9, 331n20

Asala, 98–102 *passim*, 107–17, 118–23 *passim*, 127, 159–75 *passim*, 234, 283, 340n37, 353n24. *See also* Authenticity

Stanford Studies in Middle Eastern and Islamic Societies and Cultures